Edition **27**

The Best of Newspaper Design

The 2005 Creative Competition of the Society for News Design

S **ETY FOR NEWS DESIGN**

MATLOCK Competition Committee Director

ON 27th Edition Coordinator

R 27th Edition Audit & Entry Director

SND Executive Director

Membership Manager

of Newspaper Design™ Editor

Newhouse School of Public Communications, Syracuse University (N.Y.)

The mission of the Society for News Design
is to enhance communication around the world
through excellence in visual journalism.

To that end, the Society will —

Promote the highest ethical standards in all of our crafts.
Champion visual journalism as an integral discipline.
Educate journalists on a continuing basis.
Celebrate excellence in all aspects of journalism.
Encourage innovation throughout our industry.
Provide a forum for critical review and discussion of issues.
Value our unique and diverse international and multicultural character.

SOCIETY FOR NEWS DESIGN
1130 Ten Rod Road, D 202
North Kingstown, RI 02852-4180 USA
(401) 294-5233
(401) 294-5238 fax
snd@snd.org
www.snd.org

Other distribution by Rockport Publishers
www.rockpub.com

ISBN-10: 1-59253-264-0
ISBN-13: 978-1-59253-264-3

Chapter One **15**
WORLD'S BEST-DESIGNED NEWSPAPERS™

Chapter Two **25**
JUDGES' SPECIAL RECOGNITION

Chapter Three **41**
MULTIPLE WINNERS
entries winning more than one award

Chapter Four **71**
NEWS
news, sports, inside pages & breaking news

Chapter Five **101**
FEATURES & MAGAZINES

Chapter Six **129**
VISUALS
illustration, photography,
informational graphics & miscellaneous

Chapter Seven **187**
SMALL NEWSPAPERS
circulation 49,999 & below

Chapter Eight **217**
SPECIAL COVERAGE
special coverage, special sections & reprints

Chapter Nine **235**
PORTFOLIOS

Chapter Ten **251**
REDESIGNS

followed by the indexes of people & publications

The **2005** *Society for News Design competition — edition* **27** *— attracted*

more than **14,610** *entries from* **415** *publications in* **46** *countries.*

221

GUILTY

74

96

120

128

INTRODUCTION

The winners showcased in this book represent the painstaking efforts, energy and creativity of thousands of designers around the world.

Judges selected the best of the best at the 27th Edition Best of Newspaper Design™ creative competition, and SND presents the winning images here for all to view, admire and study.

In the competition for 2005, judges did not award any Gold Medals, a first in SND history. To receive a Gold Medal, all five judges on a team must agree an entry deserves the honor, a feat none achieved this year. Gold Medal winners must embody state of the art, push the limits

of creativity and lack almost nothing. Judges did not find that perfect entry this year.

However, judges deemed the thousands of entries worthy of awards in 19 other categories.

Two publications were named the World's Best-Designed Newspapers™ for 2005.

The Silver Medal, awarded to 48 entries, was the highest award given to 2005 entries in general judging. Granted for work that exceeds excellence, the Silvers embody technical proficiency expanding the limits of the medium. These entries shine.

The Award of Excellence, given for truly exceptional work, went to the 1,077 entries that surpassed mere technical

or aesthetic competency. The award appropriately honors entries for being daring or innovative if they are outstanding but not perfect in every respect. "Be tough, but fair," judges were told. Unless otherwise noted, all winners in the book are Awards of Excellence.

Judges gave 10 Judges' Special Recognition awards. This honor is bestowed by a team of judges or by all judges for work that is outstanding in a certain aspect but not necessarily singled out by an Award of Excellence or a Silver or Gold award. The special recognition does not replace an Award of Excellence, Silver or Gold. The JSR is a complement to other awards.

Competition judges

made the tough calls among many distinguished entries. Thus you can enjoy hundreds of examples of the best newspaper design in 2005.

We hope the winners will inspire and motivate you to excel in all areas, especially news design.

Teams of **32** *judges, plus* **75** *facilitators, worked* **3,640** *hours on the competition. The result?*

Of the **212** *publications winning awards,* **2** *were designated World's Best-Designed Newspapers™.*

223

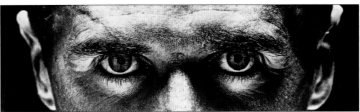

76

83

119

INTRODUCCIÓN

Los ganadores que muestra este libro representan los gigantescos esfuerzos, la enorme energía y la gran creatividad de miles de diseñadores de todo el mundo.

Los jueces seleccionaron lo mejor de lo mejor en la 27ª versión de la competencia creativa Lo Mejor del Diseño de Periódicos™, y la SND presenta aquí las imágenes ganadoras para que todos puedan verlas, admirarlas y estudiarlas.

Por primera vez en la historia de la SND, en la competición de 2005 los jueces no otorgaron ninguna medalla de oro. Para recibir una medalla de oro, los cinco jueces de un equipo deben estar de acuerdo en que un trabajo concursante se merece el honor, algo que ninguna logró este año. Los ganadores de oro deben conseguir definir el estado de las artes, llevar más allá los límites de la creatividad y no faltarles nada. Los jueces no encontraron ese trabajo este año.

Sin embargo, los jueces estimaron que miles de piezas debían ser premiadas en las demás diecinueve categorías.

Dos publicaciones fueron reconocidas como los Mejores Diseños de Periódico del Mundo™ en 2005.

La medalla de plata, entregada a 48 piezas concursantes, fue el mayor premio entregado en 2005 en la evaluación general. La de plata reconoce los trabajos que superan la excelencia y significa el dominio técnico que expande los límites del medio. Estas piezas son brillantes.

El Premio a la Excelencia, entregado a trabajos verdaderamente excepcionales, fue recibido por las 1.077 piezas que superaron la mera competencia técnica y estética. El premio ciertamente honra las piezas que son atrevidas o innovadoras si son sobresalientes pero no incomparables en cada respecto. "Sean exigentes, pero justos", se les pidió a los jueces. A no ser de que se indique lo contrario, todos los ganadores en el libro corresponden a Premios a la Excelencia.

Los jueces entregaron diez premios de Reconocimiento Especial de los Jueces. Un equipo de jueces o todos los jueces entregan este honor a los trabajos que son sobresalientes en algún aspecto pero no necesariamente logran un Premio a la Excelencia o una medalla de Plata u Oro. En todo caso, el reconocimiento especial no reemplaza ninguno de esos premios, sino que es un complemento.

Los jueces de la competencia tomaron decisiones difíciles entre las muchas piezas destacables. De esa forma, puede disfrutar de cientos de ejemplos de lo mejor del diseño de periódicos en 2005.

Esperamos que los ganadores inspiren y motiven a buscar la excelencia en todas las áreas, especialmente en el diseño de noticias.

There were **0** *Gold Medal winners and no Best of Show winner, but judges honored*

10 *Judges' Special Recognition winners,* **48** *Silver Medals and* **1,077** *Awards of Excellence.*

29

47

112

70

159

THE COMPETITION

Competition committee
director & judging director
Marshall Matlock
Syracuse University (N.Y.)

27th edition coordinator
Matt Erickson
Assistant sports editor for design
The Times of Northwest Indiana
Munster

CO-SPONSOR

S.I. Newhouse School of Public Communications

Syracuse University (N.Y.)

JUDGING FACILITATORS

Joni Alexander, graphics news assistant, USA Today, McLean, Va.

Jonathon Berlin, senior editor for design and graphics, San Jose Mercury News (Calif.), and editor of SND's Design journal

Stanley Bondy, Syracuse University (N.Y.)

Bill Bootz, presentation editor, The Oklahoman, Oklahoma City

Rich Boudet, sports designer, The News Tribune, Tacoma, Wash., and editor of SND's site, www.snd.org.

Reagan Branham, designer, St. Louis Post-Dispatch

Audrey Burian, Syracuse University (N.Y.)

Elise Burroughs, SND executive director, North Kingstown, R.I.

Alberto Cairo, assistant professor of graphic design and infographics, University of North Carolina, Chapel Hill

Steve Cavendish, assistant design editor for news, Chicago Tribune

Chris Courtney, design director, RedEye, Chicago

Wanda Damian, SND office assistant, North Kingstown, R.I.

Justin Ferrell, assistant news editor, The Washington Post

Bill Gaspard, deputy managing editor, Las Vegas Sun, and SND past president

Ron Johnson, journalism professor, Kansas State University, Manhattan, and editor of The Best of Newspaper Design™

Kris Kinkade, design editor, Kalamazoo Gazette (Mich.)

Megan Lavey, design editor, Sun Journal, Lewiston, Maine

Matt Mansfield, deputy managing editor, San Jose Mercury News (Calif.)

Sean McNaughton, assistant professor, S.I. Newhouse School of Public Communications, Syracuse University (N.Y.)

Kenny Monteith, news design team leader, The Atlanta Journal-Constitution

Suzette Moyer, graphics and design director, Hartford Courant (Conn.)

Eric Palm, staff editor, The New York Times News Services, New York

Tiffany Pease, sports designer, The Charlotte Observer (N.C.)

Leslie Plesser, designer, Star Tribune, Minneapolis

Keeli Pointer, sports designer, Fort Worth Star-Telegram (Texas)

Denise Reagan, design consultant, Fort Lauderdale, Fla., and SND Update editor

Mike Rice, visual team leader for design and graphics, Arizona Daily Star, Tucson

Epha Riche, news design director, The Indianapolis Star

Chris Ross, news design editor, The San Diego Union-Tribune

U.S. publications won **686** *awards, followed by* **86** *from Canada,* **85** *from Spain and* **52** *from México.*

Winning the most awards — with **85** *— was The New York Times.*

122

33

44

97

Chris Rukan, sports design director, The Palm Beach Post, West Palm Beach, Fla.

Kellye Sanford, senior designer and illustrator, Houston Chronicle

Susan Santoro, SND membership manager, North Kingstown, R.I.

Rob Schneider, design editor for sports, The Dallas Morning News

Emmet Smith, designer, The Plain Dealer, Cleveland

Chiyono Sugiyama, writer and designer, The Daily Yomiuri, Tokyo

Gregory Swanson, assistant managing editor for presentation, Quad-City Times, Davenport, Iowa

Dennis Varney, sports designer and copy editor, Lexington Herald-Leader (Ky.)

Shamus Walker, SND audit and entry director, Syracuse University (N.Y.)

Paul Wallen, managing editor for visuals, Sun Journal, Lewiston, Maine

Michael Whitley, news design director, Los Angeles Times

Steve Wolgast, staff editor for news design, The New York Times

Kittie Wong, artist, Winnipeg Free Press (Manitoba, Canada)

Syracuse University students

Meredith Bowen, Brian Ferguson, Sterling Gray, Taegan Grice, Andrew Kelly, Anne Kenady, Lisa Labbe, Lauren Mars, Carly Migliori, Kevin Winters Morriss, Jared Novack, Shane Rhinewald, Brandon Scott, Kim Storeygard, Michael Swartz, Lauren Sykes, Bob Thurlow and **Sahar Vahidi**

University of North Carolina students

Rachna Batra, Tracy Boyer, Lindsay DuBois and **Rachel Irvine**

THE BOOK

Editor
Ron Johnson
Kansas State University

Steve Wolgast
The New York Times

Cristobal Edwards
Universidad Catolica, Santiago, Chile

Katie Lane
Wichita Eagle (Kan.)

Kelly Furnas
Virginia Tech University, Blacksburg

Loni Woolery, Ryan Flynn and **Anthony Mendoza**
Kansas State University

Jan Hilderbrand
University of South Dakota, Vermillion

Kansas State University students

Logan Adams, Abby Brownback, Melissa Cessna, Hannah Crippen, Zachary Eckels, Christopher Hanewinckel, Angela Hanson, Sarah Hardy, Patrice Holderbach, Travis Hudson, Eileen Laux, Dayne Logan, Kelly Olson, Chris Patch, Alex Peak, Leann Sulzen and **Jackie Vondemkamp**

THE SOCIETY

President
Christine McNeal
Milwaukee Journal Sentinel (Wis.)

Vice president
Scott Goldman
The Indianapolis Star

Treasurer/Secretary
Gayle Grin
National Post, Toronto

Immediate past president
Bill Gaspard
Las Vegas Sun

Executive director
Elise Burroughs
North Kingstown, R.I.

President / SND Foundation
Steve Dorsey
Detroit Free Press

JUDGES

CASSIE ARMSTRONG is the deputy design editor at the Orlando Sentinel (Fla.) and the site chair for the Society's 2006 Annual Workshop and Exhibition in Orlando. She previously worked as the A1 lead designer at The Indianapolis Star, as a page designer at the South Florida Sun-Sentinel, Fort Lauderdale, and as a reporter, photographer and designer at a small afternoon daily in Robinson, Ill. Her work has been recognized with awards from SND and other organizations.

CASSIE ARMSTRONG es subeditora de diseño del Orlando Sentinel (Florida, EE.UU.) y la directora del taller y muestra anual de la SND en 2006 en Orlando. Anteriormente se desempeñó como diseñadora principal de la portada del diario en The Indianapolis Star, como diseñadora de página en el Sun-Sentinel, de Fort Lauderdale, sur de Florida, y como reportera, fotógrafa y diseñadora de un pequeño diario vespertino en Robinson, Illinois, EE.UU. Su trabajo ha sido premiado por la SND y otras organizaciones.

FERNANDO G. BAPTISTA is graphics director at El Correo, Bilbao, Spain, where he has been working for 14 years. His graphics have won many SND and international awards. He also teaches infographics at the University of Navarra and as the Master in Multimedia Journalism of Vocento.

FERNANDO G. BAPTISTA es director de gráficos del diario El Correo, de Bilbao, España, donde ha

trabajado durante 14 años. Sus gráficos han ganado muchos premios de la SND y de otras organizaciones internacionales. También enseña infografía en la Universidad de Navarra y en el Máster en Periodismo Multimedial de Vocento.

NANETTE BISHER, creative director for the San Francisco Chronicle, is an expert on the use of color in newspapers. She has played a leadership role in such publications as the Daily News, New York; The Orange County Register, Santa Ana, Calif.; U.S. News & World Report; and The Examiner, San Francisco. Immediately prior to joining the Chronicle, Bisher was a partner and strategic consultant for news at Danilo Black Inc. Her work has won design awards from the Society of Publication Designers, the New York Art Directors, SND and other organizations. She is a past president of SND and the SND Foundation.

NANETTE BISHER, directora creativa del periódico norteamericano San Francisco Chronicle, es una experta en el uso del color en los diarios. Ha jugado un rol de liderazgo en publicaciones tales como Daily News, de Nueva York; The Orange County Register, de Santa Ana, California; U.S. News & World Report; y The Examiner, de San Francisco. Antes de trabajar en el Chronicle, Bisher era socia y consultora estratégica de noticias del estudio Danilo Black Inc. Su trabajo ha sido premiado por organizaciones tales como la Society of Publication Designers (Sociedad de Diseñadores de Publicaciones), la New York Art Directors (Directores de Arte de Nueva York) y la SND. Fue presidenta de la SND y la SND Foundation.

JOE BREEN is managing editor for production, presentation and design at The Irish Times, Dublin. He has been involved in newspaper layout and design for 30 years. Breen has been an SND member since the mid-1990s and represents Region 15 on the SND board.

JOE BREEN es editor gerencial de producción, presentación y diseño del diario The Irish Times, de Dublín, Irlanda. Ha trabajado en diagramación y diseño de diarios durante 30 años. Breen ha sido miembro de la SND desde mediados de los años 90 y actualmente representa la Región 15 en el directorio de la SND.

J. DAMON CAIN, managing editor for presentation and design for The Denver Post, has 25 years in the newspaper business. He has worked as a reporter, photographer, designer, editor, columnist, news editor, director, assistant managing editor and managing editor. Cain was on the core team at The News & Observer, Raleigh, N.C., that won a Pulitzer Prize for public service in 1996. He also helped the paper win World's Best-Designed Newspaper™ in 1999.

J. DAMON CAIN, editor gerencial de presentación y diseño del diario The Denver Post, EE.UU., lleva 25 años en la industria de diarios. Ha trabajado como reportero, fotógrafo, diseñador, editor, columnista, editor de noticias, director editor gerencial asistente y editor gerencial . Cain fue parte del equipo central del diario The News & Observer, de Raleigh,

Carolina del Norte, EE.UU., que ganó el Premio Pulitzer por servicio público en 1996. También ayudó al diario a ganar el premio al Mejor Diseño de la SND en 1999.

SUSAN MANGO CURTIS is an educator, designer and consultant, currently teaching visual journalism at the Medill School of Journalism, Northwestern University, Evanston, Ill. She is a former assistant managing editor for the Akron Beacon Journal (Ohio), where she led a redesign in 1991. Three years later, she was part of the team that won a Pulitzer Prize for the series "The Question of Color." Curtis is a past president of SND.

SUSAN MANGO CURTIS es académica, diseñadora y consultora, y actualmente enseña periodismo visual en la escuela de periodismo Medill, Northwestern University, Evanston, Illinois, EE.UU. Fue editora gerencial asistente en el diario Akron Beacon Journal, Ohio, EE.UU., y lideró un rediseño en 1991. Tres años más tarde, fue parte de un equipo que ganó un Premio Pulitzer por la serie "The Question of Color" (El asunto sobre el color). Curtis fue presidenta de la SND.

JOE DIZNEY has been design director of The Wall Street Journal since 1999. His career at the Journal began in 1997 with the design and launch of Weekend Journal, the paper's successful Friday section. He led the redesign of The Wall Street Journal that debuted in April 2002.

JOE DIZNEY ha sido director de diseño del periódico The Wall Street Journal desde 1999. Su carrera en esa publlicación comenzó en 1997 con el diseño y el lanzamiento de Weekend Journal, la exitosa sección de fin de semana que se publica el viernes. Lideró el rediseño de The Wall Street Journal que debutó en abril de 2002.

BRIAN GROSS is sports-design supervisor at The Boston Globe, where he has worked for more than three years. Previously, he designed sports sections at the The San Diego Union-Tribune and the Savannah Morning News (Ga.), and he reported for papers in North Carolina and Illinois.

BRIAN GROSS es supervisor de diseño de deportes en el diario The Boston Globe, EE.UU., donde ha trabajado durante más de tres años. Anteriormente, diseñó secciones deportivas en los diarios norteamericanos The San Diego Union-Tribune y Savannah Morning News, de Georgia, y fue reportero de diarios de Carolina del Norte e Illinois.

KEVIN HAND, an assistant art director at Newsweek magazine, has worked in information graphics for 20 years. His career began in Fort Pierce, Fla., as a paste-up artist. He also had graphics positions at Florida Today, Melbourne; the Honolulu Star-Bulletin; and the Chicago Tribune. He has won SND and Malofiej awards, and he did a story presentation that won a Pulitzer.

KEVIN HAND, un director de arte asistente de la revista Newsweek, ha trabajado en infografía durante 20 años. Su carrera comenzó en Fort Pierce, Florida, EE.UU., como compaginador. También se desempeñó como infografista en los diarios norteamericanos Florida Today, de Melbourne; Honolulu Star-Bulletin; y Chicago Tribune. Ha obtenido premios de la SND y Malofiej, y realizó la presentación de un artículo que ganó un Premio Pulitzer.

AGNETE HOLK, a graphics director, has been employed as chief designing officer at Morgenavisen Jyllands-Posten, Viby, Denmark, since 1994. She has worked with news graphics, design and layout since 1987. She has received many awards for her work. Holk has been a member of SND since 1988.

AGNETE HOLK, directora de gráficos, ha trabajado como directora de diseño del diario Morgenavisen Jyllands-Posten, de Viby, Dinamarca, desde 1994. Ha trabajado con infográficos, diseño y diagramación desde

1987. Su trabajo ha sido muy premiado. Holk ha estado afiliada a la SND desde 1988.

AMELIA KUNHARDT has been a staff photographer at The Patriot Ledger, Quincy, Mass., since 2001. She worked as a staff photographer at The Topeka Capital-Journal (Kan.) from 1990 to 1995 and has freelanced in the United States, Russia and Italy. Her work has appeared in The Boston Globe, USA Today, The New York Times, Marie Claire Italy, American Photo and other publications. Pictures of the Year International also has honored her work.

AMELIA KUNHARDT ha sido fotógrafa contratada en el diario The Patriot Ledger, de Quincy, Massachussets, EE.UU., desde 2001. Trabajó en ese mismo puesto en el diario norteamericano The Topeka Capital-Journal, de Kansas, de 1990 a 1995 y en forma freelance en los Estados Unidos, Rusia e Italia. Su fotografía ha sido publicada en The Boston Globe, USA Today, The New York Times, Marie Claire Italy, American Photo y otras publicaciones. La competencia Pictures of the Year International (Fotografía del Año Internacional) ha premiado su trabajo.

LUCIE LACAVA is a design consultant and president of Lacava Design Inc., Montréal. Since founding her company in 1992, Lacava has developed an international reputation for award-winning editorial design and visual identity. Lacava's body of work includes the

redesign of more than 50 publications. She has received more than 100 national and international awards, and on 10 occasions, SND has named Le Devoir, Le Soleil and the National Post among the World's Best-Designed Newspapers™. She is a past president of SND.

LUCIE LACAVA es una consultora de diseño y la presidenta de Lacava Design Inc., de Montreal, Canadá. Desde que fundó su empresa, Lacava se ha ganado un renombre por su diseño editorial e identidad visual que ha sido premiado internacionalmente. El portafolio de Lacava incluye el rediseño de más de 50 publicaciones. Ha recibido más de 100 premios norteamericanos y de otros países, y en 10 ocasiones, la SND ha reconocido los diarios Le Devoir, Le Soleil y National Post entre los mejores diseñados del mundo. Fue presidenta de la SND.

INGRID LOHNE is assistant editor at DagensMedier, a trade paper owned by Norwegian Media Businesses' Association. Lohne has been editor of the Scandinavian news design magazine Aviserat since 1996. She has been the head of the Norwegian news design jury since 1999. Before that, Lohne was a member of the Swedish design jury for four years, three of them as jury head.

INGRID LOHNE es directora asistente de DagensMedier, un diario especializado de la Asociación de Medios de Negocios de Noruega. Lohne ha sido editora de Aviserat, la revista escandinava de noticias sobre diseño desde 1996. Ha estado al mando del jurado noruego de diseño de noticias desde 1999. Anteriormente, Lohne fue parte del jurado sueco de diseño durante cuatro años, tres de los cuales lo presidió.

SÓNIA MATOS has been art director at Público, in Lisbon, Portugal, since January 2006. Before that, she was art director at O Independente, in Lisbon, where she started in 2001 as a designer. She has won several design awards from SND and SND/E, SND's Spanish affiliate. Before O Independente, she worked at the national daily Diário de Notícias, Lisbon, as a designer. She also has collaborated on the design of Y and Mil Folhas, supplements of Público.

SÓNIA MATOS ha sido directora de arte del diario Público, de Lisboa, Portugal, desde enero de 2006. Anteriormente, fue directora de arte del diario O Independente, también de Lisboa, donde en 2001 comenzó como diseñadora. Ha obtenido varios premios de diseño de la SND y la SND/E, el Capítulo español de la SND. Antes de O Independente, se desempeñó como diseñadora en el periódico nacional portugués Diário de Notícias. También ha colaborado en el diseño de Y y Mil Folhas, suplementos Público.

CHRISTINE McNEAL, president of the Society for News Design, is deputy managing editor at the Milwaukee Journal Sentinel (Wis.). She previously worked at the Journal Star, Peoria, Ill., as a reporter, copy editor/designer, entertainment editor, graphics editor and assistant managing editor. Christine earned a journalism degree from Bradley University (Ill.) and studied design at the School of the

Art Institute of Chicago. She is pursuing a master's degree in media management from the University of Missouri.

CHRISTINE McNEAL, presidenta de la Sociedad de Diseño de Noticias, es subeditora gerencial del diario Milwaukee Journal Sentinel, de Wisconsin, EE.UU. Anteriormente trabajó en el Journal Star, de Peoria, Illinois, EE.UU., como reportera, editora y diseñadora, editora de entrentención , editora de gráficos y editora gerencial asistente. Christine se graduó como periodista por la Bradley University. De Illinois, EE.UU., y estudió diseño en el School of the Art Institute of Chicago. Actualmente, está realizando una maestría en gerencia de medios en la University of Missouri.

VAL B. MINA is the design director at the The Sacramento Bee (Calif.). Previously, he was with The Examiner, San Francisco, as an editorial illustrator/designer, and he later worked for the Los Angeles Times Orange County edition. Mina has a degree in editorial visual communication and illustration.

VAL B. MINA es el director de diseño del diario The Sacramento Bee, de California, EE.UU. Anteriormente, trabajó en el The Examiner, de San Francisco, EE.UU., como ilustrador editorial y diseñador, y más tarde en la edición del condado de Orange del Los Angeles Times. Mina tiene un título en comunicación visual editorial e ilustración.

JUDGES

BRUCE MOYER has been a picture editor at the Hartford Courant (Conn.) since 1998. He works on daily assignment origination and the Courant's Sunday magazine, Northeast. The National Press Photographers Association has named him photo editor of the year three times. He previously worked at The Sun, Bremerton, Wash., and the Naples Daily News (Fla.).

BRUCE MOYER ha sido editor fotográfico en el diario Hartford Courant, de Connecticut, EE.UU., desde 1998. Se desempeña en la generación de tareas diarias y en Northwest, la revista dominical del Courant. La National Press Photographers Association (Asociación Nacional de Fotoperiodistas) lo ha reconocido como editor fotográfico del año tres veces. Anteriormente trabajó en los diarios norteamericanos The Sun, de Bremerton, Washington, y Naples Daily News, de Florida.

CATHERINE NICHOLS is an art director and features designer at the Chicago Tribune, where she has worked for the past five years. She has also been a features and news designer at The Times of Northwest Indiana and the Albuquerque Journal (N.M.). She has won many SND and Print design awards.

CATHERINE NICHOLS es directora de arte y diseñadora de reportajes del diario Chicago Tribune, EE.UU., donde ha trabajado durante los últimos cinco años. También ha sido diseñadora de reportajes y noticias en los diarios norteamericanos The Times,

del noroeste de Indiana, y Albuquerque Journal, de Nuevo México. Ha ganado muchos premios de la SND y de diseño de diarios.

CATHERINE PIKE, editorial art director at the Toronto Star, started at the newspaper 24 years ago as a junior designer. While at the Star, she has won a gold award from the Advertising and Design Club of Canada for a special section, a national newspaper award in presentation for another, as well as many other awards, including those from SND. This is her fifth judging experience for various organizations.

CATHERINE PIKE, directora de arte editorial del diario canadiense Toronto Star, comenzó a trabajar en el diario hace 24 años como diseñadora junior. En su carrera en el Star ha obtenido oro de parte del Advertising and Design Club (Club de Publicidad y Diseño) de Canadá por una sección especial, y varios premios más, incluyendo los de la SND. Ésta es la quinta vez en que evalúa trabajos de varias publicaciones.

CORY POWELL is presentation director at the Star Tribune, Minneapolis, where he oversees the newspaper's design and the work of more than 50 designers and layout editors. He has led redesigns at the Star Tribune, as well as The Charlotte Observer (N.C.) and the Ledger-Enquirer, Columbus, Ga. He lives in Eagan, Minn., with his wife, Kristen, and two children, Cole and Carson.

CORY POWELL es director de presentación del diario Star Tribune, de Minneapolis, EE.UU., donde está a cargo del diseño del diario y el trabajo de más de 50 editores de diseño y diagramación. Ha liderado rediseños de su periódico y de los norteamericanos The Charlotte Observer, de Carolina del Norte, y Ledger-Enquirer, Columbus, de Georgia. Vive en Eagan, Minnesota, EE.UU., con su esposa, Kristen, y sus dos hijos, Cole y Carson.

PHILLIP RITZENBERG, an editor, publisher and designer with 50 years in journalism, has designed urban and community newspapers across North America. He has worked in almost every phase of journalism and, as assistant managing editor of the Daily News, New York, was the first person at a major American newspaper to have a senior position in newspaper design. He was a founder of SND.

PHILLIP RITZENBERG, un editor, director y diseñadores con 50 años de experiencia en periodismo, ha diseñado periódicos de ciudades y pueblos de Estados Unidos y Canadá. Ha trabajado en casi todas los puestos de periodismo, y como editor gerencial asistente de Daily News, New York, EE.UU., fue la primera persona de un diario norteamericano de gran tamaño en tener un puesto de importancia en el diseño de diarios. Es uno de los fundadores de la SND.

PIEDAD RIVADENEIRA is a graphics designer and art director of the monthly magazine Paula. She designed four weekly magazines for the newspaper Las Últimas Noticias, focusing on children, women, school and entertainment. Rivadeneira created the concept and design for Fibra magazine, winner of four merit awards from the Society of Publication Designers. In March 2005, she founded Felicidad S.A., her own design consulting company.

PIEDAD RIVADENEIRA es diseñadora de gráficos y directora de arte de la revista mensual chilena Paula. Diseñó cuatro revistas semanales del diario chileno Las Últimas Noticias, con foco en los niños, las mujeres, la escuela y la entretención. Rivadeneira creó el concepto y el diseño de la revista Fibra, ganadora de cuatro premios al mérito de la Society of Publication Designers (Sociedad de Diseñadores de Publicación). En marzo de 2005, fundó Felicidad S.A., su propia empresa de consultoría de diseño.

STEVE SALMON is art director of The Sydney Morning Herald, Australia, where he is responsible for 18 sections of the newspaper. Previously, he was deputy art director of The Observer, in London, where in 2005, in collaboration with Garcia Media, he oversaw its redesign to a compact European format.

STEVE SALMON es director de arte del diario australiano The Sydney Morning Herald, donde es responsable de 18 secciones editoriales. Anteriormente, fue subdirector de arte de The Observer, de Londres, Reino Unido, donde en 2005, en colaboración con Garcia Media, estuvo a cargo de su rediseño como diario compacto europeo.

GABRIELA SCHMIDT is an independent design consultant providing design services, training and seminars. She has worked with El Universal and Reforma, México City, and the Poynter Institute for Media Studies. She is a former features design director at the San Jose Mercury News (Calif.), winning several awards, including SND's World's Best-Designed Newspaper™. Gabi graduated from the National Fine Arts Institute of México City.

GABRIELA SCHMIDT es una consultora independiente de diseño que provee servicios, entrenamiento y seminarios. Ha trabajado para los diarios mexicanos El Universal y Reforma, y para el Poynter Institute for Media Studies, de Saint Petersburg, Florida, EE.UU. Fue directora de diseño de reportajes en el diario San Jose Mercury News, EE.UU., y obtuvo varios premios, incluyendo el al diario mejor diseñado del mundo de la SND. Gabi se tituló por el Instituto Nacional de Bellas Artes, de Ciudad de México.

BROC SEARS, assistant managing editor for design and graphics at the Fort Worth Star-Telegram (Texas), has worked in publication design for 35 years. An adjunct professor at Texas Christian University, he has been art director of The Dallas Morning News and the Dallas Times Herald. He survived six redesigns at all three newspapers, and he has received recognition as an editor, designer, illustrator and art director.

BROC SEARS, editor gerencial asistente de diseño y gráficos del diario Fort Worth Star-Telegram, de Texas, EE.UU., ha trabajado en diseño de publicaciones durante 35 años. Es profesor adjunto de Texas Christian University y ha sido director de arte de los diarios norteamericanos The Dallas Morning News y Dallas Times Herald. Ha sobrevivido seis rediseños en cada uno de los tres periódicos y ha recibido premios por su trabajo como editor, diseñador, ilustrador y director de arte.

LINDA SHANKWEILER joined The Oregonian, Portland, in 2003 as design director, overseeing news and features presentation. She has been a features designer at The Morning Call, Allentown Pa., a publication-design teacher at Temple University and art director at the Hartford Courant (Conn.), and she was a founding partner of a design studio in Connecticut and New York City before returning full time to newspaper work.

LINDA SHANKWEILER comenzó a trabajar como directora de diseño en el diario The Oregonian, de Portland, EE.UU., en

2003, y está a cargo de la presentación de noticias y reportajes. Ha sido diseñadora de reportajes del diario The Morning Call, de Allentown, Pennsylvania, EE.UU., profesora de diseño de publicaciones de Temple University y directora de arte del periódico Hartford Courant, de Connecticut, EE.UU. También fue socia fundadora de un estudio de diseño en Connecticut y la ciudad de Nueva York antes de volver a trabajar de jornada completa en los diarios.

JOHN TELFORD has worked as a graphic artist, designer, presentation editor, creative director and project-team leader at various newspapers and advertising agencies over the past 15 years. His work has appeared in projects for Time, the National Geographic Society, the Ford Motor Co., Chevron, America West Airlines and Sprint. A native Floridian, he has been a graphic artist at the St. Louis Post-Dispatch since 2000.

JOHN TELFORD se ha desempeñado como artista gráfico, diseñador, editor de presentación, director creativo y líder de equipos de proyectos especiales en varios periódicos y agencias de publicidad en los últimos 15 años. Su trabajo ha sido publicado en especiales de Time, National Geographic Society, Ford Motor Company, Chevron, America West Airlines y Sprint. Originario de Florida, ha sido artista gráfico del diario Saint Louis Post-Dispatch, EE.UU., desde 2000.

KATHERINE TOPAZ, nationally known for her work in the alternative press, has won many awards for her art direction and cover design. She founded Topaz Design in 2000, which focuses on redesigning newspapers and magazines. Topaz also helps publications with internal processes to make them stronger publications. She teaches at Pacific Northwest College of Art and speaks regularly across the country.

KATHERINE TOPAZ, conocida en Estados Unidos por su trabajo en la prensa alternativa, ha ganado muchos premios por su dirección de arte y diseño de portadas. En 2000, fundó Topaz Design, cuyo foco es el rediseño de periódicos y revistas. Topaz también trabaja en el fortalecimiento de los procesos internos de varias publicaciones. Enseña en el Pacific Northwest College of Art y da conferencias continuamente en todo Estados Unidos.

LILA VICTORIA, newsroom artist/designer, has been working at the Staten Island Advance (N.Y.) on the design team for the past 11 years. She designs feature cover pages for Your Home, Religion and Sunday Lifestyle Trends and inside pages for the FoodDay section, and she compiles and designs the company newsletter. Before coming to the Advance, Victoria worked as an advertising specialist for Nexcom, Staten Island, designing retail catalogs.

LILA VICTORIA, artista de noticias y diseñadora, ha trabajado en el equipo de diseño del diario Staten Island Advance, de Nueva

York, EE.UU., durante los últimos 11 años. Diseña portadas de reportajes para las revistas Your Home, Religion y Sunday Lifestyle Trends, y páginas de interior para la sección FoodDay, y también compila y diseña el boletín de la empresa. Anteriormente, Victoria trabajó como especialista en publicidad diseñando catálogos de venta minorista de Nexcom, de Staten Island, EE.UU.

CHRIS WATSON, executive editor at the National Post, Toronto, has worked on several newspapers in his native Britain and Canada, and he has spent many years in supervisory design roles. He was one of the launch editors of the National Post seven years ago and has won many SND awards. He has been a member of SND since its second year and was the director for central and eastern Canada for three years.

CHRIS WATSON, editor ejecutivo del diario National Post, de Toronto, Canadá, ha pasado muchos años en puestos a cargo del diseño en varios periódicos en su país, Gran Bretaña, y en Canadá. Hace siete años, fue uno de los editores del lanzamiento del National Post, y ha ganado muchos premios de la SND. Ha sido miembro de la Sociedad desde su segundo año y fue el director de la región este de Canadá durante tres años.

DON WITTEKIND is graphics director at the South Florida Sun-Sentinel, Fort Lauderdale, where he leads 10 visual journalists who produce content for print, online and broadcast

distribution. Before joining the Sun-Sentinel, he was a copy editor and designer at Florida Today, Melbourne, and a pagination editor at The Atlanta Journal-Constitution.

DON WITTEKIND es director de gráficos del diario Sun-Sentinel, de Fort Lauderdale, sur de Florida, EE.UU., donde ha está a cargo de 10 periodistas visuales que producen contenido de distribución impresa, online y audiovisual. Antes del Sun-Sentinel, fue editor y diseñador en el diario Florida Today, de Melbourne, EE.UU., y editor de compaginación en The Atlanta Journal-Constitution, EE.UU.

SUSAN ZAVOINA is coordinator of the photojournalism sequence and department chair at the University of North Texas. She has judged for Photographer of the Year International and led the visual-communication division of the Association for Education in Journalism and Mass Communication. Zavoina is co-editor of "Sexual Rhetoric in the Media" and co-author of the textbook "Digital Photojournalism."

SUSAN ZAVOINA es coordinadora de la secuencia de fotoperiodismo y jefa del departamento de la University of North Texas. Ha sido jueza de la competencia Photographer of the Year International (Fotógrafo del Año Internacional) y ha liderado la división de comunicación visual de la Association for Education in Journalism and Mass Communication (Asociación para la Educación en Periodismo y Comunicación de Masas). Zavoina es coeditora de "Sexual Rhetoric in the Media" (Retórica Sexual en los Medios) y coautora del libro manual "Digital Photojournalism" (Fotoperiodismo Digital).

WHAT THE JUDGES SAW

Feature, magazine & illustration judges

Sónia Matos
Val B. Mina
Catherine Nichols
Piedad Rivadeneira
Katherine Topaz

We searched for pages that not only were striking aesthetically, but ones that were seeking a new visual language.

We wanted the designer to take risks and try new ways of reaching out to the reader. We demanded that art and type support each other, while supporting the content. We searched for the unexpected — the designs that did not fall into pre-existing solutions.

Design is a constant evolution. It must not be static, but it must become a living thing.

Buscamos páginas que fueron llamativas no solo por su valor estético, sino porque buscaban un nuevo lenguaje visual.

Quisimos que el diseñador tomara riesgos e intentase nuevas formas de llegar al lector. Quisimos que las imágenes y la tipografía se apoyasen mutuamente, a la vez que apoyaban el contenido. Buscamos lo insospechado; el diseño que no recurría a soluciones ya conocidas.

El diseño está en continua evolución. No debe ser estático, sino algo vivo.

Photo & small newspaper judges

Amelia Kunhardt
Bruce Moyer
Gabriela Schmidt
Lila Victoria
Susan Zavoina

In the photography categories, it was encouraging to see many newspapers committing more resources to larger projects. The contest entries show that daily documentary photojournalism still has a vibrant life in newspapers.

There was some concern about a lack of photo entries from international papers. There is a different culture surrounding the use of photography in some of the international entries, as compared with U.S. newspapers. American newspapers have more opportunities to display documentary photojournalism than their Latin American counterparts.

Smaller newspapers' entries did not seem to use photography as well as the larger newspapers. We would encourage papers entering design categories not to ignore the photography categories.

In the small-newspaper design categories, some entrants were not afraid to take chances. We would like to recognize this diversity of ideas. But the majority of the entries lacked the surprise factor.

Simple, elegant design stood out from other entries that tried to crowd too much in.

We recognize there is a bias in the process because of the preponderance of U.S. judges, and we hope the Society can address this appropriately as the competition progresses. We tried to be cognizant of that bias as we looked at entries.

Our basic formula for success includes simplicity, powerful storytelling and the blend of form and function. Successful design increases legibility and readability, but it all begins with quality content.

En las categorías de fotografía, fue satisfactorio ver tantos periódicos que dedicaron más recursos a las grandes coberturas noticiosas.

Las piezas de la competencia demostraron que el fotoperiodismo documental del día a día todavía goza de una vida activa en los periódicos.

Hubo cierta preocupación por la falta de piezas fotográficas de diarios de fuera de los Estados Unidos. Hay una cultura diferente en el uso de la fotografía en algunas piezas internacionales en relacion con el de las piezas norteamericanas.

Los diarios de EE.UU. tienen más oportunidades para mostrar fotoperiodismo documental que los de América Latina.

Dio la impresión de que las piezas de los diarios más pequeños no usaron la fotografía tan bien como los de mayor tamaño. Nos gustaría incentivar a los diarios que participan en las categorías de diseño a que no dejen de hacerlo también en las de fotografía.

En las categorías de diseño de diarios pequeños, algunas piezas no dudaron en tomar riesgos, y nos gustaría destacar esta diversidad de ideas. Sin embargo, la mayoría de las piezas no tenía ese factor sorpresa.

El diseño simple y elegante sobresalió respecto de las piezas que intentaron poner demasiada información.

Nos damos cuenta de que existe un prejuicio debido a la preponderancia de los jueces norteamericanos, y esperamos que la SND pueda solucionarlo apropiadamente a medida de que la competencia progresa. Intentamos tener esto en mente durante la evaluación de las piezas.

Nuestra fórmula básica de éxito inlcuye la simplicidad, la narración de historias potente y la fusión de la forma y la función. El diseño exitoso aumenta la legibilidad y la lecturabilidad, pero todo comienza con el contenido de calidad.

News & sports judges

Cassie Armstrong
J. Damon Cain
Brian Gross
Christine McNeal
Steve Salmon

We looked for designers who are not just in control of their craft but are experts at it, regardless of whether they are working on an eighth of a page or an eight-page spread. We looked for designers whose storytelling skills are an integral part of the newspaper's journalism. The bar is high.

There was a great deal of quality work at the competition, but, in our minds, for a page to elevate itself to an award, it needed to have the following —
Simplicity.
Clarity.
Voice.
Presentation that avoids cliché.
Pacing appropriate to the content.
A willingness to be daring.

Buscamos diseñadores que no solo dominasen su trabajo sino que fuesen expertos, sin importar si trabajan en una pieza de un octavo de página o un artículo especial de ocho páginas. Buscamos diseñadores cuyas destrezas para narrar historias fuesen parte integral del periodismo del diario. La vara estaba alta.

Hubo una gran cantidad de trabajos de calidad en la competencia, pero, en nuestra opinión, para que una página se convirtiese en un premio, debía tener lo siguiente:
Simplicidad.
Claridad.
Voz.
Presentación que no recurre a clichés.
Ritmo apropiado al contenido.
La voluntad de atreverse.

Generalist judges
resolving conflicts of interest

Susan Mango Curtis
Phillip Ritzenberg

Long-form judges
judging longer entries

Joe Breen
Catherine Pike
Cory Powell
Broc Sears
Linda Shankweiler

Greatness knocks at the door infrequently, but that doesn't mean we shouldn't always aspire to it. The cream of the entries did.

With so many papers covering the same big news events — the war in Iraq, the death of Pope John Paul II, hurricanes and the tsunami — pages that stood out had a determined will to distill the story's essence and to express it visually.

Consistently good design depends on a firm grasp of the fundamentals of typography, photography, illustration and the grid — as well as their limitations and their possibilities.

This was apparent in those entries that really shone. They began with a strong foundation, and they combined those elements with a clear voice and a sharply focused vision. They were decisive, confident and imaginative.

Newsrooms must have a shared vision. It's imperative that journalists of all crafts take responsibility for the way a story is told. No longer does form follow function — they both must work hand in hand from the idea's inception.

The most impressive entries inspired us both as journalists and as readers, reminding us that great visual journalism goes beyond merely informing.

We must be prepared to seize the moment. The most outstanding examples did just that.

La excelencia rara vez toca a la puerta, pero no por eso se debe dejar de aspirar a lograrla. Las mejores piezas de la competencia llegaron a ella.

Con tantos periódicos que cubren las mismas grandes noticias; la guerra en Irak, la muerte del Papa Juan Pablo II, los huracanes y el tsunami, las páginas que se destacaron demostraban una clara determinación por destilar lo esencial de la noticia y expresarlo de forma visual.

El buen diseño consistente depende tanto de una firme base de lo fundamental de la tipografía, la fotografía, la ilustración y la retícula (grilla), como de sus limitaciones y posibilidades.

Esto se hizo evidente en las piezas que realmente deslumbraron. Comenzaron con una sólida base y combinaron esos elementos de forma clara y con un foco bien enfocado. Tuvieron decisión, seguridad e imaginación.

Las salas de noticias deben tener una visión compartida. Es imperativo que los periodistas de todas las áreas se hagan responsables de la forma en que se relata la noticia. La forma ya no sigue al fondo; ambos deben funcionar a la vez, desde la concepción de la idea.

Las piezas de la competencia más llamativas nos inspiraron tanto como periodistas y lectores, y nos recordaron que el buen periodismo visual va más allá de solo informar.

Debemos estar preparados para aprovechar la oportunidad. Los ejemplos más destacables lo hicieron.

Graphics judges

Fernando G. Baptista
Kevin Hand
Agnete Holk
John Telford
Don Wittekind

A diverse spectrum

Our team of judges found that the universal appeal of a well-designed information graphic shines through cultural differences, such as sex, language and nationality.

Un espectro diverso

Nuestro equipo de jueces se dio cuenta de que el atractivo universal de un infográfico bien diseñado brilla más allá de las diferencias culturales, como el género, el idioma y la nacionalidad.

WHAT THE JUDGES SAW

World's Best Designed Newspaper™ judges

Nanette Bisher
Joe Dizney
Lucie Lacava
Ingrid Lohne
Chris Watson

The World's Best-Designed Newspapers™ — that's quite a mouthful, and something for any newspaper to strive for, much less realistically live up to.

The five judges who chose the 2005 winners each had an idea of what qualities should define the term "world's best." After reviewing 389 entries from 46 countries, the judges' only unanimous agreement was that the winners were as close to perfect as they could be, both individually and collectively.

The financial realities of the marketplace are affecting paper size, resources and production values. The Web is competing for readers' attention and advertising income. Styles — and the insistence on freshness, youth and currency — are changing at an increasingly rapid pace. Five-minutes-from-now is so 10-minutes-ago, and to hear some analysts speak, it seems as if newspapers themselves are almost as outdated as the steamship (or auto) industry.

Yet papers continue to change, evolve and adapt to the marketplace — macro to micro, global to local.

Many newspapers achieved a high standard of overall design, photography and illustration. Editorial voice, use of resources and visual storytelling were other qualities for which we looked.

But again, we sought perfection. Other entries came very close, but these two received our unanimous vote for maintaining that quality and freshness on every page. We hope you agree.

Los periódicos mejor diseñados del mundo™: un gran título para enorgullecerse, que ya cualquier periódico querría tener, aunque para ser realistas, sería difícil de alcanzar.

Cada uno de los cinco jueces que eligieron los ganadores del año 2005 tenía su propia idea sobre las cualidades que deberían definir el término "el mejor del mundo". Tras revisar 389 piezas competidoras de 46 países, el único acuerdo unánime de los jueces fue que los ganadores estuvieron todo lo cerca de la perfección que se puede, tanto a nivel individual como colectivo.

La situación financiera del mercado está afectando el tamaño de los diarios, sus recursos y valores productivos. El web está compitiendo para captar la atención de los lectores y los ingresos publicitarios. Los estilos –y la insistencia en la frescura, juventud y actualidad-, están cambiando a paso cada vez más rápido. Lo que antes ocurría hace diez minutos, ahora toma apenas cinco, y según los analistas, parece ser que los mismo periódicos están tan pasados de moda como la industria de los buques a vapor o de los automóviles.

Y sin embargo, los periódicos continúan cambiando, desarrollándose y adaptándose al mercado, tanto a nivel macro como micro, tanto global como local.

Muchos periódicos lograron un alto nivel de diseño en general, fotografía e ilustración. La voz editorial, el uso de recursos y la narración visual fueron otras cualidades en que pusimos atención.

Pero una vez más, buscamos la perfección. Otras piezas llegaron muy cerca, pero estas dos captaron nuestro voto unánime por mantener esa calidad y frescura en cada una de sus páginas. Esperamos que usted esté de acuerdo con nosotros.

World's
Best-Designed
Newspapers

1

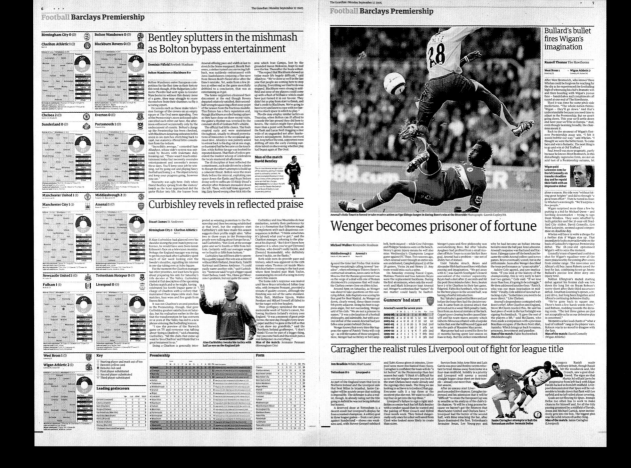

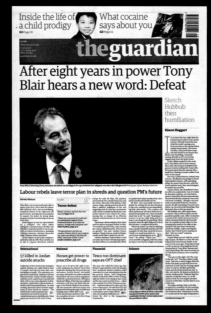

The Guardian

London | Circulation: 395,000

The 'thoroughly unlikeable' Michael Caine
The 'sick' Martin Amis 'Absurdly vain'
Terence Stamp 'Treacherous' Edna O'Brien
The 'idiocy' of Twiggy

The final diaries of John Fowles

Review Page 4

£1.20
Saturday 12.11.05
Published
in London and
Manchester
guardian.co.uk

Gwyneth Paltrow's strange doctor
England's nervous rugby coach
David Morrissey's giant leap
William Dalrymple's Morocco

Plus 36 page gadget handbook

theguardian

Outcry over diplomatic memoirs

Ambassadors told secrecy is vital

Vikram Dodd
Tania Branigan
Owen Gibson

The head of the diplomatic corps has ordered ambassadors and senior officials to keep their silence after leaving office, warning that tell-all books such as the one published, his week by the former ambassador to Washington, Sir Christopher Meyer, will damage British foreign policy.

Sir Michael Jay's private memo was issued to all British ambassadors, high commissioners and consul generals around the world after extracts of Sir Christopher's book, DC Confidential, were serialised in the Guardian.

He warned: "Let us stress that we can not serve ministers effectively unless they trust and confide in us, which they will only do if we respect that confidence, not just when we're doing our jobs, but afterwards, too. If we don't have ministers' trust, they will not consult us, involve us or take our advice – and we will all lose, ministers, the [diplomatic] service, and the conduct of foreign policy, under no matter what administration."

Sir Michael continued: "Please remember this simple but important point and act accordingly – now and after you've left the service."

The Foreign Office released the memo as the foreign secretary, Jack Straw, attacked the former Washington ambassador and questioned his fitness to remain chairman of the Press Complaints Commission, following his extensive criticisms of the government in his memoirs.

Sir Christopher's disclosures about Tony Blair's behaviour in the run-up to war in Iraq prompted scathing assaults from former mandarins and politicians, who said he had undermined the trust between ministers and officials with his damaging claims about prime minister and "political pygmies" in his cabinet.

But opposition politicians argued that his role at the PCC had nothing to do with his former job and said the government was trying to undermine him because he had embarrassed ministers.

The influential public administration committee of MPs has announced that it will question the former diplomat and other former officials next month as it examines whether diary-keeping is threatening the quality of decision-making.

Sir Gus O'Donnell, the cabinet secretary, told the PAC last month that he was strongly against the idea of selling information and wanted to stop it.

Sir Christopher claimed Mr Blair was so seduced by US power that he failed to halt its rush to war in Iraq and argued that the Foreign Office had been kept out of crucial decisions. But Mr Straw told BBC Radio 4's Today programme that it was Sir Christopher who had been a marginal player. He added: "It is completely unacceptable for someone like Christopher Meyer to break trust in the way he has done. It undermines the key relationship between civil servants and ministers and has led to very great concern amongst the whole of the diplomatic service."

Pointing to Sir Christopher's role as chairman of the PCC, Mr Straw said: "What are people supposed to do? He is in the newspapers saying controversial things. If people want to complain to the newspapers about what he has said, who do they complain to?"

He added that he was much angrier about Sir Christopher breaking the personal confidences of John Major and his wife than about criticisms of himself, citing a "preposterous and demeaning" section in which the diplomat explained that, as a press secretary, he would brief the then PM as he got dressed in the morning.

Lord Butler of Brockwell, a former cabinet secretary and friend of Sir Christo-

Continued on page 2 »

Lord Lichfield dies at 66

Lord Lichfield, the cousin of the Queen who became a fashion photographer, died yesterday after suffering a stroke. See page 3 » Photograph: Efrem Raimondi

Revealed: UK wartime torture camp

Ian Cobain

The British government operated a secret torture centre during the second world war to extract information and confessions from German prisoners, according to official papers which have been unearthed by the Guardian.

More than 3,000 prisoners passed through the centre, where many were systematically beaten, deprived of sleep, forced to stand still for more than 24 hours at a time and threatened with execution or unnecessary surgery.

Some are also alleged to have been starved and subjected to extremes of temperature in specially built showers, while others later complained that they had been threatened with electric shock torture or menaced by interrogators brandishing red-hot pokers.

The centre, which was housed in a row of mansions in one of London's most affluent neighbourhoods, was carefully concealed from the Red Cross, the papers show. It continued to operate for three years after the war, during which time a number of German civilians were also tortured.

A subsequent assessment by MI5, the Security Service, concluded that the commanding officer had been guilty of "clear breaches" of the Geneva convention and that some interrogation methods "completely contradicted" international law.

On at least one occasion, an MI5 officer noted in a newly declassified report, a German prisoner was convicted of war crimes and hanged on the basis of a confession which he had signed after he was, at the very least, "worked on psychologically". A number of people who appeared as prosecution witnesses at war crimes trials are also alleged to have been tortured.

The official papers, discovered in the National Archives, depict the centre as a dark, brutal place which caused great unease among senior British officers. They appear to have turned a blind eye partly because of the usefulness of the information extracted, and partly because the detainees were thought to deserve ill treatment.

Not all the torture centre's secrets have yet emerged, however: the Ministry of Defence is continuing to withhold some of the papers almost 60 years after it was closed down.

8 »

National	National	International	Financial	Sport
Blair wrong on 90 days, say voters	**Guardian sales continue to grow**	**Married couple in suicide bomb team**	**Increase in ATMs which charge fees**	**Captain Beckham aims for record**
A quarter of voters want Tony Blair to step aside immediately after this week's Commons defeat on the terror bill, according to a Guardian/ICM poll published today. Only a fifth of respondents felt Mr Blair was right to push ahead with the 90-day vote when it became clear he was going to lose – his first parliamentary defeat since Labour came to power in 1997. Underlining calls from several Labour backbenchers that Mr Blair must learn to listen to criticism from inside the party, the ICM poll suggests more than half the electorate want the prime minister to compromise over his third-term plans. 4 »	The Guardian continues to perform strongly, in both its new Berliner format and online. The latest figures from the Audit Bureau of Circulation for the print version of the paper show the Guardian to be selling 403,297 copies a day – up 6.57% year on year against an overall increase of 1.5% for the quality market. The new paper launched almost nine weeks ago. According to Comscore, Guardian Unlimited remains by far the most popular British newspaper site, with 2.5 million unique users in September in the UK alone, 73% more than the Times Online (1.45m) and 97% more than Telegraph.co.uk (1.28m).	The suicide bombers who killed 57 people in Jordan included a husband and wife team, al-Qaida said yesterday. Jordanian police believe they have found the bodies of three male bombers but the wife could be among the victims although she would probably not have been carrying a bomb. According to the al-Qaida statement, the bombers "comprised three men and a woman who decided to accompany her husband on the path to martyrdom". The statement also claimed that an attack on Israel was imminent. Police yesterday arrested 120 Jordanians and Iraqis for questioning as thousands of people joined protests. 18 »	Consumers will pay around £250m next year to withdraw money from fee-charging cash machines, according to a report. There are now nearly 24,000 such machines across the country which charge up to £5 a time for withdrawals, a 16% increase on last year. Independent operators have been buying unwanted ATMs from banks and building societies, and converting them from free to charging, as well as introducing their own machines into pubs, convenience stores and petrol stations. Nationwide, which produced the report, said there was a possibility that access to free machines could be reduced still further. 25 »	David Beckham will win his 50th England cap today against the side that made him infamous, however briefly, at the World Cup in 1998 when he was sent off in the World Cup quarter-finals. Sven-Goran Eriksson's side play Argentina in a friendly in Geneva and Beckham has his eye on becoming the most-capped England captain; he is currently fourth on the list behind Bryan Robson, Billy Wright and Bobby Moore. "It's the biggest honour I have ever been given in football and I want to keep it for as long as I can," he said yesterday. Eriksson is expected to field a full-strength side for the fixture. Sport, 7 »

Wow! As soon as The Guardian came out of the bag, we all knew it would be a winner. Right away, it looks like a newspaper designed for the 21st century.

It sparkles all the way through, while the Berliner-tabloid size makes it very comfortable to read. The photography is strong. The headlines are well written and smart, and they tie perfectly with the images. The typography is bold, crisp, elegant and consistent, even though a full range of weights is used — from extra light to extra bold. The graphics and illustrations are clever and sophisticated. Inside pages are strongly designed, even around advertising stacks.

There is a masterly control of contrast throughout. The color palette is vibrant, fun and au courant. The navigation is clear and simple, with content, not decoration, driving the look of this newspaper.

Brilliant. Simply brilliant.

¡Guau! Tan pronto The Guardian salió del sobre, todos nos dimos cuenta de que sería un ganador. De inmediato se ve como un periódico diseñado para el siglo XX.

Brilla de punta a cabo, mientras que su tamaño de tabloide berlinés lo hace muy cómodo para leer. La fotografía es poderosa. Los títulos están bien escritos y son inteligentes, y calzan perfectamente con las imágenes. La tipografía es firme, fresca, elegante y consistente, aunque se usa todo un rango de grosores, desde extra ligera hasta extra gruesa. Los gráficos y las ilustraciones son inteligentes y sofisticados. Las páginas interiores están diseñadas con fuerza, incluso alrededor de los avisos apilados.

En todas partes se nota un control maestro de contraste. La paleta de color es vibrante, divertida y actual. La navegación es clara y simple, con contenido y no decoración, lo que da el carácter de cómo se ve este diario.

Estupendo, simplemente, estupendo.

technologyguardian T

the guardian Thursday 27.10.05

The crash test

As one of its biggest cheerleaders, **Henry Blodget** was at the heart of the dotcom bubble. Now, with money flooding back into the sector, the former Wall Street analyst asks whether the current boom will once again end in a bust

A familiar shockwave jolted Wall Street and the technology, media, and telecoms industries a week ago, when Google reported its third-quarter results. As usual, the company exceeded earlier forecasts, posting numbers that can only be described as mind-boggling. On Friday morning, Google's stock responded accordingly, leaping more than 10%, driving its market value to $100bn for the first time and leaving those of Time Warner, Viacom, Disney, Verizon, and other esteemed bellwethers in the dust.

To those who have watched Google for the past few years, such events have become routine: this is Google, after all, and this is the internet; we should expect the unexpected. For those who remember similarly miraculous events in the industry in the late 1990s, however – along with what happened afterwards – a sane response to the recent resurgence is to wonder whether it is deja vu all over again.

The answer, in the opinion of this casualty of the first boom, is this: in most ways, no, and in some ways, yes. Today's internet boom is different enough from the 90s version that those who dismiss it as a hallucination have their heads firmly buried in the sand. On the other hand, the giddiness at today's internet industry confabs – where attendees babble about "20th-century thinking", "revolutions", and "web 2.0" in a way that implies the 90s was mere child's play – suggests that some bubble-headed exuberance is alive and well.

The vicious circle

Before leaping into the details, it is helpful to put today's internet events in perspective. The commercial internet industry is, by now, about 10 years old. The first online companies tiptoed onto the scene in the early 90s, and the one that defined and launched the first boom, Netscape, went public in 1995. In the context of a typical communications industry lifecycle, 10 years equates to early adolescence. The telephone industry, for example, is more than a century old (and, now, thanks to the internet, is experiencing the biggest threat in its history). Radio is about 90; television, 70. The telegraph – first optical, then electric – had a one-and-a-half-century reign, then died off. We've been selling printed material since Gutenberg (or thereabouts).

More important than an industry's age is its phase of development. Specifically, most industries tend to evolve in a similar pattern: boom, bust, build-out, and decay. In the initial boom, a few visionary companies such as Netscape inspire a frantic rush of speculation and experimentation as investors and entrepreneurs try to cash in. This phase usually produces a few long-term winners, but it also leads to intense, unsustainable competition: The firehose of human and financial capital, combined with understandable uncertainty about what will and won't work, inevitably creates more companies that can survive, and a brutal bust follows. After the fact, this phase is usually viewed as a prime example of human stupidity, but history suggests that industries can't develop any other way.

After the bust, if an opportunity is real, the survivors (or later entrants) find themselves in a position to dominate the most profitable phase of the industry's development: the long boom. As Microsoft, Dell, Intel, and other personal computer survivors can attest, the fortunes made in

> "The giddiness at internet industry confabs – where attendees babble about 'revolutions' and 'web 2.0' - suggests bubble-headed exuberance is alive and well"

these periods dwarf those made and lost in the initial frenzy. Sadly, all things come to an end, and when a better, cheaper, or more convenient technology arrives, even companies and industries that seem as safe as, well, AT&T, often wither or become marginalised.

By all appearances, the internet industry is now in the early years of the long boom. The companies that survived the bust (Yahoo, eBay, Amazon, Google et al) should be able to enjoy several decades of above-average growth. Whether they capitalise on this depends on them – being at the right place at the right time with the right assets is a major advantage but doesn't guarantee a thing – and the industry's development will likely be far from smooth. The roughest part of the ride, though, should be over.

Dynamic evolution

The opportunity, moreover, seems as big or bigger than it did in the late 90s. The growth and profitability of Yahoo, eBay, and Amazon are the envy of most traditional media and retailing companies, and they have achieved their profits with a tiny fraction of the usual invested capital (it costs more to make a movie, print a newspaper, or open a store than to record mouse clicks). Given the dynamic evolution of the industry, all three companies face continual challenges, but the growth of the medium relative to that of traditional communications, media, and commerce channels gives them a leg up.

And then there is Google, whose development has been so dissimilar to that of the average media and communications company that it belongs in a freak show. A mere seven years old, Google is on track to book about $6bn of revenue this year. More impressively, the company is so profitable that it already generates almost half as much cash as Time Warner, a global media conglomerate with online, cable, film, TV, and magazine divisions and some 85,000 employees (Google has 5,000). And unlike Time Warner and other traditional competitors, Google is still growing at a rate of nearly 100% a year.

The success of Google and Yahoo, moreover, is not happening in a vacuum, but it often coming at the expense of incumbents. Almost every dollar spent on Google keywords or Yahoo sponsorships is a dollar that would otherwise have been spent on TV, print, radio or direct marketing. Many eBay listings

»2

Inside

2 Innovations
Sky's Gnome throws down the gauntlet to digital radio

3 Just for kicks
Pro Evolution and Fifa fight it out for the title of top soccer sim

4 Poor reception
Why do mobiles with all mod cons fail to keep you in touch?

5 Take note
The online initiative to identify new musical talent

6 Staking a claim
The fight to use the Gmail name could become a three-way battle

Jobs index

6 IT & T

technology.guardian.co.uk

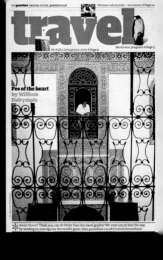

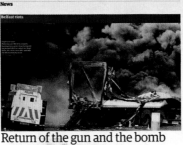

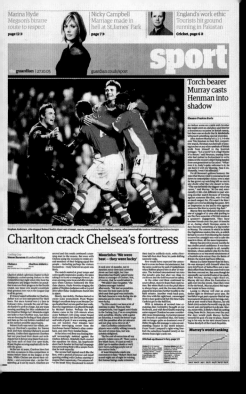

sport

the guardian | 27.10.05
guardian.co.uk/sport

Torch bearer
Murray casts
Henman into
shadow

Eleanor Preston Basle

Charlton crack Chelsea's fortress

Carling Cup
Simon Burnton Stamford Bridge

Charlton Athletic 1
Chelsea 0

Mourinho: 'We were best — they were lucky'

Murray's world ranking

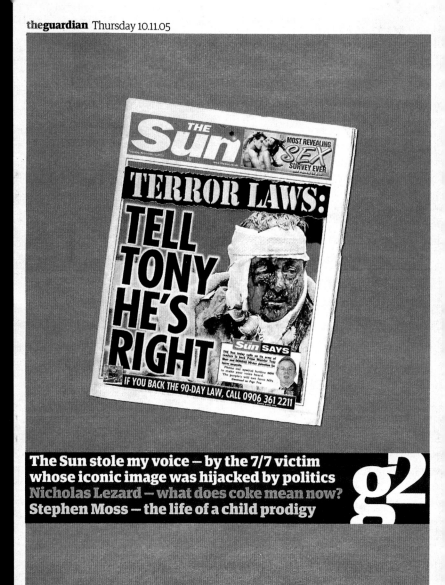

theguardian Thursday 10.11.05

The Sun stole my voice — by the 7/7 victim
whose iconic image was hijacked by politics
Nicholas Lezard — what does coke mean now?
Stephen Moss — the life of a child prodigy

g2

News

Amman bombings

Al-Qaida accused after suicide bombers
attack hotels in Jordan, killing at least 57

Conal Urquhart Tel Aviv

The scene
'I saw blood,
people killed.
It was ugly'

Mary Fitzgerald, Amman

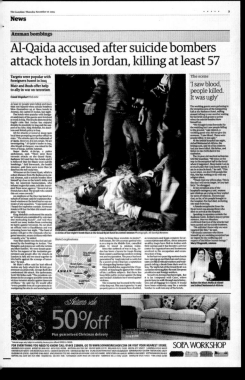

A victim of last night's bomb blast at the Grand Hyatt hotel in central Amman Photograph: AP/Jamlyn Momen

International

Merkel seals deal for grand coalition

Germany to have its first
female chancellor

Beleaguered
Bush hits out at
'irresponsible'
Iraq war critics

Obituaries

Lord Lichfield

Society photographer
and doyen of the
'swinging 60s'
who was a cousin
of the Queen

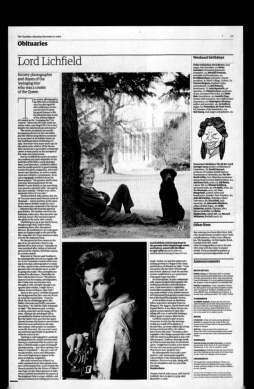

Weekend birthdays

Other lives

Rzeczpospolita

Warsaw, Poland | Circulation: 180,000

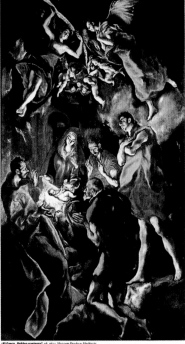

Rzeczpospolita, one of Poland's largest national dailies, shows the ability to adapt to the news while keeping a clean, fresh look. It is great to see this newspaper reaching out to the 25- to 45-year-old readership of highly educated professionals — without excessive fanfare.

Each section's design reflects the tone of its subject. Different paper stocks assert their own identities through clean and playful typography — from the green business section, with a more graphically conservative but engaging and energetic look, to the yellow legal section. While respectful of tradition, the newspaper displays a definite modernity in its mix of serif and san serif, black and red, even within single headlines.

There is an admirable continuity, with Eastern European illustrative tradition strongly present on numerous full-page opinion and essay pages.

Rzeczpospolita is truly beautiful and timeless.

Rzeczpospolita, uno de los diarios nacionales más grandes de Polonia, demuestra habilidad para adaptarse a las noticias mientras que mantiene un estilo limpio y fresco. Es fantástico ver como este diario llega a lectores de entre 25 y 45 años, profesionales y bien educados, sin fanfarria excesiva.

El diseño de cada sección refleja el tono de sus temas. Las diferentes secciones de un periódico declaran sus propias identidades por medio de la tipografía cuidada y juguetona –desde el verde de la sección de negocios, con un estilo gráfico más conservador, aunque atractivo y energético, al amarillo de la sección legal. Aunque respetuoso de la tradición, este diario exhibe una modernidad evidente en su mezcla de serif y sans serif, negro y rojo, incluso dentro de un mismo título.

Hay una continuidad admirable, con una tradición ilustrativa del este de Europa fuertemente presente en muchas páginas completas de opinión y de ensayos.

Rzeczpospolita es verdaderamente bello y siempre al día.

Lockheed ląduje w Pionkach

WIG najwyższy w historii

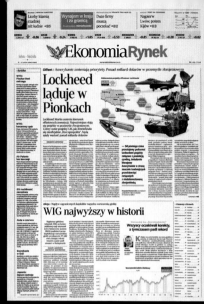

Coraz dalej od Zachodu

Terror faktów niesprawdzonych

DAJĘ PRACĘ

tematygodnia

Na osiedlu

MAGDALENA KOZMANA

FINANSOWO NIE ZYSKAŁEM

tematygodnia

Jaja, pióra, mięso

MAGDALENA PINKIEWICZA-WALCZAK

NIEPEWNY RYNEK ZBYTU

BIZNES MARZEŃ

Drugastrona

Wydawca „Hutnika"

Polityczne duety egzotyczne

Wyrusz w podróż

Odtwórca pilnie poszukiwany

Rosja bolszewików

dF dobra firma

tematygodnia

Hodowanie albo zarządzanie

23 tys. zł

plus

Rzecz o Książkach

Numer 7 (68)

Andrzej Budziński

Ósma powieść
na lato

ELŻBIETA SAWICKA

Jakie książki zapakować do plecaka
i walizki na wakacje? Relaksujące
popularne czytadła czy coś
poważniejszego? Odrobiną
zaległości czy najnowsze bestsellery?
Proponujemy kilka nowości.
Ambitnych, ale do czytania.

+ **A15–16** Wydarzenia miesiąca

Krzysztof Masłoń:
Żeby nie było wątpliwości:
narrator swoją historię
spisuje na Oddziale Nerwic
i Depresji Poużarowych
wojskowego szpitala w Oak
Road na Florydzie.

Krzysztof Andrzejczak:
Portretując kobiety, Toni
Morrison jest dla nich
Akcentuje, że potrafią być
niesympatyczne, fanatyczne i
porywcze.

+ **A14** Wyznania akrobaty
+ **A15** Drogą ku metafizyce
+ **A15** Półka z poezją
+ **A17** Piąta pora roku
+ **A17** Lista bestsellerów Andrzeja Rostockiego

– „Osobowość ćmy" Katarzyny Grocholi
– „Zahir" Paulo Coelho
– „Pamięć i tożsamość" Jana Pawła II

+ **A18** Mile Stojić

Następne wydanie „Rzeczy o Książkach" ukaże się
w sobotę, 6 sierpnia

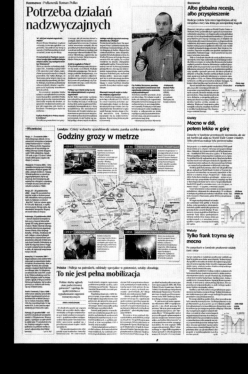

Rozmowa | Pułkownik Roman Polko

Potrzeba działań nadzwyczajnych

Albo globalna recesja, albo przyspieszenie

Mocno w dół, potem lekko w górę

Tylko frank trzyma się mocno

Londyn: Cztery wybuchy sparaliżowały miasto, panika szybko opanowana

Godziny grozy w metrze

Polska | Policja na patrolach, oddziały specjalne w gotowości, służby obradują

To nie jest pełna mobilizacja

Wir

Wozzeck · I – IV

Gwiazdy spadają z nieba

Szansa dla dwojga

kino
30.12

Rodzinny dom wariatów

reklama | nieruchomości 7

Wybuduj z nami ciepły dom

Porotherm

Pierwsza liga piłkarska | Wisła Kraków w ostatniej chwili uratowała remis z Pogonią

Męki faworytów

Beznadzieja

Komentarz

Stefan Szczepłek

Sport | 29

Liga zagraniczna | Nowy lider we Włoszech · Hiszpańscy kibice obawiają czuwaniającego bankructwa

Dziesiąty raz o tytuł

Hokej – Polska – Wielka Brytania 2:5

Emocje w końcówce

Kocia muzyka w Chorzowie

Judges'
Special
Recognition

2

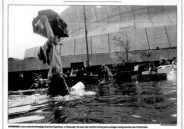

The Times-Picayune

HITTING BOTTOM

THE WATER HAS FINALLY STOPPED POURING IN BUT IT COULD BE OCTOBER BEFORE THE CITY DRIES OUT

Engineers punching holes in levee to speed draining

Nightmare in the 9th Ward all too real for one woman

JUDGES' SPECIAL RECOGNITIONS
for dedication, courage and commitment

The Times-Picayune
New Orleans

Awards of Excellence
News design, page(s) / A-Section / 175,000 and over (4)

Staff

Hurricane Katrina made it remarkable that this newspaper could publish anything at all, but it did more than that. The staff gave great care and attention to detail, with nice simplicity and consistency to all of these pages. These journalists didn't have a home to go to, but they didn't abandon their readers. They did the reporting, took the pictures and designed the pages knowing that they couldn't print the paper. These pages represent a very strong voice for the community.

El huracán Katrina muestra lo notable de la sola publicación de este diario, pero fue incluso más allá. El personal tuvo mucho cuidado y prestó mucha atención a los detalles, con un buen nivel de simplicidad y consistencia en todas las páginas. Estos periodistas ni siquiera tenían casa a donde irse, pero no abandonaron a sus lectores. Reportearon, tomaron fotos y diseñaron las páginas sabiendo que no podían imprimir el diario. Estas páginas representan una voz muy fuerte de la comunidad.

The Times-Picayune

50 CENTS 169th year No. 221 **TUESDAY, AUGUST 30, 2005** HURRICANE EDITION

CATASTROPHIC

STORM SURGE SWAMPS 9TH WARD, ST. BERNARD

LAKEVIEW LEVEE BREACH THREATENS TO INUNDATE CITY

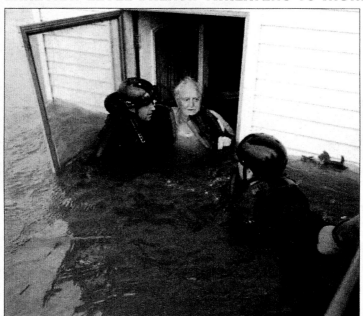

NINTH WARD: An elderly resident is rescued from chest-high floodwaters by two New Orleans police officers.

STAFF PHOTO BY ALEX BRANDON

By Bruce Nolan
Staff writer

Hurricane Katrina struck metropolitan New Orleans on Monday with a staggering blow, far surpassing Hurricane Betsy, the landmark disaster of an earlier generation. The storm flooded huge swaths of the city, as well as Slidell on the north shore of Lake Pontchartrain, in a process that appeared to be spreading even as night fell.

A powerful storm surge pushed huge waves ahead of the hurricane, flooding much of St. Bernard Parish and New Orleans' Lower 9th Ward, just as Betsy 40 years ago. But this time the flooding was more extensive, spreading upriver as well to cover parts of the Bywater, Marigny and Treme neighborhoods.

As with Betsy, people scrambled into their attics or atop their roofs, pleading for help from the few passers-by.

The powerful Category 4 storm crossed the coast near the mouth of the Pearl River shortly after daybreak with winds of 135 mph. Naval Air Station-Joint Reserve Base in Belle Chasse reported an early morning gust of 105 mph.

With the power out throughout the area and fierce winds raging throughout the day, officials barely began Monday to assess the full damage of the monstrous storm, which was expected to leave thousands homeless and many more coping with damage from the wind and water.

Meantime, 5 miles to the west, engineers worked to close a breach along the New Orleans side of the 17th Street Canal.

Huge drainage pumps ordinarily can drive millions of gallons of rainwater uphill through

See KATRINA, A-4

Flooding wipes out two communities

By Brian Thevenot and Manuel Torres
Staff writers

As Jerry Rayes piloted his boat down St. Claude Avenue, just past the Industrial Canal, the eerie screams that could barely be heard from the roadway grew louder as, one by one, faces of desperate families appeared on rooftops, on balconies and in windows, some of them waving white flags.

The scene wouldn't change for the next three hours, as Rayes and his son and nephew boated down St. Claude Avenue and deep into St. Bernard Parish, where water smothered two-story houses, people and animals. The men had to duck to miss streetlights that towered over Judge Perez Drive, the parish's main thoroughfare.

The people Rayes rescued all told the same story, already written on their stunned and shivering

See FLOOD, A-6

INSIDE

DOWNTOWN: The damage to the Hyatt Regency on Poydras Street shows that vertical evacuation is no solution to the dangers of a Category 4 hurricane. **See story, A-15**

PHOTO BY A.J. SISCO

After the mighty storm came the rising water

By Doug MacCash and James O'Byrne
Staff writers

A large section of the vital 17th Street Canal levee, where it connects to the brand new 'hurricane proof' Old Hammond Highway bridge, gave way late Monday morning in Bucktown after Katrina's fiercest winds were well north. The breach sent a churning sea of water from Lake Pontchartrain coursing across Lakeview and into Mid-City, Carrollton, Gentilly, City Park and neighborhoods farther south and east.

As night fell on a devastated region, the water was still rising in the city, and nobody was willing to predict when it would stop. After the destruction already apparent in the wake of Katrina, the American Red Cross was mobilizing for what regional officials were calling the largest recovery operation in the organization's history.

Police officers, firefighters and private citizens, hampered by a lack of even rudimentary communication capabilities, continued a desperate and impromptu boat-borne rescue operation across Lakeview well after dark. Coast Guard helicopters with searchlights criss-crossed the skies.

Officers working on the scene said virtually every home and business between the 17th Street Canal and the Marconi Canal, and between Robert E. Lee Boulevard and City Park Avenue, had water in it. Nobody had confirmed any fatalities as a result of the levee breach, but they conceded that hundreds of homes had not been checked.

As the sun set over a still-rolling Lake Pontchartrain, the smoldering ruins of the Southern Yacht Club were still burning, and smoke streamed out over

See BREACH, A-2

INSIDE • Residents' insurance claims sure to set record, A-14 • Looters in the city strike hard and fast, A-19 • LATEST STORM COVERAGE @ NOLA.COM

The Times-Picayune

50 CENTS · 169TH YEAR NO. 225 · FRIDAY, SEPTEMBER 2, 2005 · HURRICANE EDITION

'HELP US, PLEASE'

AFTER THE DISASTER, CHAOS AND LAWLESSNESS RULE THE STREETS

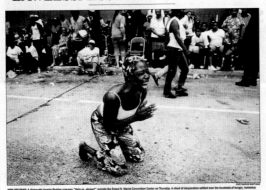

NEW ORLEANS: A distraught Angela Perkins screams "Help us, please!" outside the Ernest N. Morial Convention Center on Thursday. A cloud of desperation settled over the hundreds of hungry, homeless people at the Convention Center.

Local leaders call relief efforts too little, too late

By Jed Horne
Staff writer

NEW ORLEANS: Renowned singer Charmaine Neville wraps Thursday after taking New Orleans police Capt. Jeff Winn how she and others were attacked at her home after the hurricane.

Blanco demands thousands of troops

By Paul Purpura and Ed Anderson
Staff writers

See EFFORTS, page 4

The Times-Picayune

$1.50 · 169TH YEAR NO. 227 · SUNDAY, SEPTEMBER 4, 2005 · HURRICANE EDITION

After five days, thousands of anguished storm victims finally have a reason for hope

HELP AT LAST

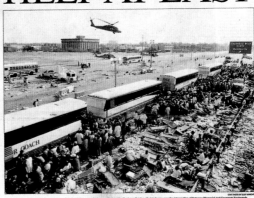

METAIRIE: Helicopters evacuate people in need of medical help as crowds of others displaced by Hurricane Katrina pile into buses near the intersection of Veterans Memorial and Causeway boulevards.

Amid chaos, a rare voice of strength

By Brian Thevenot
Staff writer

NEW ORLEANS: Anita Roach, who used to live in the Lower 9th Ward, leads those around her in gospel songs. Hundreds of people were waiting for a bus to take them from the Ernest N. Morial Convention Center.

See KATRINA, page

Authorities regaining grip on city

From staff reports

INSIDE: Seeking help, finding death at Convention Center, page 5 • Talk resurfaces of possible Saints move to San Antonio, page 6 • St. Bernard assesses find horrific piles, page 12

"Then, next thing you know, it's just gushing, gushing, gushing ..."

JOAN HANSON
St. Bernard Parish resident

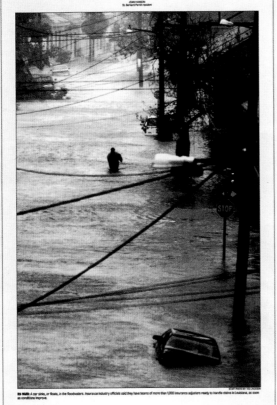

9th WARD: A car sinks, or floats, in the floodwaters. Insurance industry officials said they have teams of more than 1,000 insurance adjusters ready to handle claims in Louisiana as soon as conditions improve.

LAKEVIEW: A cooler and toys are among the debris floating on floodwater near the intersection of Filmore and Orleans avenues.

STAFF PHOTO BY DOUG MacCASH and JAMES O'BYRNE

Hundreds believed to be trapped in their attics

FLOODING, from A-1

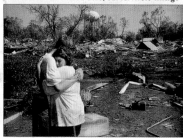

JUDGES' SPECIAL RECOGNITION
for excellence under pressure

The Sun Herald
Biloxi, Miss.

Awards of Excellence

Special coverage / Single subject
Special news topics / Natural disasters

Jared Head, Designer; **Kevin Wendt,** News Design Director, San Jose Mercury News (Calif.); **Rudy Nowak,** Designer; **Paul Hampton,** Wire Editor; **Blake Kaplan,** Metro Editor; **Bryan Monroe,** Vice President/News, Knight Ridder; **Randy Waters,** Presentation Editor, Macon Telegraph (Ga.); **Staff,** Sun Herald; **Staff,** Columbus Ledger-Enquirer (Ga.)

This series shows great bravery in use of photography. There's an emotional, restrained attachment to the subject matter. These pages were produced under extraordinary circumstances. The staff not only rallied to get the paper published, but it took chances and produced memorable coverage that presented the angst in their communities.

Esta serie muestra una gran valentía en el uso de la fotografía. Hay una fijación a la materia temática emotiva y controlada. Estas páginas fueron producidas bajo circunstancias extraordinarias. El personal del diario no sólo hizo grandes esfuerzos para conseguir publicar el diario, sino que se arriesgó para producir una cobertura memorable que mostró el temor de sus comunidades.

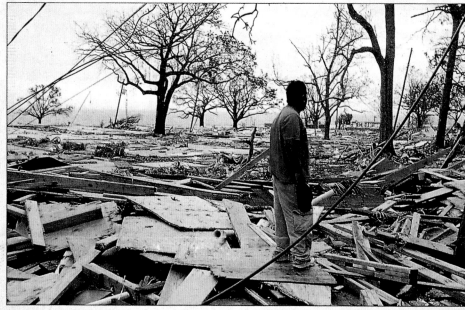
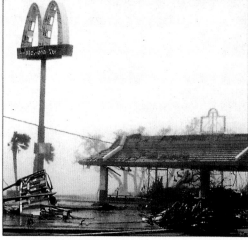

Pascagoula
15 people confirmed dead in Jackson County, page 18

Hancock County
Residents escape storm in sailboat, page 14

Biloxi
Point Cadet residents sift through emotions, page 16

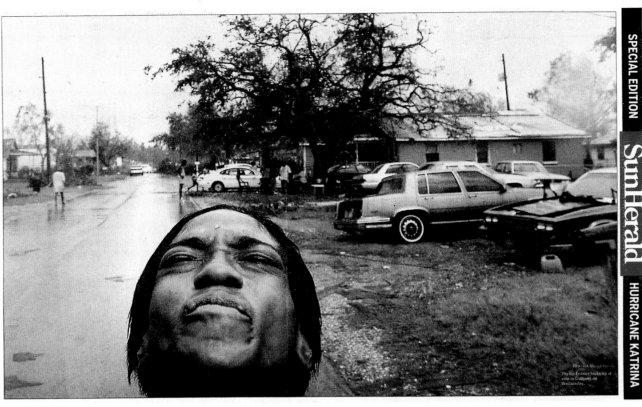

Phyllis Frasier looks up at rain in Gulfport on Wednesday.

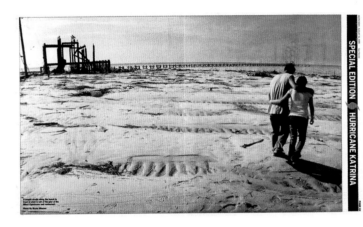

SPECIAL EDITION ● HURRICANE KATRINA

SunHerald
SOUTH MISSISSIPPI'S NEWSPAPER

VOL. 121, NO. 333 FRIDAY, SEPTEMBER 2, 2005 www.sunherald.com

TODAY BUSH ARRIVES | AID INCREASES

HELP TRICKLES IN
Frustration mounting as agencies become overwhelmed

Downtown residents pick up ice and water at an aid station in Biloxi. Most people waited for hours. Relief from Hurricane Katrina has been slow to arrive.

By SCOTT DODD, TOM WILEMON and SCOTT HAWKINS
SUN HERALD

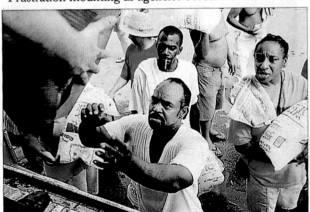

What the world need now is love God's love

A message for Hurricane Katrina victims is posted on a bench in Biloxi.

What happened to the relief response?

By GARY FINEOUT
SUN HERALD

Health
Workers try to attack multitude of problems. Page 3

Governor
Haley Barbour asks for patience. Page 3

Education
Schools unsure how long they'll be closed. Page 4

Call out to a loved one
To track relatives and loved ones, leave a message at 1-866-453-1925

To our readers The Sun Herald produced this edition remotely from Columbus, Ga. The paper will resume normal delivery times and routes as quickly as possible.

THE EDITORS

FRIDAY, SEPTEMBER 2, 2005 Sun Herald PAGE 19

SPECIAL EDITION ● HURRICANE KATRINA

LOVED ONES LEAVE MESSAGES

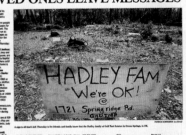

THE NEXT GENERATION
South Florida teens key to Judaism's survival

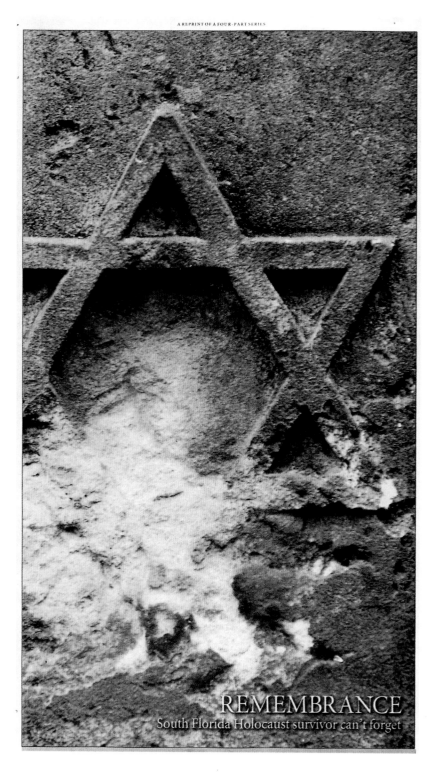

REMEMBRANCE
South Florida Holocaust survivor can't forget

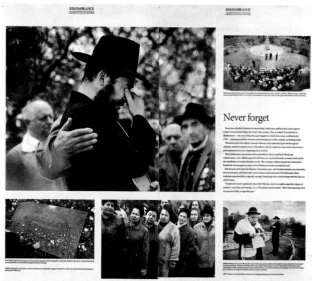

Never forget

JUDGES' SPECIAL RECOGNITION
for visual storytelling

South Florida Sun-Sentinel
Fort Lauderdale

Awards of Excellence
Information-graphics portfolio, staff / Extended coverage / 175,000 and over
Photo portfolio, individual
Photo portfolio, staff
Reprints
Special coverage / Multiple sections, no ads
Special coverage / Section pages / Inside page or spread
Special coverage / Sections, no ads
Special news topics / Editor's choice, local/regional

Joe Amon, Staff Photographer; **Nicole Bogdas,** Designer; **Robert Duyos,** Staff Photographer; **Karsten Ivey,** Graphic Artist, Senior Graphics Reporter; **Carline Jean,** Staff Photographer; **Michael Laughlin,** Staff Photographer; **Belinda Long,** Graphic Artist; **Robert Mayer,** Staff Photographer; **Tom Peyton,** Visual Editor; **Tim Rasmussen,** Director of Photography; **Carl Seibert,** Staff Photographer; **Mike Stocker,** Staff Photographer; **Rhonda Vanover,** Photographer; **Mary Vignoles,** Deputy Photo Director, Photo Editor; **John White,** Staff Photographer

The depth of the story, the theme and the consistency in design bring you full circle. The typography is quite manicured. We're thrilled that this paper chose to do this project. It is the spirit of community-service journalism.

This four-part series on Judaism's new century is an amazing piece of work. The photographer did a great job finding intriguing photographs from everyday situations and capturing hard-to-get situations, such as a grown man getting a circumcision. Every photograph works together — their mood, tone, light and proportions flow perfectly.

La profundidad del relato, el tema y la consistencia en el diseño forman un círculo virtuoso. La tipografía está muy bien cuidada. Nos alegramos de que este diario haya realizado este proyecto, porque es el espíritu del servicio a la comunidad del periodismo.

Esta serie de cuatro partes sobre el nuevo siglo del judaísmo es una obra sobresaliente. El fotógrafo hizo un gran trabajo al encontrar fotos intrigantes de situaciones de la vida diaria y captar situaciones difíciles, como la de un hombre adulto que es circuncidado. Cada foto funciona con las demás; su ánimo, tono, luz y proporciones funcionan perfectamente.

Surviving on fading memories

South Floridian fears history of the Holocaust will disappear with his generation

"I could go back, you know, but I think I would see in the faces of the families too many of the killers."

Rediscovering Judaism

Synagogues, religious schools are booming as Russian Jews reclaim their culture

"We almost lost Judaism in Russia; another generation of communism and most Jews would have lost all knowledge of *Yiddishkeit* [Jewishness]."

You cannot believe what the Germans were capable of.
ISRAEL BAKCHER, 80

But we were so resilient.
SABA BAKCHER, 80

(14)

It's very painful to remember, but it's very hard to forget.
WILLIAM FRIEDMAN, 79

(5)

I knew I was going to die. It was just a matter of time.
ISAAC BAKCHER, 79

(3)

CONFRONTING HATE
The new anti-Semitism

Outlook

SURVIVORS

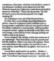
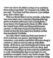
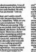
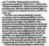

They are the last witnesses to one of the most horrific crimes in history.
Your neighbors. Their stories.

O SACO DE PLÁSTICO
A FRASE MAIS LOUCA
O CANTINHO XENÓFOBO
AS JOKEMAILS MAIS
INDECENTES

indígena

SEXTA-FEIRA 22 ABRIL 2005 O INDEPENDENTE

Este suplemento é parte integrante da edição 884 do jornal Independente e não pode ser vendido separadamente

JUDGES' SPECIAL RECOGNITION
for consistent and superior-quality conceptual design

O Independente
Lisbon, Portugal

Silver
Feature design, page(s) / Entertainment / 49,999 and under

Awards of Excellence
Feature design, page(s) / Entertainment / 49,999 and under (2)

Sónia Matos, Art Director & Designer; **Leonardo Ralha,** Editor;
Inês Serra Lopes, Editor in Chief

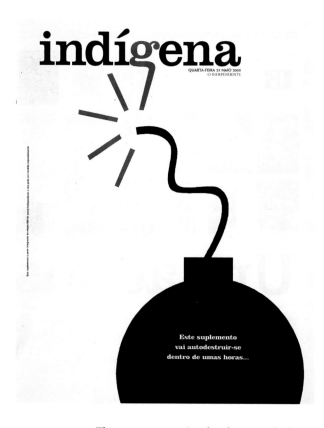

indígena

QUARTA-FEIRA 25 MAIO 2005
O INDEPENDENTE

Este suplemento
vai autodestruir-se
dentro de umas horas...

O SACO DE PLÁSTICO
A FRASE MAIS LOUCA
O CANTINHO XENÓFOBO
AS JOKEMAILS MAIS
INDECENTES

indígena

SEXTA-FEIRA 15 ABRIL 2005 O INDEPENDENTE

Alain de Botton Douglas Coupland na meia-idade Samuel Fuller no Indie Lisboa

✱ O Indígena comemora esta semana a 100.ª edição. Parabéns a nós e aos nossos leitores

These covers are simple, clever reads that quickly pull you in. The color palette is understated and consistent. The designers know a hell of a lot about design. Really friggin' cool.

Estas portadas son simples e inteligentes lecturas que rápidamente atrapan al lector. La paleta de color es sutil y consistente. Los diseñadores saben muchísimo sobre diseño. Son realmente 'cool'.

JUDGES' SPECIAL RECOGNITION

Rocky Mountain News
Denver

Silver
Photography / Single photos / General news

Awards of Excellence
Photo portfolio, individual
Photography / Multiple photos / Project page or spread

Todd Heisler, Photographer

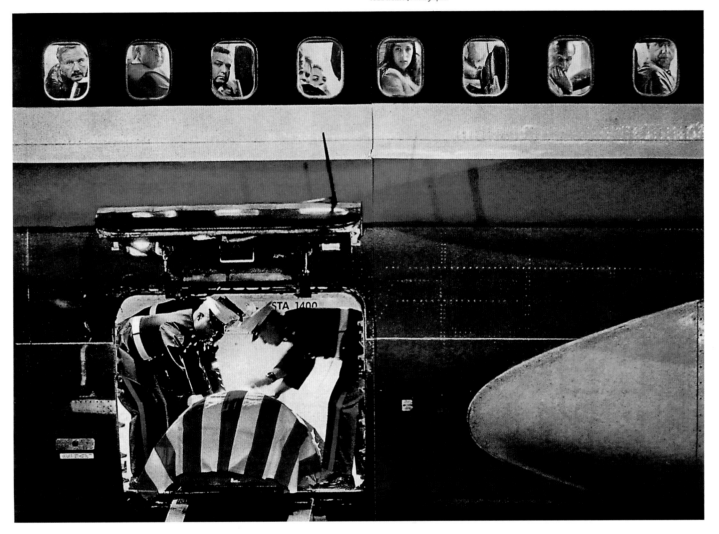

This photo of the casket of Lt. Jim Cathey arriving at the Reno, Nev., airport has many layers — it's about war, it's about death, it's about life at home. It's a fantastic image that captures many levels of reality and emotions. In a very difficult shooting situation, at night, with low light, the photographer managed to keep the detail of all the people in the windows.

Esta foto del ataúd del teniente Jim Cathey que llega al aeropuerto de Reno, Nevada, EE.UU., es sobre la guerra, la muerte y la vida en casa. Es una imagen fantástica que captura muchos niveles de realidad y emociones. Pese a que era una situación muy difícil para tomar fotos, de noche y con poca luz, el fotógrafo logró captar el detalle de toda la gente en las ventanas.

IN UGANDA, LIVES STEEPED IN AGONY

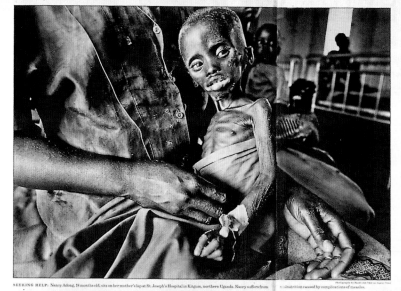

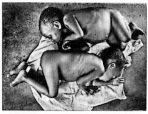

NOTHING WANTED: A child gathers grain spilled from World Food Program trucks at the Patongo camp in northern Uganda. People who leave the camp to look for food or firewood risk being attacked by Lord's Resistance Army fighters.

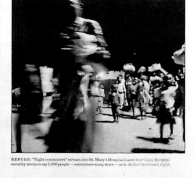

ALONE TOGETHER: Orphans Sarah Alimo, top, and Vicki Abony sleep on the cool concrete floor of the feeding center at St. Joseph's Hospital in Kitgum.

SEEKING HELP: Nancy Adong, 18 months old, sits on her mother's lap at St. Joseph's Hospital in Kitgum, northern Uganda. Nancy suffers from malnutrition caused by complications of measles.

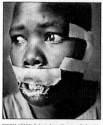

MUTILATION: Lokeria Aciro, 80, rests at St. Joseph's Hospital in Kitgum after having been attacked by a boy of about 11 who cut off her lips and ears. She had been collecting firewood outside a camp.

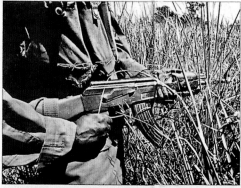

STANDING GUARD: The threat of ambushes, looting and land mines is widespread in northern Uganda. When vehicles break down during the delivery of food to a camp for the displaced, troops escorting the convoy go on heightened alert.

REFUGE: "Night commuters" stream into St. Mary's Hospital Lacor near Gulu. Hospital security workers say 5,500 people — sometimes many more — seek shelter there each night.

JUDGES' SPECIAL RECOGNITION
for visual storytelling

Los Angeles Times

Silvers
News design, page(s) / A-Section / 175,000 and over (2)
News design, page(s) / Other / 175,000 and over

Awards of Excellence
News design, page(s) / Inside page / 175,000 and over
Photography / Multiple photos / Page design
Photography / Multiple photos / Project page or spread
Photography / Single photos / Feature
Special news topics / Editor's choice, international

Wesley Bausmith, Deputy Design Director; **Dave Campbell,** Design Editor; **Kirk Christ,** Design Editor; **Colin Crawford,** A.M.E./Photo; **Christian Potter Drury,** Features Design Director; **Les Dunseith,** Graphic Director; **Gail Fisher,** Photo Editor; **Bill Gaspard,** News Design Director; **Tim Hubbard,** Design Editor; **Joseph Hutchinson,** Creative Director; **Lorena Iniguez,** Graphics Editor; **Pete Metzger,** Design Editor; **Jan Molen,** Design Editor; **Francine Orr,** Photographer; **Judy Pryor,** Design Editor; **Dan Santos,** Design Editor; **Kelli Sullivan,** Deputy Design Director; **Lorraine Wang,** Design Editor; **Michael Whitley,** Deputy Design Director; **Steve Stroud,** Photo Editor; **Mary Cooney,** Photo Editor; **Alan Hagman,** Photo Editor; **Julie Rogers,** Photo Editor; **Photography/Photo Editing Staff; Staff**

It doesn't matter what the subject is — terrible conditions in Uganda, the celebration of pop culture at the Oscars, the death of the pope. What the Los Angeles Times does with shooting, editing and play of photos stands above.

No importa cuál sea el tema; las terribles condiciones en Uganda, la celebración de la cultura pop en la entrega de los premios Óscar o la muerte del Papa, el Los Angeles Times lo hace con una toma, una edición y un uso de fotografías sobresaliente.

SUNDAY PREVIEW

Los Angeles Times

JUNE 5, 2005

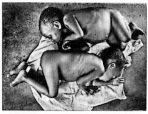

Rumsfeld Sees China's Arsenal as Asia Threat

Defense chief implies that the goal may be to control Taiwan and threaten U.S. supremacy, the Chinese counterpart objects.

By MARK MAZZETTI

A LAND OF GRIEF

Fanatical rebels have terrorized northern Uganda for years, enslaving and torturing those who seek safety in squalid camps and at town facilities

Bush Pushes Global Vision

Spreading democratic reform has become a top U.S. priority, at times trumping urgent issues.

By TYLER MARSHALL

ESCAPED WITH THEIR LIVES: Keela Abur and grandson Peter Ojok were stopped on a road in northern Uganda by LRA rebels, who beat Abur, robbed her and left her naked. Peter was threatened but not physically harmed.

Petroleum Supplies Expected to Drain

REARING FOR WAR

Marine Battles the Scars of War

INSIDE

TRAVEL
Scotland in Miniature

REAL ESTATE
Courtesy Can Help Remodel

BOOK REVIEW
Wicked Summer Reading

OPINION
Scary Preschool Utopia

Los Angeles Times

On The Internet: WWW.LATIMES.COM SATURDAY, APRIL 9, 2005 COPYRIGHT 2005-138 PAGES-CC 50¢ Designated Areas Higher

Millions Say Farewell to Pope

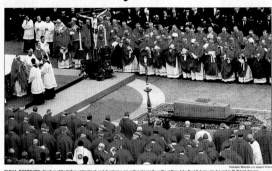

FINAL RESPECTS: Members of the College of Cardinals and dignitaries are gathered near the coffin of Pope John Paul II during his funeral in St. Peter's Square.

After a ceremony rich in emotion and ritual, John Paul II is quietly laid to rest in the grottoes beneath St. Peter's Basilica.

By TRACY WILKINSON AND RICHARD BOUDREAUX
Times Staff Writers

VATICAN CITY — In death, as in life, he mesmerized the world. Pope John Paul II was laid in a plain cypress coffin Friday and eulogized on the steps of St. Peter's Basilica in a grand funeral that drew millions of pilgrims and leaders from all corners of the Earth.

Spirit May Be Guiding, but Politicking Is Strong

Deal brokering among the 'elector' cardinals is an inevitable part of choosing the next pope.

By TRACY WILKINSON
Times Staff Writer

VATICAN CITY — Cardinals gathering to choose the next pope like to say they are guided by the Holy Spirit. But the Lord moves in mysterious ways, and his delegates can be real wheeler-dealers.

IN POLAND: A woman watches the rites on a screen.

RELATED STORIES

Pallbearers: "Pope's footmen," a 600-year-old brotherhood, cherish their task. A8
Global loss: Pilgrims flock to Rome from all nations and religions. A11
Burial site: A look at the preparations at the site where the pope was laid to rest. A14
Shared grief: Millions around the world gather to watch the televised rites. A15
Sainthood: Poles lead the calls to speed up the process for John Paul II. A18
Sacred music: The Gregorian chant heard this week sounds different for a reason. A20

RESTING PLACE: The pope's casket is placed beneath St. Peter's Basilica in keeping with his wish to be buried "in the ground" and not in an aboveground sarcophagus.

Major Port Proposed for Baja Region

Shippers want to build in Mexico because of logjams at the complex in L.A. and Long Beach.

By CHRIS KRAUL AND DEBORAH SCHOCH
Times Staff Writers

MEXICO CITY — A coalition of shipping and freight concerns announced plans Friday for a $1-billion port on deserted seaside farmland about 150 miles south of Tijuana on the Baja peninsula.

State to Scrap Key Parole Reform

Violators will go back to prison instead of into diversion programs now deemed ineffective.

By JENIFER WARREN
Times Staff Writer

SACRAMENTO — Corrections officials will scrap the centerpiece of their effort to reform California's beleaguered parole system because there is no evidence the new approach is working.

Royal Fairy Tale Ending?

As Charles prepares to marry his first love today, Britons debate the merits of a monarchy.

By JOHN DANISZEWSKI
Times Staff Writer

LONDON — Will Charles find happiness with Camilla? Will the queen yield her throne to the newlyweds after a decent interval? Will the charming Prince William stop upstaging his dad?

INSIDE

Bush's Social Security Proposal Hits a Wall
Some conservatives worry about pressure for tax increases and benefit cuts but a rejection of private accounts. A21

Shriver Says Our House, Not the White House
Maria Shriver says she would prefer that the governor not run for president. B3

Weather
Mostly clear skies with gusty winds today and tonight. L.A. Downtown: 70/52. B18

News Summary A2
Beliefs B7 Obituaries ..B14
EditorialsB16 ScienceA29

Plea Deal Is Reached in Olympic Bombing

By ELLEN BARRY
Times Staff Writer

ATLANTA — With his trial underway, Eric Robert Rudolph agreed to plead guilty to a series of bombings that advanced a militant antigay, antiabortion ideology — including a deadly explosion at the 1996 Summer Olympics here.

REMEMBERING JOHN PAUL II

Grief and Grandeur

The elaborate Vatican funeral offers many indelible and colorful images.

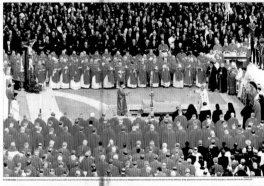

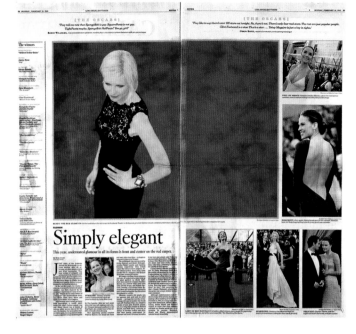

Simply elegant

This year, understated glamour in all its forms is front and center on the red carpet.

Los Angeles Times
CALENDAR
PART 1

Monday, February 28, 2005 calendarlive.com

Arts
Entertainment
Style
Culture

[THE OSCARS]

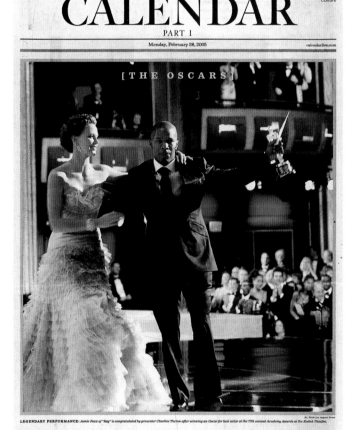

LEGENDARY PERFORMANCE: Jamie Foxx of "Ray" is congratulated by presenter Charlize Theron after winning an Oscar for best actor at the 77th annual Academy Awards at the Kodak Theatre.

New tune, but song's the same

The big surprise is that Rock turns out to be not too dangerous.

By PAUL BROWNFIELD
Times Staff Writer

OH, cruel Oscar world, with your caste systems and not-so-subtle slights! I know that this year's telecast was designed to streamline things, to head off the collective unconsciousness that tends to kick in around hour three. But all the little stylistic changes — barring some winners from going onstage, limiting Robin Williams to 10 jokes about Beverly Hills face-lifts — couldn't save the show from devolving into the overblown TV event it wants always to be. It doesn't matter where you place Scarlett Johansson to talk about technical achievement, the Oscars are a popularity contest that pretends also to honor the boulder pushers who spend months of their lives applying makeup to a celebrity's puss at 5 in the morning.

Those would be the makeup artists, among the categories in which the winner accepted the award in the aisle, like an audience member asking a question on a daytime talk show. Lacking a great race for best picture and fearing the audience fatigue that has seen ratings for the Oscar telecast — and other award shows — spiral downward in recent years, the PR strategy this year was to plug its "dangerous" host, Chris Rock. By the time Rock took the stage Sunday night, so many thou- [See Rock, Page E7]

Understatements
Safe red carpet picks keep mishaps to a minimum. Page 7

All choked up
The academy votes with their emotions. Page 7

Simply the best
For a complete list of Oscar winners, see Page 2

Backstage, just another calm Hollywood night

By MARY McNAMARA
Times Staff Writer

This is not your grandfather's metro section. The Globe has redefined what a metro section can be. It's not the dumping ground for stories that didn't make it on the front page, but a flexible home where stories are planned and written for the section. And this newspaper has redefined the news on a metro section — issues important to people's lives. It's just so innovative compared to everything we saw.

No se trata de la sección de ciudad de nuestros abuelos. El Globe ha redefinido lo que puede ser esta sección. No es el depósito de los artículos que no cupieron en la primera página, sino un área flexible en la cual los artículos han sido planificados y redactados para esta sección. Este periódico ha cambiado el significado de las noticias en la sección sobre ciudad; son los temas importantes en la vida de la gente. Es muy innovador en comparación con lo que vimos.

City Weekly

BOSTON SUNDAY GLOBE, JUNE 19, 2005

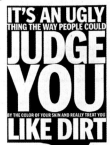

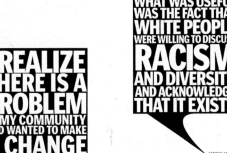

IT'S AN UGLY THING THE WAY PEOPLE COULD **JUDGE YOU** BY THE COLOR OF YOUR SKIN AND REALLY TREAT YOU **LIKE DIRT**

I REALIZE THERE IS A **PROBLEM** IN MY COMMUNITY AND WANTED TO MAKE **A CHANGE**

AFRICAN-AMERICAN, CODMAN SQUARE, DORCHESTER*

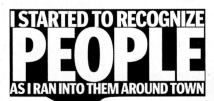

I STARTED TO RECOGNIZE **PEOPLE** AS I RAN INTO THEM AROUND TOWN

FERNANDO BOSSA, LATINO, FIELDS CORNER, DORCHESTER

MULTIRACIAL, SOUTH END*

* Quotes as recorded by the City-Wide Dialogues project, which does not identify individuals by name.

WHITE, ROSLINDALE*

TALK ABOUT RACE

Quietly, under the media radar, some folks are tackling Boston's touchiest topic

By Christine MacDonald
GLOBE CORRESPONDENT

As a black child riding a school bus from Roxbury to East Boston in the 1970s, recalls Michael James, he was frightened by stone-throwing whites protesting forced school desegregation.

As one of the few white children growing up in the Bromley-Heath public housing project, says Paul MacEachern, he often got into fights with other white boys, who picked on him for hanging around with African-Americans.

As a member of one of the first Latino families to move into the Fields Corner section of Dorchester, says Fernando Bossa, he was spit on as a boy, called names, chased by kids with bats, and told repeatedly that he should go back to where he came from.

"It's an ugly thing the way people could judge you by the color of your skin and really treat you like dirt," Bossa says.

Today minorities make up the majority of residents in a city that has gone, according to the US Census, from predominantly white to multiracial and multicultural in recent decades. While this diversity is sometimes touted as one of Boston's strengths, many residents and community leaders lament that people from different races, economic brackets, and lifestyles often share the same city blocks without acknowledging one another's existence.

So James, Bossa, MacEachern, and a few hundred others have set out to build bridges between different groups and make Boston a more neighborly place for all of its residents.

As participants in City-Wide Dialogues on Boston's Ethnic & Racial Diversity, they aim to have frank conversations about the often painful, even unspeakable topic of race. Since the project's launch in late 2003, about 480 people have taken part.

The goal: to attack the city's stubborn standoffishness, ease tensions, and build civic trust
DIALOGUES, Page 7

CAMBRIDGE

For classic Hub cruisin', now a particular place to go

By Robert Preer
GLOBE CORRESPONDENT

Drivers zooming along the river roads on a sweltering Saturday afternoon slow down at the Eliot Bridge and do a double take. Cyclists and joggers stop and stare.

At the base of the bridge stands an unusual lineup of vehicles, including a blue 1961 Corvair, a gray 1951 Chevy coupe, and a black 1969 Mustang.

Bruce Kline of Brighton stood next to his 1955 Mercedes Benz 190SL, a black two-seat roadster and, he says, one of the first 500 Mercedes models imported to the United States. A retired Boston and Chelsea teacher, the 61-year-old Kline rebuilt the engine and is now working on the body.

"I bought it in 1978 from a mechanic who ran out of money," says Kline. "I take it out every weekend if there's no salt on the road. I don't believe in letting it sit."

Last weekend, Kline and his exotic race car were part of the regular Saturday classic car meet, started a month ago by the American Legion Marsh Post 442 next door to the bridge. While cruise nights and car meets are fairly common in the suburbs, this one in the post's parking lot is

GLOBE STAFF PHOTO/WENDY MAEDA
Bruce Kline of Brighton showed off his 1955 Mercedes Benz 190SL at the classic car meet, held Saturdays by the American Legion Marsh Post 442.

CARS, Page 12

HYDE PARK

Economic woes hit home, as foreclosure rate soars

By Jim Cronin
GLOBE CORRESPONDENT

Mary Adamson knows the agony of losing a home. "I felt like I was a total failure," she said. "I tried so hard to take care of my family and wasn't able to. I felt useless, like I was worth nothing."

After years of trying to save her three-bedroom house in Hyde Park, Adamson lost it to foreclosure April 28. She now lives in a Roslindale two-bedroom apartment with her husband.

As devastating as her story is, key elements in it have become all too common, according to Virginia Pratt, a foreclosure prevention counselor at Ensuring Stability through Action in our Community in Jamaica Plain.

"The big thing is loss of income," Pratt said. "We see people who don't have the good jobs that they had when they got their mortgage due to a downturn in the economy.

"With the job market, in relation to the high cost of housing, they just can't afford to pay their mortgage," she said.

49.80%
Rise
in foreclosures
in Suffolk County,
which includes Boston,
from January-April 2004
to January-April 2005

27.82%
Rise
in foreclosures
statewide
over the same period.

SOURCE:
ForeclosuresMass.Corp.

FORECLOSURES, Page 11

Inside Jamaica Plain students prepare to **float** their **African** model **boat,** *Page 3* . . . **Rozzie bookstore** is a **bestseller,** but it's looking for a **buyer,** *Page 4* . . . In **Brighton,** the **shutdown** of **Provident** Nursing Home **hits 100 patients** hard, *Page 5* . . . **Full index,** *Page 2*

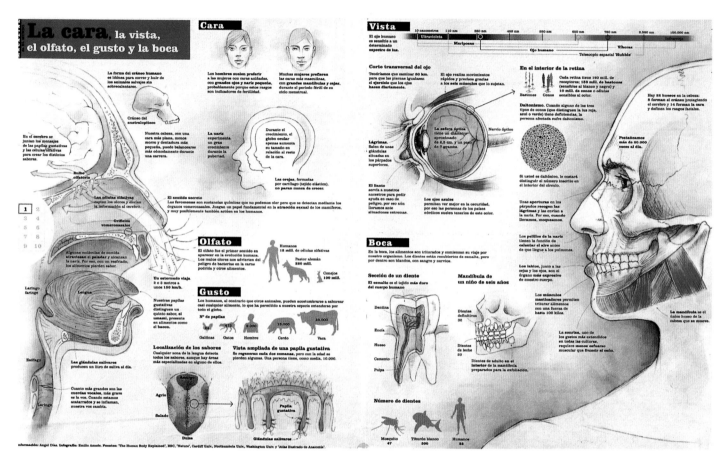

This graphic of the human body tells its story through 10 spreads, each graphic done in a different style. Many of these graphics are excellent on their own, but the full project pushes the envelope of everything we've seen. The magnitude, the daring, the risk-taking, the brass, the planning, the research, the execution — it's near perfection.

Este gráfico del cuerpo humano cuenta su historia a través de diez series, donde cada gráfico está realizado en un estilo diferente. Muchos de estos gráficos son excelentes en sí mismos, pero el proyecto completo va más allá de todo lo visto anteriormente. La magnitud, el atrevimiento, la toma de riesgo, la temeridad, la planificación, la investigación y la ejecución; es casi perfecto.

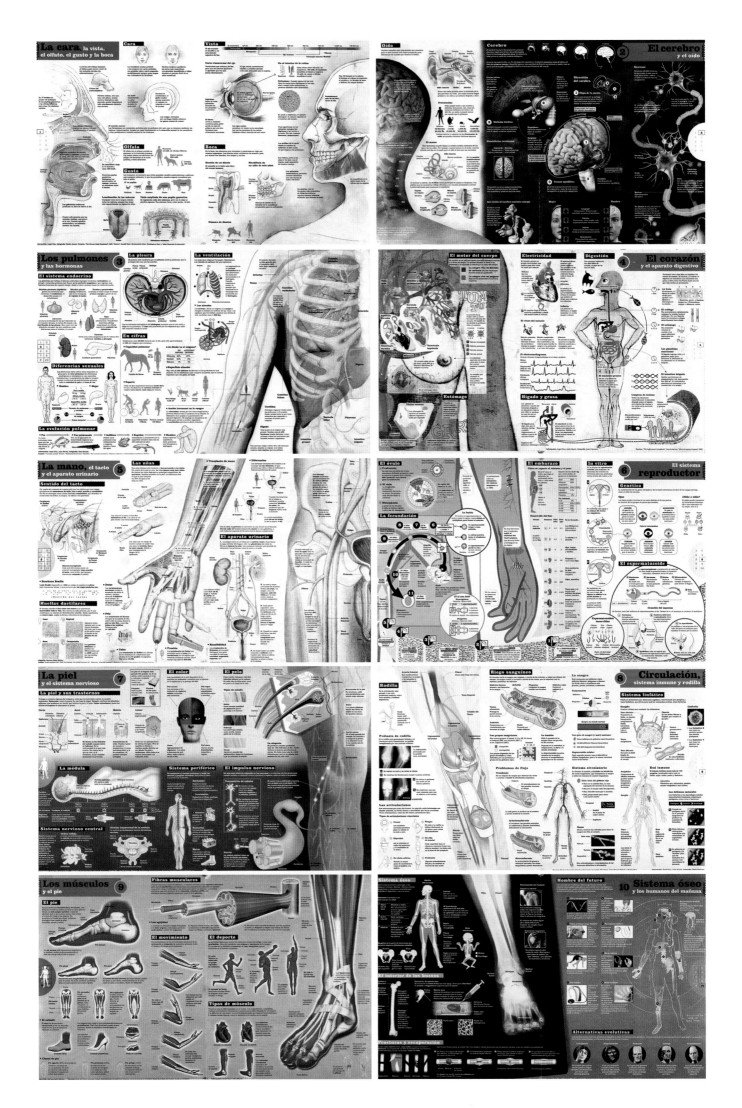

JUDGES' SPECIAL RECOGNITION
for concept and execution

El Mundo Metropoli
Madrid, Spain

Awards of Excellence
Illustration portfolio, individual
Page-design portfolio / Magazine / 175,000 and over (4)

Rodrigo Sánchez, Designer

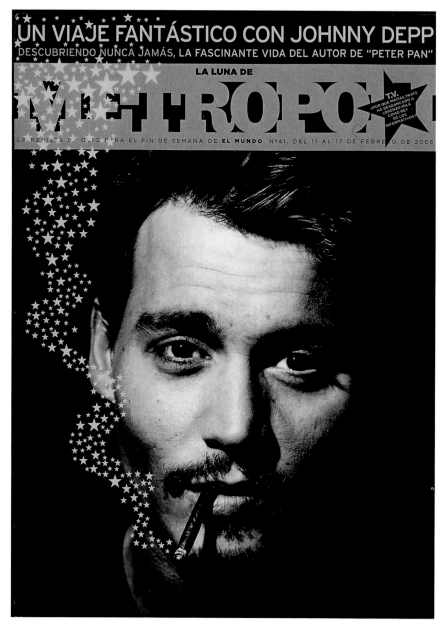

Seeing a group of Metropoli covers is like being punched — in the best possible way, of course. All different styles. All executed to the highest standards. Each style precisely matches the story it is telling. This is remarkable work unlike what anyone else is doing. Who else does this so well?

Mirar un grupo de portadas de Metrópoli es como recibir un golpe – en el mejor de los significados, claro está. Todos de diferentes estilos. Todos realizados con los más altos estándares. Cada estilo calza precisamente con lo que el artículo está relatando. Este trabajo es significativo, diferente a lo que los demás están haciendo. ¿Quién más hace esto tan bien?

Multiple
Winners

3

CASH CROP
SPECIAL REPORT

Many years after following the Blues Highway north to Chicago, Ellis Johnson returns to his native soil near Lake Cormorant, Miss., where he helps local farmer Malcolm McClanahan harvest cotton. Johnson picks up loose cotton and throws it in a "mule wagon."

THE LAND OF
COTTON

Take a journey into the history and culture of cotton through photography and personal accounts

Photography and reporting by LANCE MURPHEY

IN THE MID-SOUTH, cotton is on our backs.
Slavery and sharecropping built it.
Our history, economy and culture are knee-deep in it.
We grow, ship, celebrate and speculate cotton. We swaddle our babies in its soft fibers, yet remember the sweat, dirt and torn hands that made it so.
We wonder about cotton's future.
On the following pages, Commercial Appeal photojournalist Lance Murphey explores cotton with pictures and firsthand accounts from people whose lives are interwoven with cotton.

MORE ONLINE
See more photos and hear special audio interviews at commercialappeal.com

Chris Cornaghie, Dick Ashman, Joe Walker and Jim Brooks (from left) watch the comings and goings at the Carnival Memphis Crown and Sceptre Ball.

VIEWPOINTS INSIDE: Editorials, opinion and letters to the editor appear in this section. | PAGES 8 AND 9

EDICIÓN ★ ESPECIAL

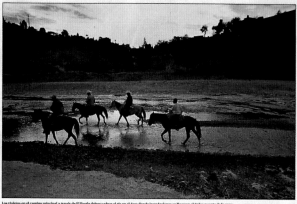

Los viajeros en el camino principal a través de El Paxtle deben vadear el río en el área donde inundaciones se llevaron el único puente de la zona.

PUENTE DE
MÉXICO

POR KELLY LECKER | FOTOS POR CHRIS RUSSELL

ADENTRO

PRIMERA PARTE
La gente se muda al norte | 1-3

SEGUNDA PARTE
El dinero fluye hacia el sur | 4-6

TERCERA PARTE
La cultura cambia a las
comunidades | 7-10

LLEGAN DESDE MÉXICO por millares, en búsqueda de una vida mejor.
Estos nuevos inmigrantes en su mayoría están entre ellos y no hablan mucho, evitando encuentros que puedan terminar en deportación para aquellos sin documentos legales.
Pero al crecer en números se han vuelto más visibles. Se les encuentra tomando órdenes en los restaurantes de comida rápida, instalando techos en casas, y plantando en la parte de afuera de los negocios.
Familias grandes y grupos de hombres solos viven en apartamentos pequeños, pero en mejores condiciones que los que tendrían viviendo en la pobreza de sus pueblos natales. Cuando un fuego mató a diez mexicanos el pasado septiembre en los apartamentos de Lincoln Park West, la tragedia encontró a los investigadores y el público sin defensas.
Muy pocos de nosotros entendemos a nuestros vecinos. ¿Cómo viven? ¿Qué los atrajo a esta ciudad? ¿Qué es lo que dejaron atrás?
Para responder esas preguntas, The Dispatch exploró el creciente flujo de personas, dinero y cultura entre Columbus y Guanajuato, el estado mexicano de las víctimas de aquel fuego.
Muchos inmigrantes de todo México se han mudado al condado de Franklin. La oficina del censo de Estados Unidos estima que éstos llegan a 17,000 personas; trabajadores de servicios sociales dicen que ese número es de unos 50,000.
Los miembros de una familia mexicana que reside en la zona norte de la ciudad le dieron permiso a The Dispatch para contar su historia. Algunos viven en Columbus ilegalmente, así que acordaron ser entrevistados solamente si lo único que publicásemos era su primer nombre.
Durante los últimos años más de 50 personas del pueblito de El Paxtle se han mudado a Columbus — un patrón repetido a través de Guanajuato y México.
Esta última ola de inmigrantes trae consigo su propia cultura y sus propios retos, tal como sucedió con aquellos que llegaron de Inglaterra, Irlanda y Alemania. Llegar a conocer más profundamente a una de estas familias nos dice mucho de la comunidad mexicana misma.

The Commercial Appeal
Memphis, Tenn.

Lance Murphey, Photographer; **John K. Nelson,** Art Director, Design Director; **John Sale,** Photo Director

Photography / Multiple photos / Project page or spread
Special news topics / Editor's choice, local/regional

The Columbus Dispatch
Ohio

Scott Minister, Art Director & Designer; **Chris Russell,** Photographer

Page-design portfolio / Combination / 175,000 and over
Special coverage / Section covers

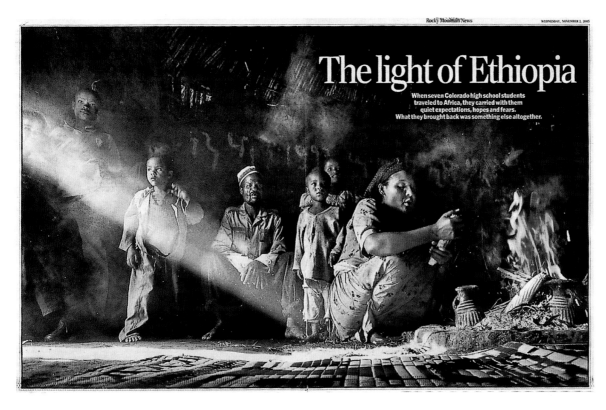

Rocky Mountain News
Denver

Todd Heisler, Photographer;
Chris Schneider, Photographer;
Rodolfo Gonzalez, Photographer;
Judy DeHaas, Photographer; **Joe Mahoney,**
Photographer; **Marc Piscotty,** Photographer

Photo portfolio, staff

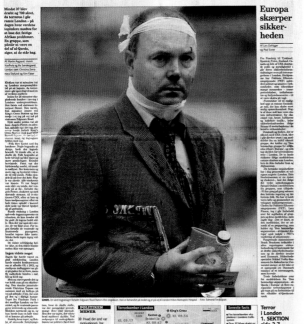

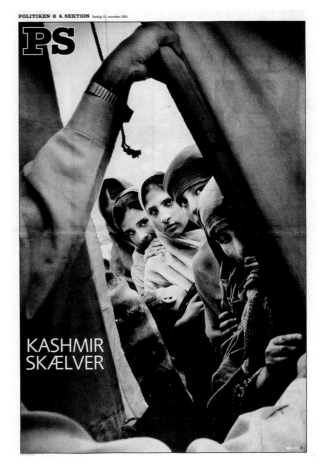

Politiken
Copenhagen, Denmark

Per Bülow, Page Designer; **Søren Nyeland,** Editor of Design;
Tine-Maria Winther, News Editor

Breaking-news topics / War on terrorism
News design, page(s) / A-Section / 50,000-174,999

Politiken
Copenhagen, Denmark

Søren Nyeland, Design Editor; **Jan Grarup,** Photographer;
Tomas Østergren, Page Designer; **Per Folkver,** Photo Editor;
Kjeld Hybel, Editor; **Bo Søndergaard,** Copy Editor

News design, page(s) / Other / 50,000-174,999
Photography / Multiple photos / Project page or spread

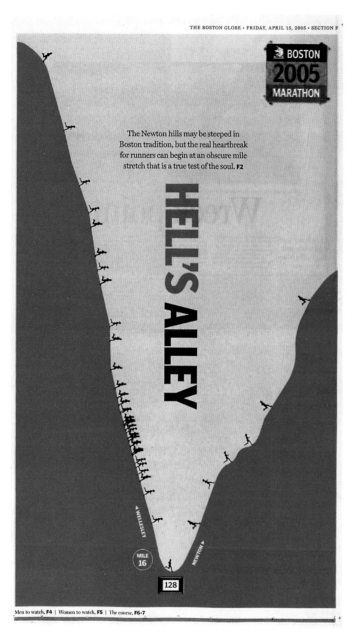

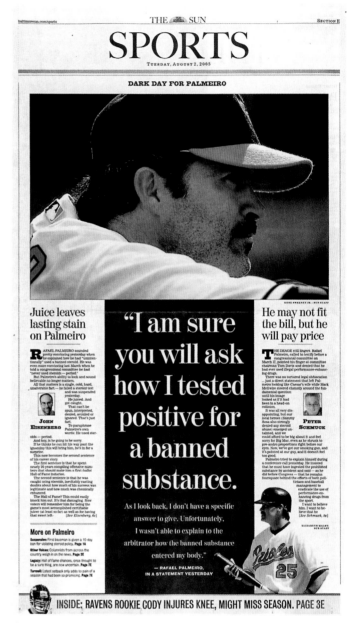

The Boston Globe

Brian Gross, Designer; **Dan Zedek,** Design Director

News design, page(s) / Sports / 175,000 and over
Page-design portfolio / Sports / 175,000 and over

The Baltimore Sun

Michael Workman, Sports Design Director; **Monty Cook,** DME/Presentation
& News Editing

News design, page(s) / Sports / 175,000 and over
Breaking-news topics / Editor's choice, sports

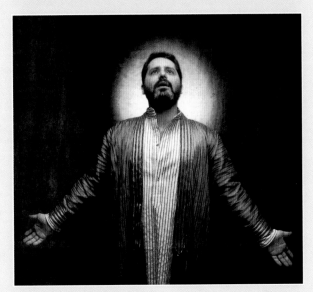

THE SUNDAY MAGAZINE OF THE HARTFORD COURANT | SEPTEMBER 4, 2005

NORTHEAST

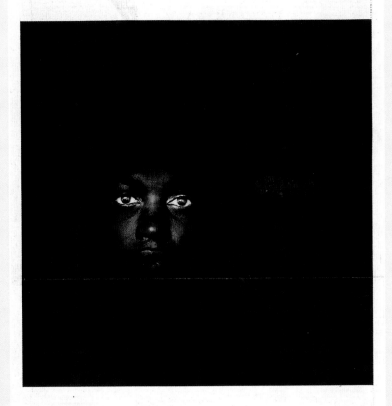

crimes against us

THE HORRORS OF WAR AND GENOCIDE AGAINST PEOPLES OF THE WORLD ... IN THEIR OWN WORDS

photo essay by adam nadel
with commentary by the head of uconn's human rights institute

SILVERS

Hartford Courant
Conn.

Photography / Multiple photos / Project page or spread
Photography / Multiple photos, Use of

Thom McGuire, A.M.E./Photo & Design; **Bruce Moyer,** Picture Editor; **Suzette Moyer,** Director/Design & Graphics; **Adam Nadel,** Freelance Photographer; **John Scanlan,** Director of Photography

This paper has a respect for photographs. It lets them speak for themselves. The size and number of photos show a strong hierarchy on every page — even on inside pages. Each page has a dominant image; you're not overwhelmed with tiny images. Visual planning is evident throughout the paper. You can tell the photo department has a strong voice in that planning.

Este diario tiene rspeto por las fotografías. Les permite hablar por sí solas. El tamaño y el número de fotos demuestra una evidente jerarquía en cada página, incluso en las interiores. Cada página tiene una imagen dominante; no se abruma con imágenes pequeñitas. La planificación visual es evidente en todo el diario. Queda claro que la sección de fotografía tiene una voz fuerte en esa planificación.

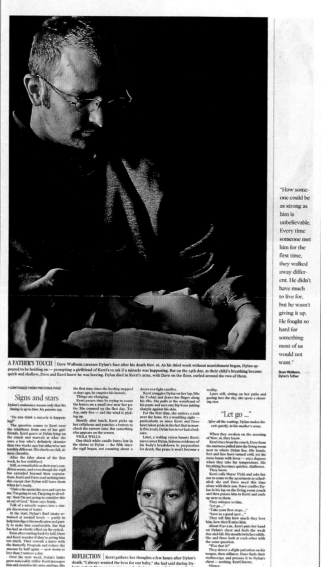

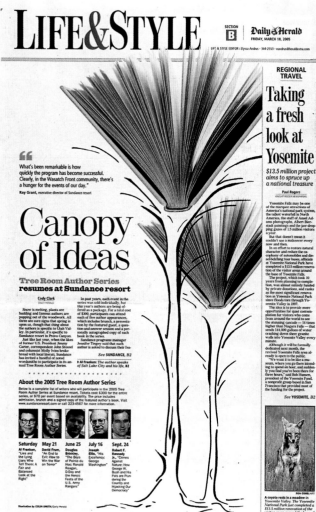

Daily Herald
Provo, Utah

Colin Smith, Designer; **Elyssa Andrus,** Life & Style Editor; **Randy Wright,**
Executive Editor

Feature design, page(s) / Lifestyle / 49,999 and under
Page-design portfolio / Combination / 49,999 and under

The Denver Post

Ingrid Muller, Design Director; **Andy Cross,** Photographer;
Larry Price, A.M.E./Photo; **John Sutherland,** Photo Director;
J. Damon Cain, M.E. Presentation & Design

Photography / Multiple photos / Project page or spread
Special coverage / Sections, no ads

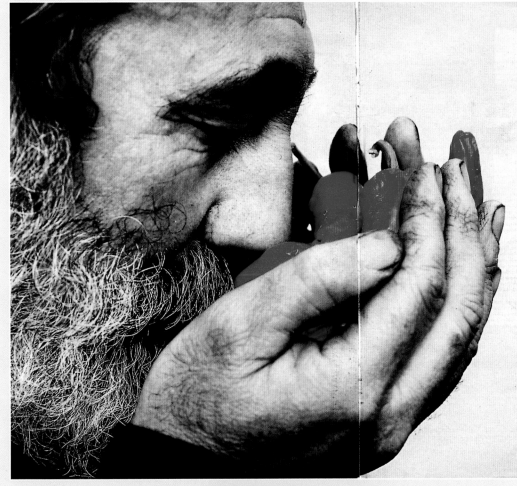

Vår nya folkdrog

I hundratals år har den varit världens mest använda krydda. Utom i kalla Norden. Men det senaste decenniet har Sverige blivit hetare. Vår nya folkdrog är chilipepparn. Två Dagars Karin Teghammar Arell och Jonny Mattsson har besökt Sveriges två främsta ambassadörer för frukten som gett en ny innebörd åt begreppet "att ha eld i baken".

JONAS BORSSEN KNÄPPER HÄNDERNA bakom nacken, lutar sig tillbaka på stolen, ser cool ut och säger:
– Chilipepparn har blivit killarnas krukväxt. Den är lite macho, ingen vanlig prydnadsgrej.

Och han borde ju ha koll på läget. Kock, kokboksförfattare och ordförande i Svenska Chilipepparföreningen "met tam och mesig mat". Man dessutom, liksom de flesta av föreningens 250 medlemmar.

Det kan ju vara en slump, men när Jonas Borssens bok Eat the Heat kom ut för nio år sedan ökade importen av chilipeppar till 466 ton från 15 ton två år tidigare. När trädgårdsmästaren Philippe Plöninge några år senare visade upp 170 chilipepparsorter som han hade odlat i Sverige på Bergianska trädgården i Stockholm blev det rusning till fröfirmorna. Handlare som sålt två-tre chilifröpåsar om året fick plötsligt hundratals beställningar. Philippe Plöninge skänkte frön till handlarna, som i sin tur drev upp plantor att ta nya frön från.

Samtidigt stod Jonas Borssén vid grytorna på Bergianskas trädgårdskafé och visade vad skörden kunde användas till. Till och med smilkakorna fick gästerna att ropa på brandsläckare. Men alla överlevde och de mest lidelsefulla ungis numera via chile- ►

två dagar 9

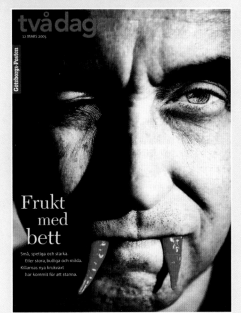

SILVER

Göteborgs-Posten
Goteborg, Sweden

Feature design, page(s) / Food / 175,000 and over

Award of Excellence
Page-design portfolio / Features / 175,000 and over

Gunilla Wernhamn, Designer; **Jonny Mattsson,** Photographer

For a food page about peppers, this page is spicy. Look at it, and feel your temperature rise. What a surprise — and the surprise keeps building. There is beautiful photography, with the red peppers popping out, and a simple design, with useful bits woven throughout.

Para ser una página sobre pimientas, ésta pica. Basta con mirarla para sentir cómo sube la temperatura. Es toda una sorpresa; y la sorpresa continúa. La fotografía es bella, con los pimientos rojos que saltan a la vista y pequeños recuadros útiles integrados en toda la página.

The Free Lance-Star
Fredericksburg, Va.

Meredith Sheffer, Page Designer

Feature design, page(s) / Food / 49,999 and under
Page-design portfolio / Features / 49,999 and under

The Free Lance-Star

FOOD&LIFE

Inside
TV & Comics, D6–7

D

WEDNESDAY
AUGUST 31, 2005

Food Editor:
Laura L. Hutchison ■ 374-5485

Local cookbook has extras

Fawn Lake effort to aid fire and rescue

BY CATHY DYSON
THE FREE LANCE-STAR

everything is cooler in a
martini glass

By CAROLYN JUNG
KNIGHT RIDDER NEWSPAPERS

ON THE SHELF

Kid-friendly snacks

Grate Improvements

— Renee Enna,
Chicago Tribune

ON LINE

bottledwater.org

— By Connie Bloom
Knight Ridder
Newspapers

INSIDE FOOD

Menu Planner	Pig Roast toppers	Glass Act	Desperation Dinners
Baked Salmon With Wasabi Cream ... D2	Memphis Style Barbecue Rub ... D4	Berries in Minted Gelatin ... D4	Two Cheese Potato Pancakes ... D5
Greek Burgers With Cucumber Sauce ... D2	Spicy BBQ Rub ... D4	Shrimp 'Ceviche' ... D4	Sweet Treats
Mediterranean Grape and Lamb Pitas ... D2	Hawaiian Barbecue Sauce ... D4	Buttermilk Panna Cotta ... D4	Funnel Cakes ... D5

COMING TOMORROW IN WEEKENDER • 14TH ANNUAL LOUISA COUNTY AIRSHOW

MAINEIACS: Lewiston ships Legault to the Volts C5 BASEBALL: Millwood joins Rangers C5

SPORTS

TUESDAY, DECEMBER 27, 2005

SECTION C

SPORTS IN MAINE: AN OFFICIAL SHORTAGE

| PATRIOTS | 31 |
| JETS | 21 |

Patriots Vrabel ground Jets, 31-21

THE INCREDIBLE VANISHING REFEREE

STORY BY KALLE OAKES ■ STAFF PHOTO ILLUSTRATION

ATHLETES ARE BIGGER AND STRONGER. More girls play sports than ever. Schools are expanding their athletic departments, buying new equipment and expanding fields. Pretty picture, isn't it? Now visualize a girls' lacrosse match being officiated by only one person.

The official shortage is also a national issue

GAME 15
Quick hits

Sun Journal
Lewiston, Maine

Paul Wallen, M.E. / Visuals; **Bill Foley,** Assistant Sports Editor; **Photo Staff;**
Pete Gorski, News Artist

News design, page(s) / Sports / 49,999 and under
Page-design portfolio / Combination / 49,999 and under

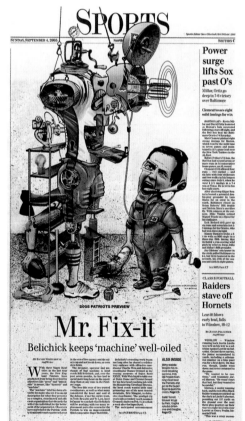

SPORTS

SUNDAY, SEPTEMBER 4, 2005

SECTION C

Power surge lifts Sox past O's

Millar, Ortiz go deep in 7-4 victory over Baltimore

2005 PATRIOTS PREVIEW

Mr. Fix-it

Belichick keeps 'machine' well-oiled

ALSO INSIDE

Raiders stave off Hornets

Sun Journal
Lewiston, Maine

Paul Wallen, M.E. / Visuals; **Pete Gorski,** News Artist; **Bill Foley,** Assistant Sports
Editor; **Steve Sherlock,** Sports Editor

News design, page(s) / Sports / 49,999 and under
Page-design portfolio / Combination / 49,999 and under

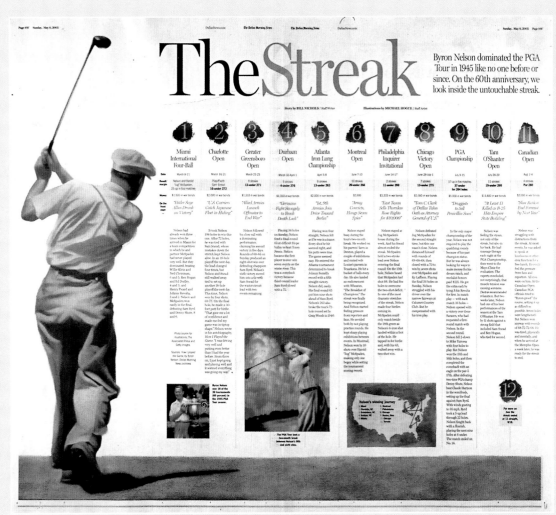

TheStreak

Byron Nelson dominated the PGA Tour in 1945 like no one before or since. On the 60th anniversary, we look inside the untouchable streak.

Story by BILL NICHOLS / Staff Writer Illustrations by MICHAEL HOGUE / Staff Artist

1	2	3	4	5	6	7	8	9	10	11
Miami International Four-Ball	Charlotte Open	Greater Greensboro Open	Durham Open	Atlanta Iron Lung Championship	Montreal Open	Philadelphia Inquirer Invitational	Chicago Victory Open	PGA Championship	Tam O'Shanter Open	Canadian Open

Some sports pages offer too much information, but this is so elegant, in both typography and graphics. The staff didn't try to stuff the golfing encyclopedia into each text leg. It was really well organized, and easy to read and to navigate. And seeing Byron Nelson from behind is an unexpected touch.

Algunas páginas deportivas entregan demasiada información, pero ésta es muy elegante, tanto en tipografía como en gráficos. El personal del diario no intentó repletar de datos la enciclopedia de golf. Realmente, la información está bien organizada, y resulta fácil tanto leerla como navegar por ella. Además, ver a Byron Nelson por detrás es un toque inesperado.

The Dallas Morning News

Rob Schneider, Design Editor/Sports; **Michael Hogue,** Illustrator

News design, page(s) / Sports / 175,000 and over
Special coverage / Section covers

★ Cowboys Ring of Honor ★ SPORTSDAY

Power of 3

By channeling their energies for the good of the team, the Triplets helped bring three Super Bowl victories to Dallas. Now, the Cowboys give them their stars.

The Triplets Top 'Monday Night Football' moments — Sept. 15, 1997

★ EMMITT SMITH ★

The Dallas Morning News

Rob Schneider, Design Editor/Sports; **Jason Dugger,** Sports Designer; **Chris Velez,** Sports Graphic Artist; **Michael Hogue,** Illustrator; **Andrew P. Scott,** Photo Editor; **Kevin Stone,** Sports Designer; **Noel Nash,** Assistant Sports Editor

Special coverage / Sections, with ads
Special news topics / Editor's choice, sports

Top-left clipping

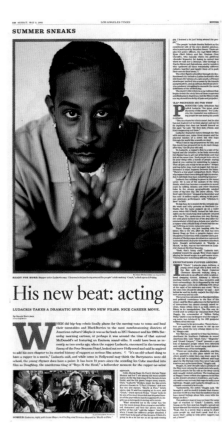

His new beat: acting

LUDACRIS TAKES A DRAMATIC SPIN IN TWO NEW FILMS. NICE CAREER MOVE.

Los Angeles Times

Steven E. Banks, Design Editor; **Jim Brooks,** Design Editor; **Paul Gonzales,** Deputy Design Director/Features; **Cindy Hively,** Photo Editor; **Tim Hubbard,** Design Editor; **Joseph Hutchinson,** Creative Director; **Kirk McKoy,** Senior Photo Editor; **Pete Metzger,** Design Editor; **Christian Potter Drury,** Design Director/Features

Feature design, sections / Entertainment / 175,000 and over
Special coverage / Single subject

Top-right clipping

JOHN PAUL II | 1920–2005

The globetrotting leader who energized the papacy was shaped early in life by family tragedies and political oppression in Poland

FIRST COMMUNION

OUTDOORSMAN

EARLY CAREER

BECOMING A CARDINAL

Bottom-left clipping

Los Angeles Times

HEALTH

SPECIAL MEN'S HEALTH ISSUE

The defining element

Testosterone is what creates men. Hormone therapy may help them keep their youthful vigor. But at what cost?

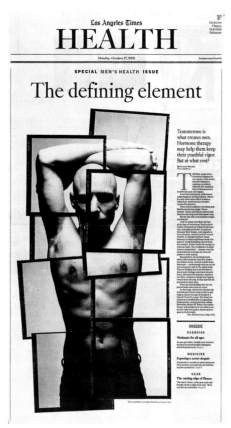

INSIDE

Los Angeles Times

Steve R. Hawkins, Deputy Design Director/Features; **Kirk McKoy,** Senior Photo Editor; **Pete Metzger,** Design Editor; **Ron Neal,** Design Editor, Designer; **Christian Potter Drury,** Design Director/Features; **Hal Wells,** Photo Editor; **Damon Winter,** Photographer

Feature design, sections / Science, technology / 175,000 and over
Photography / Single photos / Illustration

Bottom-right clipping

JOHN PAUL II | 1920–2005

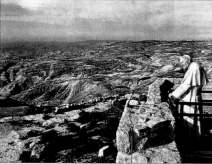

Voices

Innovator Revised Papacy

JOHN PAUL II | 1920-2005

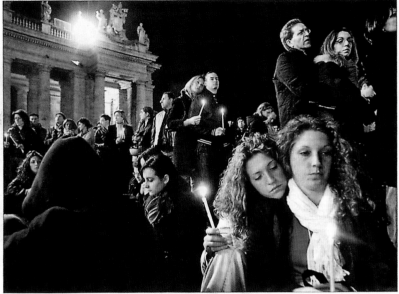

SOMBER MOOD: *The crowd at St. Peter's Square in Rome is quiet shortly after the announcement of the pope's death. The throng nearly doubled in an hour.*
GENARO MOLINA *Los Angeles Times*

At St. Peter's, Sad News Swells the Multitude

Despite the crowd's size, a quiet grief prevails at the square as visitors from around the world are joined by Romans hearing of the pope's death.

By LAURA KING
AND SEBASTIAN ROTELLA
Times Staff Writers

ROME — It was the pope's last gift to Rome: a spontaneous urban event magnificent in its emotion and spectacle.

At the time of Pope John Paul II's death Saturday at 9:37 p.m., St. Peter's Square was already crowded with about 60,000 worshipers attending an open-air rosary. After Archbishop Leonardo Sandri made the announcement, the rosary became a ceremony of mourning.

And the streets around the Vatican came alive.

More people appeared, surging over cobblestones and through archways toward the place where the pope finally lay at peace. They flocked into the plaza, an open-air, starkly illuminated amphitheater of stone ringed by 96 statues of saints and martyrs standing vigil atop ancient walls.

There were platoons of nuns in black, packs of teenagers in Saturday night finery, tourists from Poland and Africa and Japan. There were Romans swept up by a wave of sorrow, solidarity and faith, whether long-felt or suddenly resurgent.

Within an hour, the size of the crowd in St. Peter's had almost doubled. Some went to the edge of the plaza near the papal apartments where John Paul had spent his last days and where lights still burned.

Rick Rosales, a 46-year-old pilgrim from the Philippines, stared up at the windows. He clutched a candle that fluttered in the light breeze, while tears ran down his cheeks.

"I am so sad," he said. "He suffered so much, especially at the end, and it touched all of our hearts."

Despite the prayers and songs amplified by a sound system, despite the crush of people, the quiet of the plaza was remarkable.

People talked in whispers. You could hear the sound of matches striking to light candles, the click of cellphone cameras held aloft, the oc-

casional sob.

Even at so enormous a gathering, the overwhelming sense was one of personal loss, of private grief. A middle-aged woman suddenly rested her head on a metal railing and wept. Others clasped their hands in silent prayer.

When the single deep pealing of a bell resonated across the square, a young Italian student named Ilaria placed her hand on her heart and closed her eyes. Over and over, those gathered in the vast expanse of the square said the same thing: Wherever they had been when they heard of the pope's death, they felt the need to come to this place to pray.

"I loved him, that's why I am here," said Salvo Santos, a 62-year-old Sicilian. "He was our pope, he was our father, but he was first and most importantly a man. It was easy to feel that you knew him."

Many couples and families stood close, holding hands or hugging, as they stared silently toward the basilica. Gianni Albanese, 21, draped an arm around his teary-eyed girlfriend, Paola Tucci.

The two were not dressed for a mournful vigil. They looked the part of hip young Romans on a Saturday night. He wore a black North Face vest and brimmed cap, she sported a diamond stud by her right nostril and multicolored jeans. When they heard the news in a nearby pizzeria, they hurried to St. Peter's.

"We knew this moment would come, but that does not make it easier," Albanese said. "It's true we don't go to church that much, but this is different. This affects us all. This is history."

There was a striking number of young Italians in the crowd. The youths tended to mumble a bit when reciting the Hail Marys and Our Fa-

thers in the pope's honor. Some sounded rusty. Many young Europeans have drifted from the church, their religious activity reduced mainly to the major rituals: baptisms, weddings, funerals.

But the pope, first with his activist vigor and in recent years with his stoic suffering, struck a chord with them and many others.

Even people who considered themselves outsiders said they were deeply moved by the outpouring of emotion around them.

"There is such a powerful feeling here," said Aiko Kumamoto, a Japanese tourist. "When I look around at all these people, I feel as if I am swimming in a sea of sorrow."

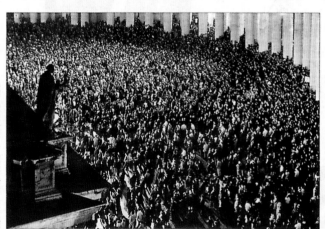

SOLIDARITY: *The crowd is revealed in the stark illumination of the square, site of the papal apartments where Pope John Paul II spent his last days. About 60,000 people attending an open-air rosary were joined by others as word of the pope's passing spread.*
ALESSANDRA TARANTINO *Associated Press*

RELATED STORIES

Memories: An Oregonian recalls an encounter with John Paul. **A44**
Local reaction: Southern Californians pay tribute. **A46**

SPECIAL SECTION
Sunday, April 24, 2005 | Section E
Los Angeles Times

IN THE FOOTSTEPS OF ST. PETER
Pope Benedict XVI on the balcony of St. Peter's basilica after his election last week. Above him, the new pope has sought to project a gentle, imaginative image in contrast with his previous role as the Roman Catholic Church's doctrinal watchdog and stifler of dissent.

The Path Ahead

Catholicism sits on shifting ground as Benedict XVI's papacy begins. A billion strong but riven by dissent, the church waits to learn its new shepherd's direction.

By TRACY WILKINSON
Times Staff Writer

Vatican City

The Peruvian priest turned his back on St. Peter's Square and walked away. He did not wait for the first words of Pope Benedict XVI. No need to, he said. The priest knew where the new pope stood on the important issues. Benedict's election, he said, was a major step backward in a church already reeling from scandal, divisions and the desertions of a wayward flock.

The priest represents just one of the many troubles that Benedict inherits as he begins his reign as the Roman Catholic Church's 265th pope.

Although the church counts more than a billion adherents, it is plagued more than ever by apathy, confrontations with other religions and conflict with secular societies. Benedict's challenge will be to show believers and doubters alike that he is their universal pastor, a "humble shepherd" for all his people.

[See Path, Page E8]

INAUGURATION OF THE POPE

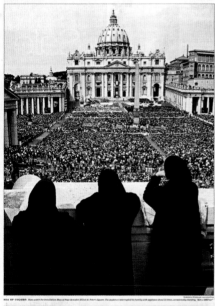

SEA OF COLORS: *Nuns watch the inauguration Mass of Pope Benedict XVI at St. Peter's Square. The onlookers interrupted his homily with applause about 30 times, an unusually churning "God is God" and cheering.*

PAPAL JEWELRY: *The fisherman's ring, set Benedict's hand as he enters, bears an image of St. Peter casting a net, and frame the pontiff's name in Latin. But it no longer bears the pope's seal.*

SOLEMN CEREMONY: *The pontiff walks in St. Peter's Basilica on his way to inaugurate his first papal Mass in St. Peter's Square.*

This is a great obituary, with a rhythm from the smallest detail to the largest image. That the newspaper did it on deadline makes it even more wonderful. The texture in the headers, cutlines, headlines and packaging is top notch. The staff had a plan — a good plan — and it was well executed.

Éste es un gran obituario, con un cierto ritmo desde lo más ínfimo hasta la imagen más grande. El hecho que el diario lo produjo al cierre lo hace aún más impresionante. La textura en los antetítulos, los pies de foto, los títulos y el empaquetado general es de primera línea. El personal del periódico tenía un plan –uno bueno-, y fue bien llevado a cabo.

SILVER

Los Angeles Times
Breaking-news topics / Obituaries

Awards of Excellence
Photography / Multiple photos, Use of
Special coverage / Sections, no ads
Special news topics / Papal funeral and ascension

Michael Whitley, Deputy Design Director; **Bill Gaspard,** News Design Director; **Joseph Hutchinson,** Creative Director; **Dave Campbell,** Design Editor; **Lorraine Wang,** Design Editor; **Doug Stevens,** Graphics Editor; **Lorena Iniguez,** Graphics Editor; **Steve Stroud,** Photo Editor; **Mary Cooney,** Photo Editor; **Colin Crawford,** A.M.E./Photo; **Alan Hagman,** Photo Editor; **Julie Rogers,** Photo Editor; **Doug Smith,** Graphics Editor; **Les Dunseith,** Graphic Director; **Raoul Rañoa,** Graphics Editor; **Genaro Molina,** Photographer; **Staff**

Los Angeles Times

Michael Whitley, Deputy Design Director; **Carolyn Cole,**
Photographer; **Gail Fisher,** Photo Editor; **Bill Gaspard,**
News Design Director; **Joseph Hutchinson,** Creative Director;
Mary Cooney, Photo Editor

News design, page(s) / A-Section / 175,000 and over
News design, page(s) / Inside page / 175,000 and over
Page-design portfolio / News / 175,000 and over
Photography / Multiple photos / Project page or spread
Photography / Multiple photos / Series
Photo portfolio, individual
Special news topics / Editor's choice, international

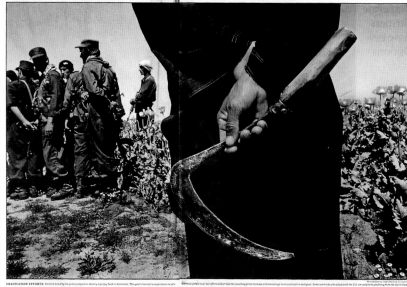

Afghanistan: A Harvest of Despair

Taliban Militants Sharing in Trade

Los Angeles Times

Les Dunseith, Graphics Editor;
Ray Enslow, Graphics Coordinator;
Joseph Hutchinson,
Creative Director;
Thomas Lauder, Assistant Graphics
Editor, Graphics Projects Director;
Sandra Poindexter, Data Analyst;
Paul Rodriguez, Graphic Artist;
Doug Smith, Data Analyst

*Information graphics / Charting /
175,000 and over*
*Information-graphics portfolio, staff /
Extended coverage /
175,000 and over*

HOMICIDE BY THE NUMBERS
Where the killings occur

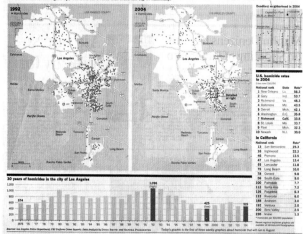

Los Angeles Times

Colin Crawford, A.M.E./Photo;
Gail Fisher, Photo Editor;
Bill Gaspard, News Design
Director; **Joseph Hutchinson,**
Creative Director; **Francine Orr,**
Photographer; **Michael Whitley,**
Deputy Design Director

*News design, page(s) / Inside page /
175,000 and over*
*Photography / Single photos /
Feature*

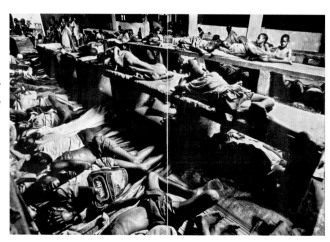

Los Angeles Times

JibJab Media, Illustration; **Tom Trapnell,** Design Editor

Feature design, page(s) / Opinion / 175,000 and over
Illustration / Single

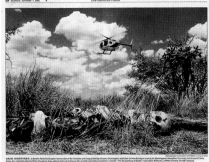

DEATH AND DELIVERANCE

'I told her that she was too heavy, that she wouldn't last, but her mind was made up. It was her decision. We had to respect it.'

Los Angeles Times

Carolyn Cole, Photographer; **Mary Cooney,** Photo Editor; **Colin Crawford,** AME Photo; **Gail Fisher,** Photo Editor; **Bill Gaspard,** News Design Director; **Robert Gauthier,** Photographer; **Alan Hagman,** Photo Editor; **Francine Orr,** Photographer; **Julie Roberts,** Photo Editor; **Luis Sinco,** Photographer; **Steve Stroud,** Photo Editor; **Michael Whitley,** Deputy Design Director

Page-design portfolio / News / 175,000 and over
Photography / Single Photos, General news (planned)
Photo portfolio, staff

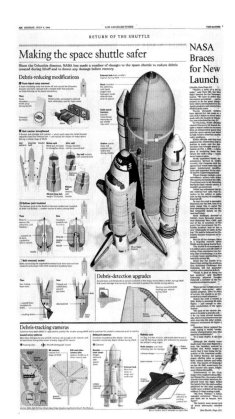

RETURN OF THE SHUTTLE

Making the space shuttle safer

NASA Braces for New Launch

Debris-reducing upgrades

Debris-detection upgrades

Debris-tracking cameras

Los Angeles Times

Raoul Rañoa, Senior Graphic Artist; **Doug Stevens,** Data Analyst, Senior Graphic Artist; **Brady MacDonald,** Graphics Reporter; **Tom Reinken,** Graphics Reporter; **Les Dunseith,** Graphics Editor; **Joseph Hutchinson,** Creative Director

Information graphics / Non-breaking news, features / 175,000 and over
Information-graphics portfolio, staff / Extended coverage / 175,000 and over

Los Angeles Times

On The Internet: WWW.LATIMES.COM THURSDAY, JANUARY 27, 2005 COPYRIGHT 2005 158 PAGES CC 50¢ Designated Areas Higher

Chain-Reaction Crash Kills 11

Apparent Suicide Attempt Triggers Metrolink Tragedy; 180 Aboard Trains Injured

31 Die in Iraq Copter Crash

By Edmund Sanders
Times Staff Writer

BAGHDAD — Thirty-one U.S. troops were killed in a desert helicopter crash and six more died in insurgent attacks Wednesday on the deadliest day for American forces since they led the invasion of Iraq in March 2003.

With just four days before Iraq's national election, at least 23 Iraqis were also reported killed Wednesday in a series of suicide bombings and ambushes by insurgents intent on disrupting the vote. Anxious residents are preparing for a virtual three-day national lockdown beginning Friday, in which Iraq's borders will be sealed, schools and businesses closed and driving banned.

The military transport helicopter crash, which killed 30 Marines and one sailor, occurred during bad weather as troops conducted a mission to prepare for Sunday's election, officials said. The cause of the crash was under investigation and the names of the victims were not released immediately by the military. There were no survivors, officials said.

President Bush, who is facing growing skepticism at home over his handling of the war, expressed condolences to the vic-
[See Iraq, Page A8]

RELATED STORIES

Dark day: Gloom descends on Camp Pendleton. A8
Iraqi election: Middle Eastern neighbors watch warily. A10

PHILIP JOHNSON
1906-2005

America's Dean of Architects

By Christopher Hawthorne
Times Staff Writer

Philip Johnson, who reigned for much of the 20th century as architecture's leading taste maker and designed some of America's most recognizable buildings, including the Crystal Cathedral in Garden Grove, has died. He was 98.

Johnson died Tuesday night at the Glass House, his masterpiece of unadulterated International Style Modernism in New Canaan, Conn., said Terence Riley, chief curator for architecture and design at the Museum of Modern Art in New York. The cause of death was not announced.

With his trademark oversize black-frame glasses, crisp dark suits and ready store of witty, trenchant commentary, Johnson was not only the long-standing dean of American architects, but someone who enjoyed broad celebrity beyond the profession.

Known more for his remarkable ability to anticipate trends and paradigm shifts rather than for the consistency of his work,
[See Johnson, Page A22]

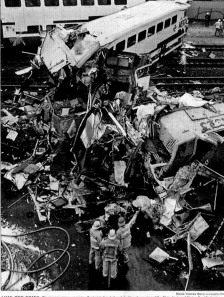

AMID THE RUINS: *Emergency crews examine the twisted-metal and shattered remains of the Metrolink and Union Pacific trains. Workers from a nearby supermarket warehouse heard the crash and rushed to help free passengers pinned in the wreckage.*

A Troubled Past, a Startling Action

By Richard Winton
and Jill Leovy
Times Staff Writers

Juan Manuel Alvarez's troubles had been building long before he drove his Jeep Cherokee onto the train tracks in an aborted suicide attempt that derailed two commuter trains and killed 11 people, according to family members, acquaintances and court records.

Alvarez, a pony-tailed sometime construction worker, had been separated from his wife for several months amid allegations that he had threatened her and her family.

Carmelita Alvarez alleged that drug use had added his mind, according to court papers she filed in support of a restraining order. She described him as a jealous man possessed by para-

noid fantasies that she was cheating.

Family members and acquaintances said he used drugs heavily.

Alvarez, 25, described as a devotee of ancient Mexican rituals, was in custody late Wednesday, booked on suspicion of murder.

Authorities disclosed little about his background, and even some of those close to Alvarez said they were mystified about what led him to a railroad crossing near Glendale early Wednesday.

Alvarez had never been convicted of a serious crime, but was arrested several times on suspicion of burglary and drug possession beginning in 1994, authorities said. A cocaine possession charge against him, dating from
[See Alvarez, Page A14]

MORE COVERAGE: A12-17

A Compton man is held on suspicion of murder after he flees his vehicle left on tracks near the Glendale station. Four people remain missing.

By David Pierson
and Mitchell Landsberg
Times Staff Writers

A man apparently intending to commit suicide parked his SUV in the path of a Metrolink commuter train Wednesday morning, then jumped out of the way in time to watch a chain-reaction wreck that killed at least 11 people and injured about 180.

The crash, which involved three trains, was the deadliest on a railroad in the United States since 1999. It shattered the predawn stillness near Griffith Park with what witnesses described as the sound of scraping gravel followed by a sustained boom that shook the ground.

"Before I knew it, there was a big, big bang. I looked out the window and saw fire," said Teresa Alderete, 50, of Reseda, a commuter whose train car was transformed in an instant from a rolling island of morning serenity into a nightmare of flying bodies, torn metal and shattered glass.

"I was one of the fortunate ones to walk out."

Officials said the carnage was caused by a despondent man from Compton, Juan Manuel Alvarez, 25, who parked his green Jeep Grand Cherokee on the tracks that run along the border of Glendale and the Los Angeles neighborhood of Atwater Village. As Metrolink's regular commuter train No. 100 from Moorpark to Union Station bore down on him just after 6 a.m., Alvarez leaped from the vehicle, Glendale Police Chief Randy Adams said. He was arrested at the scene and, after being taken to County-USC Medical Center, was booked on suspicion of murder. Prosecutors are weighing
[See Trains, Page A12]

Survival a Matter of Chance

Some regular riders narrowly escape; some who changed routine are caught in the chaos.

By Erika Hayasaki
and Megan Garvey
Times Staff Writers

They rode the southbound train in the predawn darkness, some napping, some reading, staring at the world beyond they had made over the years.

Los Angeles County Sheriff's Deputy James Tutino, 47, boarded at the first stop, Simi Valley, before 5:30 a.m.

He needed to make it to downtown Los Angeles for an early meeting.

Tutino rode only a few times a month. He sat in the first car, with a group of fellow deputies. He told them his knee was bothering him and he didn't want to work the clutch of his Mustang in rain-soaked traffic.

About half an hour later, Steve Toby, 51, boarded the second car at the downtown Burbank station. A stranger was sitting in his regular seat. He chose another several rows back.

Theresa Cohen, 27, boarded at the same station, en route to her job at a Los Angeles day-care center. Her mother, Eleanor, had dropped her off, as she did each day. She got on the first car of the southbound train.
[See Wreckage, Page A14]

How it happened

Metrolink train No. 100 was cruising toward the Glendale Station shortly before dawn when passengers realized that something was horribly wrong. They heard scraping gravel. Then a bang. And then saw fire. The train had struck an SUV, then an idle freight train and jackknifed into train No. 901, traveling the other way.

- Southbound Metrolink train strikes an SUV, pushing it a quarter of a mile down the track

- Southbound train derails, strikes unoccupied Union Pacific train on adjacent track

- Southbound train jackknifes, ripping into second car of northbound Metrolink train

Source: Times research. Graphics reporting by Tom Reinken, Raoul Rañoa
Raoul Rañoa Los Angeles Times

INSIDE			
News SummaryA2	**THE NATION**	**BUSINESS**	**SPORTS**
Astrology...B3 Obituaries B10	**Bush Pushes on Iraq;**	**Record Label**	**Serena Williams**
Comics ...B3-4 OpinionB13	**Rice Is Confirmed**	**Chief Is Indicted**	**Moves to Finals**
BusinessC1 Radio..........H4	The president urges Iraqis to	Irv "Gotti" Lorenzo is ac-	She saves three match
Editorials B12 The State ...B6	participate in Sunday's vote	cused of using Murder Inc.	points and advances at
ErskineF5 The World .A3	despite continued violence. A19	to help hide drug money	the Australian Open with
HomeF1 TV grid.......H4	The Senate approves his choice	for a friend charged with	a three-set victory over
	for secretary of State. A24	three murders. C1	Maria Sharapova. D1

Weather: Partly cloudy and cool with light winds today and a slight chance of showers tonight. L.A. Downtown: 63/50. B14

Los Angeles Times

Dave Campbell, Design Editor; **Bill Gaspard,** News Design Director; **Matt Moody,** Graphics Editor; **Raoul Rañoa,** Graphics Editor; **Dan Santos,** Graphics Editor; **Lorraine Wang,** Design Editor; **Michael Whitley,** Deputy Design Director; **Photo Editor; Staff**

Breaking-news topics / Editor's choice, local/regional
News design, page(s) / A-Section / 175,000 and over

The New York Times

Charles M. Blow, Deputy Design Director; **Tom Bodkin,** A.M.E./Design Director; **Chris Carroll,** News Designer; **Archie Tse,** Graphics Editor; **Graphics Staff**

Information graphics / Breaking news / 175,000 and over
Information graphics / Charting / 175,000 and over
News design, page(s) / A-Section / 175,000 and over

The New York Times

Charles M. Blow, Deputy Design Director News; **Tom Bodkin,** A.M.E. Design Director; **Jonathan Corum,** Graphics Editor; **Amanda Cox,** Graphics Editor; **Matthew Ericson,** Graphics Editor; **Hannah Fairfield,** Graphics Editor; **Brian Fidelman,** News Designer; **Archie Tse,** Deputy Graphics Director; **Graphics Staff**

Breaking-news topics / Editor's choice, national
Information graphics / Breaking news / 175,000 and over
Information graphics / Charting / 175,000 and over
Information-graphics portfolio, staff / Extended coverage / 175,000 and over

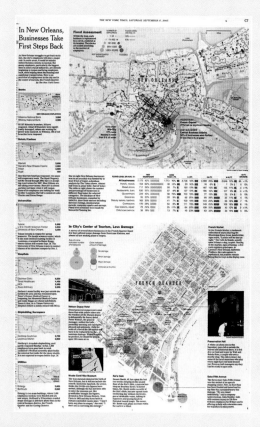

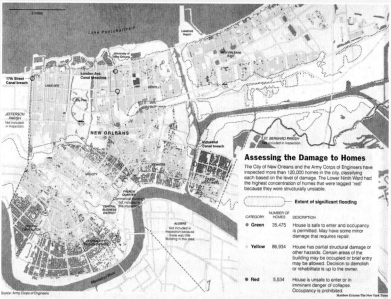

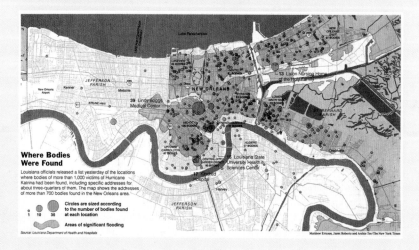

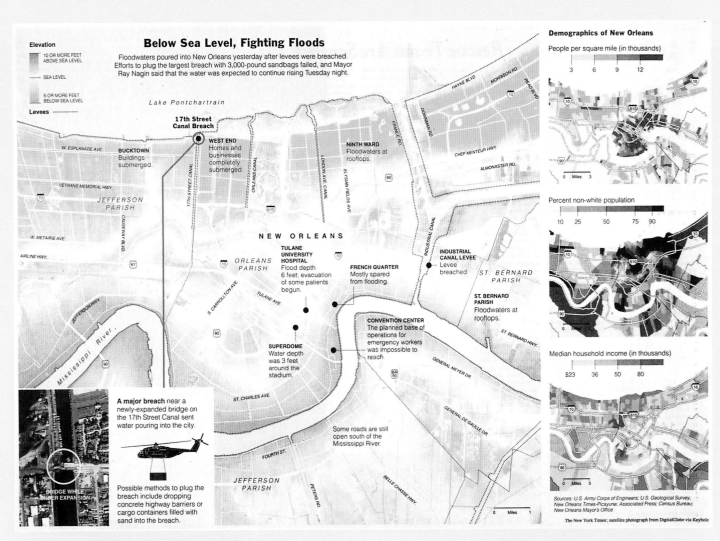

Below Sea Level, Fighting Floods

Floodwaters poured into New Orleans yesterday after levees were breached. Efforts to plug the largest breach with 3,000-pound sandbags failed, and Mayor Ray Nagin said that the water was expected to continue rising Tuesday night.

Elevation
- 10 OR MORE FEET ABOVE SEA LEVEL
- SEA LEVEL
- 5 OR MORE FEET BELOW SEA LEVEL

Levees

Lake Pontchartrain

17th Street Canal Breach

WEST END Homes and businesses completely submerged.

BUCKTOWN Buildings submerged.

NINTH WARD Floodwaters at rooftops.

W. ESPLANADE AVE.

VETRANS MEMORIAL HWY.

JEFFERSON PARISH

W. METAIRIE AVE.

AIRLINE HWY.

HAYNE BLVD.

MORRISON RD.

READ BLVD.

DOWNMAN RD.

PARIS RD.

CHEF MENTEUR HWY.

ALMONASTER RD.

ELYSIAN FIELDS AVE.

LONDON AVE. CANAL

ORLEANS CANAL

17TH STREET CANAL

NEW ORLEANS

ORLEANS PARISH

S. CARROLLTON AVE.

TULANE UNIVERSITY HOSPITAL Flood depth 6 feet; evacuation of some patients begun.

TULANE AVE.

FRENCH QUARTER Mostly spared from flooding.

INDUSTRIAL CANAL LEVEE Levee breached.

ST. BERNARD PARISH

ST. BERNARD PARISH Floodwaters at rooftops.

CONVENTION CENTER The planned base of operations for emergency workers was impossible to reach.

SUPERDOME Water depth was 3 feet around the stadium.

ST. BERNARD HWY.

Mississippi River

ST. CHARLES AVE.

GENERAL MEYER DR.

GENERAL DE GAULLE DR.

A major breach near a newly-expanded bridge on the 17th Street Canal sent water pouring into the city.

BRIDGE WHILE UNDER EXPANSION

Possible methods to plug the breach include dropping concrete highway barriers or cargo containers filled with sand into the breach.

Some roads are still open south of the Mississippi River.

FOURTH ST.

JEFFERSON PARISH

PETERS RD.

BELLE CHASSE HWY.

0 Miles 1

Demographics of New Orleans

People per square mile (in thousands)
3 6 9 12

0 Miles 3

Percent non-white population
10 25 50 75 90

Median household income (in thousands)
$23 36 50 80

0 Miles 3

Sources: U.S. Army Corps of Engineers; U.S. Geological Survey; New Orleans Times-Picayune; Associated Press; Census Bureau; New Orleans Mayor's Office

The New York Times; satellite photograph from DigitalGlobe via Keyhole

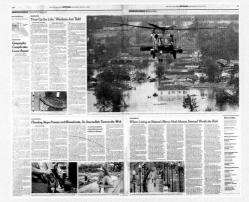

SILVER

The New York Times

Information graphics / Breaking news / 175,000 and over

Awards of Excellence

Breaking-news topics / Natural disasters
Information graphics / Breaking news / 175,000 and over
Information graphics / Mapping / 175,000 and over
Information-graphics portfolio, staff / Extended coverage / 175,000 and over
Photography / Single photos / Spot news
Photo portfolio, individual
Special news topics / Natural disasters

Erin Aigner, Graphics Editor; **Charles M. Blow,** Deputy Design Director/News; **Tom Bodkin,** A.M.E./Design Director; **David Constantine,** Graphics Editor; **Matthew Ericson,** Graphics Editor; **Hannah Fairfield,** Graphics Editor; **Mika Grondahl,** Graphics Editor; **Vincent Laforet,** Photographer; **Jack Pfeifer,** News Designer; **Janet Roberts,** Database Editor; **Archie Tse,** Deputy Graphics Director; **Staff**

This information — what areas of New Orleans were flooded and what areas were not — is the information we all wanted to find. And The New York Times presented it well, with a map that clearly told the story. As mapping, it's good. As breaking-news mapping, it's incredible.

Esta información –cuáles zonas de Nueva Orleáns estaban inundadas y cuáles no-, es lo que todos queríamos saber, y The New York Times la presenta bien, con un mapa que claramente relata lo ocurrido. Como mapa es bueno. Como mapa de noticia de último minuto, es increíble.

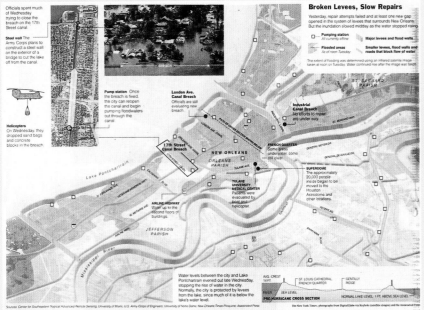

Science

WEDNESDAY • MAY 18, 2005

SCIENCE EDITOR: VICKI MARTIN • 503-221-8313 • VMARTIN@NEWS.OREGONIAN.COM

Recovery and discovery: Trees grow taller, elk abound, and the volcano is covered with new high-tech instruments scientists developed to stay ahead of the geologic activity. Pages D12-13

INSIDE
COMICS, D14-15
WEATHER, D16

MOUNT ST. HELENS: 25 YEARS LATER

Volcano threat is never over

MOUNT ST. HELENS AND OTHER CASCADES PEAKS SUCH AS HOOD REMAIN CANDIDATES FOR ERUPTION

By RICHARD L. HILL
THE OREGONIAN

Mount St. Helens had been asleep for 123 years when scientists got the first alarm.

An earthquake set off the only seismometer positioned near the volcano. The magnitude 4.1 quake, strong enough to be felt nearby, sent snow avalanches tumbling down the mountain.

That was March 20, 1980, two months before the big blow — just the beginning.

More than 10,000 earthquakes rattled the mountain from that day forward. Hundreds of explosions blasted a crater into the summit, and rising magma shoved part of the north side upward in an ominous bulge.

When the big one hit, at 8:32 a.m. May 18, it was the most lethal eruption in the starting years of modern U.S. history. Within minutes, 57 people died, including Spirit Lake innkeeper Harry Truman and geologist David Johnston.

▲ **May 18, 1980:** Ric Cole, director of emergency services in Yakima, brushes off his windshield after a cloud of ash from Mount St. Helens turned the city completely dark at noon.

▼ **May 3, 2005:** Steam pours from Mount St. Helens, the youngest of the Cascades volcanoes, which began to erupt again last fall. Spirit Lake and Mount Rainier are visible to the north.

The mountain didn't blow its top in a single burst, but in a nine-hour-long cataclysm that left 230 square miles of once-green forests a gray wasteland.

"It was worse than the worst-case scenario," said seismologist Steve Malone of the University of Washington. "We weren't able to predict that eruption on a time scale that was socially useful, meaning hours or a day or so ahead. There was no indication that was going to take place."

Today the mountain is active again, not only heightening awareness of its massive dome-building activity but also intensifying scientists' scrutiny of other Cascades peaks, among them Rainier and Hood, that also could become monsters.

Though they are dormant, Rainier and Hood are perilous volcanoes because they are filled with rock weakened into soft clay by centuries of exposure to hot, acidic fluids in their plumbing systems. An earthquake, oversaturation from intense warm rains, a high rate of glacial melting or even gravity could trigger a collapse of the weakened rock.

Rainier, the highest Cascades mountain at 14,410 feet, is considered the most dangerous. A decade ago, a National Academy of Sciences report on Rainier warned that a major eruption or debris flow could kill thousands of residents and cripple the economy of the Pacific Northwest. More than 150,000 people live on ancient mudflow deposits from the volcano.

Please see THREAT, Page D11

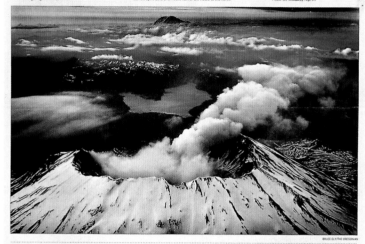

BRUCE ELY/THE OREGONIAN

The boom that (almost) nobody heard

SOUND WAVES THAT BOUNCE OFF EARTH'S ATMOSPHERE MISS PORTLAND BUT HIT THE COAST AND MONTANA

By RICHARD L. HILL
THE OREGONIAN

Clara Fairfield and her husband were enjoying the sunny, quiet morning near the coastal town of Netarts when a jolting noise like a barrage tore through the air.

"The initial sound was very loud — it

would have awakened the dead," she said, remembering back 25 years. "Then there were five or six more booms following that. I looked at my watch, and it was 8:32."

Minutes later, a phone call from her daughter on Skyline Boulevard in Portland revealed the startling news: Mount St. Helens had exploded. Even more surprising, Fair-

field's daughter had not heard the blast although she was only 50 miles away and could easily see the ash plume.

That intrigued Fairfield, a curator and exhibit designer at the Oregon Museum of Science and Industry. When she returned from her vacation home to work the next day, she and her colleagues launched a survey asking people whether they had heard the eruption. More than 1,200 people replied.

The results revealed two striking findings: Hardly anyone from Albany north to Olympia reported hearing the eruption, but hundreds who were more than 100 miles

away did.

Fairfield, who described the results later that year in Oregon Geology magazine, said the sound was heard as far as Montana, Idaho, Northern California, and the Canadian provinces of Alberta and British Columbia.

"One letter I got later was from a ship's mate on a freighter 500 miles off the Oregon coast," Fairfield said. "They heard it, and they couldn't imagine where it was coming from."

The "loudest zones" in Oregon were along the coast from Tillamook to Newport, in Central Oregon from Redmond to La Pine, and in

Please see BOOM, Page D11

ST. HELENS MEMORIES

Where were you when the mountain blew?

An invitation to share memories of May 18, 1980, brought nearly 400 e-mails and letters from readers. Many of them are online at www.oregonlive.com/special/ mtsthelens/

CHARLIE CRISAFULLI/U.S. FOREST SERVICE

INSIDE THE SECTION

Scientists study fish at Spirit Lake (left), now as clear as it was before the eruption. **Page D10**

The new glacier is squeezed and nearly pinched in two. **Page D10**

By the numbers. **Page D10**

Red-legged frogs (right) and other wildlife have returned to Mount St. Helens. **Page D11**

ALBINE THOMPSON
ASSOCIATED PRESS

MORE ON THE MOUNTAIN

◆ The U.S. Forest Service on the 25th anniversary and tourist information: a "volcano cam" shows the crater from Johnston Ridge Observatory. www.fs.fed.us/gpnf/mshp25

◆ The U.S. Geological Survey's Cascades Volcano Observatory's updates about the volcano, photographs and information about other Cascades peaks. http://vulcan.wr.usgs.gov

◆ The Pacific Northwest Seismograph Network at the University of Washington about earthquakes. www.pnsn.org

◆ Weyerhaeuser, the largest private landowner affected by the eruption, on reforestation. www.theforestreturns.com

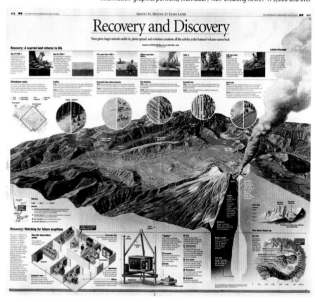

Recovery and Discovery

Trees grow, larger animals amble in, plants spread, and scientists scrutinize all the activity as the national volcano comes back

Recovery: A scarred land returns to life

Discovery: Watching for future eruptions

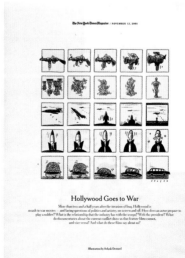

The New York Times Magazine • NOVEMBER 13, 2005

Hollywood Goes to War

More than two and a half years after the invasion of Iraq, Hollywood is assault-to-war movies — and facing questions of politics and artistry, on screen and off. How does an actor prepare to play a soldier? What is the relationship that the industry has with the troops? With the president? What do documentaries about the current conflict show us that feature films cannot, and vice versa? And what do these films say about us?

Illustrations by Selcuk Demirel

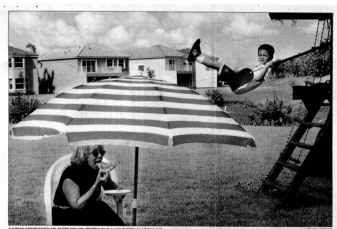

ACCENT
SECTION D • SUNDAY, DECEMBER 18, 2005

The Palm Beach Post • PalmBeachPost.com

There's no place like
suburbia

A slice of life in a Wellington neighborhood

The grass is green, the children are safe (at least it feels that way), and you're not likely to have a view of your neighbor's big-rig truck parked in his yard or his homemade screened-porch flapping in the slightest breeze.

There is a sameness to life in the suburbs.

And therein lies the beauty. Within the walls of a Wellington neighborhood, the American Dream plays out on a South Florida scale. Very big (very similar) homes on very small (very similar) lots.

And hey, it doesn't hurt if the

closets are walk-in, the tubs are Roman, and the countertops are granite.

So yes, say those who've chosen to make Olympia home, there is that sameness. But comfortable predictability to their neighborhood. "Cookie-cutter," you might say with a sneer.

But, residents would respond, is their cookie-cutter cul-de-sac — which spring from better-familused mornings overnight — a community? Enjoy the neighborhood . . . **PAGES 16D-15D**

At an Olympia neighborhood birthday party, Sunki Berg gets a bite, while Zachary Howard, 7, swings. The birthday boy is Zachary's cousin.

Staff photos by CAROLYN DRAKE

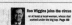

And now for something completely different . . .
Tour D11 foolsround. The historic neighborhood of Mediterranean Revival and Mission-style homes — early built in the '20s — is beloved for the holidays and rolling out the welcome mats. Drop by for a candlelight tour of 13 homes, plus complimentary music from d'amore. **Details, 8D**

'Snooped' gets nosy on behalf of the science museum
What kind of lab partners were society needs? Did they like giveaways, biology — or any "okey" or "sneaky" in-between? **Page 6D**

Ron Wiggins joins the circus
at least a local woman, whose dad walked under the big top. **Page 8D**

charm

10 tips to help your kids get their holiday rest
And much more, in Charm. **Page 9D**

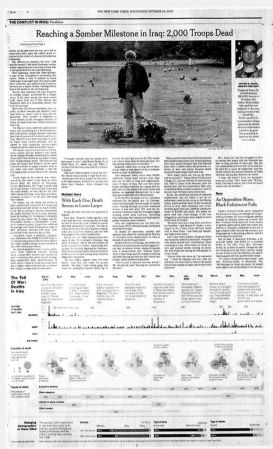

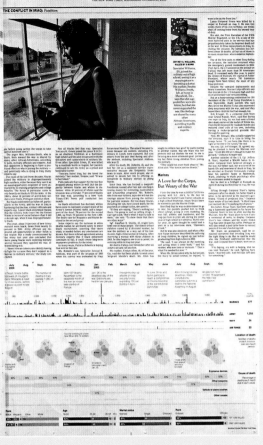

This page carries an incredible amount of information, yet it is delivered in an incredibly simple way. This is not easy to do. There are so many different levels explaining the 2,000 casualties, so many ways of explaining the story.

Eta página contiene una increíble cantidad de información, pero la entrega de forma muy simple, lo que no es nada de fácil de hacer. Hay muchos niveles que explican las dos mil muertes, muchas formas de contar la historia.

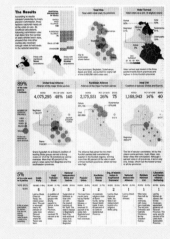

SILVER

The New York Times

Information graphics / Charting / 175,000 and over

Awards of Excellence

Information graphics / Breaking news / 175,000 and over
Information-graphics portfolio, individual / Non-breaking news / 175,000 and over
Information-graphics portfolio, staff / Extended coverage / 175,000 and over
News design, page(s) / A-Section / 175,000 and over
News design, page(s) / Inside page / 175,000 and over

Tom Bodkin, A.M.E. Design Director; **Ann Leigh,** Art Director; **Matthew Ericson,** Graphics Editor; **Don Donnofrio,** Assistant Editor; **Hannah Fairfield;** **Archie Tse;** Staff

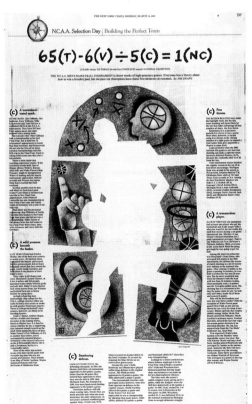

The New York Times

Wayne Kamidoi, Art Director;
Barry Fitzgerald, Illustrator

News design, page(s) / Sports / 175,000 and over
Special news topics / Editor's choice, sports

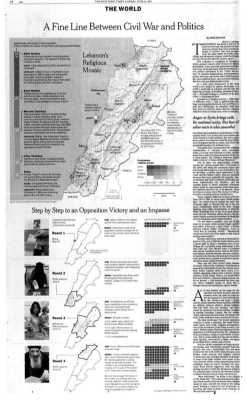

The New York Times

Erin Aigner, Graphics Editor;
Matthew Ericson, Graphics Editor; **James Glanz,** Reporter;
Bill Marsh, Graphics Editor;
Archie Tse, Deputy Graphics Director

Information graphics / Mapping / 175,000 and over
Information-graphics portfolio, staff / Non-breaking news / 175,000 and over

TRAVEL

Swimming And Sunbathing Are Out, But There Are Many Other Pleasures

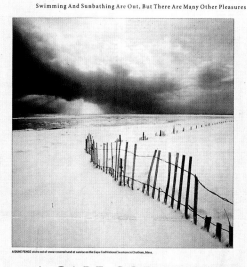

A DUNE FENCE sticks out of a snow-covered sand at sunrise on the Cape Cod National Seashore in Chatham, Mass.

A CAPE COD WINTER

STORY BY DENIS HORGAN COURANT TRAVEL EDITOR | PHOTOS BY MARK MIRKO THE HARTFORD COURANT

CHATHAM, Mass. — The Top 10 Things to do on Cape Cod in the winter are: 1) Walk the lovely, empty beaches. 2) Relax.

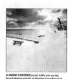
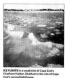

ICICLES hang from the roof of a closed cafe on Route 6 in Eastham, Mass., with the setting sun reflected in the window.

A SNOW-COVERED picnic table sits on the beach during sunset at Herring Cove Beach in Provincetown, Mass.

ICE FLOATS in a small inlet of Cape Cod's Chatham Harbor. Chatham is the site of Cape Cod's second lighthouse.

Hartford Courant
Conn.

Mark Mirko, Staff Photographer

Photo portfolio, individual
Photography / Single photos / Feature

Hartford Courant
Conn.

Suzette Moyer, Director of Design/Graphics;
Mel Shaffer, Designer; **Bruce Moyer,** Photo Editor;
Michael McAndrews, Photographer

Photography / Multiple photos / Page design
Photography / Single photos / Portrait

PHOTOGRAPHER'S EYE | MICHAEL McANDREWS

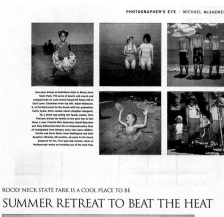

ROCKY NECK STATE PARK IS A COOL PLACE TO BE

SUMMER RETREAT TO BEAT THE HEAT

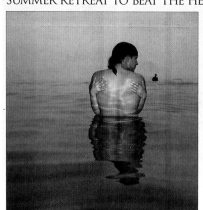

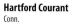

POPE JOHN PAUL II • KAROL WOJTYLA: 1920 - 2005

REQUIEM

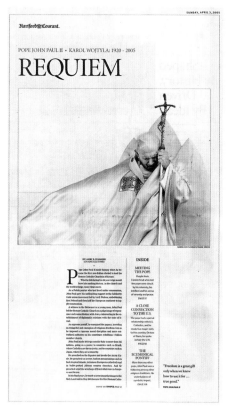

Hartford Courant
Conn.

Greg Harmel, Designer; **Suzette Moyer,** Director/Design & Graphics;
David Grewe, Photo Editor; **John Scanlan,** Director/Photography;
Thom McGuire, A.M.E. Graphics/Photography

Special coverage / Section covers
Special coverage / Sections, no ads

THE BATTLE OF KENT: PART ONE

Yearning For What Once Was

Schaghticoke Family Tree

Hartford Courant
Conn.

Greg Harmel, Designer; **Suzette Moyer,** Director/Design & Graphics;
Richard Messina, Photographer; **Jim Kuykendall,** Artist; **Allison Corbett,**
Photo Editor; **John Scanlan,** Director/Photography; **Thom McGuire,** A.M.E.
Graphics/Photography; **Staff**

News design, page(s) / A-Section / 175,000 and over
News design, sections / A-Section / 175,000 and over

ARTS

FABULOUS READING FOR FALL

Curling Up With A Good Book
Is More Tempting Than Ever, Thanks
To A Bounty Of Riches From Publishers

BY CAROLE GOLDBERG · COURANT BOOKS EDITOR

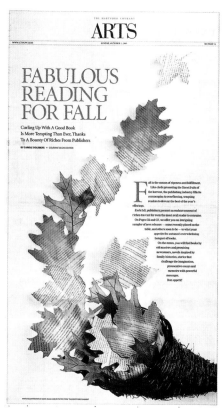

Hartford Courant
Conn.

Beth Bristow, Photo Editor; **John Woike,** Photographer; **Suzette Moyer,**
Designer; **Thom McGuire,** AME/Photography & Graphics

Feature design, page(s) / Entertainment / 175,000 and over

SILVER

El Correo
Vizcaya, Spain

Information graphics / Non-breaking news, features / 50,000-174,999

Award of Excellence
Information-graphics portfolio, staff / Non-breaking news / 50,000-174,999

Fernando G. Baptista, Editor; **José Miguel Benítez,** Co-Editor; **Gonzalo de las Heras,** Graphic Artist; **Daniel García,** Graphic Artist; **María Almela,** Graphic Artist; **Jorge Dragonetti,** Graphic Artist; **Isabel Toledo,** Graphic Artist

Explaining bull fighting in Basque country. Size, type, breeding, training, cost, process, famous bulls — who, what, where, how and why. There isn't much on bullfighting this graphic doesn't explain — and it does so beautifully. There are so many levels, so many places to start, but all of it is organized, with a helpful flow.

Explicación de la corrida de toro en el País Vasco. Tamaño, tipo, crecimiento, entrenamiento, costo, proceso y toros famosos: quién, qué, dónde, cómo y por qué. No queda mucho sobre la corrida de toros que este gráfico no explique, y lo hace en forma hermosa. Hay muchos niveles, muchas entradas, pero todo está organizado con un flujo útil.

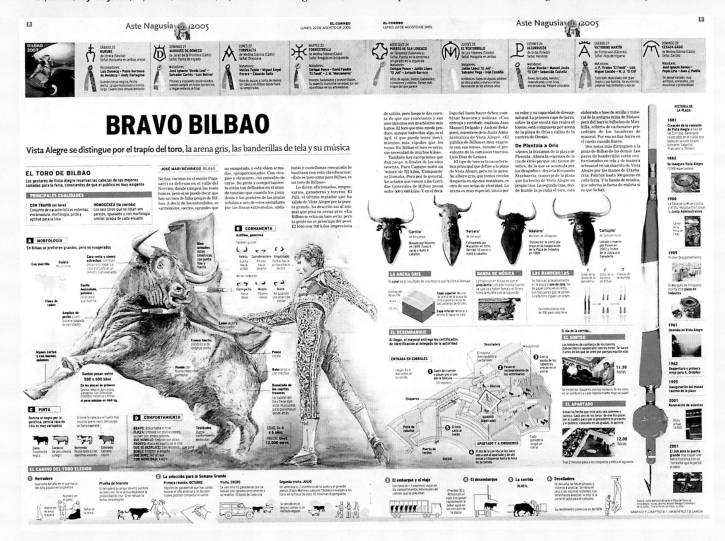

South Florida Sun-Sentinel
Fort Lauderdale

Steve Zimmerman, Designer; **Joe Amon,** Photographer; **Jonathan Boho,** Sports Presentation Editor;
Amy Beth Bennett, Photo Editor;
Tim Rasmussen, Director of Photography;
Tom Peyton, Visual Editor

Special coverage / Section covers
Special coverage / Section pages / Inside page or spread
Special news topics / Editor's choice, sports

The Plain Dealer
Cleveland

Andrea Levy, Illustrator/Photographer

Photography / Single photos / Illustration
Photo portfolio, individual

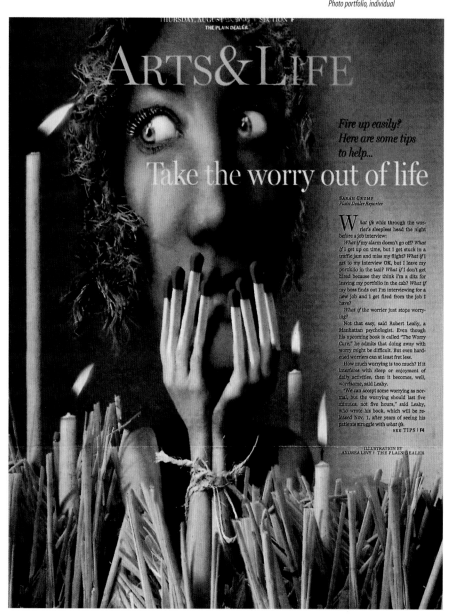

ARTS&LIFE

Fire up easily?
Here are some tips
to help...

Take the worry out of life

SARAH CRUMP
Plain Dealer Reporter

What ifs whiz through the worrier's sleepless head the night before a job interview?

What if my alarm doesn't go off? *What if* I get up on time, but I get stuck in a traffic jam and miss my flight? *What if* I get to my interview OK, but I leave my portfolio in the taxi? *What if* I don't get hired because they think I'm a ditz for leaving my portfolio in the cab? *What if* my boss finds out I'm interviewing for a new job and I get fired from the job I have?

What if the worrier just stops worrying?

Not that easy, said Robert Leahy, a Manhattan psychologist. Even though his upcoming book is called "The Worry Cure," he admits that doing away with worry might be difficult. But even hardened worriers can at least fret less.

How much worrying is too much? If it interferes with sleep or enjoyment of daily activities, then it becomes, well, worrisome, said Leahy.

"We can accept some worrying as normal, but the worrying should last five minutes, not five hours," said Leahy, who wrote his book, which will be released Nov. 1, after years of seeing his patients struggle with *what ifs.*

SEE TIPS | F4

ILLUSTRATION BY
ANDREA LEVY | THE PLAIN DEALER

The Plain Dealer
Cleveland

Emmet Smith, Designer; David Campbell, Associate Sports Editor; Roy Hewitt, Sports Editor; David Kordalski, A.M.E./Visuals

News design, page(s) / Sports / 175,000 and over
Page-design portfolio / News / 175,000 and over

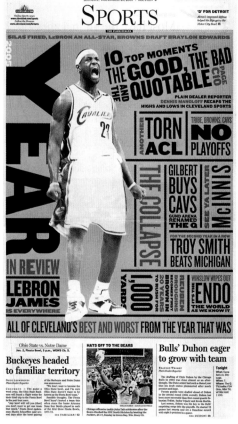

The Plain Dealer
Cleveland

Mike Levy, Photographer; Dale Omori, Photographer; Gus Chan, Photographer; Marvin Fong, Photographer; Bill Gugliotta, Director of Photography; Jeff Greene, Deputy Director of Photography; David Kordalski, A.M.E./Visuals

Photography / Single photos / Feature
Photo portfolio, staff

The Plain Dealer
Cleveland

Emmet Smith, Designer; Mike Levy, Photographer; Mike Starkey, Deputy Sports Editor; Roy Hewitt, Sports Editor; David Kordalski, A.M.E./Visuals

News design, page(s) / Sports / 175,000 and over
Photography / Single photos / Portrait

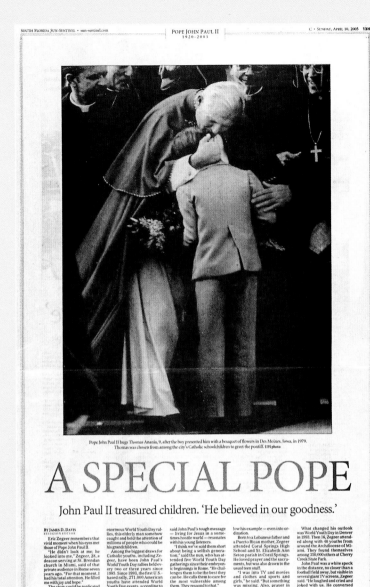

Pope John Paul II hugs Thomas Anania, 9, after the boy presented him with a bouquet of flowers in Des Moines, Iowa, in 1979. Thomas was chosen from among the city's Catholic schoolchildren to greet the pontiff. **UPI photo**

A SPECIAL POPE

John Paul II treasured children. 'He believed in our goodness.'

BY JAMES D. DAVIS
RELIGION EDITOR

Eric Zegeer remembers that vivid moment when his eyes met those of Pope John Paul II.

"He didn't look at me; he looked into me," Zegeer, 28, a deacon serving at St. Brendan church in Miami, said of that private audience in Rome seven years ago. "For that moment, I had his total attention. He filled me with joy and hope."

The story could be replicated over and over, retold by young people who have seen, heard and read John Paul. At private audiences, papal tours and

enormous World Youth Day rallies, this elderly man somehow caught and held the attention of millions of people who could be his grandchildren.

Among the biggest draws for Catholic youths, including Zegeer, have been John Paul's World Youth Day rallies held every two or three years since 1985. Since 1993, the first U.S.-based rally, 271,000 American youths have attended World Youth Day events, according to the United States Conference of Catholic Bishops.

Sister Eileen McCann, the conference's youth coordinator,

said John Paul's tough message — living for Jesus in a sometimes hostile world — resonates with his young listeners.

"I think we've said them short about being a selfish generation," said the nun, who has attended five World Youth Day gatherings since their embryonic beginnings in Rome. "He challenges them to be the best they can be. He calls them to care for the most vulnerable among them. They respond to that."

Not all of them live out the ideals as thoroughly as John Paul, of course; but some, like Zegeer, have felt impelled to fol-

low his example — even into ordination.

Born to a Lebanese father and a Puerto Rican mother, Zegeer attended Coral Springs High School and St. Elizabeth Ann Seton parish in Coral Springs. He loved prayer and the sacraments, but was also drawn to the usual teen stuff.

"I was into TV and movies and clothes and sports and girls," he said. "But something was missing. Also, prayer in schools was at the forefront when I was a teenager. I felt very much alone. No one there shared my love for the faith."

What changed his outlook was World Youth Day in Denver in 1993. Then 16, Zegeer attended along with 40 youths from around the Archdiocese of Miami. They found themselves among 350,000 others at Cherry Creek State Park.

John Paul was a white speck in the distance, no closer than a football field away, but visible in several giant TV screens, Zegeer said. "He laughed and cried and joked with us. He conversed with us in many languages."

Amid the celebration, John

■ **YOUTH** CONTINUES ON 14H

To all of you, dear young people, who hunger and thirst for truth, the church offers herself as a traveling companion. She offers the eternal gospel message and entrusts you with an exalting apostolic task: to be the protagonists of the new evangelization."
— DURING WORLD YOUTH DAY, 1993

South Florida Sun-Sentinel
Fort Lauderdale

Special coverage / Section pages / Inside page or spread
Special coverage / Sections, with ads
Special news topics / Obituaries

Award of Excellence
Special coverage / Sections, with ads

Jonathan Boho, Designer; **Hiram Henriquez,** Graphic Artist; **Tom Peyton,** Visual Editor; **Denise Reagan,** News Design Editor; **Mary Vignoles,** Photo Editor

This package's strength is consistency. There is considerable typography, but it never feels as though it's too much. The pacing and use of chapters is very appropriate for the subject matter. Every page is inviting. You don't come to a page that says "move along, for there's nothing to see." You're drawn into the presentation. It's classic, very subtle.

La fortaleza de este paquete informativo es su consistencia. Hay una considerable tipografía, pero nunca se siente como en demasía. El ritmo y el uso de capítulos son muy apropiados para este tema. Cada una de las páginas invita. No hay páginas que hagan pensar que "hay que saltársela para seguir adelante, porque no ofrece nada". Las presentación es cautivante, es clásica y sutil.

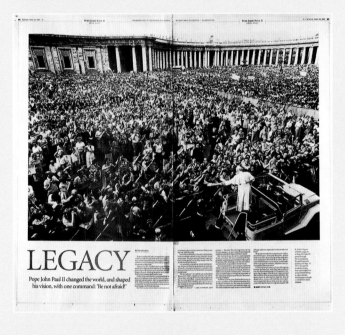

LEGACY

Pope John Paul II changed the world, and shaped his vision, with one command: 'Be not afraid!'

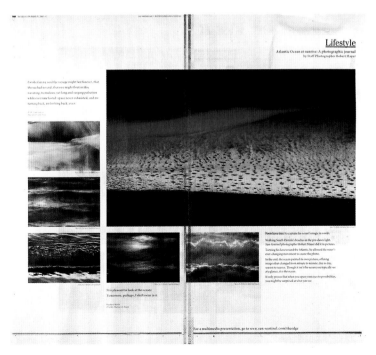

Lifestyle
Atlantic Ocean at sunrise: A photographic journal
by Staff Photographer Robert Mayer

South Florida Sun-Sentinel
Fort Lauderdale

Laura Kelly, Features Designer; **Robert Mayer,** Staff Photographer; **Mary Vignoles,** Deputy Director of Photography; **Tom Peyton,** Visual Editor; **Tim Rasmussen,** Director of Photography; **Tim Frank,** Deputy M.E.Visuals/Creative Director

Photography / Multiple photos / Page design
Photography / Multiple photos / Project page or spread
Photo portfolio, individual

POPE JOHN PAUL II | 1920-2005

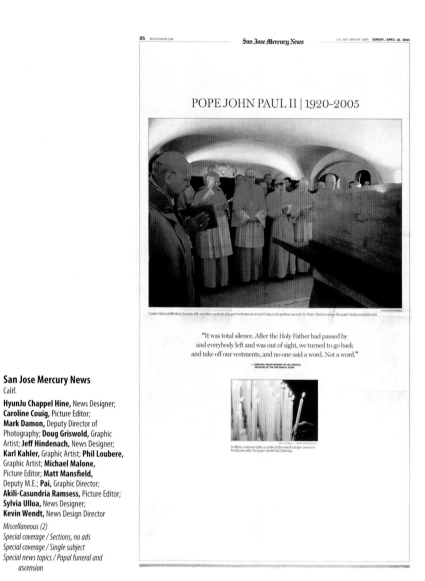

Cardinal Eduard Martínez Somalo, left, and other cardinals take part in the burial service Friday in the grottoes beneath St. Peter's Basilica where the pope's body was laid to rest.

"It was total silence. After the Holy Father had passed by and everybody left and was out of sight, we turned to go back and take off our vestments, and no one said a word. Not a word."

CARDINAL ROGER MAHONY OF LOS ANGELES
SPEAKING OF THE PRE-BURIAL SCENE

In Milan, a woman lights a candle at the end of a prayer service in the Duomo after the pope's death last Saturday.

San Jose Mercury News
Calif.

HyunJu Chappel Hine, News Designer;
Caroline Couig, Picture Editor;
Mark Damon, Deputy Director of
Photography; **Doug Griswold,** Graphic
Artist; **Jeff Hindenach,** News Designer;
Karl Kahler, Graphic Artist; **Phil Loubere,**
Graphic Artist; **Michael Malone,**
Picture Editor; **Matt Mansfield,**
Deputy M.E.; **Pai,** Graphic Director;
Akili-Casundria Ramsess, Picture Editor;
Sylvia Ulloa, News Designer;
Kevin Wendt, News Design Director

Miscellaneous (2)
Special coverage / Sections, no ads
Special coverage / Single subject
Special news topics / Papal funeral and
ascension

POPE JOHN PAUL II | 1920-2005

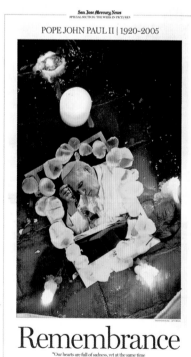

Remembrance

"Our hearts are full of sadness, yet at the same time
of joyful hope and profound gratitude."
— CARDINAL JOSEPH RATZINGER, AT THE POPE'S FUNERAL MASS

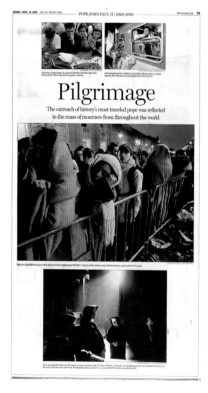

The pope's body begins its journey Monday from the Apostolic Palace to St. Peter's Basilica for public viewing.

A Polish girl and her mother say goodbye Wednesday as a train departs from Krakow carrying pilgrims to the funeral.

Pilgrimage

The outreach of history's most traveled pope was reflected
in the mass of mourners from throughout the world

Mourners file past the pope's body as it lies in state inside St. Peter's Square after being honored Wednesday as crowds lined the streets.

Nuns pray Wednesday near the pope as he lies in state inside St. Peter's Basilica. It took a crowd that grew to an estimated 2 million during the funeral Friday and gathering. Worldwide millions joined in a common disbelief at official lest.

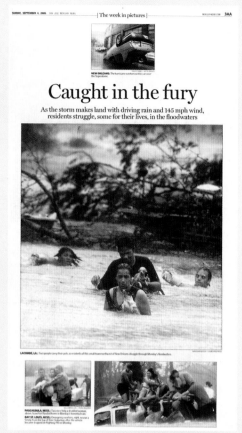

NEW ORLEANS: The hurricane overturned this car near the Superdome.

Caught in the fury

As the storm makes land with driving rain and 145 mph wind,
residents struggle, some for their lives, in the floodwaters

LACOMBE, LA.: Two people carry their pets as residents of this small town northeast of New Orleans struggle through Monday's floodwaters.

PASCAGOULA, MISS.: Two men help a disabled woman, above, leave her flooded home in Monday's hurricane.

BAY ST. LOUIS, MISS.: Emergency workers, right, rescue a family from the top of their Saturday after the vehicle became trapped on Highway 90 on Monday.

San Jose Mercury News
Calif.

Matt Mansfield, Deputy M.E.; **Jonathon Berlin,** Senior Editor/Design &
Graphics; **Mark Damon,** Deputy Director of Photography;
Akili-Casundria Ramsess, Photo Editor

News design, page(s) / Other / 175,000 and over

NEW ORLEANS: A man and boy set camp as they carry a boat into their lair in the French Quarter on Sunday.

Expectant calm

With warnings of a 'nightmare' hurricane headed their way,
residents of the Gulf Coast hunkered down on Sunday night

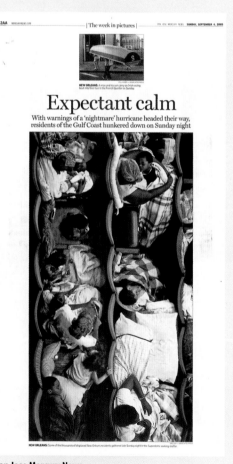

NEW ORLEANS: Some of the thousands of displaced New Orleans residents gathered late Sunday night in the Superdome seeking shelter.

San Jose Mercury News
Calif.

Matt Mansfield, Deputy M.E.; **Jonathon Berlin,** Senior Editor/Design &
Graphics; **Mark Damon,** Deputy Director of Photography;
Akili-Casundria Ramsess, Photo Editor

News design, page(s) / Other / 175,000 and over

San Jose Mercury News

Hurricane Katrina
The week in pictures

NEW ORLEANS: These are the wrinkled hands of Shirley Ward, 40, who spent two days stranded and soaking in water on Rocheblave Street until she was rescued Tuesday.

'A lot of people had nowhere to go. So they stayed.
And we have to get them out.'
— LOUISIANA NATIONAL GUARD CPL. JOHN JARREAU

San Jose Mercury News

Hurricane Katrina
The week in pictures

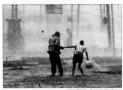

PASCAGOULA, MISS.: An unidentified man helps a woman through the floodwaters Monday morning as the hurricane made landfall.

Under siege

The dire forecast of a killer storm proved all too accurate,
and now Hurricane Katrina's victims battle to survive amid ruin

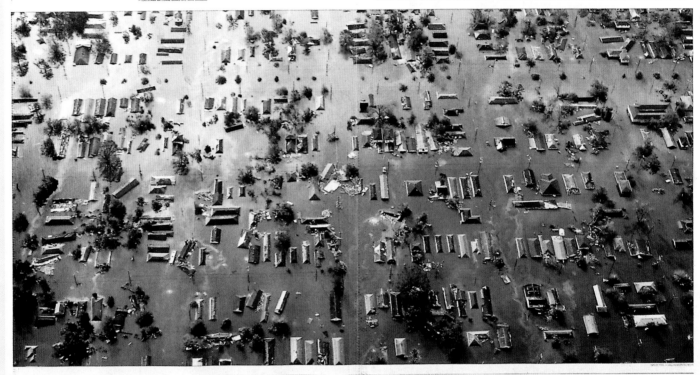

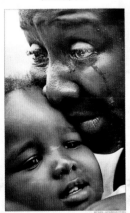

Mounting toll
In storm's wake, authorities face two-fold problem:
caring for the living and cleaning up ravaged cities

NEW ORLEANS: Days after the storm struck, cloudy floats in the floodwaters. Thursday, as authorities struggled to collect corpses of hurricane victims.

SILVER

San Jose Mercury News
Calif.

Miscellaneous

Award of Excellence
Page-design portfolio / News / 175,000 and over
Miscellaneous
Photography / Multiple photos, Use of
Special coverage / Sections, no ads
Special coverage / Section pages / Inside page or spread
Special news topics / Natural disasters

Jonathon Berlin, Senior Editor/Design & Graphics; **Akili-Casundria Ramsess,** Photo Editor; **Caroline Couig,** Picture Editor; **Mark Damon,** Deputy Director of Photography; **Matt Mansfield,** Deputy M.E.; **Geri Migielicz,** Director of Photography; **Jami C. Smith,** Picture Editor; **Staff**

Destruction, defiance, desperation
Surviving the massive power of the storm was just the first part of the ordeal. Emotions frayed as residents waited for assistance.

This elegant wraparound allows the powerful photo of New Orleans under water to unfold dramatically. The image selection is perfect. A traditional secondary photo might have been a closeup of a crying face, but instead it's the subtle, misty image of two people holding hands in the beating rain. And the closeup of the waterlogged hands holding a trash bag speaks volumes about the people caught in the storm.

Este marco elegante permite que la poderosa foto de Nueva Orleáns bajo el agua se revele en forma dramática. La selección de la imagen es perfecta. Una foto secundaria tradicional podría haber sido la de una cara en llanto, pero en vez, es la imagen sutil y brumosa de dos personas tomadas de la mano bajo una lluvia fuerte. Y el closeup de las manos mojadas que llevan una bolsa de basura habla mucho sobre la gente afectada por la tormenta.

The Times-Picayune
New Orleans

Angela Hill, Graphics Editor; **Emmett Mayer III,** Graphic Artist;
Dan Swenson, Graphic Artist

Information graphics / Breaking news / 175,000 and over
Information-graphics portfolio, staff / Extended coverage / 175,000 and over

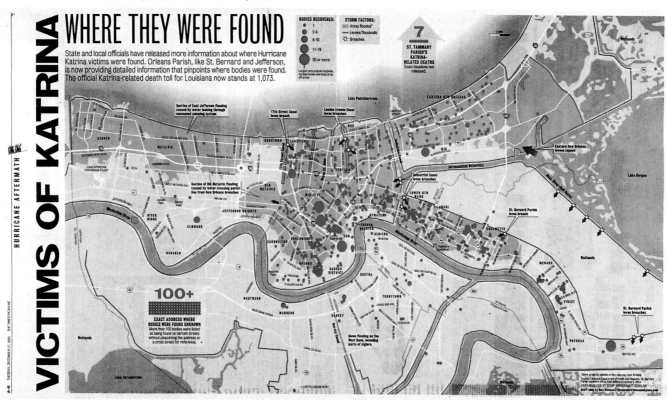

VICTIMS OF KATRINA

WHERE THEY WERE FOUND

State and local officials have released more information about where Hurricane
Katrina victims were found. Orleans Parish, like St. Bernard and Jefferson,
is now providing detailed information that pinpoints where bodies were found.
The official Katrina-related death toll for Louisiana now stands at 1,073.

**The San Diego
Union-Tribune**

Josh Penrod, Designer;
David Mollering, Illustrator;
Bruce Huff, Photo Editor;
Sean M. Haffey, Photographer;
K.C. Alfred, Photographer;
Don Kohlbauer, Photographer

*Breaking-news topics / Editor's choice,
sports*
*Special news topics / Editor's choice,
sports*

BUICK INVITATIONAL

North stars

Lehman leads a charge to the top on easier Torrey course

2005 PLAYOFFS

NATIONAL LEAGUE DIVISION SERIES

Taking a shot

Armed with the puniest record of any playoff team ever,
the Padres aim to slay the mighty St. Louis Cardinals,
the team with the best record in baseball

**The San Diego
Union-Tribune**

Josh Penrod, Designer;
Michael Price,
Presentation Director;
Nadia Borowski Scott,
Photographer

*Page-design portfolio / Sports /
175,000 and over*
Special coverage / Section covers

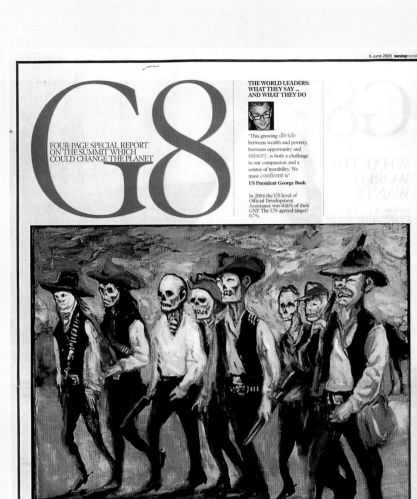

G8

FOUR-PAGE SPECIAL REPORT
ON THE SUMMIT WHICH
COULD CHANGE THE PLANET

**THE WORLD LEADERS:
WHAT THEY SAY ...
AND WHAT THEY DO**

"This growing divide between wealth and poverty, between opportunity and misery, is both a challenge to our compassion and a source of instability. We must confront it"

US President George Bush

In 2004 the US level of Official Development Assistance was 0.16% of their GNP. The UN agreed target? 0.7%.

WHAT THE WORLD WANTS

Turn to page 10

This fresh approach to the G8 summit has aggression that hits you at the start. There's a darkness and a drama through the series. The newspaper broke the subject into digestible chunks, each day offering a clean break from the front to inside. It's a brave, bold, refreshing approach to the subject matter, tackled with courageous commitment.

Este fresco enfoque sobre la cumbre del G8 tiene una agresión que golpea desde el inicio. Hay una oscuridad y un drama a través de la serie. El periódico partió el tema en pedazos digestibles y cada día ofreció uno limpio desde la portada hasta el interior. Es un enfoque valiente, atrevido y refrescante a este tema, unido a un compromiso decidido.

The Seattle Times

Alan Berner, Photographer; **Denise Clifton,** Page Designer; **Barry Fitzsimmons,** Photo Editor; **Greg Gilbert,** Photographer; **Angela Gottschalk,** Photo Editor; **Thomas James Hurst,** Photographer; **Barbara Kinney,** Photo Editor; **Ken Lambert,** Photographer; **Rod Mar,** Photographer; **Fred Nelson,** Photo Editor

Photography / Single photos / Portrait
Photo portfolio, staff

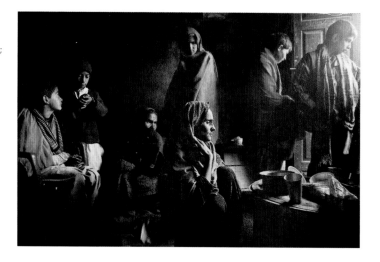

Toronto Star

Rick Madonik, Photographer; **Hans Deryk,** Photographer; **Richard Lewtons,** Photographer; **Peter Power,** Photographer; **Lucas Oleniuk,** Photographer; **Charla Jones,** Photographer

Photography / Single photos / General news
Photo portfolio, staff

Situation Critical

'DONOR' CYCLISTS: That's what they're called when they arrive at Sunnybrook near death. Emily Collins was one. No one thought she would make it, but her family kept the faith

'No helmet, high speed, hit a tree'

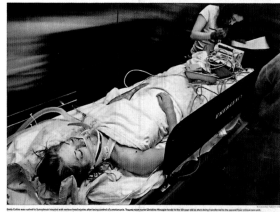

Orlando Sentinel

Fla.

Melissa Angle, Designer; **Red Huber,** Photographer; **Ken Lyons,** Picture Editor; **Cassie Armstrong,** Deputy Design Editor; **Stephen Komives,** Design Editor; **Bonita Burton,** A.M.E./Visuals

Miscellaneous
News design, page(s) / A-Section / 175,000 and over

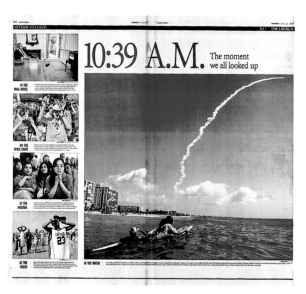

10:39 A.M. The moment we all looked up

Katrina's Aftermath on the Gulf Coast

As President Bush toured the region yesterday, cleanup and relief efforts continued. These aerial photos taken by the National Oceanic and Atmospheric Administration give a snapshot of damage throughout the Gulf Coast region.

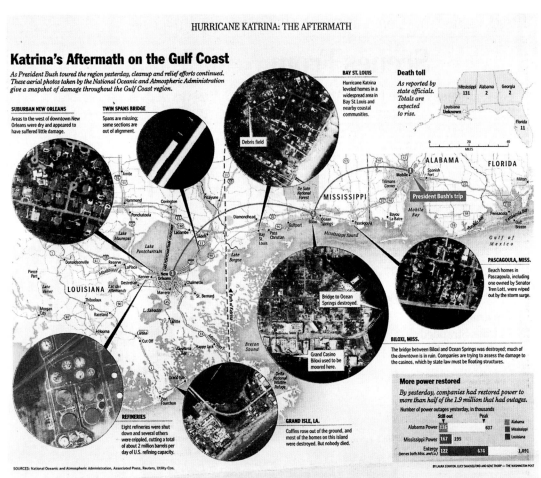

SUBURBAN NEW ORLEANS
Areas to the west of downtown New Orleans were dry and appeared to have suffered little damage.

TWIN SPANS BRIDGE
Spans are missing; some sections are out of alignment.

BAY ST. LOUIS
Hurricane Katrina leveled homes in a widespread area in Bay St. Louis and nearby coastal communities.

Death toll
As reported by state officials. Totals are expected to rise.

PASCAGOULA, MISS.
Beach homes in Pascagoula, including one owned by Senator Tren Lott, were wiped out by the storm surge.

BILOXI, MISS.
The bridge between Biloxi and Ocean Springs was destroyed; much of the downtown is in ruin. Companies are trying to assess the damage to the casinos, which by state law must be floating structures.

GRAND ISLE, LA.
Coffins rose out of the ground, and most of the homes on this island were destroyed. But nobody died.

REFINERIES
Eight refineries were shut down and several others were crippled, cutting a total of about 2 million barrels per day of U.S. refining capacity.

More power restored
By yesterday, companies had restored power to more than half of the 1.9 million that had outages.

Number of power outages yesterday, in thousands

SOURCES: National Oceanic and Atmospheric Administration, Associated Press, Reuters, Utility Cos.

BY LAURA STANTON, LUCY SHACKELFORD AND GENE THORP — THE WASHINGTON POST

The Washington Post

Dennis Brack, Deputy AME/News Art, Deputy Art Director; **Michael Keegan,** AME/News Art; **Lucy Shackelford,** Research Editor; **Laura Stanton,** Graphic Artist, News Artist; **Gene Thorp,** Cartographer

Information graphics / Breaking news / 175,000 and over
Information graphics / Mapping / 175,000 and over

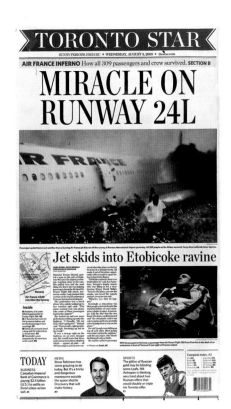

Toronto Star

Eddie Ho; Staff

Breaking-news topics / Editor's choice, local/regional
Photography / Single photos / Spot news

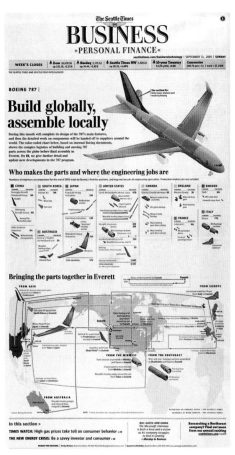

The Seattle Times

Michele Lee McMullen, Graphic Artist; **Kriss Chaumont,** Graphic Artist; **Mark Nowlin,** Graphic Artist, News Artist; **Paul Schmid,** Graphic Artist; **Kristopher Lee,** Graphic Artist; **Whitney Stensrud,** Assistant Art Director

Information graphics / Non-breaking news, features / 175,000 and over
Information-graphics portfolio, staff / Non-breaking news / 175,000 and over

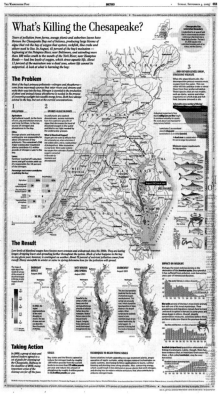

The Washington Post

Larry Fogel, Cartographer; **Michael Keegan,** AME/News Art; **Brenna Maloney,** Graphic Editor; **Laura Stanton,** Graphic Artist, News Artist

Information graphics / Mapping / 175,000 and over
Information graphics / Non-breaking news, features / 175,000 and over

San Francisco Chronicle

Matt Petty, Art Director;
Chris Hardy, Photographer;
Joe Brown, Pink Editor;
Nanette Bisher, Creative Director;
Randy Greenwell, Director of
Photography; **Apak Studio,** Plush Doll
Maker; **Staff**

Feature design, page(s) / Entertainment /
175,000 and over
Illustration, Use of

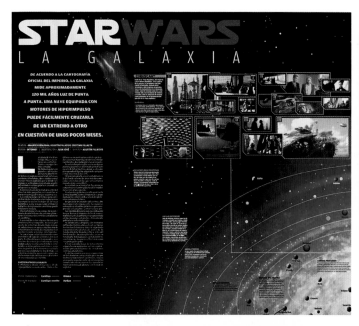

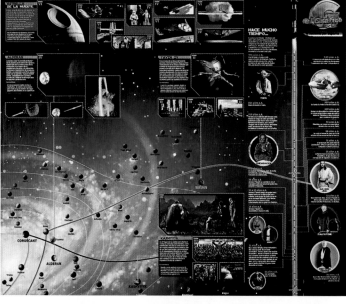

El Gráfico

Antiguo Cuscatlán, El Salvador

Agustín Palacios, Design
Coordinator;
Mauricio Boulogne, Editor;
Orus Villacorta, Editor;
Rodrigo Baires, Editor;
Juan José, Illustrator;
Cristian Villalta, Editor

Miscellaneous
Special coverage / Multiple sections,
with ads
Special coverage / Single subject

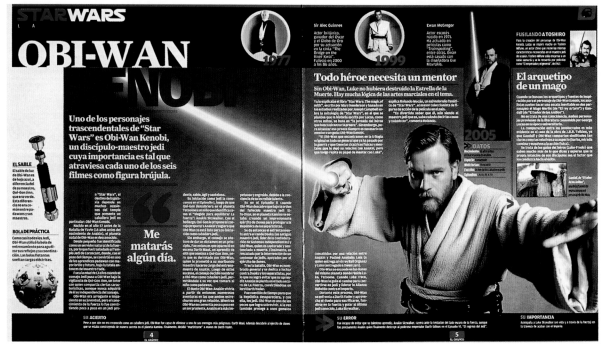

EL MUNDO / BALANCE DE 2005
LUNES 26 DE DICIEMBRE DE 2005

EL ENEMIGO DEL AÑO

LA FURIA DE LA TIERRA

Los desastres naturales que han asolado a la Humanidad

'Tsunamis', huracanes, terremotos... A lo largo de 2005, 350.000 personas han perdido la vida como consecuencia de los cataclismos que han vuelto a demostrar la fragilidad del ser humano ante las fuerzas de la naturaleza

ILUSTRACIÓN RAÚL ARIAS

El Mundo
Madrid, Spain

Carmelo Caderot, Art Director & Designer; **Manuel De Miguel,** Designer; **Raul Arias,** Illustrator
Page-design portfolio / Features / 175,000 and over
Special coverage / Sections, no ads

Sunday Herald
Glasgow, Scotland
Staff
News design, sections / A-Section / 50,000-174,999
Special coverage / Single subject

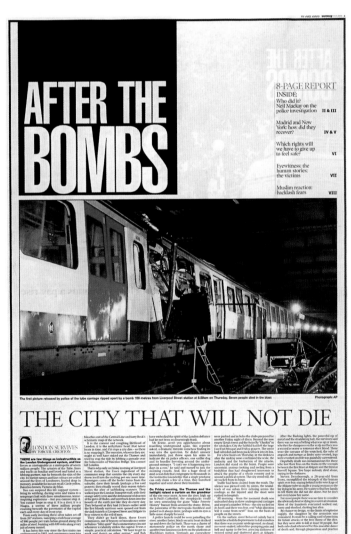

AFTER THE BOMBS

8-PAGE REPORT
INSIDE:

Who did it?
Neil Mackay on the
police investigation II & III

Madrid and New
York: how did they
recover? IV & V

Which rights will
we have to give up
to feel safe? VI

Eyewitness: the
human stories:
the victims VII

Muslim reaction:
backlash fears VIII

The first picture released by police of the tube carriage ripped apart by a bomb 100 metres from Liverpool Street station at 8.50am on Thursday. Seven people died in the blast. Photograph: AP

THE CITY THAT WILL NOT DIE

LONDON SURVIVES
BY TORCUIL CRICHTON

The Seattle Times

Erin Jang, Illustrator

Illustration portfolio, individual
Page-design portfolio / Features / 175,000 and over

El Mundo Metropoli
Madrid, Spain

Raúl Arias, Illustrator; **Rodrigo Sánchez,** Designer

Illustration portfolio, individual
Illustration / Single
Page-design portfolio / Magazine / 175,000 and over

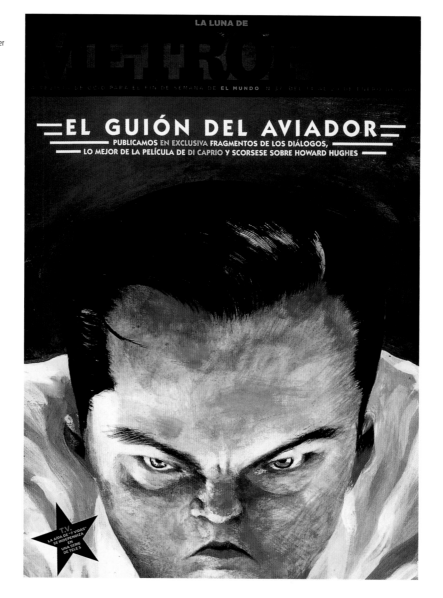

News

4

The Globe and Mail
Toronto

Adrian Norris, Presentation & Production Editor; **David Pratt**, Executive Art Director; **Erin Elder**, Photo Editor

News design, sections / A-Section / 175,000 and over

The Tribune
San Luis Obispo, Calif.

Joe Tarica, Presentation Editor; **Beth Anderson**, Page Designer; **Jessica Fearnow**, Page Designer; **Rex Chekal**, Page Designer; **Andrew Castagnola**, News Editor

News design, sections / A-Section / 49,999 and under

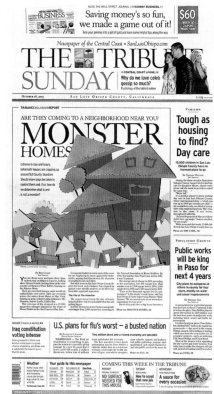

Toronto Star

Devin Slater, Designer; **Carl Neustaedter**, A.M.E. Design; **Alison Uncles**, Sunday Editor

News design, sections / A-Section / 175,000 and over

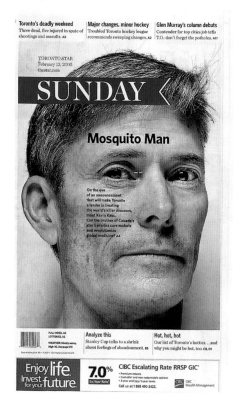

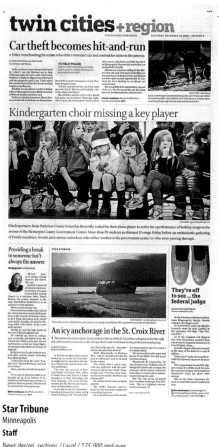

Star Tribune
Minneapolis

Staff

News design, sections / Local / 175,000 and over

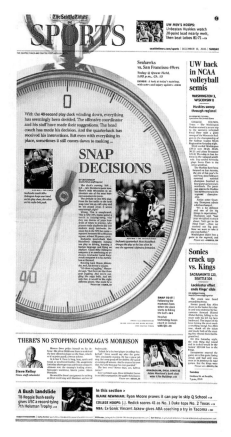

The Seattle Times

Mark McTyre, Designer; **Susan Jouflas**, Illustrator; **Rod Mar**, Photographer; **Angela Gottschalk**, Photo Editor; **Jeff Paslay**, Designer; **Rick Lund**, Presentation Editor

News design, sections / Sports / 175,000 and over

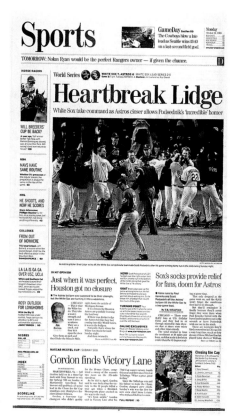

Fort Worth Star-Telegram
Texas

Ellen Alfano, M.E./Sports; **Celeste Williams**, A.M.E./Sports; **Cody Baily**, Senior Deputy Sports Editor; **Michael Currie**, Assistant Sports Editor; **Staff**

News design, sections / Sports / 175,000 and over

Toronto Star

Devin Slater, Designer; **Rob Grant,** Editor;
Carl Neustaedter, A.M.E. Design; **Alison Uncles,** Sunday
Editor; **Graham Parley,** Sports Editor

News design, sections / Sports / 175,000 and over

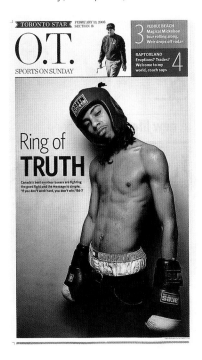

Heraldo de Aragón
Zaragoza, Spain

Pilar Ostalé, Designer; **Iban Santos,** Designer; **Ana Pérez,**
Designer; **Kristina Urresti,** Designer; **Jorge Mora,** Designer

News design, sections / Sports / 50,000-174,999

Sunday Herald
Glasgow, Scotland

Stephen Penman, Sports Editor; **Roddy Thomson,** Deputy Sports Editor; **Kathryn Course,**
Chief Sports Sub Editor; **Elaine Livingstone,** Picture Editor

News design, sections / Sports / 50,000-174,999

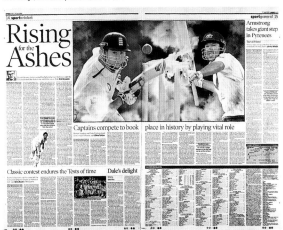

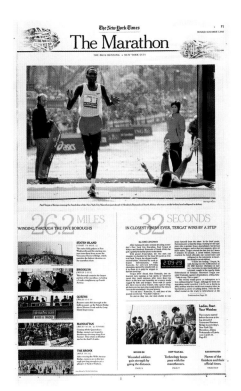

The New York Times

Wayne Kamidoi, Art Director

News design, sections / Sports / 175,000 and over

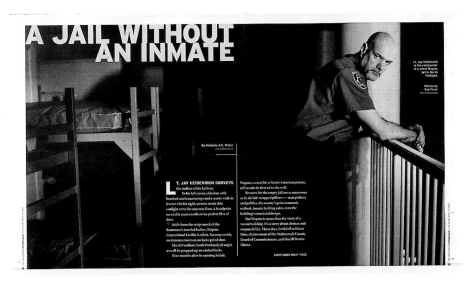

The Oregonian
Portland

Joan Carlin, InPortland Editor; **Debra Pang,** Designer; **Francesca Genovese-Finch,** Designer

News design, sections / Other / 175,000 and over

Correio Braziliense
Brasilia, Brazil

Josemar Giminez, Newsroom Director; **Ana Dubeux,** Editor in Chief;
Carlos Marcelo, Executive Editor; **João Bosco Adelino de Almeida,** Art
Director; **Luis Tajes,** Photo Editor; **Plácido Fernandes,** Front Page Editor;
Cristine Gentil, Assistant Editor; **Itamar Figueredo,** Page Designer

News design, page(s) / A-Section / 50,000-174,999

The Patriot-News
Harrisburg, Pa.

Kris Strawser, A.M.E./Visuals

News design, page(s) / A-Section / 50,000-174,999

RedEye
Chicago

Michael Morgan, Designer; **Wendy Pierro,** Photo Editor

News design, page(s) / A-Section / 50,000-174,999

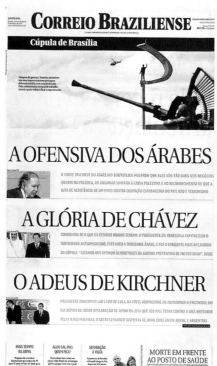

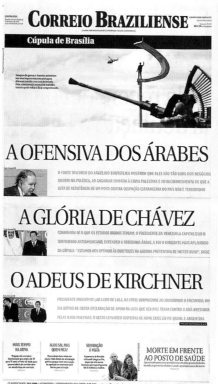

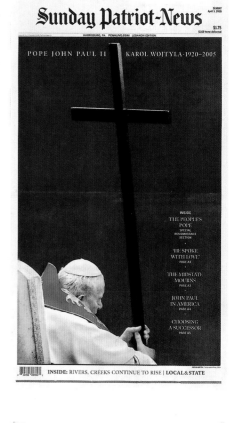

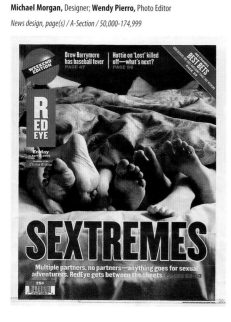

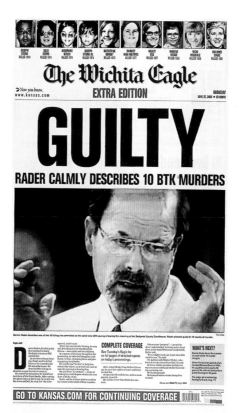

News & Record
Greensboro, N.C.

Benjamin J. Villarreal, Design Desk Chief

News design, page(s) / A-Section / 50,000-174,999

The Wichita Eagle
Kan.

Amy DeVault, Designer; **Coryanne Graham,** Designer; **Mike Sullivan,**
Graphics; **Paul Soutar,** Graphics; **Arlice Davenport,** Design Director

News design, page(s) / A-Section / 50,000-174,999

The Gazette
Montreal

Nuri Ducassi, Designer & Design Director; **Catherine Wallace,** ME/Weekend

News design, page(s) / A-Section / 50,000-174,999

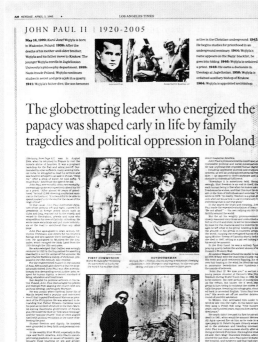

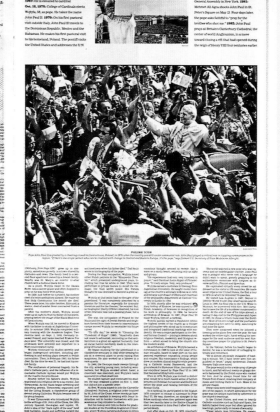

SILVER

Los Angeles Times

Michael Whitley, Deputy Design Director; **Bill Gaspard,** News Design Director; **Joseph Hutchinson,** Creative Director; **Dave Campbell,** Design Editor; **Lorraine Wang,** Design Editor; **Doug Stevens,** Graphics Editor; **Lorena Iniguez,** Graphics Editor; **Steve Stroud,** Photo Editor

News design, page(s) / A-Section / 175,000 and over

This staff does a great job with photo play and, more importantly, photo editing. There's not a wasted photo, and each is played appropriately. In a series of just six pages, this staff is not afraid to use a whole page to give a photo the proper play. It's the perfect pairing of photos and stories.

Este personal del diario hace un buen trabajo con el uso de la fotografía y, más importante aun, la edición fotográfica. No se desperdicia ninguna foto y cada una se usa en forma apropiada. Es la congruencia perfecta entre las fotos y los textos.

Savannah Morning News
Ga.

Josh Jackson, News Planner/Designer
News design, page(s) / A-Section / 50,000-174,999

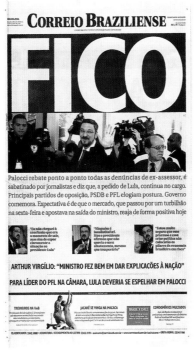

Correio Braziliense
Brasilia, Brazil

Josemar Gimenez, Newsroom Director; **Ana Dubeux,** Editor in Chief; **Carlos Marcelo,** Executive Editor; **João Bosco Adelino de Almeida,** Art Director; **Luis Tajes,** Photo Editor; **Plácido Fernandes,** Front Page Editor; **Carlos Alexandre,** Assistant Editor; **Marcelo Ramos,** Page Designer
News design, page(s) / A-Section / 50,000-174,999

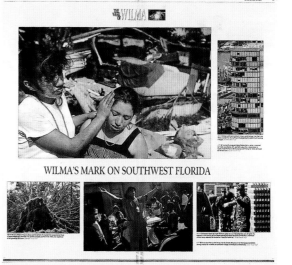

Naples Daily News
Fla.

Eric Strachan, Picture Editor/Page Designer; **Judy Lutz,** Picture Editor; **Michel Fortier,** Photographer; **Lexey Swall,** Photographer; **Darron Silva,** Photographer
News design, page(s) / A-Section / 50,000-174,999

National Post
Toronto

Douglas Kelly, Editor in Chief; **Gayle Grin,** M.E./Presentation;
Stephan Meurice, M.E./News; **Angela Murphy,** Page Editor;
Jeff Wasserman, Photo Editor

News design, page(s) / A-Section / 175,000 and over

National Post
Toronto

Douglas Kelly, Editor in Chief; **Gayle Grin,** M.E./Presentation; **Laura Koot,**
News Presentation Editor; **Jeff Wasserman,** Photo Editor; **Angela Murphy,**
Page One Editor; **Stephan Meurice,** M.E./News

News design, page(s) / A-Section / 175,000 and over

National Post
Toronto

Douglas Kelly, Editor in Chief; **Gayle Grin,** M.E./Presentation;
Stephan Meurice, M.E./News; **Angela Murphy,** Page Editor

News design, page(s) / A-Section / 175,000 and over

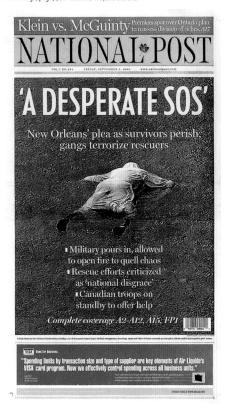

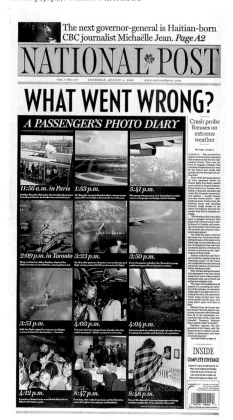

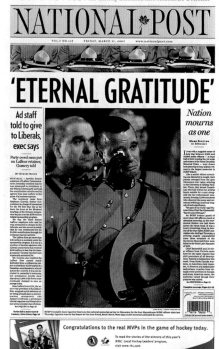

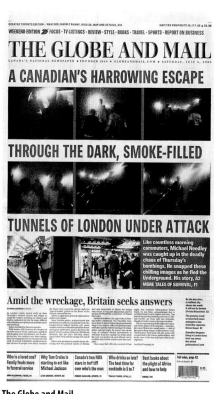

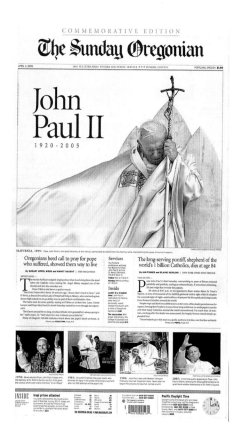

The Globe and Mail
Toronto

Adrian Norris, Presentation and Production Director/News; **David Pratt,**
Executive Art Director; **Erin Elder,** Chief Photo Editor

News design, page(s) / A-Section / 175,000 and over

The Globe and Mail
Toronto

Adrian Norris, Presentation & Production Director, News; **David Pratt,**
Executive Art Director; **Michael Needley,** Photographer; **Erin Elder,** Chief
Photo Editor

News design, page(s) / A-Section / 175,000 and over

The Oregonian
Portland

Mark Friesen, Designer; **Patty Reksten,** Director of Photography;
Randy Cox, Senior Editor/Visuals; **Linda Shankweiler,** Design Director

News design, page(s) / A-Section / 175,000 and over

National Post Front Page

News inside: Suitcase of cash at Gomery; Spector predicts Slovak hockey gold; plus New India series in FP

NATIONAL ★ POST

VOL.7 NO.167 WEDNESDAY, MAY 11, 2005 www.nationalpost.com

Tories win vote, Grits ignore it

YES	NO
153	*150*

Harper pledges 'additional steps' today after Liberals deny vote calling for their resignation was an expression of non-confidence

ANNE DAWSON AND ALLAN WOODS
IN OTTAWA

The federal government waded into uncharted constitutional waters last night after the Liberals were defeated in a vote that the Conservatives insist should topple the fragile minority government, but that Paul Martin says he will ignore.

Just back from the Netherlands after a 46-hour trip to commemorate the 60th anniversary of the liberation of Europe, the Prime Minister stood in the House along with his Liberal and NDP supporters to vote against the motion put forward by the Conservatives calling on the government to resign. But the motion passed by a three-vote margin, 153 to 150.

The result only deepened the stalemate gripping a paralyzed Parliament and was widely interpreted as the beginning of the end for the government.

Immediately after winning the vote, Conservative leader Stephen Harper rose in the Chamber to challenge Mr. Martin to call a full-fledged vote of confidence, a vote the Liberals were sure to lose. "This is a corrupt party which is in the process of ruining the country's finances and which is now ignoring the democratically expressed will of the House of Commons. This government does not have the moral authority to govern this country," Mr. Harper said.

Bloc Québécois leader Gilles Duceppe vowed to find a way to bring down the government, but joined Mr. Harper in refusing to give any hints about his plans. "We won't wait for them. We will keep on finding ways to finish with that," Mr. Duceppe said.

When asked what was next for the opposition, Conservative House leader Jay Hill borrowed a line from former Liberal prime minister Pierre Trudeau. "Just watch me, I guess, is a pretty famous line. Parliament is over tonight. It's done," said Mr. Hill, who would not even confirm that his party will show up for work today.

See VOTE on Page A8

COMMENT

Government by technicality

ANDREW COYNE

Let's say the government is right, that a vote of the majority of the House of Commons expressing no confidence in the government does not count as a vote of non-confidence: that although the House may have demanded "that the government resign," it forgot to preface this with the critical words, "Simon says." What does this mean?

It means that we now have a new form of government in this country: government by technicality. The government can no longer claim to govern with the consent of the governed, the traditional standard of legitimacy in a democracy. It governs with the consent of itself. It is the constitutional equivalent of a circular argument, a government that rules solely on the strength of its own assertions. It holds a new kind of power: the power of positive thinking.

A majority of members of the House clearly believe they have passed a motion of non-confidence. Yet the government, with the support of a minority of the House, assures them they are mistaken: no, no, no, old chaps, that's not what you meant at all. No, trust us: what you *meant* was merely to instruct a committee to report back to the House with a demand that the government resign. But that doesn't mean you want the government to resign. Trust us.

See COYNE on Page A8

Clarkson likely to stay out, Page A3; John Ivison, A7; Editorial, A18; More comment, A18

NOW BOARDING!

See page A9, and take off to just about anywhere with our great low fares. Plus, we have lots more for this summer, too. Hurry, offer ends soon!

AIR CANADA
★ A STAR ALLIANCE MEMBER

SILVER

National Post
Toronto

Douglas Kelly, Editor in Chief; **Gayle Grin,** M.E./Presentation; **Stephan Meurice,** M.E./News; **Angela Murphy,** Page Editor; **Jeff Wasserman,** Photo Editor

News design, page(s) / A-Section / 175,000 and over

You can design a section front with only type and have it tell the story. That is the National Post's trademark. Its nameplate is close in texture to the main headline typography, but it works with an amber screen behind it. This page really works in the newsstand. The story is yes or no, and that's the story told.

Se puede diseñar la portada de una sección con apenas una tipografía y conseguir que cuente el tema. Ésta es la marca del National Post. Su mancheta se parece en textura a la tipografía del título principal, pero tiene una trama de color ámbar al fondo. Esta página ciertamente funciona en el kiosko. El artículo trata de sí o no, y así está contado.

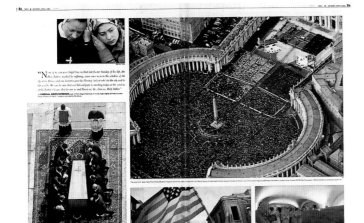

St. Petersburg Times
Fla.

Amy Hollyfield, News Design Director; **Scott DeMuesy,** Photo Editor

News design, page(s) / A-Section / 175,000 and over

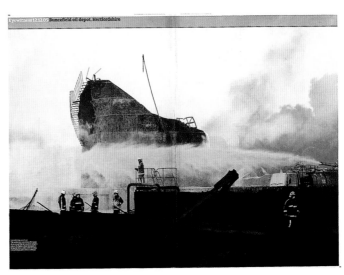

The Guardian
London

Staff

News design, page(s) / A-Section / 175,000 and over

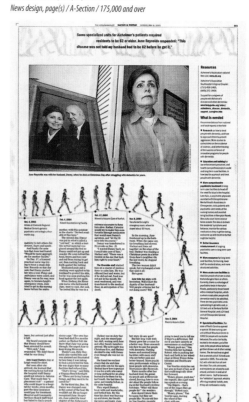

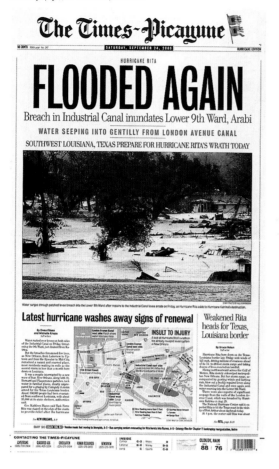

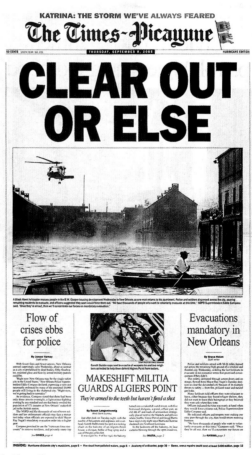

HIROSHIMA
60 ANOS DEPOIS

SILVER

Estado de Minas
Belo Horizonte, Brazil
Julio Moreira, Design Assistant
News design, page(s) / A-Section / 50,000-174,999

This page marking Hiroshima 60 years after the atomic bomb communicates beyond language. This presentation shows such restraint; there are pictures of badly injured people and the devastation, but they are secondary. This is a tough photo edit, but there is a rhythm to it. The timepiece breaks the balance on the page and keeps it from being too symmetrical.

Esta página que marca el sexagésimo aniversario de la bomba atómica sobre Hiroshima comunica más allá del lenguaje. Esta presentación muestra mucha restricción; hay fotos de gente muy herida y de la destrucción, pero son secundarias. Hay una edición fotográfica potente, pero hay ritmo en ella. El reloj rompe el equilibrio en la página y evita que se vea muy simétrica.

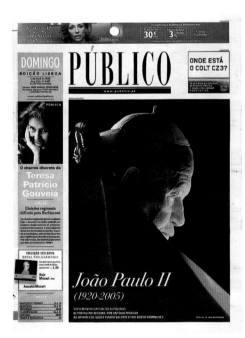

Público
Lisbon, Portugal
Gil Lourenco, Graphics Editor; **Max Rossi,** Reuters Photographer;
José Manuel Fernandes, Editor in Chief
News design, page(s) / A-Section / 50,000-174,999

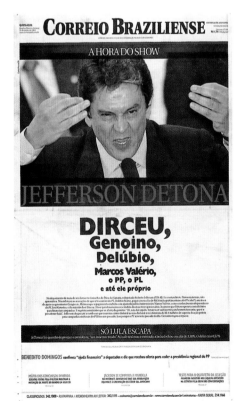

Correio Braziliense
Brasilia, Brazil
Josemar Giminez, Newsroom Director; **Ana Dubeux,** Editor in Chief;
Carlos Marcelo, Executive Editor; **João Bosco Adelino de Almeida,**
Art Director; **Luis Tajes,** Photo Editor; **Plácido Fernandes,**
Front Page Editor; **Cristine Gentil,** Assistant Editor; **Marcelo Ramos,**
Page Designer
News design, page(s) / A-Section / 50,000-174,999

Hartford Courant
Conn.

Greg Harmel, Designer; **Suzette Moyer,** Director/Design & Graphics;
David Grewe, Photo Editor; **John Scanlan,** Director/Photography;
Thom McGuire, A.M.E. Graphics/Photography

News design, page(s) / A-Section / 175,000 and over

Hartford Courant
Conn.

Greg Harmel, Designer; **Suzette Moyer,** Director/Design & Graphics;
David Grewe, Photo Editor; **John Scanlan,** Director/Photography;
Thom McGuire, A.M.E. Graphics/Photography

News design, page(s) / A-Section / 175,000 and over

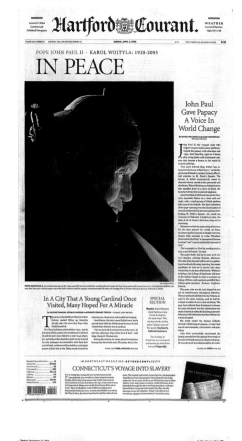

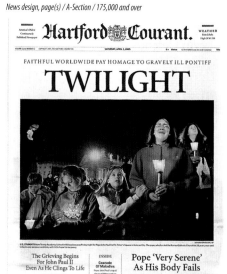

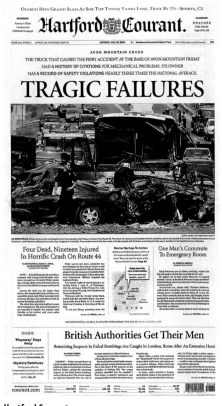

Hartford Courant
Conn.

Greg Harmel, Designer; **Suzette Moyer,** Director/Design & Graphics;
Shana Sureck, Photographer; **Jim Kuykendall,** Artist; **David Grewe,**
Photo Editor; **John Scanlan,** Director/Photography; **Thom McGuire,** A.M.E.
Graphics/Photography

News design, page(s) / A-Section / 175,000 and over

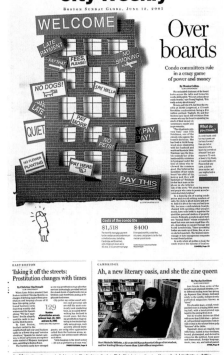

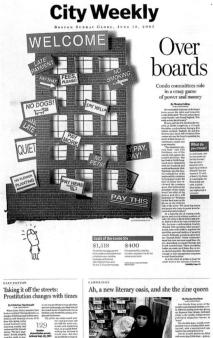

The Denver Post

Jeff Neumann, Designer/Photo Editor

News design, page(s) / A-Section / 175,000 and over

The Boston Globe

Lesley Becker, Designer

News design, page(s) / Local / 175,000 and over

The Boston Globe

David Schutz, Assistant Design Director/News;
David Filipov, Assistant Metro Editor; **Thea Breite,**
Photo Editor; **Dan Zedek,** Design Director

News design, page(s) / Local / 175,000 and over

Público

Lisbon, Portugal

José Manuel Fernandes, Director; **Manuel Carvalho,** Editorial Director;
Amílcar Correia, Editorial Director; **Pedro Almeida,** Graphics Editor/
Designer; **José Soares,** Designer; **Nuno Costa,** Designer; **Vanessa Taxa,**
Designer

News design, page(s) / Local / 50,000-174,999

Público

Lisbon, Portugal

José Manuel Fernandes, Director; **Manuel Carvalho,** Editorial Director;
Amílcar Correia, Editorial Director; **Pedro Almeida,** Graphics Editor/
Designer; **José Soares,** Designer; **Nuno Costa,** Designer; **Vanessa Taxa,**
Designer

News design, page(s) / Local / 50,000-174,999

El Diario de Hoy

San Salvador, El Salvador

Juan Durán, Art Director & Designer; **Teodoro Wilson Torres Lira,**
Graphics Editor; **Jorge Castillo,** Infographic Editor; **José Santos,**
Graphics Co-Editor; **Jorge Beltrán,** Periodista

News design, page(s) / Local / 50,000-174,999

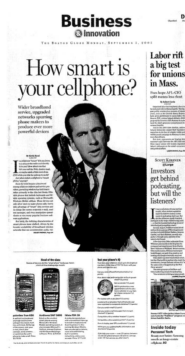

The Boston Globe

Vic DeRobertis, Art Director & Designer; **Dan Zedek,**
Design Director

News design, page(s) / Business / 175,000 and over

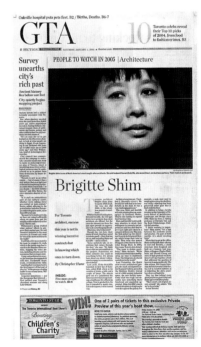

Toronto Star

Spencer Wynn, Designer; **Lucas Oleniuk,** Photographer

News design, page(s) / Local / 175,000 and over

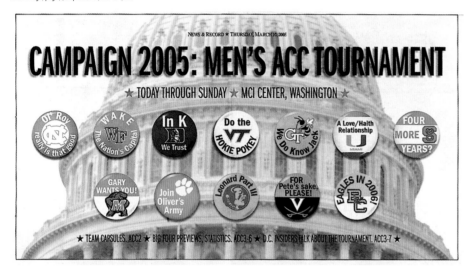

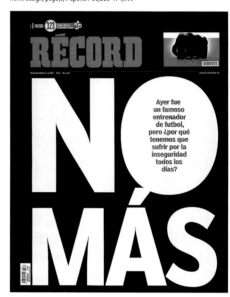

SPEAK NO EVIL

While the Scottish media is on tenterhooks awaiting Roy Keane's first outburst, the man himself has vowed to keep his own counsel ... for a while at least. Michael Grant reports

It looks as though everyone is going to have to calm down, be patient, and wait to see if the fuse will be lit. A combination of SPL registration rules and his own self-restraint will ensure that it will be January 8 before Scotland can watch Roy Keane and longer still until he might be worth listening to. The full Keane experience, the compelling cocktail which makes him worthy of respect and trepidation in equal measure, has been put on hold.

Self-restraint! Keane? So it seems. If the man is true to his word he will resist the temptation to make any declarations about his first impressions of life as a Celtic and SPL footballer and instead remain diplomatic, or perhaps even silent, until he feels he has earned the right to proffer an opinion.

Being surrounded by dozens and dozens of journalists' microphones during a long, smoothly-handled press conference at Parkhead on Thursday might have made him feel as though he was facing a firing squad. Think of the turmoil caused by the words he has poured into mics in the past. His own uncompromising opinions, relayed by the media in one form or another, have resulted in most of the controversies of his extraordinary career. Had he kept his thoughts to himself on Alfie Inge Haaland, Mick McCarthy, Carlos Queiroz and eventually some of his last Manchester United teammates, Celtic would have no more to concern them than whether a combative 34-year-old midfielder still has much to offer on the battleground. But, with Keane, the full package includes unquenchable commitment and an explosive inability to contain critical views of others who fail to meet his perceived standards.

With Scottish journalists salivating at the prospect of dramas to come, Keane was asked whether he would continue to speak his mind now that he was in Glasgow. "Maybe not for the first few weeks ... I'll have to settle in first. But I think in the long run players appreciate that." So, open your new diary and make a note of February as a month when he might be likely to burn this way into the headlines. Might Celtic face a Valentine's Day massacre on the 14th?

In fact, no-one at Parkhead need worry about being on the receiving end of a Keane eruption if they maintain the level of professionalism that ought to already exist at the club. Some observers anticipate Keane destroying Celtic's dressing room morale by making unfavourable comparisons to what he has been used to at Old Trafford. That overlooks the fact that it is the suspicion of a lack of commitment – not ability or even facilities – which tends to cause Keane's inner lava to bubble over.

His new manager bristled at the notion that he or the Celtic players might operate at a level of professionalism which could offend the former Manchester United captain's sensibilities. "No-one should think Roy is a one-off in this situation, in wanting to stand up and speak his mind," said Gordon Strachan, who shared his latest signing's experience of having played under arguably the most driven manager of them all, Sir Alex Ferguson. "As a United player I was in a dressing room with 11 of them every half-time. When he [Ferguson] wasn't in we'd be fighting each other, and those guys went on to be managers themselves.

"Maybe not for the first few weeks ... I'll have to settle in first." "I was the same at Leeds. You get it sorted out in the dressing room and that's fine. It saves anything festering. I remember Jim Beglin at Leeds telling me to sit down or he was going to knock my head off. I wasn't an idle threat so I said 'fine by me then, I'll sit down then'. That's what happens.

"Once at United I had dislocated my shoulder and when I got back playing I was wary of it for about four weeks. Then at half-time in one game somebody told me straight: 'when are you going to get involved in the game'. I realised that I was trying to keep out of trouble and protect my shoulder. That was what I needed." Keane's mouth might be a force for good, in other words.

The relentless self-policing of Keane's approach to the game owed much to formative influences such as Stuart Pearce at Nottingham Forest and Bryan Robson at United. "Robbo would fight you then go for a drink with you. I'm kind of from that old school," said Keane. "I think the game has changed in that most players want an arm put round them these days. I think that has crept in to the game." At that point it was all he could do to prevent his lip from curling in contempt.

"Sometimes a player just wants to win. It doesn't matter if there are five people at training or 50,000 at a game. It comes from within. Sometimes you have to create your own atmosphere. It is the same even as a kid playing in the streets."

Not that he cares about what is written about him, but had he bothered with Friday's coverage of his unveiling Keane might have felt a little hurt. All those mentions of his charm and wit, of the fact he was surprisingly impressive, amounted to back-handed compliments; what sort of brute had people expected? Those more familiar with dealing with him in Manchester and Ireland testify to the fact that Keane is a complex and deep character rather than simply a cold-eyed savage. There was something fascinatingly chilling about how still, almost detached, he was at the centre of the Parkhead press scrum on Thursday. He looked like a cat toying with the media mice.

Commitment and an uncompromising tongue are part of the Keane package but what really drew hundreds of supporters to the car park outside Parkhead for 1.30pm on Thursday – more so even than 15 years of world class performances as a midfielder – was the combination of aggression, intimidation and attitude which conspire to create the force that is "Keano". Being an Irish icon with a soft spot for Celtic was enough for some ludicrous phone-in claims on Thursday evening that he was the club's "best ever" signing. He is far too old to steal that accolade from Henrik Larsson, but fans can get ahead of themselves when they know a player with Keane's reputation will be in their colours for the next few Old Firm games.

In more than a decade in the flying boots of Premiership, Champions League and international midfield play Keane has dealt with harder, cleverer, more provocative opponents than he can expect to face in the Scotland.

He knows every trick in the book. He will have his moments, but it would be naïve to believe he will be sucked into regular controversies here by players intent on denting his reputation. Punters should steer clear of the 20/1 available on him receiving a red card in his likely Old Firm debut at Ibrox on February 11.

Keane is not the force he was five years ago – Celtic would not have him if he was – but some observers regarded him as the most effective player on the field in his final appearance for Manchester United against Liverpool on September 18. He succumbed to a broken toe that day and has not played since, but has claimed to be fit and only a couple of weeks away from the sharpness required to return for a probable Tennent's Scottish Cup third round debut against Clyde on January 8.

The general wear and tear on his body will eat into his effectiveness for Celtic over the course of his initial 18-month contract, but, as an indication of his willingness to return to the trenches, he offered the following response when praised on Thursday for his powerful contribution to Manchester United's FA Cup final performance against Arsenal only seven months ago: "I enjoyed the cup final in terms of being in the middle of a battle. I like the battles.

"I've been in the game long enough to know that when people write you off you shouldn't take much notice. It's the same when they say you're a great, great player. Years ago when they were saying I was in my prime I took it with a pinch of salt. Over the last few years I've really focused on looking after myself, stretching, trying to do the right things. If I'd turned this down I probably would have regretted it for a long, long time. I think I'm quietly confident I can come up here and do well for Celtic."

What an understated sentence that was. It sounded like Nick Ross at the end of Crimewatch, urging viewers not to have nightmares.

> Bryan Robson would fight you then go for a drink with you. I'm kind of from that old school. I think the game has changed in that most players want an arm put round them these days. I think that has crept in to the game

This spread about soccer star Roy Keane's vow to use self-restraint shows a powerful command of color. A simple design, an intense crop, beautiful typography and effective use of white space produce a page that shines.

Este artículo extenso y bien editado sobre la estrella del fútbol Roy Keane demuestra un poderoso dominio del color. Un diseño simple, un recorte decidido, una tipografía atractiva y un uso efectivo del espacio blanco producen una página que se destaca.

SILVER

Sunday Herald
Glasgow, Scotland

Stephen Penman, Sports Editor; **Jody Megson,** Assistant Picture Editor

News design, page(s) / Sports / 50,000-174,999

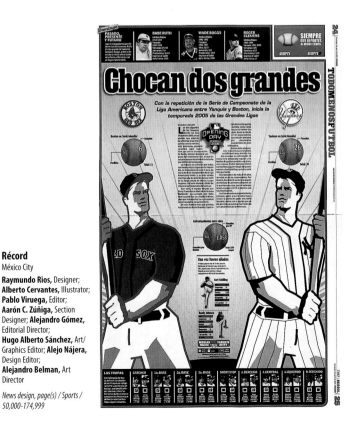

Récord
México City

Raymundo Rios, Designer;
Alberto Cervantes, Illustrator;
Pablo Viruega, Editor;
Aarón C. Zúñiga, Section Designer; **Alejandro Gómez,** Editorial Director;
Hugo Alberto Sánchez, Art/Graphics Editor; **Alejo Nájera,** Design Editor;
Alejandro Belman, Art Director

News design, page(s) / Sports / 50,000-174,999

The Globe and Mail
Toronto

David Woodside, Design Editor; **David Pratt,** Executive Art Director; **Steve McAllister,** Sports Editor; **Jeff Brooke,** Page Editor

News design, page(s) / Sports / 175,000 and over

Los Angeles Times

Michael Whitley, Deputy Design Director; **Vic Seper,** Design Editor; **Gary Kelley,** Illustrator

News design, page(s) / Sports / 175,000 and over

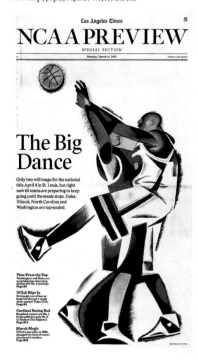

The Australian

Sydney, Australia

Trevor Timms, Designer; **Mark David,** 3-D Illustration; **Bob Ross,** Journalist

News design, page(s) / Sports / 175,000 and over

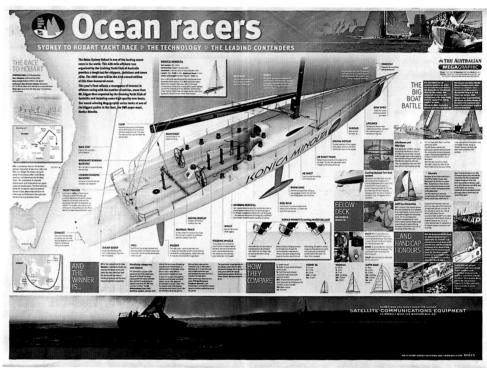

The Boston Globe

Brian Gross, Designer;
Dan Zedek, Design Director

News design, page(s) / Sports / 175,000 and over

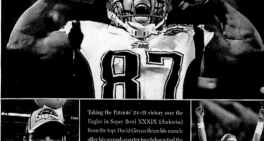

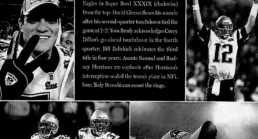

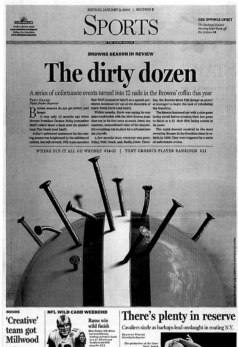

The Plain Dealer

Cleveland

Emmet Smith, Designer; **Andrea Levy,** Photographer/Illustrator; **Roy Hewitt,** Sports Editor; **David Kordalski,** A.M.E./Visuals

News design, page(s) / Sports / 175,000 and over

SPORTS

Like magic, Cavs lose
McInnis' tying 3-pointer disappears in James' return

Crennel gives Browns glimpse of the future

Buckeyes still awaiting decisions from prospects

SPORTS

DON'T LET UP. DON'T LET DOWN. SHARE THE BALL. TAKE YOUR SHOT. BE CREATIVE. DON'T FORCE THINGS. DON'T GET COMPLACENT. DON'T PUSH TOO HARD. TRY TO BE AN IMPACT PLAYER. PLAY WITHIN YOURSELF. STICK TO YOUR ROUTINE. AMOUNT ON THE FLY. BE PHYSICAL. DON'T COMMIT SILLY FOULS. BE A CONSISTENT. KEEP IMPROVING YOUR GAME. PLAY AGGRESSIVELY. LET THE GAME COME TO YOU. PROMOTE THE TEAM. DON'T BELIEVE ALL THE HYPE. TAKE IT ALL IN. IGNORE THE DISTRACTIONS. NOW GO OUT AND WIN A NATIONAL TITLE. TAKE IT ONE GAME AT A TIME. RUN. JUMP. CLAP. JET.

EVER WONDER WHY IT'S SO HARD TO GO UNDEFEATED?

Dilfer solves passing mystery
Browns trade for Seattle QB

Heat will be tough to beat

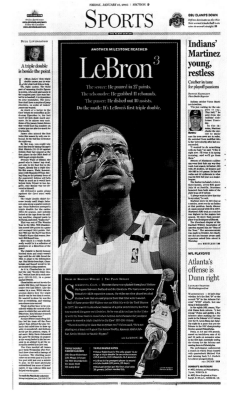

SPORTS

ANOTHER MILESTONE REACHED

LeBron³

The scorer: He poured in 27 points.
The rebounder: He grabbed 11 rebounds.
The passer: He dished out 10 assists.
Do the math: It's LeBron's first triple double.

Indians' Martinez young, restless
Catcher in tune for playoff passions

Atlanta's offense is Dunn right

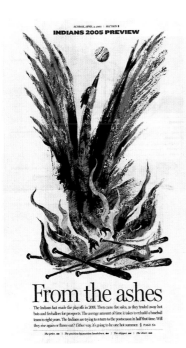

INDIANS 2005 PREVIEW

From the ashes

GOLF MONDAY

BACK ON THE PROWL

THE OUTSIDERS

The Denver Post

Ingrid Muller, Design Director;
Aleta Labak, Designer;
Cyrus McCrimmon,
Photographer

*News design, page(s) / Sports /
175,000 and over*

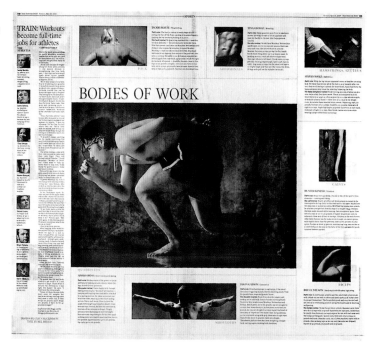

BODIES OF WORK

The Buffalo News
N.Y.

Vincent J. Chiaramonte,
Designer; **James P. McCoy,**
Photographer; **Steve Jones,**
Deputy Sports Editor;
Howard Smith, Executive
Sports Editor

*News design, page(s) / Sports /
175,000 and over*

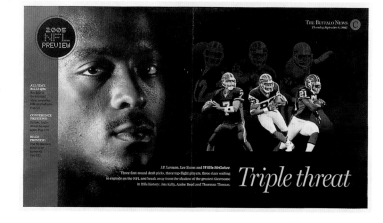

Triple threat

Récord
México City

Leonardo Torres, Designer;
Marco Garcia, Editor;
Aarón C. Zúñiga, Section
Designer; **Alejandro Gómez,**
Editorial Director;
Hugo Alberto Sánchez, Art/
Graphics Editor; **Alejo Nájera,**
Design Editor;
Alejandro Belman, Art Director

*News design, page(s) / Sports /
50,000-174,999*

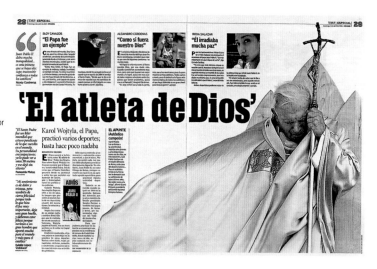

'El atleta de Dios'

Detroit Free Press

Christoph Fuhrmans, Designer; **Gene Myers,** Sports Editor;
John Fleming, Deputy Graphics Director; **Fred Fluker,** News Artist;
Steve Dorsey, AME/Presentation

News design, page(s) / Sports / 175,000 and over

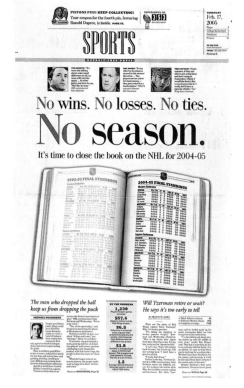

No wins. No losses. No ties.

No season.

It's time to close the book on the NHL for 2004-05

LOOK WHO'S PLAYING
CATCH-UP

For the first time in seemingly forever, the Yankees
find themselves chasing their rivals from Boston

Omaha World-Herald
Neb.

Dave Elsesser, Deputy Design Director

News design, page(s) / Sports / 175,000 and over

The Boston Globe

Grant Staublin, Designer; **Shirley Leung,**
Senior Assistant Business Editor;
Christine Murphy, Designer; **Thea Breite,**
Photo Editor; **Lane Turner,** Photographer;
Dan Zedek, Design Director

News design, page(s) / Business / 175,000 and over

The New York Times

Peter Morance, Art Director

News design, page(s) / Business / 175,000 and over

La Presse
Montréal

Benoit Giguere, Art Director; **Francis Leveillee,** Designer; **Michel Marois,**
A.M.E./Sports; **Jean-Sebastien Gagnon,** Sports Editor; **Martin Tremblay,**
Photographer; **Alain-Pierre Hovasse,** Photo Director

News design, page(s) / Sports / 175,000 and over

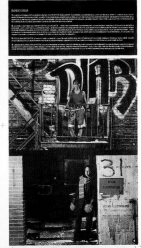

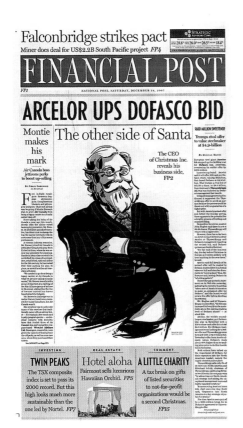

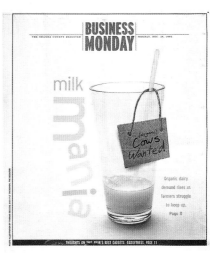

The Orange County Register
Santa Ana, Calif.

Kyle Sackowski, Designer/Illustrator; **Neil Pinchin,** Senior Editor/Design;
Brenda Shoun, Deputy Editor; **Karen Kelso,** Design Team Leader

News design, page(s) / Business / 175,000 and over

National Post
Toronto

Douglas Kelly, Editor in Chief; **Gayle Grin,** M.E./
Presentation; **Ron Wadden,** FP Design Director;
Charles Lewis, M.E./FP; **Mike Faille,** Graphic Artist;
Gigi Suhanic, Deputy FP Design Director

News design, page(s) / Business / 175,000 and over

San Jose Mercury News
Calif.

Matt Mansfield, Deputy M.E.; **Kevin Wendt,** News Design Director;
Chuck Burke, Designer; **Phil Loubere,** Graphic Artist

News design, page(s) / Business / 175,000 and over

The Orange County Register
Santa Ana, Calif.

Kristin Lenz, Designer; **Tamará Chuang,** Writer; **Neil Pinchin,** Senior Editor/Design; **Brenda Shoun,** Deputy Editor; **Karen Kelso,** Design Team Leader

News design, page(s) / Business / 175,000 and over

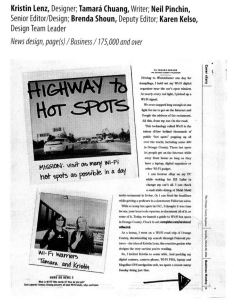

The Plain Dealer
Cleveland

Lisa Griffis, Projects Designer; **Kim Moy,** Designer; **David Kordalski,** A.M.E./Visuals; **John Kroll,** Deputy Business Editor

News design, page(s) / Business / 175,000 and over

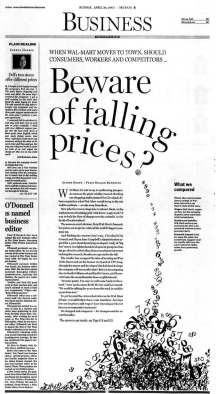

The Gazette
Montreal

David Fitzpatrick, Design Editor; **Jane Davenport,** Nation Editor; **Nuri Ducassi,** Design Director

News design, page(s) / Inside page / 50,000-174,999

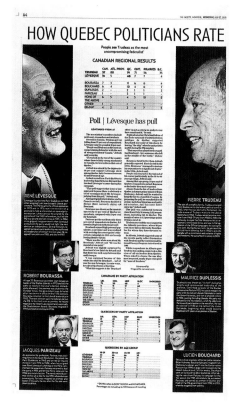

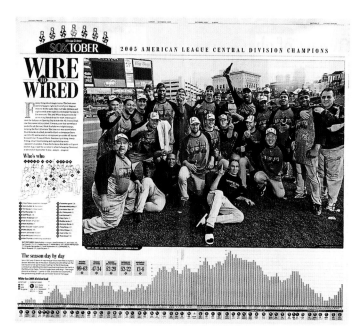

Chicago Tribune

Charles Cherney, Photographer; **Steve Layton,** Senior Artist; **Mike Kellams,** Associate Sports Editor

News design, page(s) / Inside page / 175,000 and over

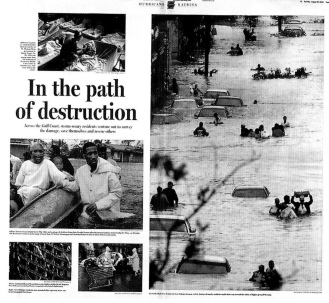

The Dallas Morning News

Chuck Stewart, News Design Editor

News design, page(s) / Inside page / 175,000 and over

The Palm Beach Post
West Palm Beach, Fla.

Mark Edelson, Presentation Editor; **Uma Sanghvi,**
Photographer

News design, page(s) / Inside page / 50,000-174,999

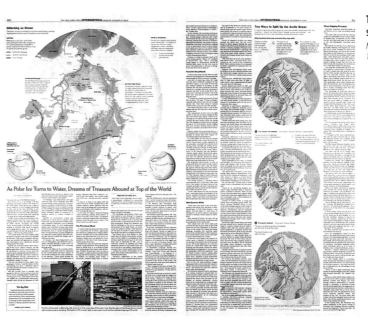

As Polar Ice Turns to Water, Dreams of Treasure Abound at Top of the World

The New York Times
Staff

News design, page(s) / Inside page / 175,000 and over

Sri Lanka: A photographer's notebook

It's the little things you remember.
And that you're remembered by.

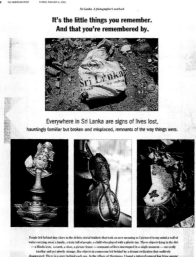

Everywhere in Sri Lanka are signs of lives lost,
hauntingly familiar but broken and misplaced, remnants of the way things were.

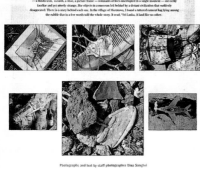

Photographs and text by staff photographer Uma Sanghvi

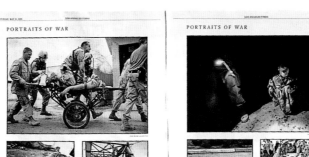

PORTRAITS OF WAR

Los Angeles Times

Bill Gaspard, News Design
Director; **Michael Whitley,**
Deputy Design Director;
Joseph Hutchinson,
Creative Director; **Steve Stroud,**
Photo Editor

News design, page(s) / Inside page / 175,000 and over

American losses:

Iraqi losses:

Titles and deeds

Remembering the faces and the numbers that led to the Patriots' championship reigns

2001-02 2003-04 2004-05

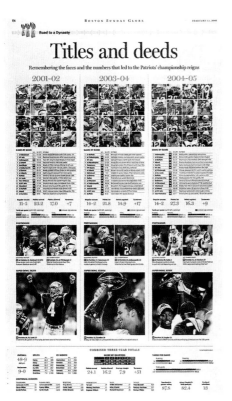

Photos Tend to Look the Other Way

The Boston Globe

Brian Gross, Designer; **Dan Zedek,** Design Director
News design, page(s) / Inside page / 175,000 and over

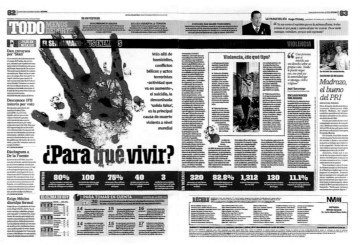

¿Para qué vivir?

Récord
México City

Raymundo Ríos, Designer;
Aarón C. Zúñiga, Designer/
Section Designer;
Alejandro Rodríguez,
Illustrator; **Francisco Sánchez,**
Editor; **Alejandro Gómez,**
Editorial Director;
Hugo Alberto Sánchez,
Art/Graphics Editor;
Alejo Nájera, Design Editor;
Alejandro Belman, Art Director

*News design, page(s) / Inside page /
50,000-174,999*

Zeta Weekly
Tijuana, México

Ariel Freaner, Designer/Digital Illustrator; **J. Jesus Blancornelas,** Editor/Co-Director; **Zeta Photography Archives**

News design, page(s) / Other / 49,999 and under

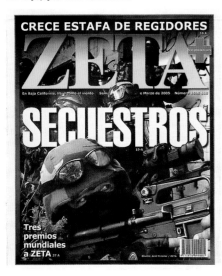

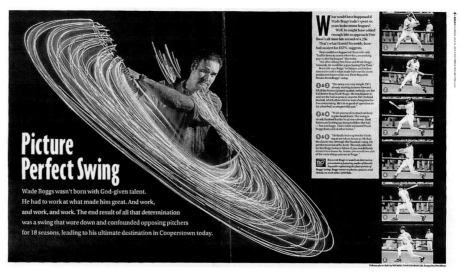

Picture
Perfect Swing

Wade Boggs wasn't born with God-given talent.
He had to work at what made him great. And work,
and work, and work. The end result of all that determination
was a swing that wore down and confounded opposing pitchers
for 18 seasons, leading to his ultimate destination in Cooperstown today.

The Tampa Tribune
Fla.

Andrew Smith, Designer; **Greg Williams,** Designer; **Michael Spooneybarger,** Photographer

News design, page(s) / Inside page / 175,000 and over

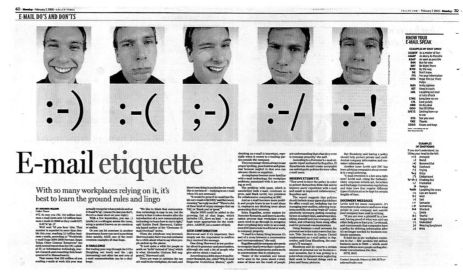

E-mail etiquette

With so many workplaces relying on it, it's
best to learn the ground rules and lingo

Corpus Christi Caller-Times
Texas

Patrick Birmingham, Publisher; **Libby Averyt,** Editor; **Shane Fitzgerald,** M.E.; **Jorge Vidrio,** Design Director; **David Holub,** Designer

News design, page(s) / Inside page / 50,000-174,999

Der
Profi

Die Welt
Berlin

Katja Wischnewski, Page Designer; **Michael Dilger,** Photo Editor

News design, page(s) / Inside page / 175,000 and over

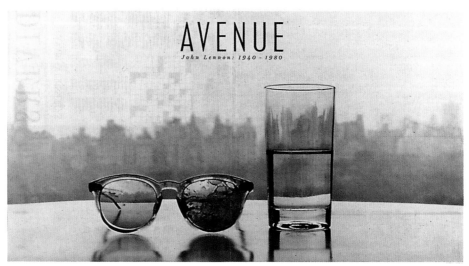

AVENUE
John Lennon: 1940 – 1980

National Post
Toronto

Douglas Kelly, Editor in Chief; **Gayle Grin,** M.E./Presentation; **Ben Errett,** Arts & Life Editor; **Brad Frenette,** Senior Designer

News design, page(s) / Other / 175,000 and over

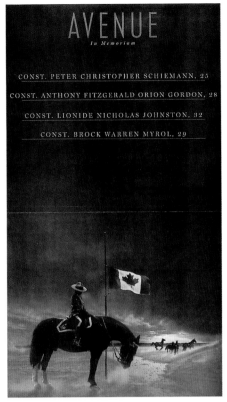

National Post
Toronto

Douglas Kelly, Editor in Chief; **Gayle Grin,** M.E./Presentation

News design, page(s) / Other / 175,000 and over

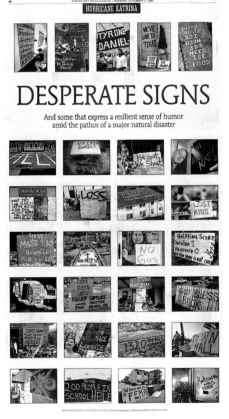

Seattle Post-Intelligencer

Scott Stoddard, News Designer; **Andy Rogers,** Photo Editor

News design, page(s) / Inside page / 50,000-174,999

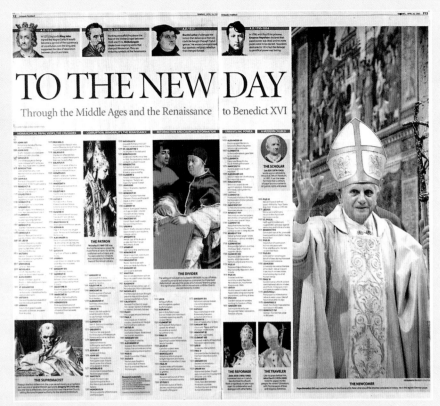

Orlando Sentinel
Fla.

Stephen Komives, Design Editor; **Bonita Burton,** A.M.E./Visuals

News design, page(s) / Other / 175,000 and over

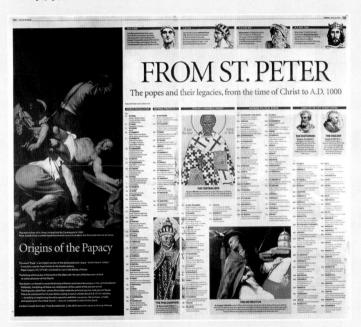

A tremendous amount of research and effort went into this entry. It is encyclopedic but not overpowering. It stood out among many pope pages, telling the story not just of Pope John Paul II, but of all the popes, replacing the usual 80-inch narrative with a timeline that offers many ways to access information.

En esta pieza concursante, es evidente una investigación exhaustiva y un gran esfuerzo. Es enciclopédica, pero no agotadora. Se destacó de entre varios trabajos sobre el Papa, al contar no solamente la historia de Juan Pablo II, sino de todos los Papas, con lo que reemplaza la convencional narración de 240 cm. (80 pulgadas), con una línea de tiempo que ofrece muchas alternativas de entrada a la información.

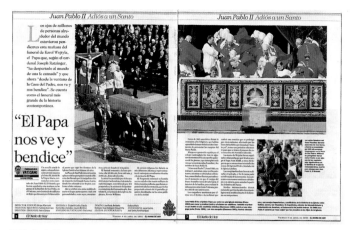

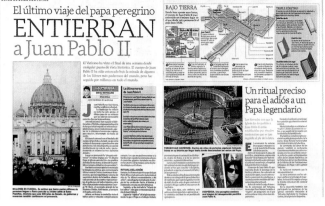

El Diario de Hoy
San Salvador, El Salvador

Juan Durán, Art Director; **Teodoro Wilson Torres Lira,** Graphics Editor; **Jorge Castillo,** Infographics Editor; **José Santos,** Infographics Co-Editor; **Juan Durán,** Designer; **Remberto Rodríguez,** Designer; **Hugo Rodríguez,** Designer; **Enrique Peña,** Designer

Breaking-news topics / Papal funeral and ascension

La Prensa Gráfica
San Salvador, El Salvador

Enrique Contreras, Design Editor; **Héctor Ramírez,** Design Co-Editor; **Wilson Carranza,** Designer

Breaking-news topics / Papal funeral and ascension

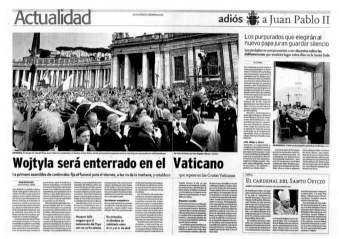

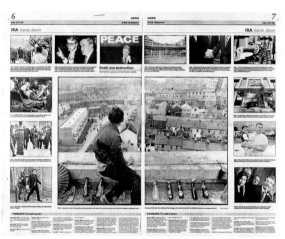

Sur
Malaga, Spain

Baldomero Villanueva, Section Designer; **Rafael Ruiz,** Designer; **Mª Dolores de la Vega,** Designer; **Fernando González,** Director of Photography; **Francisco Sánchez Ruano,** Art Director; **Alberto Torregrosa,** Editorial Design Consultant

Breaking-news topics / Papal funeral and ascension

The Irish Examiner
Cork, Ireland

Conor O'Donnell, Night Editor; **Jack Powers,** Associate Editor

Breaking-news topics / War on terrorism

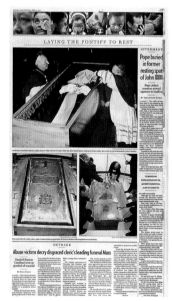

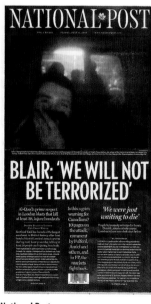

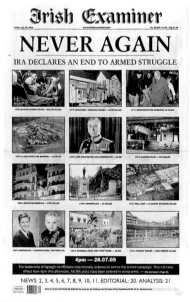

National Post
Toronto

Douglas Kelly, Editor in Chief; **Gayle Grin,** M.E./ Presentation; **Stephan Meurice,** M.E./News; **Laura Koot,** News Presentation Editor; **John Racovali,** A.M.E.; **Kelly McParland,** Foreign Editor; **Jeff Wasserman,** Photo Editor

Breaking-news topics / Papal funeral and ascension

National Post
Toronto

Douglas Kelly, Editor in Chief; **Gayle Grin,** ME/ Presentation; **Stephan Meurice,** ME/News; **Laura Koot,** News Presentation Editor; **John Racovali,** A.M.E.; **Kelly McParland,** Foreign Editor; **Jeff Wasserman,** Photo Editor

Breaking-news topics / War on terrorism

The Irish Examiner
Cork, Ireland

Conor O'Donnell, Night Editor

Breaking-news topics / War on terrorism

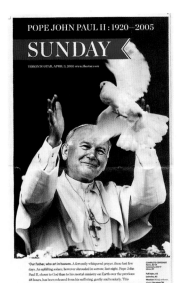

POPE JOHN PAUL II : 1920—2005

SUNDAY

TORONTO STAR, APRIL 3, 2005 www.thestar.com

'Our Father, who art in heaven.' A fervently whispered prayer, those last few days. An uplifting solace, forever shrouded in sorrow, last night. Pope John Paul II, closer to God than to his mortal ministry on Earth over the previous 48 hours, has been released from his suffering, gently and tenderly. This globe-trotting pontiff, who firmly kissed the soil of 129 countries over the course of a remarkable 26-year reign, embarked on his final journey at 9:37 p.m., Rome time, bound for what he firmly trusted would be a far, far better place.'

Rosie DiManno reports from Rome, page A3

Toronto Star

Devin Slater, Designer; **Carl Neustaedter,** A.M.E. Design; **Alison Uncles,** Sunday Editor

Breaking-news topics / Obituaries

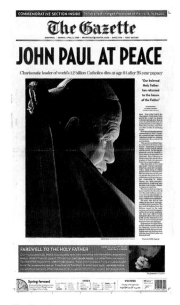

COMMEMORATIVE SECTION INSIDE | Polish priest changed the course of the world. 16 PAGES

The Gazette

JOHN PAUL AT PEACE

Charismatic leader of world's 1.2 billion Catholics dies at age 84 after 26-year papacy

'Our beloved Holy Father has returned to the house of the Father'

FAREWELL TO THE HOLY FATHER

Spring forward

The Gazette
Montreal

Jeanine Lee, Design Editor; **Katherine Sedgewick,** Assistant Managing Editor; **Lynn Farrell,** Photo Editor

Breaking-news topics / Obituaries

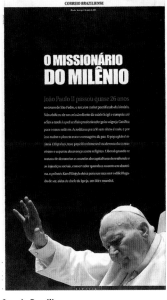

CORREIO BRAZILIENSE

O MISSIONÁRIO DO MILÊNIO

João Paulo II passou quase 26 anos

Correio Braziliense
Brasilia, Brazil

Josemar Giminez, Newsroom Director; **Ana Dubeux,** Editor in Chief; **Carlos Marcelo,** Executive Editor; **João Bosco Adelino de Almeida,** Art Director; **Luis Tajes,** Photo Editor; **Renato Ferraz,** Feature Editor

Breaking-news topics / Obituaries

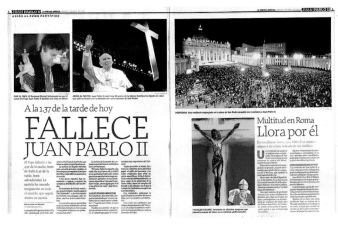

JUAN PABLO II

A la 1.37 de la tarde de hoy

FALLECE JUAN PABLO II

Multitud en Roma
Llora por él

La Prensa Gráfica
San Salvador, El Salvador

Enrique Contreras, Design Editor & Designer; **Héctor Ramírez,** Design Co-Editor; **Wilson Carranza,** Designer; **Esteban Rodas,** Designer; **Oscar Corvera,** Infographic Artist; **Magno Orellana,** Designer

Breaking-news topics / Obituaries

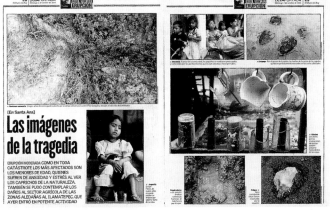

DE LA PORTADA | ERUPCIÓN

ERUPCIÓN | DE LA PORTADA

[En Santa Ana]
Las imágenes de la tragedia

ERUPCIÓN NOTICIADA COMO EN TODA CATÁSTROFE LOS MÁS AFECTADOS SON LOS MENORES DE EDAD, QUIENES SUFREN DE ANSIEDAD Y ESTRÉS AL VER LOS CAPRICHOS DE LA NATURALEZA. TAMBIÉN SE PUDO CONTEMPLAR LOS DAÑOS AL SECTOR AGRÍCOLA DE LAS ZONAS ALEDAÑAS AL ILAMATEPEC, QUE AYER ENTRÓ EN POTENTE ACTIVIDAD

El Diario de Hoy
San Salvador, El Salvador

Juan Durán, Art Director; **Teodoro Wilson Torres Lira,** Graphics Editor; **Jorge Castillo,** Infographics Editor; **José Santos,** Infographics Co-Editor; **Remberto Rodríguez,** Graphics Co-Editor; **Design Staff; Periodicals Staff; Photography Staff**

Breaking-news topics / Natural disasters

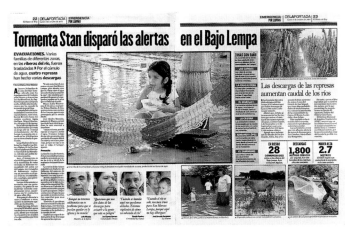

DE LA PORTADA | EMERGENCIA POR LLUVIAS

EMERGENCIA POR LLUVIAS | DE LA PORTADA

Tormenta Stan disparó las alertas en el Bajo Lempa

EVACUACIONES. Varias familias de diferentes zonas, en las riberas del río, fueron trasladadas ▶ Por el cúmulo de agua, cuatro represas han hecho varias descargas

Las descargas de las represas aumentan caudal de los ríos

EN RIESGO	DESCARGAS	MAREA ALTA
28	1,800	2.7

El Diario de Hoy
San Salvador, El Salvador

Juan Durán, Art Director & Designer; **Teodoro Wilson Torres Lira,** Graphics Editor; **Jorge Castillo,** Infographic Editor; **José Santos,** Infographic Co-Editor; **Remberto Rodríguez,** Graphic Co-Editor; **National Staff; Photo Staff**

Breaking-news topics / Natural disasters

HURACÁN ADRIÁN | DE LA PORTADA
ALERTA EN CENTROAMÉRICA

SAN MIGUEL | PELIGRO

CUIDADO ESPECIAL

Lluvias angustian a familias pobres

Sin recursos. En San Miguel **no hay fondos** para atender varios problemas ▶ El río Grande es una **grave amenaza**

Un tramo de bordas en mejor condición

El Diario de Hoy
San Salvador, El Salvador

Juan Durán, Art Director; **Teodoro Wilson Torres Lira,** Graphics Editor; **Jorge Castillo,** Infographics Editor; **José Santos,** Infographics Co-Editor; **Remberto Rodríguez,** Graphics Co-Editor; **Design Staff; Periodicals Staff; Photography Staff**

Breaking-news topics / Natural disasters

Sur
Malaga, Spain

Ma Dolores de la Vega, Section Designer; **Rafael Ruiz,** Designer; **Baldomero Villanueva,** Designer; **Fernando González,** Director of Photography; **Francisco Sánchez Ruano,** Art Director; **Alberto Torregrosa,** Editorial Design Consultant

Breaking-news topics / Editor's choice, national

The Washington Post

Beth Broadwater, Deputy News Editor/Design; **Seth Hamblin,** Graphics Editor; **Linda Davidson,** Photo Editor; **Ed Thiede,** A.M.E./News; **Jim Forrest,** Graphics Editor; **Dwuan June,** Assistant News Editor

Breaking-news topics / Editor's choice, local/regional

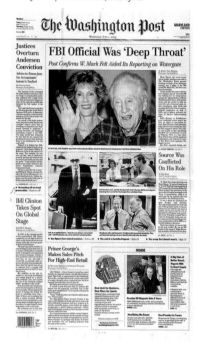

Orlando Sentinel
Fla.

Melissa Angle, Designer; **Red Huber,** Photographer; **Ken Lyons,** Picture Editor; **Cassie Armstrong,** Deputy Design Editor; **Stephen Komives,** Design Editor; **Bonita Burton,** A.M.E./Visuals

Breaking-news topics / Editor's choice, local/regional

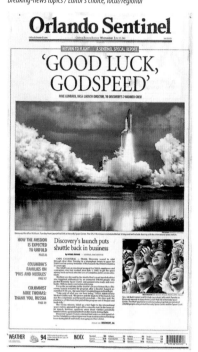

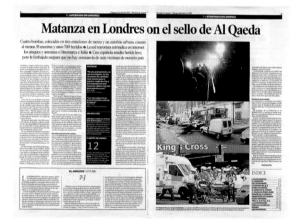

Heraldo de Aragón
Zaragoza, Spain

Pilar Ostalé, Designer; **Iban Santos,** Designer; **Ana Pérez,** Designer; **Kristina Urresti,** Designer; **Jorge Mora,** Designer

Breaking-news topics / Editor's choice, international

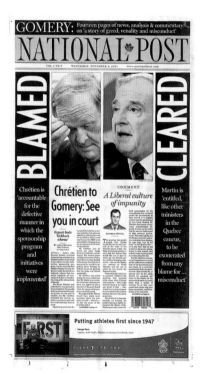

National Post
Toronto

Douglas Kelly, Editor in Chief; **Gayle Grin,** ME/Presentation; **Stephan Meurice,** ME/News; **Laura Koot,** News Presentation Editor; **John Racovali,** A.M.E.; **Kelly McParland,** Foreign Editor; **Jeff Wasserman,** Photo Editor

Breaking-news topics / Editor's choice, national

The San Diego Union-Tribune

Josh Penrod, Designer; **Jason Brown,** Designer; **Bruce Huff,** Photo Editor; **Sean M. Haffey,** Photographer; **K.C. Alfred,** Photographer; **John McCutchen,** Photographer

Breaking-news topics / Editor's choice, sports

[THE OSCARS]

'I am going to start by thanking my husband because I'd like to think I learned from past mistakes. Chad, you're my everything.'

HILARY SWANK, best actress winner, thanking Chad Lowe after forgetting him five years ago

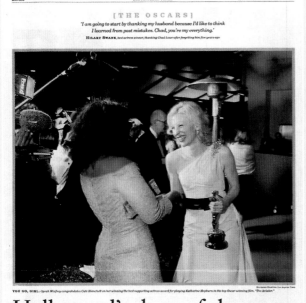

YOU GO, GIRL: Oprah Winfrey congratulates Cate Blanchett on her winning the best supporting actress award for playing Katharine Hepburn in the top Oscar-winning film, "The Aviator."

Hollywood's show of shows

Stars of the silver screen descended on Kodak Theatre for another glamorous night of honoring their own.

WHO DESIGNED YOUR GOWN?: Nominees Sophie Okonedo, left, and Imelda Staunton chat before the show.

QUARTET: Scarlett Johansson introduces the act back to winners.

WHERE TO NEXT?: A dapper Orlando Bloom is escorted down the red carpet outside the Kodak Theatre in Hollywood.

SILVER

Los Angeles Times

Kelli Sullivan, Deputy Design Director; **Wesley Bausmith,** Deputy Design Director; **Pete Metzger,** Design Editor; **Kirk Christ,** Design Editor; **Jan Molen,** Design Editor; **Judy Pryor,** Design Editor; **Tim Hubbard,** Design Editor; **Christian Potter Drury,** Features Design Director; **Joseph Hutchinson,** Creative Director; **Photography/Photo Editing Staff**

Breaking-news topics / Editor's choice, national

The Los Angeles Times coverage of the Academy Awards is a pretty remarkable piece of work, especially since it was on deadline. Not only were photographers and photo editors working together, but also copy editors and designers — the entire team. Each page plays off another. Each cutline connects with the essence of its photo. The mission was clear and well executed.

La cobertura de The Los Angeles Times sobre la entrega de premios de cine es una obra sorprendente, especialmente dado que fue hecha bajo la presión del cierre. No solo trabajaron juntos los editores fotográficos y los fotógrafos, sino también los editores de redacción y diseñadores; el equipo completo. Cada página está entrelazada con la siguiente. Cada lectura de foto se conecta con lo esencial de su foto. El objetivo quedó claro y bien ejecutado.

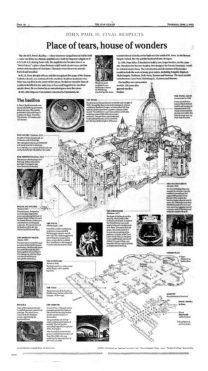

JOHN PAUL II: FINAL RESPECTS

Place of tears, house of wonders

The Star-Ledger
Newark, N.J.

Andre Malok, Graphic Artist; **George Frederick,** Deputy Design Director

Special news topics / Papal funeral and ascension

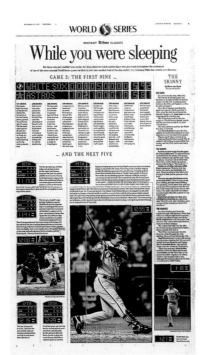

WORLD SERIES

INSTANT TRIBUNE CLASSIC

While you were sleeping

GAME 3: THE FIRST NINE ...

... AND THE NEXT FIVE

Chicago Tribune
Staff

Breaking-news topics / Editor's choice, sports

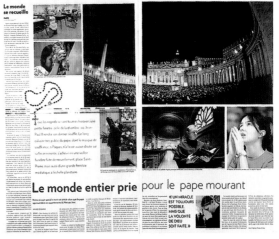

Le monde se recueille

Le monde entier prie pour le pape mourant

La Presse
Montréal

Benoit Giguere, Art Director; **Michele Ouimet,** A.M.E./News; **Alain-Pierre Hovasse,** Photo Director; **Eric Trottier,** M.E.; **Staff Designer; Staff Photographer**

Special news topics / Obituaries

San Francisco Chronicle

Nanette Bisher, Creative Director; **Frank Mina,** Art Director; **Dorothy Yule,** Deputy Art Director; **Ed Rachles,** Designer; **Erik Ninomiya,** News Editor; **John Blanchard,** Graphic Artist; **Gail Bensinger,** Foreign Editor; **John Curley,** DME/News; **James Merithew,** Photo Editor

Special news topics / Obituaries

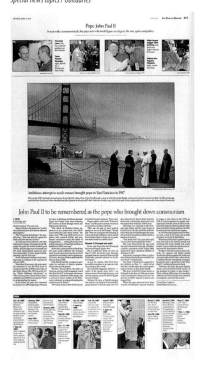

The Virginian-Pilot
Norfolk

Jim Haag, Designer; **Robert Suhay,** Designer; **Paul Nelson,** News Editor/Design Team Leader; **Martin Smith-Rodden,** Photo Editor; **Norm Shafer,** Photo Editor; **Alex C. Burrows,** Director of Photography; **John Earle,** Graphic Artist; **Charles Apple,** Graphic Director; **Deborah Withey,** Deputy M.E. Presentation

Special news topics / Natural disasters

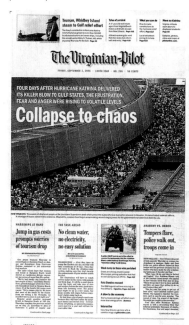

Dagens Nyheter
Stockholm, Sweden

Jenny Herrström-Gemzell, Art Director; **Pär Bjorkman,** Photo Editor; **Maria Muldt,** Page Designer

Special news topics / Natural disasters

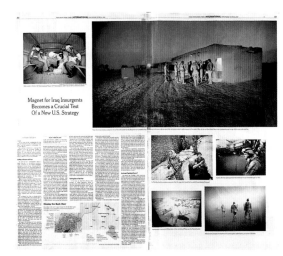

The New York Times
Staff

Special news topics / War on terrorism

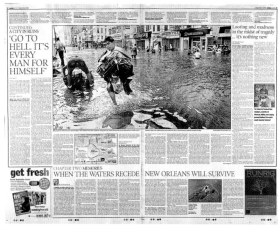

Sunday Herald
Glasgow, Scotland

Richard Walker, Editor; **Roxanne Sorooshian,** Production Editor; **Elaine Livingstone,** Picture Editor; **Staff**

Special news topics / Natural disasters

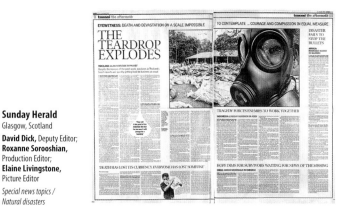

Sunday Herald
Glasgow, Scotland

David Dick, Deputy Editor;
Roxanne Sorooshian,
Production Editor;
Elaine Livingstone,
Picture Editor

*Special news topics /
Natural disasters*

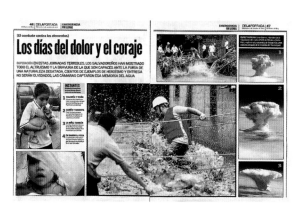

El Diario de Hoy
San Salvador, El Salvador

Juan Durán, Art Director; **Teodoro Wilson Torres Lira,** Graphics Editor; **Jorge Castillo,** Infographic Editor; **José Santos,** Infographic Co-Editor; **Remberto Rodríguez,** Graphics Co-Editor; **Design Staff; Periodicals Staff; Photography Staff**

Special news topics / Natural disasters

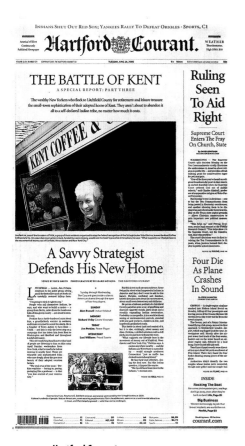

THE BATTLE OF KENT
A SPECIAL REPORT: PART THREE

The wealthy New Yorkers who flock to Litchfield County for retirement and leisure treasure the small-town sophistication of their adopted home of Kent. They aren't about to abandon it all to a self-declared Indian tribe, no matter how much it costs.

Ruling Seen To Aid Right

Supreme Court Enters The Fray On Church, State

A Savvy Strategist Defends His New Home

Four Die As Plane Crashes In Sound

Hartford Courant
Conn.

Greg Harmel, Designer; **Suzette Moyer,** Director/Design & Graphics; **Richard Messina,** Photographer; **Jim Kuykendall,** Artist; **Allison Corbett,** Photo Editor; **John Scanlan,** Director/Photography; **Thom McGuire,** A.M.E. Graphics/Photography

Special news topics / Editor's choice, local/regional

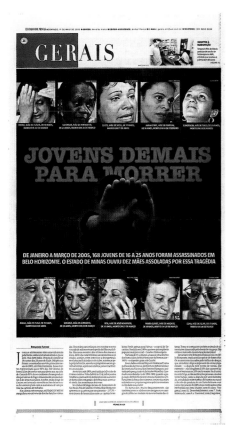

GERAIS

JOVENS DEMAIS PARA MORRER

DE JANEIRO A MARÇO DE 2005, 168 JOVENS DE 16 A 25 ANOS FORAM ASSASSINADOS EM BELO HORIZONTE. O ESTADO DE MINAS OUVIU DEZ MÃES ASSOLADAS POR ESSA TRAGÉDIA

Estado de Minas
Belo Horizonte, Brazil

Júlio Moreira, Designer; **Marcos Michelin,** Photographer; **Euler Júnior,** Photographer; **Beto Magalhães,** Photographer; **Paulo Filgueiras,** Photographer; **Marcelo Santanna,** Photographer

Special news topics / Editor's choice, local/regional

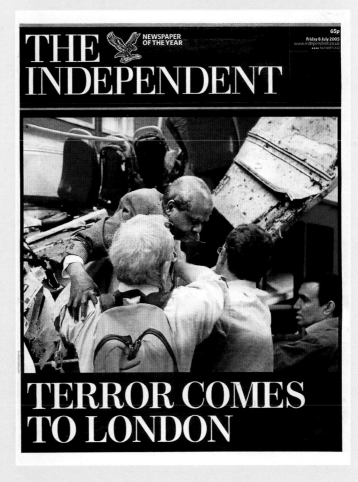

Dozens die in worst attack since Second World War

THE INDEPENDENT

65p
Friday 8 July 2005
www.independent.co.uk

NEWSPAPER OF THE YEAR

TERROR COMES TO LONDON

SILVER

The Independent
London

Kevin Bayliss, Art Director; **Ian Birrell,** Deputy Editor; **John Mullin,** Executive News Editor; **Kristina Ferris,** Graphics Editor

Breaking-news topics / Editor's choice, national

The Independent's coverage of the London transit bombings is the picture of consistency — consistency across 30 pages — produced when the city and the newsroom were in chaos. The pages are very, very well structured, with great pacing. The breakouts and small bites are done perfectly. Great care is taken to tell every part of the story.

La cobertura de The Independent' de los atentados al transporte público de Londres es la imagen de la consistencia –la que se da a lo largo de 30 páginas–, producida cuando toda la ciudad y el personal del diario estaban sumidos en el caos. Estas páginas están muy, muy bien estructuradas, con un favorable ritmo. Los despieces y las pequeñas notas están realizas a la perfección. Se ha tomado mucho cuidado en relatar cada parte de la historia.

The New York Times
Staff

Special news topics / Editor's choice, national

The New York Times
Staff

Special news topics / Editor's choice, national

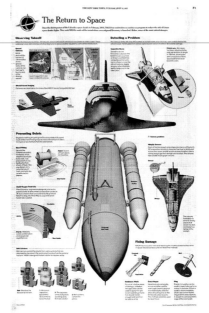

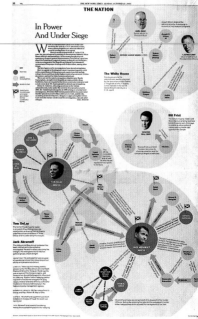

Östgöta Correspondenten
Linköping, Sweden

Åke Alvin, Page Designer; **Annelie Boström,** Page Designer

Special news topics / Editor's choice, local/regional

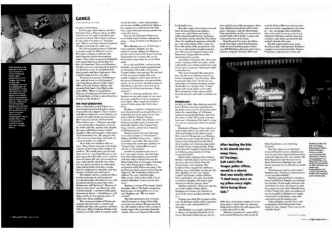

High Country News
Paonia, Colo.

Cindy Wehling, Art Director & Designer; **JT Thomas,** Photographer; **Greg Hanscom,** Editor;
Paul Larmer, Executive Editor

Special news topics / Editor's choice, local/regional

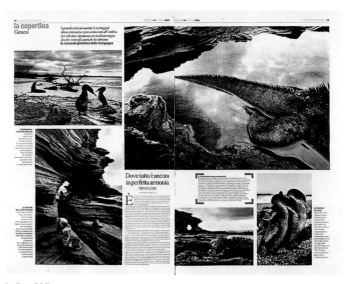

La Repubblica
Rome

Angelo Rinaldi, Art Director; **Silvia Rossi,** Graphic Designer; **Stefano Cipolla,** Graphic Designer;
Isabella Maoloni, Graphic Designer; **Sebastiao Salgado,** Photographer

Special news topics / Editor's choice, international

La Prensa Gráfica

TODOS CONTRA LA VIOLENCIA

Este problema social abate cada día a los salvadoreños. Las víctimas se cuentan por cientos. La solución está en manos de las autoridades y en cada ciudadano de esta nación.

SILVER

La Prensa Gráfica
San Salvador, El Salvador

Enrique Contreras, Design Editor & Designer; **Héctor Ramírez,** Design Co-Editor & Designer; **Esteban Rodas,** Designer; **Mauricio Santamaría,** Designer; **Ricardo Quezada,** Designer; **Francisco Campos,** Photo Editor

Special news topics / Editor's choice, national

The use of typography and white space was really striking. The presentation drives you through every page, and every page has its own identity. This subject has so much you can't photograph, so the staff took a measured approach, with considerable contrast and confidence, but without statistical overload. The absolute power of black and white — the new color. It's one of the strongest packages we've seen.

El uso de la tipografía y el espacio en blanco son muy llamativos. La presentación conduce al lector por cada página, y cada una tiene su propia identidad. Este tema contiene mucho que no puede ser fotografiado, por lo que el personal del diario tomó un enfoque mesurado, con considerable contraste y confianza, pero sin sobrecargar las estadísticas. El absoluto poder del blanco y negro; el nuevo color. Es uno de los paquetes informativos más poderosos que se vio en la competencia.

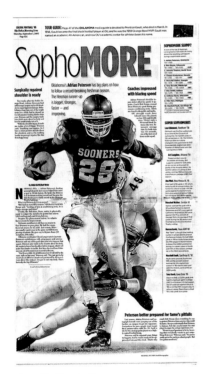

The Dallas Morning News

Jason Dugger, Sports Designer; **Rob Schneider,** Design Editor/ Sports; **Chris Velez,** Sports Graphic Artist; **Damon Marx,** Sports Designer; **Michael Mulvey,** Photographer; **Michael Hogue,** Illustrator; **Michael Hamtil,** Photo Editor; **Mark Konradi,** Assistant Sports Editor; **Noel Nash,** Assistant Sports Editor; **Garry Leavell,** Sports Editor

Special news topics / Editor's choice, sports

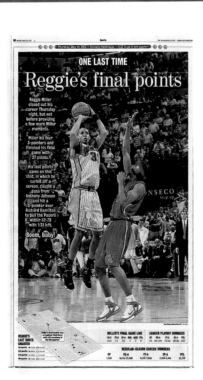

The Indianapolis Star

Scott Goldman, A.M.E./Visuals; **Phil Mahoney,** Sports Designer; **Tim Ball,** News Design Director; **Epha Riche,** News Design Director; **Robert Dorrell,** Graphics Editor; **Greg Nichols,** Graphic Artist; **Mike Fender,** Director of Photography; **Design Staff; Photo Staff; Graphics Staff**

Special news topics / Editor's choice, sports

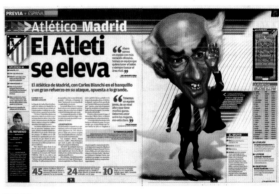

El Gráfico
Antiguo Cuscatlán, El Salvador

Alexander Rivera, Designer; **Cristian Villalta,** Editor; **Graphics Editor; Juan José,** Illustrator

Special news topics / Editor's choice, sports

El Gráfico
Antiguo Cuscatlán, El Salvador

Agustín Palacios,
Design Coordinator;
José Jaén, Designer;
Alexander Rivera, Designer;
Gabriel Orellana, Designer;
Cristian Villalta, Editor;
Agencias Redactor;
Juan José, Illustrator

Special news topics /
Editor's choice, sports

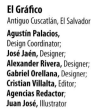

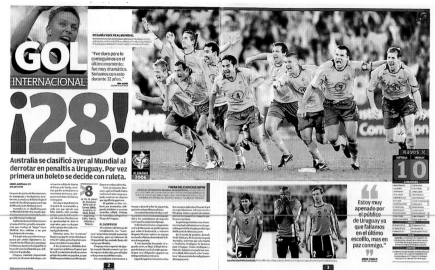

GOL
INTERNACIONAL
¡28!

Australia se clasificó ayer al Mundial al derrotar en penaltis a Uruguay. Por vez primera un boleto se decide con ruleta.

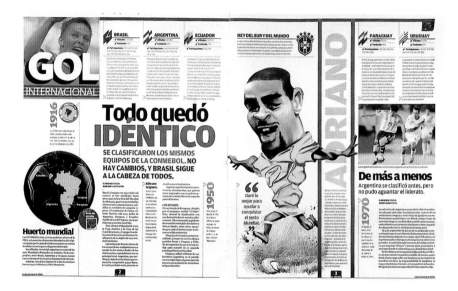

El Gráfico
Antiguo Cuscatlán, El Salvador

Agustín Palacios,
Design Coordinator;
José Jaén, Designer;
Alexander Rivera, Designer;
Cristian Villaltta, Editor;
Juan José, Illustrator;
Graphics Staff

Special news topics /
Editor's choice, sports

GOL
INTERNACIONAL

Todo quedó IDÉNTICO

SE CLASIFICARON LOS MISMOS EQUIPOS DE LA CONMEBOL. NO HAY CAMBIOS, Y BRASIL SIGUE A LA CABEZA DE TODOS.

Huerto mundial

De más a menos
Argentina se clasificó antes, pero no pudo aguantar el liderato.

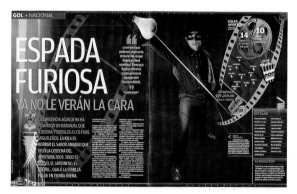

ESPADA FURIOSA
YA NO LE VERÁN LA CARA

El Gráfico
Antiguo Cuscatlán, El Salvador

Agustín Palacios, Design Coordinator; **José Jaén,** Designer; **Cristian Villalta,** Editor;
Francisco Belloso, Photographer; **Staff**

Special news topics / Editor's choice, sports

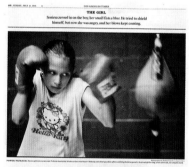

THE GIRL

An Early Passion for Boxing

The Only Girl in the Place

Los Angeles Times
Michael Whitley, Deputy Design Director; **Anne Cusack,**
Photographer; **Robert St. John,** Photo Editor; **Colin Crawford,**
A.M.E./Photo; **Kurt Streeter,** Writer; **David Bowman,**
Copy Editor; **Rick Meyer,** Editor

Special news topics / Editor's choice, sports

Our human bracket is down to 16. These *crazy Carolinians* can taste the...

SWEETNESS

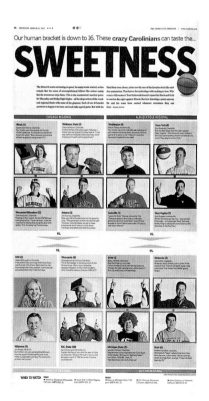

The Charlotte Observer
N.C.

Staff

Special news topics / Editor's choice, sports

Features & Magazines

5

Ming Pao Daily News
Hong Kong

Feature Desk; Art Team

Feature design, sections / Lifestyle / 50,000-174,999

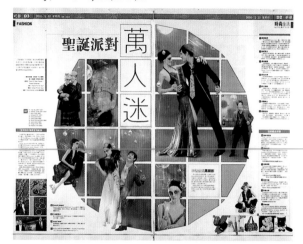

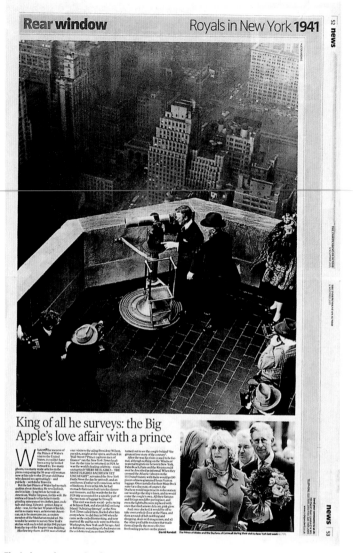

King of all he surveys: the Big Apple's love affair with a prince

The Independent on Sunday
London

Tristan Davies, Editor in Chief; **Victor Gil,** Art Director; **Sarah Morley,** Deputy Art Director;
Sophie Batterbury, Picture Editor; **Keith Howitt,** Production Editor

Feature design, sections / Opinion / 175,000 and over

A DIFFERENT CRUSADE: AFRICA NEEDS MORE THAN EUROPEAN PLATITUDES

Sunday Herald
Glasgow, Scotland

Roxanne Sorooshian, Production Editor; **Richard Walker,** Editor;
David Dick, Deputy Editor; **Staff**

Feature design, sections / Opinion / 50,000-174,999

my fabulous year

The Independent on Sunday
London

Tristan Davies, Editor in Chief; **Victor Gil,** Art Director;
Sarah Morley, Deputy Art Director; **Sophie Batterbury,** Picture
Editor; **Keith Howitt,** Production Editor

Feature design, sections / Entertainment / 175,000 and over

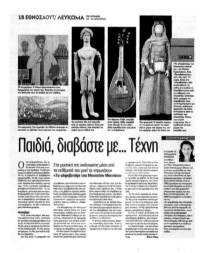

Παιδιά, διαβάστε με... Τέχνη

Ethnos Tis Kiriakis
Athens, Greece

Valentina Villegas-Nika, Design Consultant; **Antonis Prekas,**
Chief Culture Editor; **Nikos Veletakos,** Copy Editor;
Mary Papakosta, Layouter

Feature design, sections / Entertainment / 50,000-174,999

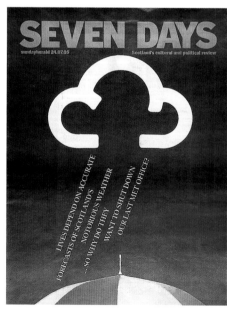

SEVEN DAYS

Sunday Herald
Glasgow, Scotland

Roxanne Sorooshian, Production Editor; **Richard Walker,**
Editor; **David Dick,** Deputy Editor; **Staff**

Feature design, sections / Opinion / 50,000-174,999

O Estado de São Paulo
São Paulo, Brazil

Sandro Vaia, Newsroom Director; **Flavio Pinheiro,** Editor in Chief;
Fabio Sales, Art Director & Designer; **Ilan Kow,** Editor;
Luiz Americo Camargo, Assistant Editor; **Miguel Icassatti,** Assistant Editor;
Maria Suely Andreazzi, Designer; **Wilson Pedrosa,** Photo Editor;
Cases I Associats, Design Consultant

Feature design, sections / Food / 175,000 and over

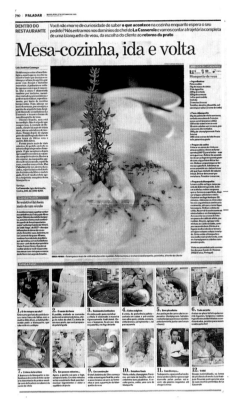

Sunday Morning Post
Hong Kong

Troy Dunkley, Features Art Director

Feature design, sections / Entertainment / 50,000-174,999

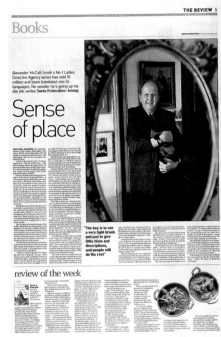

The Guardian
London

Sarah Harershon, Art Director

Feature design, sections / Travel / 175,000 and over

South China Morning Post
Hong Kong

Solveig Bang, Page Designer; **Michael Logan,** Technology Editor;
Wilson Tsang, Cartoonist; **James Whittle,** Graphic Designer

Feature design, sections / Science, technology / 50,000-174,999

Berliner MorgenPost
Berlin

Ralf Jacob, Page Designer; **Barbara Krämer,** Page Designer; **Jan Draeger,** Editor;
Sandra Garbers, Editor

Feature design, sections / Other / 175,000 and over

Der Tagesspiegel
Berlin

Ursula Dahmen, Art Director; **Norbert Thomma,** Editor

Feature design, sections / Other / 50,000-174,999

The Naftermporiki
Athens, Greece

Valentina Villegas-Nika, Design Consultant; **Katerina Anesti,** Chief Arts Editor; **Afroditi Xipolitidou,** Copy Editor/Page Designer; **Dimitra Kamdila,** Layouter; **Poly Mery,** Layouter

Feature design, sections / Other / 49,999 and under

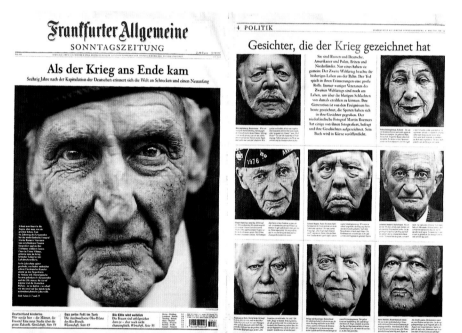

Frankfurter Allgemeine Sonntagszeitung
Frankfurt am Main, Germany

Peter Breul, Art Director & Designer; **Andreas Kuther,** Picture Editor; **Thomas Schmid,** Politics Editor; **Martin Roemers,** Photographer

Feature design, page(s) / Opinion / 175,000 and over

The Boston Globe

Gregory Klee, Designer; **James Turner,** Illustrator; **Jennifer Schuessler,** Editor; **Dan Zedek,** Design Director

Feature design, page(s) / Opinion / 175,000 and over

Público
Lisbon, Portugal

Hugo Pinto, Designer; **Vasco Câmara,** Editor; **José Manuel Fernandes,** Newspaper Director

Feature design, page(s) / Entertainment / 50,000-174,999

Zaman
Yenibosna, Turkey

Fevzi Yazici, Art Director; **Ekrem Dumanli,** Editor in Chief; **Mustafa Saglam,** Design Director; **Babur Boysal,** Designer; **Cem Kiziltug,** Illustrator; **Ahmet Ayhan,** Editor

Feature design, page(s) / Opinion / 175,000 and over

Zaman
Yenibosna, Turkey

Fevzi Yazici, Art Director; **Ekrem Dumanli,** Editor in Chief; **Mustafa Saglam,** Design Director; **Yasemin Alay,** Designer; **Ahmet Ayhan,** Editor

Feature design, page(s) / Opinion / 175,000 and over

Zaman
Yenibosna, Turkey

Fevzi Yazici, Art Director; **Ekrem Dumanli,** Editor in Chief; **Mustafa Saglam,** Design Director; **Yasemin Alay,** Designer; **Cem Kiziltug,** Illustrator; **Ahmet Ayhan,** Editor

Feature design, page(s) / Opinion / 175,000 and over

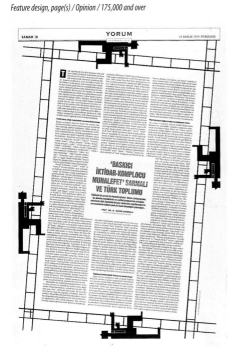

Calgary Herald
Alberta, Canada

Kathryn Molcak, Graphic Designer; **Alan Rach,** Observer Editor; **Janet Matiisen,** Assistant News Editor-Design

Feature design, page(s) / Opinion / 50,000-174,999

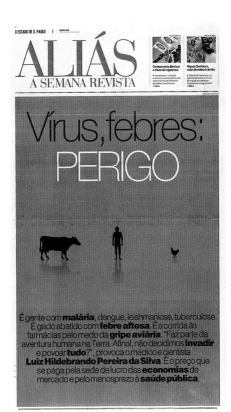

O Estado de São Paulo
São Paulo, Brazil

Sandro Vaia, Newsroom Director; **Flavio Pinheiro,** Editor in Chief; **Fabio Sales,** Art Director & Designer; **Maria Isabel G.A. Campos,** Designer; **Laura Greenhalg,** Editor

Feature design, page(s) / Opinion / 175,000 and over

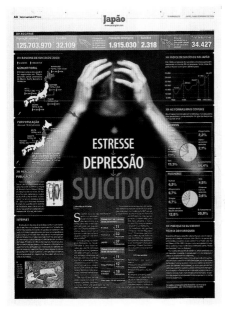

International Press Portuguese Edition
Tokyo

Julio Kohji Shiiki, Art Editor & Designer; **Roger Hiyane Yzena,** Designer

Feature design, page(s) / Opinion / 50,000-174,999

The Times of Northwest Indiana
Munster

Mike Rich, Features Designer

Feature design, page(s) / Lifestyle / 50,000-174,999

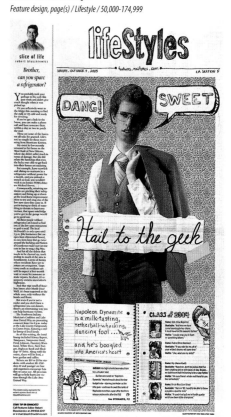

International Press Portuguese Edition
Tokyo

Julio Kohji Shiiki, Art Editor & Designer;
Roger Hiyane Yzena, Designer

Feature design, page(s) / Opinion / 50,000-174,999

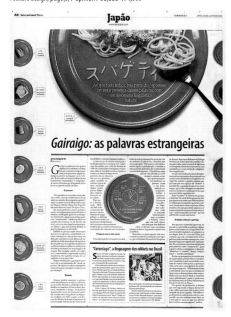

International Press Spanish Edition
Tokyo

Julio Kohji Shiiki, Art Editor & Designer;
Roger Hiyane Yzena, Designer

Feature design, page(s) / Opinion / 49,999 and under

Politiken
Copenhagen, Denmark

Søren Nyeland, Design
Editor; **Tomas Østergren,**
Page Designer; **Kjeld Hybel,**
Editor; **Bo Søndergard,**
Copy Editor; **Finn Frandsen,**
Photographer

*Feature design, page(s) /
Lifestyle / 50,000-174,999*

Politiken
Copenhagen, Denmark

Søren Nyeland, Design
Editor; **Peter Sætternissen,**
Page Designer;
Christian Ilsøe, Culture
News Editor

*Feature design, page(s) /
Lifestyle / 50,000-174,999*

Sydsvenskan
Malmö, Sweden

Jenny Rydqvist, Page Designer; **Peter Frennesson,** Photographer

Feature design, page(s) / Lifestyle / 50,000-174,999

La Presse
Montréal

Benoit Giguere, Art Director; **Andre Rivest,** Designer; **Michele Ouimet,** AME/Lifestyle; **Marie-Claude Lortie,** Lifestyle Editor; **Mc Gilles,** Journalist; **François Roy,** Photographer; **Alain-Pierre Hovasse,** Photo Director

Feature design, page(s) / Lifestyle / 175,000 and over

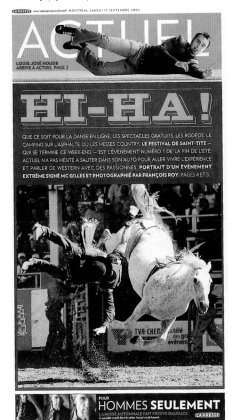

La Presse
Montréal

Benoit Giguere, Art Director; **Alexandre Roy,** Designer; **Michele Ouimet,** AME/Lifestyle; **Marie-Claude Lortie,** Lifestyle Editor; **Mc Gilles,** Journalist; **Bernard Brault,** Photographer

Feature design, page(s) / Lifestyle / 175,000 and over

Dagens Nyheter
Stockholm, Sweden

Jenny Herrström-Gemzell, Art Director; **Beatrice Lundborg,** Photographer; **Britt-Marie Schrammel,** Photo Editor

Feature design, page(s) / Lifestyle / 175,000 and over

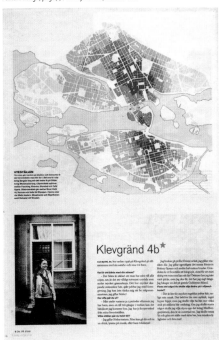

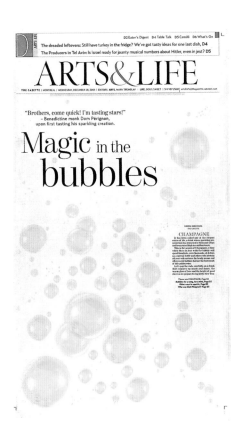

The Gazette
Montreal

Marie A. Cuffaro, Design Editor; **Nuri Ducassi,** Design Director; **Doug Sweet,** Lifestyles Editor

Feature design, page(s) / Lifestyle / 50,000-174,999

South Florida Sun-Sentinel
Fort Lauderdale

Angela Brennan, Designer; **Tim Frank,** DME of Visuals; **Tom Peyton,** Visual Editor

Feature design, page(s) / Lifestyle / 175,000 and over

The Tampa Tribune
Fla.

Kiely Agliano, Team Leader for Feature Design

Feature design, page(s) / Lifestyle / 175,000 and over

SÖNDAG.
UPPDRAG: MAN

Dagens Nyheter
Stockholm, Sweden

Beatrice Hellman, Art Director;
Jesper Waldersten, Illustrator

*Feature design, page(s) / Lifestyle /
175,000 and over*

Dagens Nyheter
Stockholm, Sweden

Beatrice Hellman, Art Director; **Anneli Steen,** Page Designer; **Pär Björkman,**
Photo Editor; **Paul Hausen,** Photographer

Feature design, page(s) / Lifestyle / 175,000 and over

**ETT PALESTINA
PÅ HÖJDEN**

Kolsyrefabriken

Dagens Nyheter
Stockholm, Sweden

Jenny Herrström Gemzell, Art
Director; **Linus Meyer,** Photographer;
Britt-Marie Schrammel, Photo Editor

*Feature design, page(s) / Lifestyle /
175,000 and over*

St. Petersburg Times
Fla.

Ellen E. Freiberg, Features Designer;
James Borchuck, Photographer; **Patty Yablonski,**
Photo Editor

Feature design, page(s) / Lifestyle / 175,000 and over

**The beauty
of the belly**

The Gazette
Montreal

Susan Ferguson, Design Editor; **Nuri Ducassi,**
Design Director; **Evangeline Sadler,** Weekend Life
Editor; **Tim Snow,** Photographer

Feature design, page(s) / Lifestyle / 50,000-174,999

THE WAY OF ALL FLESH

A Sweet Tooth Cut In My Crib, And Long Enough To Trip Over

Hartford Courant
Conn.

Jen Rochette, Designer; **Beth Bristow,** Photo Editor;
Suzette Moyer, Director/Design & Graphics

Feature design, page(s) / Lifestyle / 175,000 and over

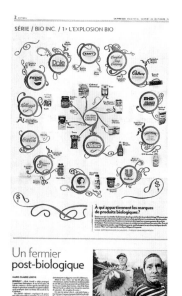

SÉRIE : BIO INC. / 1> L'EXPLOSION BIO

Un fermier
post-biologique

La Presse
Montréal

Benoit Giguere, Art Director; **David Lambert,**
Designer; **Michele Ouimet,** A.M.E./Lifestyle;
Marie-Claude Lortie, Lifestyle Editor

Feature design, page(s) / Lifestyle / 175,000 and over

Fort Worth Star-Telegram
Texas

Monique Miller, Designer; **Jill Johnson,** Photographer;
Andrew Marton, Reporter; **John McAlley,** Arts Editor

Feature design, page(s) / Lifestyle / 175,000 and over

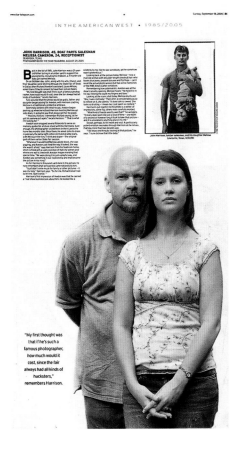

Fort Worth Star-Telegram
Texas

Monique Miller, Designer; **Mark Hoffer,** Designer

Feature design, page(s) / Lifestyle / 175,000 and over

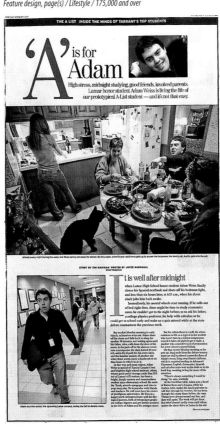

Dagens Nyheter
Stockholm, Sweden

Johan Ruthherhagen, Art Director; **Sara Hernández,** Illustrator;
Malin Hellberg, Photographer; **Britt-Marie Schrammel,** Photo Editor

Feature design, page(s) / Lifestyle / 175,000 and over

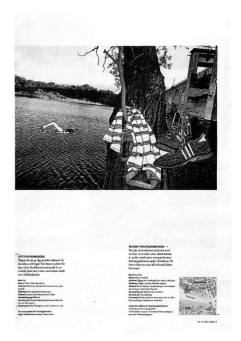

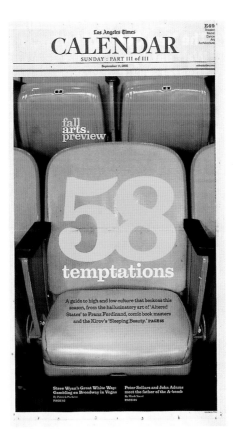

San Jose Mercury News
Calif.

Stephanie Grace Lim, Features Design Director

Feature design, page(s) / Lifestyle / 175,000 and over

Los Angeles Times

Steven E. Banks, Designer

Feature design, page(s) / Lifestyle / 175,000 and over

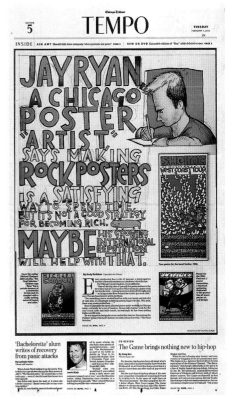

Chicago Tribune

Tom Heinz, Designer; **Jay Ryan,** Illustrator; **Lilah Lohr,** Editor

Feature design, page(s) / Lifestyle / 175,000 and over

Público
Lisbon, Portugal

Jorge Guimaraes, Designer; **Nuno Ferreira Santos,**
Photographer; **Isabel Coutinho,** Editor;
José Manuel Fernandes, Newspaper Director

Feature design, page(s) / Entertainment / 50,000-174,999

Star Tribune
Minneapolis

Tippi Thole, Designer/Photographer; **Lisa Clausen,** Design Director/Features

Feature design, page(s) / Lifestyle / 175,000 and over

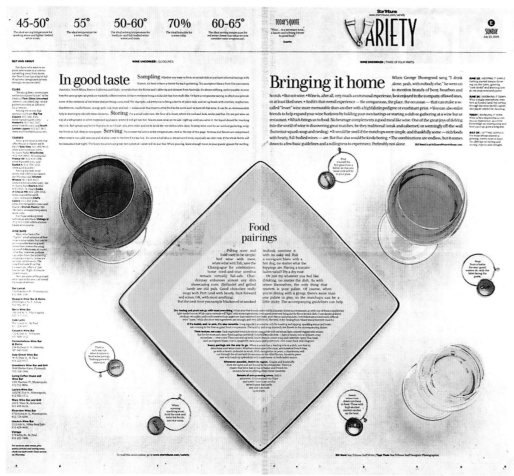

Dayton Daily News
Ohio

Randy Palmer, Designer; **Alexis Larsen,** Editor

Feature design, page(s) / Entertainment / 50,000-174,999

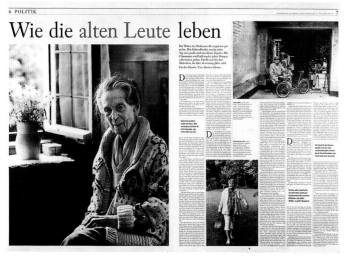

Frankfurter Allgemeine Sonntagszeitung
Frankfurt am Main, Germany

Peter Breul, Art Director & Designer; **Andreas Kuther,** Picture Editor; **Iris Hanika,** Writer;
Barbara Klemm, Photographer

Feature design, page(s) / Lifestyle / 175,000 and over

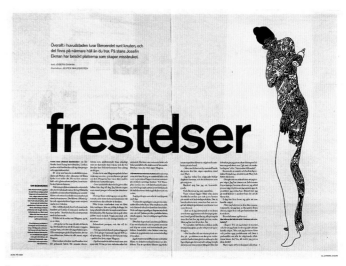

Dagens Nyheter
Stockholm, Sweden

Johan Rutherhagen, Art Director; **Jesper Waldersten,** Illustrator

Feature design, page(s) / Lifestyle / 175,000 and over

La Gaceta
San Miguel de Tucumán, Argentina
Daniel Fontanarrosa, Designer; **Sergio Fernandez,** Art Director
Feature design, page(s) / Entertainment / 50,000-174,999

Akzia
Moscow
Tatiana Sokolova, Art Director; **Svetlana Maximchenko,**
Editor in Chief; **Georgy Birger,** Entertainment Editor;
Alla Gorobets, Illustrator
Feature design, page(s) / Entertainment / 50,000-174,999

Público
Lisbon, Portugal
Jorge Guimarães, Designer; **Luis Pedro Nunes,** Editor;
José Manuel Fernandes, Newspaper Director
Feature design, page(s) / Entertainment / 50,000-174,999

La Gaceta
San Miguel de Tucumán, Argentina
Daniel Fontanarrosa, Designer; **Sergio Fernandez,** Art Director
Feature design, page(s) / Entertainment / 50,000-174,999

Público
Lisbon, Portugal
Hugo Pinto, Designer; **Vasco Câmara,**
Editor; **José Manuel Fernandes,**
Newspaper Director
*Feature design, page(s) / Entertainment /
50,000-174,999*

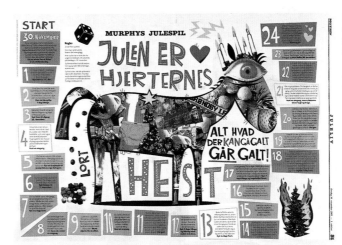

Politiken
Copenhagen, Denmark
Søren Nyeland, Editor of Design;
Claus Nørregard, Artist; **Henrik Palle,**
Editor; **Charlotte Jensen,** Editor
*Feature design, page(s) / Entertainment /
50,000-174,999*

San Francisco Chronicle
Matt Petty, Art Director; **Margaret Kilgallen,** Artist; **Joe Brown,** Pink Editor;
Nanette Bisher, Creative Director
Feature design, page(s) / Entertainment / 175,000 and over

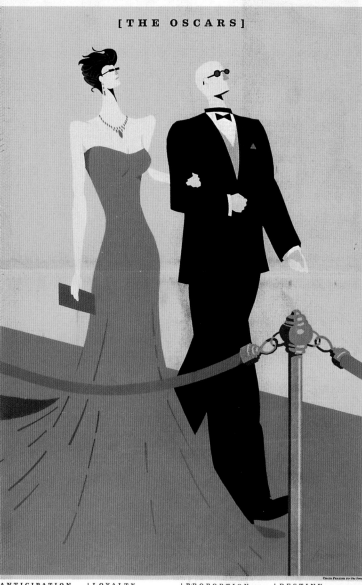

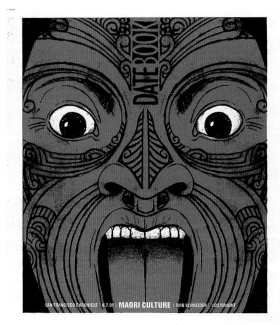

San Francisco Chronicle
Matt Petty, Art Director; **Edel Rodriguez,** Illustrator; **Joe Brown,** Pink Editor;
Nanette Bisher, Creative Director
Feature design, page(s) / Entertainment / 175,000 and over

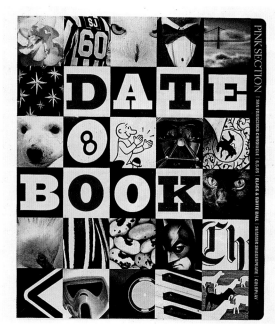

San Francisco Chronicle
Matt Petty, Art Director; **Joe Brown,** Pink Editor; **Nanette Bisher,** Creative Director
Feature design, page(s) / Entertainment / 175,000 and over

Hartford Courant
Conn.
Nicole Dudka, Designer/Illustrator; **Suzette Moyer,**
Design & Graphics Editor
Feature design, page(s) / Entertainment / 175,000 and over

Hartford Courant
Conn.
Nicole Dudka, Designer/Illustrator; **Suzette Moyer,**
Design & Graphics Editor
Feature design, page(s) / Entertainment / 175,000 and over

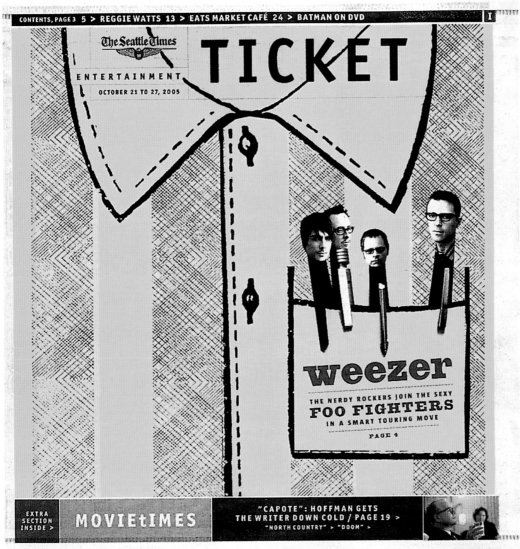

The Seattle Times
Erin Jang, Designer/Illustrator

*Feature design, page(s) / Entertainment /
175,000 and over*

The Sacramento Bee
Calif.

Margaret Spengler, Designer; **Val B. Mina,** Design
Director; **Barbara Stubbs,** Assistant Design Director;
Pam Dinsmore, A.M.E. Features/Design

Feature design, page(s) / Entertainment / 175,000 and over

Público
Lisbon, Portugal

Hugo Pinto, Designer; **Vasco Câmara,** Editor;
José Manuel Fernandes, Newspaper Director

Feature design, page(s) / Entertainment / 50,000-174,999

Público
Lisbon, Portugal

Hugo Pinto, Designer; **Vasco Câmara,** Editor;
José Manuel Fernandes, Newspaper Director

Feature design, page(s) / Entertainment / 50,000-174,999

Público
Lisbon, Portugal

Hugo Pinto, Designer; **Vasco Câmara,** Editor;
José Manuel Fernandes, Newspaper Director

Feature design, page(s) / Entertainment / 50,000-174,999

Público
Lisbon, Portugal

Hugo Pinto, Designer; **Vasco Câmara,** Editor;
José Manuel Fernandes, Newspaper Director

Feature design, page(s) / Entertainment / 50,000-174,999

Público
Lisbon, Portugal

Hugo Pinto, Designer; **Vasco Câmara,** Editor;
José Manuel Fernandes, Newspaper Director

Feature design, page(s) / Entertainment / 50,000-174,999

Público
Lisbon, Portugal

Hugo Pinto, Designer; **Vasco Câmara,** Editor;
José Manuel Fernandes, Newspaper Director

Feature design, page(s) / Entertainment / 50,000-174,999

Público
Lisbon, Portugal

Hugo Pinto, Designer; **Vasco Câmara,** Editor;
José Manuel Fernandes, Newspaper Director

Feature design, page(s) / Entertainment / 50,000-174,999

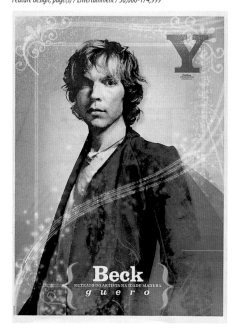

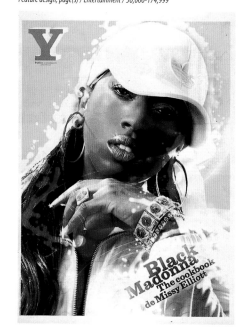

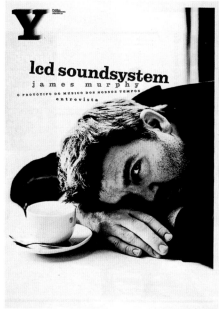

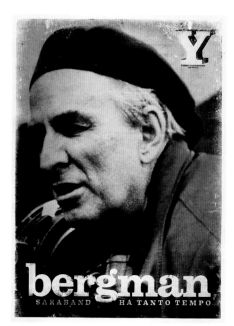

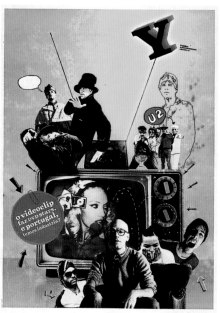

Público
Lisbon, Portugal

Hugo Pinto, Designer; **Vasco Câmara,** Editor;
José Manuel Fernandes, Newspaper Director

Feature design, page(s) / Entertainment / 50,000-174,999

Público
Lisbon, Portugal

Hugo Pinto, Designer; **Vasco Câmara,** Editor;
José Manuel Fernandes, Newspaper Director

Feature design, page(s) / Entertainment / 50,000-174,999

Público
Lisbon, Portugal

Hugo Pinto, Designer; **Vasco Câmara,** Editor;
José Manuel Fernandes, Newspaper Director

Feature design, page(s) / Entertainment / 50,000-174,999

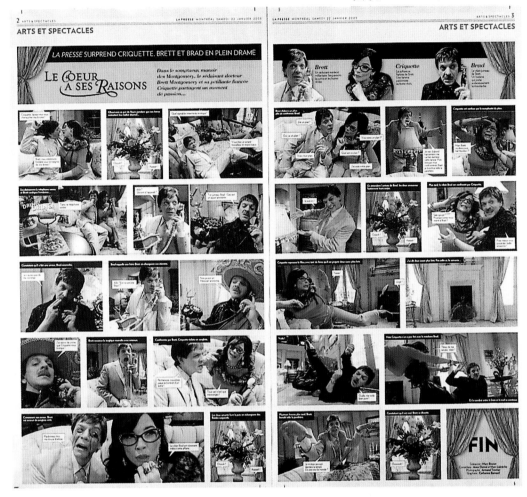

La Presse
Montréal

Benoit Giguere, Art Director; **Francis Leveillee,** Designer;
Alain De Repentigny, AME/Entertainment;
Yves de Repentigny, Entertainment Editor;
Alexandre Vigneault, Journalist

Feature design, page(s) / Entertainment / 175,000 and over

La Presse
Montréal

Benoit Giguere, Art Director; **Catherine Bernard,** Designer;
Alain De Repentigny, A.M.E./Entertainment; **Yves de Repentigny,**
Entertainment Editor; **Hugo Dumas,** Journalist; **Armand Trottier,**
Photographer; **Alain-Pierre Hovasse,** Photo Director

Feature design, page(s) / Entertainment / 175,000 and over

Chicago Tribune

Joan Cairney, Art Director; **Jason McKean,**
Art Director; **Zohar Lazar,** Illustrator;
Scott Powers, Art Editor

*Feature design, page(s) / Entertainment /
175,000 and over*

Público
Lisbon, Portugal

Hugo Pinto, Designer; **Vasco Câmara,** Editor;
José Manuel Fernandes, Newspaper Director

Feature design, page(s) / Entertainment / 50,000-174,999

Clarín
Buenos Aires, Argentina

Gustavo Lo Valvo, Art Director; **Jorge Donelger,** Art Editor;
Valeria Castresana, Designer; **Verónica Colombo,** Designer;
Mariana Zerman, Designer; **Adrián Segal,** Designer; **Silvina Fuda,**
Designer; **Matilde Oliveros,** Designer

Feature design, page(s) / Entertainment / 175,000 and over

Hartford Courant
Conn.

Nicole Dudka, Designer; **Beth Bristow,** Features Photo Editor; **Suzette Moyer,** Design & Graphics Editor

Feature design, page(s) / Entertainment / 175,000 and over

Hartford Courant
Conn.

Timothy Reck, Graphic Artist; **Suzette Moyer,** Design Director; **John Scanlan,** Photo Editor; **Beth Bristow,** Photo Editor; **John Long,** Photographer

Feature design, page(s) / Food / 175,000 and over

National Post
Toronto

Douglas Kelly, Editor in Chief; **Gayle Grin,** M.E./Presentation; **Donna MacMullin,** Features Presentation Editor; **Ben Errett,** Art & Life Editor; **Kagan McLeod,** Illustrator

Feature design, page(s) / Entertainment / 175,000 and over

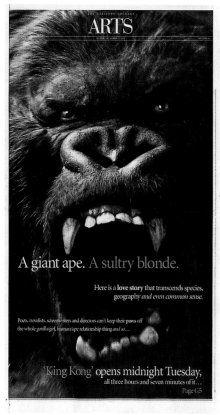

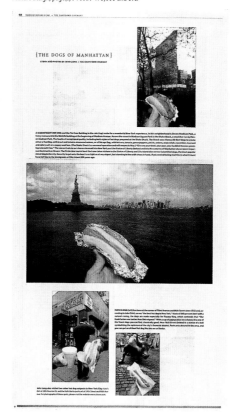

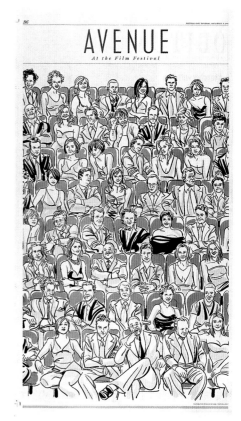

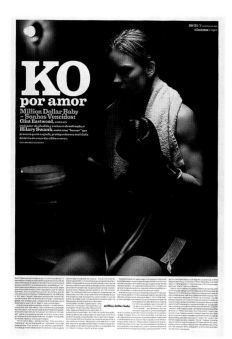

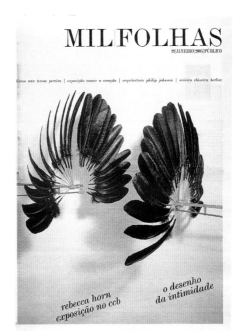

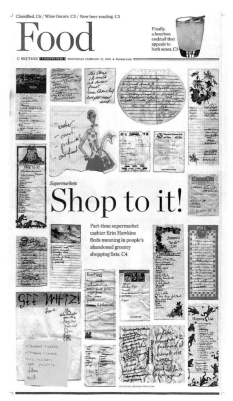

Publico
Lisbon, Portugal

Hugo Pinto, Designer; **Vasco Câmara,** Editor; **José Manuel Fernandes,** Newspaper Director

Feature design, page(s) / Entertainment / 50,000-174,999

Público
Lisbon, Portugal

Jorge Guimarães, Designer; **Isabel Coutinho,** Editor; **José Manuel Fernandes,** Newspaper Director

Feature design, page(s) / Entertainment / 50,000-174,999

Toronto Star

Neil Cochrane, Designer; **Jennifer Bain,** Editor

Feature design, page(s) / Food / 175,000 and over

The Times-Picayune
New Orleans

Dan Swenson, Graphic Artist; **Emmett Mayer III,** Graphic Artist;
Angela Hill, Graphics Editor

Information-graphics portfolio, staff / Breaking news / 175,000 and over

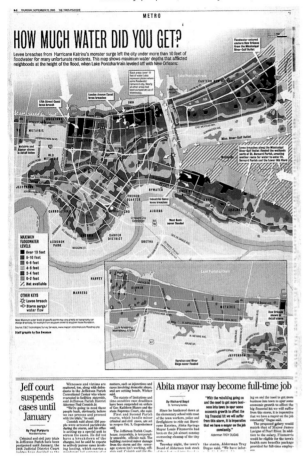

HOW MUCH WATER DID YOU GET?

Levee breaches from Hurricane Katrina's monster surge left the city under more than 10 feet of floodwater for many unfortunate residents. This map shows maximum water depths that affected neighbors at the height of the flood, when Lake Pontchartrain leveled off with New Orleans.

Chicago Tribune

Stephen Ravenscraft, Art Director & Designer;
Linda Bergstrom, Editor; **Mike Miner,** Design Editor;
Ted Yee, Design Editor

Feature design, page(s) / Entertainment / 175,000 and over

Dayton Daily News
Ohio

Randy Palmer, Designer; **Alexis Larsen,** Editor

Feature design, page(s) / Entertainment / 50,000-174,999

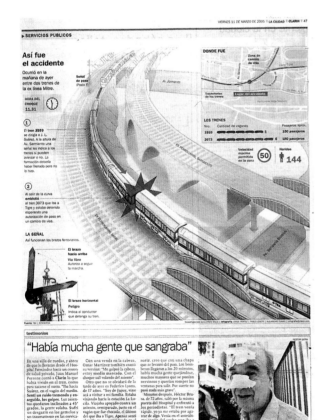

Clarín
Buenos Aires, Argentina

Staff

Information-graphics portfolio, staff / Breaking news / 175,000 and over

O Estado de São Paulo
São Paulo, Brazil

Sandro Vaia, Newsroom Director; **Flavio Pinheiro,** Editor in Chief; **Fabio Sales,** Art Director & Designer; **Ilan Kow,** Editor; **Luiz Americo Camargo,** Assistant Editor; **Miguel Icassatti,** Assistant Editor; **Maria Suely Andreazzi,** Designer; **Wilson Pedrosa,** Photo Editor; **Marcos Mendes,** Photographer; **Cases I Associats,** Design Consultant

Feature design, page(s) / Food / 175,000 and over

Correio Braziliense
Brasilia, Brazil

Josemar Giminez, Newsroom Director; **Ana Dubeux,** Editor in Chief; **Carlos Marcelo,** Executive Editor; **João Bosco Adelino de Almeida,** Art Director; **Kleber Sales,** Illustrator; **Severino José da Paz,** Page Designer

Feature design, page(s) / Entertainment / 50,000-174,999

Chicago Tribune

Catherine Nichols, Designer;
Carol Haddix, Editor

*Feature design, page(s) / Food /
175,000 and over*

Star Tribune
Minneapolis

Colleen Kelly, Features Page Designer; **Lisa Clausen,** Assistant Design Director, Features

Feature design, page(s) / Food / 175,000 and over

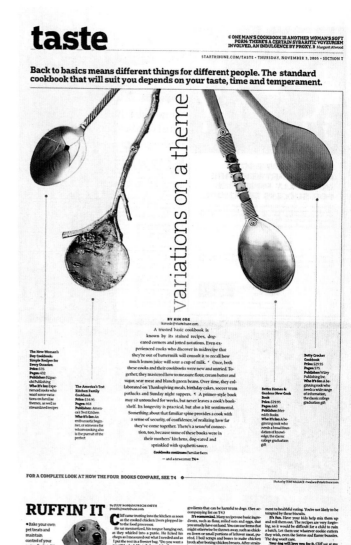

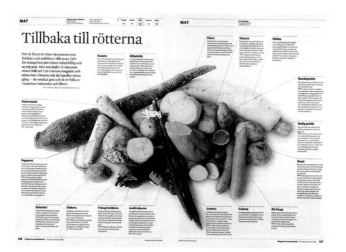

Chicago Tribune

Catherine Nichols, Designer;
Carol Haddix, Editor

*Feature design, page(s) / Food /
175,000 and over*

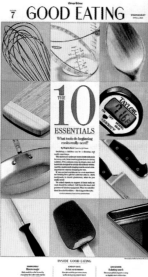
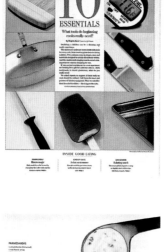

Göteborgs-Posten
Goteborg, Sweden

Karin Teghammar Arell, Designer; **Stefan Edetoff,** Photographer

Feature design, page(s) / Food / 175,000 and over

Östgöta Correspondenten
Linköping, Sweden

Berit Grenestam, Page Designer

Feature design, page(s) / Food / 50,000-174,999

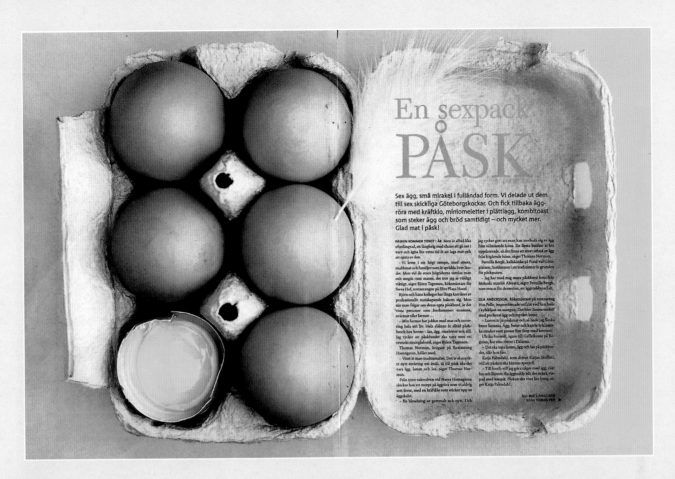

En sexpack.
PÅSK

Sex ägg, små mirakel i fulländad form. Vi delade ut dem till sex skickliga Göteborgskockar. Och fick tillbaka äggröra med kräftklo, miniomeletter i plättlagg, kombitoast som steker ägg och bröd samtidigt — och mycket mer. Glad mat i påsk!

PÅSKEN KOMMER TIDIGT I ÅR. Men är alltid lika efterlängtad, en längtad chans att gå ner i varv och ägna lite extra tid åt att laga mat och att njuta av dem.

— Vi lever i ett högt tempo, med stress, snabbmat och familjer som är spridda över landet. Men vid de stora högtiderna samlas man och umgås runt maten, det tror jag är väldigt viktigt, säger Björn Tagesson, köksmästare för Swea Hof, restaurangen på Elite Plaza Hotel.

Björn och hans kollegor har långa karriärer av professionellt matskapande bakom sig. Men när man frågar om deras egna påskbord, är det vissa personer som återkommer: mamma, svärmor eller farmor ...

— Min farmor har jobbat med mat och servering hela sitt liv. Hela släkten är alltid påsklunch hos henne — lax, ägg, omeletter och sill. Jag tycker att påskbordet ska vara norr till svenskt smörgåsbord, säger Björn Tagesson.

Thomas Norman, krögare på Restaurang Hamngatan, håller med:

— Visst är man traditionalist. Det är så mycket nytt omkring oss ändå, så till påsk ska det vara ägg, lamm och lax, säger Thomas Norman.

Från 1700-talsälven vid Norra Hamngatan skickar han ett recept på äggröra som vi aldrig sett förut, med en kräftklo som sticker upp ur äggskalet.

— En blandning av gammalt och nytt. Och

jag tycker gott att man kan snobba sig av ägg från välmående höns. De flesta butiker är bra uppdaterade, så det finns ett stort utbud av ägg från frigående höns, säger Thomas Norman.

Pernilla Bergh, källskänka på Fond vid Götaplatsen, instämmer i att traditioner är grunden för påskmaten.

— Jag har med mig mors påskbord hemifrån Moheda utanför Alvesta, säger Pernilla Bergh, som svarar för desserten, en äggtoddygräddel.

OLA ANDERSSON, köksmästare på restaurang Hos Pelle, improviserade utifrån vad han hade i kylskåpet en morgon: Det blev lammentorttell med pocherat ägg och mycket bctér.

— Lamm är ju påskmat och så hade jag färska betor hemma. Ägg, betor och kapris är klassiska smaker som passar fint ihop med lammet.

Ulrika Forssell, agare till Gullekonst på Götgatan, har sina rötter i Dalarna.

— Det ska vara lamm, ägg och lax på påskbordet, slår hon fast.

Katja Palmdahl, som driver Katja Skafferi, vill att påsken ska kännas speciell.

— Till lunch vill jag göra något med ägg, vikt lax och björsen. En äggtoddy blir det också, visspad med konjak. Påsken ska vara lite lyxig, säger Katja Palmdahl.

Text MATS FAHLGREN
Bilder TOMAS YEH ▶

SILVER

Göteborgs-Posten
Goteborg, Sweden

Gunilla Wernhamn, Designer;
Tomas Yeh, Photographer

Feature design, page(s) / Food / 175,000 and over

There's much happening in this food page that's beyond the photography. The recipes are so simple and beautiful. The arrows offer navigation. Not a detail is missed. The design is a clean, holistic approach. These designs were head and shoulders above other food pages.

Mucho está ocurriendo en esta página sobre comida, más allá de la fotografía. Las recetas son muy simples y atractivas. Las flechas ofrecen navegación. No se pierde ningún detalle. El diseño tiene un enfoque limpio y holístico. Estos diseños claramente sobrepasaron a las demás páginas sobre comida.

Hartford Courant
Conn.

Timothy Reck, Graphic Artist; **Suzette Moyer,** Director of Design; **Stephanie Heisler,** Photo Editor; **Sherry Peters,** Photographer

Feature design, page(s) / Travel / 175,000 and over

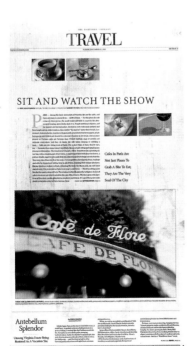

Upsala Nya Tidning
Uppsala, Sweden

John Hällström, Design;
Karl Åstrand, Infographics;
Maria Ringborg, Reporter;
Jörgen Hagelquist, Photo

Feature design, page(s) / Fashion / 50,000-174,999

Dagens Nyheter
Stockholm, Sweden

Beatrice Hellman, Art Director;
Christina Drejenstam, Illustrator

Feature design, page(s) / Fashion / 175,000 and over

The Gazette
Montreal

Susan Ferguson, Design Editor; **Nuri Ducassi,** Design Director; **Doug Sweet,** Life Editor

Feature design, page(s) / Home, real estate / 50,000-174,999

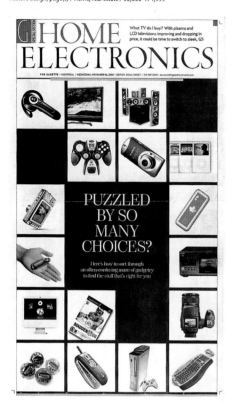

The Boston Globe

Chin Wang, Designer; **Michael Prager,** Editor; **Dan Zedek,** Design Director

Feature design, page(s) / Home, real estate / 175,000 and over

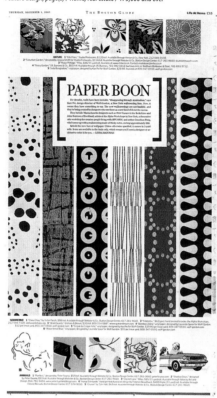

The Boston Globe

Chin Wang, Designer; **Lane Turner,** Photographer; **Michael Prager,** Editor; **Dan Zedek,** Design Director

Feature design, page(s) / Home, real estate / 175,000 and over

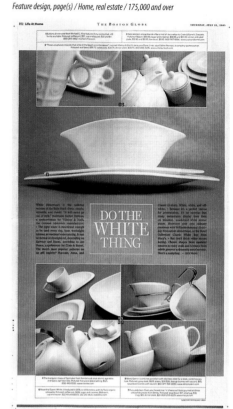

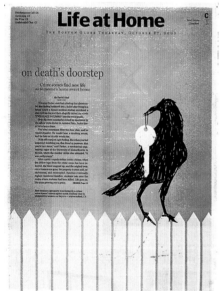

The Boston Globe

Chin Wang, Designer; **Dustin Summers,** Illustrator; **Michael Prager,** Editor; **Dan Zedek,** Design Director

Feature design, page(s) / Home, real estate / 175,000 and over

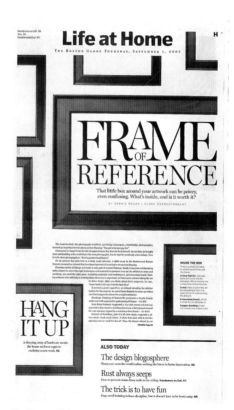

The Boston Globe

Chin Wang, Designer; **Michael Prager,** Editor; **Dan Zedek,** Design Director

Feature design, page(s) / Home, real estate / 175,000 and over

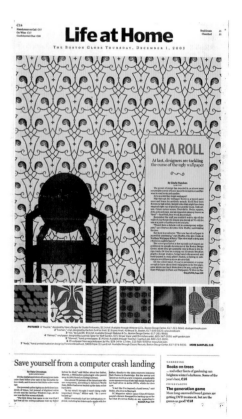

The Boston Globe

Chin Wang, Designer; **Michael Prager,** Editor; **Dan Zedek,** Design Director

Feature design, page(s) / Home, real estate / 175,000 and over

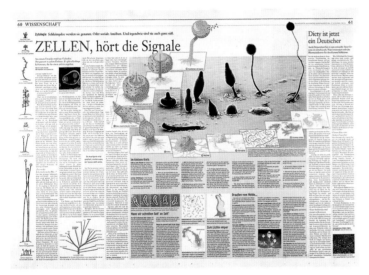

WUNDERHEILER – das Geheimnis des Dr. Plattwurm

Frankfurter Allgemeine Sonntagszeitung
Frankfurt am Main, Germany

Thomas Heumann, Infographics Director; **Karl-Heinz Döring,** Infographics Artist;
Doris Oberneder, Layouter; **Volker Stollorz,** Text Editor; **Andreas Kuther,** Photo Editor

Feature design, page(s) / Science, technology / 175,000 and over

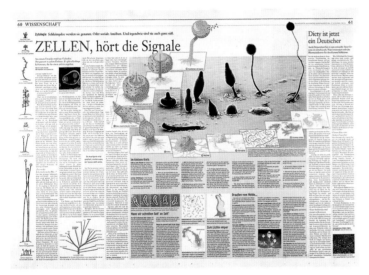

ZELLEN, hört die Signale

Frankfurter Allgemeine Sonntagszeitung
Frankfurt am Main, Germany

Thomas Heumann, Infographics Director; **Karl-Heinz Döring,** Infographics Artist;
Doris Oberneder, Layouter; **Richard Friebe,** Science Editor; **Barbara Weissenmayer,** Scientist;
Andreas Kuther, Photo Editor

Feature design, page(s) / Science, technology / 175,000 and over

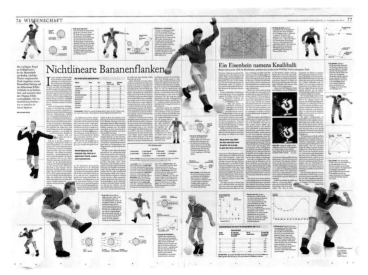

Nichtlineare Bananenflanken

Frankfurter Allgemeine Sonntagszeitung
Frankfurt am Main, Germany

Peter Breul, Art Director & Designer; **Andreas Kuther,** Picture Editor;
Richard Friebe, Writer; **Rainer Wohlfahrt,** Photographer

Feature design, page(s) / Other / 175,000 and over

SonntagsZeitung
Zürich, Switzerland

Tobias Gaberthuel, Designer; **Stefan Semrau,** Art Director

Feature design, page(s) / Science, technology / 175,000 and over

Grastablette gegen Heuschnupfen

Meer dan 49.000 jobs in de gezondheidszorg

Vacature
Groot-Bygaarden, Belgium

Pieter Ver Elst, Art Director; **Jon Troch,** Assistant Art Director; **Bob Haentjens,**
Designer; **Ren Vangeemput,** Designer; **Patricia Kempeneers,** Designer;
Marian Kin, Editor in Chief; **Nico Jchoofs,** Editor

Feature design, page(s) / Other / 175,000 and over

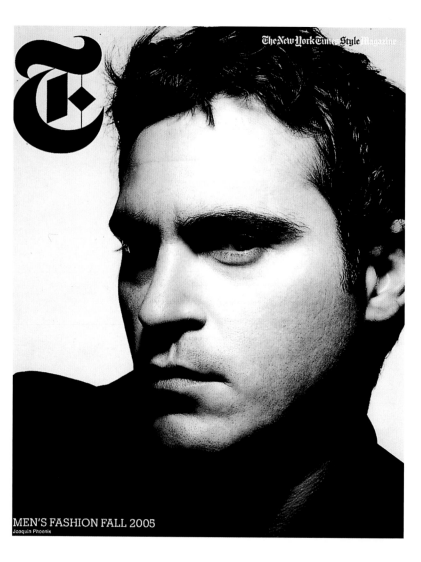

MEN'S FASHION FALL 2005
Joaquin Phoenix

The New York Times Magazine

Janet Froelich, Creative Director; **David Sebbah,** Art Director

Magazines / Overall design

Light
Moscow

Irina Borisova, Art Director; **Irina Deshalyt,** Vice Art Director;
Ilya Baranov, Chief Designer

Magazines / Overall design

El Mundo Magazine
Madrid, Spain

Rodrigo Sánchez, Art Director & Designer; **María González,** Designer; **Natalia Buño,** Designer; **Javier Sanz,** Designer; **Eva López,** Designer; **Francisco Alarcos,** Designer

Magazines / Overall design

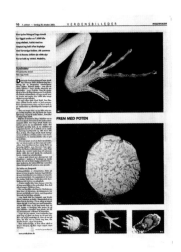

La Presse
Montréal

Benoit Giguere, Art Director; **Andre Rivest,** Designer; **Michele Ouimet,** A.M.E./News; **Alexandre Sirois,** Journalist

Feature design, page(s) / Other / 175,000 and over

Politiken
Copenhagen, Denmark

Søren Nyeland, Design Editor; **Tomas Østergren,** Page Designer; **Christian Ilsøe,** Editor; **Per Folkver,** Photo Editor; **Søren Hansen,** Copy Editor

Feature design, page(s) / Other / 50,000-174,999

Financial Times Deutschland
Hamburg, Germany

Olaf Schmidt, Designer; **Heike Burmeister,** Photo Editor

Magazines / Overall design

El Mundo Magazine
Madrid, Spain

Rodrigo Sánchez, Art Director & Designer; **María González,** Designer; **Natalia Buño,** Designer; **Javier Sanz,** Designer; **Eva López,** Designer; **Francisco Alarcos,** Design Consultant; **Carmelo Caderot,** Design Director

Magazines / Special sections

The Independent on Sunday
London

Ben Brannan, Art Director; **Sara Ramsbottom,** Deputy Art Director; **Victoria Lukens,** Picture Editor; **Susan Glen,** Deputy Picture Editor; **Andrew Tuck,** Editor

Magazines / Overall design

El Mundo Magazine
Madrid, Spain

Rodrigo Sánchez, Art Director & Designer; **María González,** Designer; **Natalia Buño,** Designer; **Javier Sanz,** Designer; **Eva López,** Designer; **Francisco Alarcos,** Design Consultant

Magazines / Special sections

El Mundo Magazine
Madrid, Spain

Rodrigo Sánchez, Art Director & Designer; **María González,** Designer; **Natalia Buño,** Designer; **Javier Sanz,** Designer; **Eva López,** Designer; **Francisco Alarcos,** Designer

Magazines / Special sections

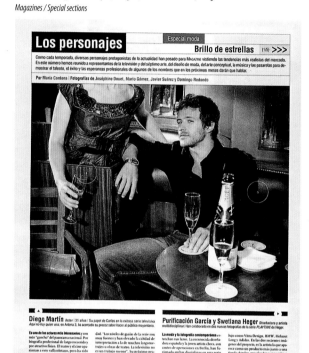

El Mundo Magazine
Madrid, Spain

Rodrigo Sánchez, Art Director & Designer; **María González,** Designer; **Natalia Buño,** Designer; **Javier Sanz,** Designer; **Eva López,** Designer; **Francisco Alarcos,** Designer

Magazines / Special sections

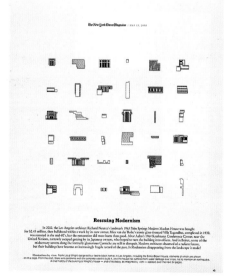

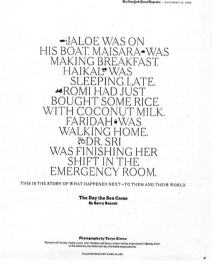

The New York Times Magazine

Janet Froelich, Creative Director; **Arem Duplessis,** Art Director; **Nancy Harris,** Designer; **Kathy Ryan,** Photo Editor & Photographer

Magazines / Special sections

The New York Times Magazine

Janet Froelich, Creative Director; **Arem Duplessis,** Art Director; **Kristina DiMatteo,** Designer; **Kathy Ryan,** Photo Editor & Photographer

Magazines / Special sections

The New York Times Magazine

Janet Froelich, Creative Director; **Arem Duplessis,** Art Director; **Jeff Glendenning,** Designer; **Kathy Ryan,** Photo Editor; **Taryn Simon,** Photographer

Magazines / Special sections

Radar-Pagina / 12
Buenos Aires, Argentina

Alejandro Ros, Art Director; **Vanina Osci,** Designer

Magazines / Cover design

Radar-Pagina / 12
Buenos Aires, Argentina

Alejandro Ros, Art Director; **Vanina Osci,** Designer

Magazines / Cover design

ЯADAR

Quién fue el Gran Gattoni
Werner Herzog en la Lugones
Visita guiada por la Bienal de Venecia
La trastienda de la Conferencia de Yalta

EL CUENTO QUE HACE DESMAYAR A LA GENTE

Cuando **Chuck Palahniuk**, el autor de **El Club de la Pelea**, escribió **Tripa**, sabía que era un cuento literalmente impresionante. Lo que no sabía era que, al leerlo ante su público, se terminarían desmayando 67 personas. Léalo y pruebe.

ЯADAR

Chanel por Karl Lagerfeld
Los epitafios según Luis Gusmán
Por qué Hollywood resuelve todo a sablazos
Jeremy Deller: el arte popular al alcance del ojo

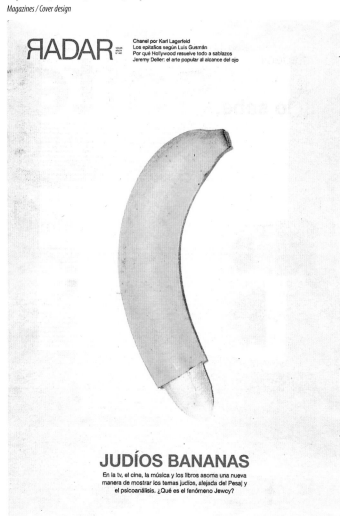

JUDÍOS BANANAS

En la tv, el cine, la música y los libros asoma una nueva manera de mostrar los temas judíos, alejada del Pesaj y el psicoanálisis. ¿Qué es el fenómeno Jewcy?

LAS / 12-Pagina
Buenos Aires, Argentina

Alejandro Ros, Art Director;
Juliana Rosato, Designer

Magazines / Cover design

LAS12

TETAS

LAS12

www.pedofilia.com

Las12

Secretos del corazón

LAS / 12-Pagina
Buenos Aires, Argentina

Alejandro Ros, Art Director; **Juliana Rosato,** Designer

Magazines / Cover design

LAS / 12-Pagina
Buenos Aires, Argentina

Alejandro Ros, Art Director; **Juliana Rosato,** Designer

Magazines / Cover design

El Mundo Metropoli
Madrid, Spain

Rodrigo Sánchez, Art Director & Designer; **Carmelo Caderot,** Design Director

Magazines / Cover design

El Mundo Metropoli
Madrid, Spain

Rodrigo Sánchez, Art Director & Designer; **Carmelo Caderot,** Design Director

Magazines / Cover design

Público
Lisbon, Portugal

Hugo Pinto, Designer;
Ana Carvalho, Designer;
Dulce Neto, Editor;
João Fazenda, Illustrator;
David Clifford, Photo Editor;
Adriano Miranda, Photo Editor;
José Manuel Fernandes,
Director

Magazines / Cover design

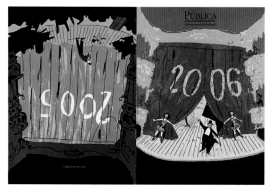

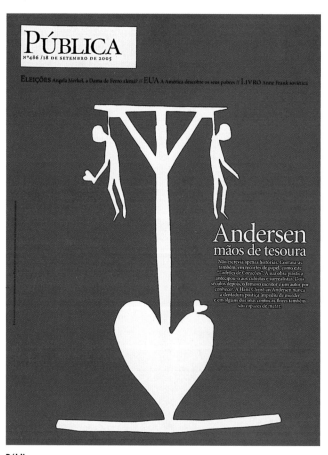

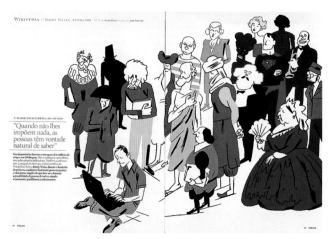

Público
Lisbon, Portugal

Hugo Pinto, Designer; **Ana Carvalho,** Designer; **Dulce Neto,** Editor; **João Fazenda,** Illustrator;
David Clifford, Photo Editor; **Adriano Miranda,** Photo Editor; **José Manuel Fernandes,** Director

Magazines / Inside pages

Público
Lisbon, Portugal

Hugo Pinto, Designer; **Ana Carvalho,** Designer; **Dulce Neto,** Editor; **David Clifford,** Photo
Editor; **Adriano Miranda,** Photo Editor; **José Manuel Fernandes,** Director

Magazines / Cover design

The New York Times Magazine

Janet Froelich, Creative
Director; **David Sebbah,** Art
Director; **Vault 49,** Illustrator

Magazines

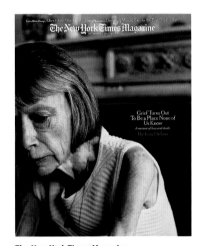

The New York Times Magazine

Janet Froelich, Creative Director; **Arem Duplessis,** Art Director;
Kristina DiMatteo, Designer; **Kathy Ryan,** Photo Editor;
Eugene Richards, Photographer

Magazines / Cover design

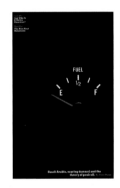

The New York Times Magazine

Janet Froelich, Creative Director;
Arem Duplessis, Art Director;
Kristina DiMatteo, Designer;
Kathy Ryan, Photo Editor;
Tom Schierlitz, Photographer

Magazines / Cover design

CHARTING A COURSE AMONG THE MANY HIGHWAYS
AND BYWAYS OF FASHION REQUIRES A CERTAIN NAVIGATIONAL SKILL. HERE, AN
ORIENTATION COURSE. START WITH THE BIG DIPPER AND TURN THE PAGE.

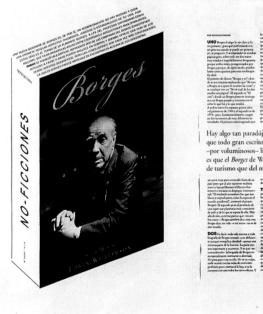

Radar-Pagina / 12
Buenos Aires, Argentina

Alejandro Ros, Art Director; **Vanina Osci,** Designer

Magazines / Inside pages

Gaceta Universitaria
Madrid, Spain

José Juan Gámez, Art Director; **Antonio Martín,** Design Editor;
Antonio Pardo, Photographer; **Staff**

Magazines / Cover design

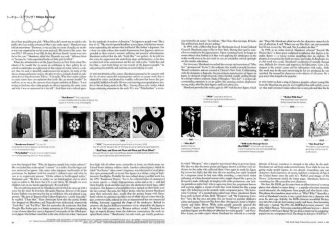

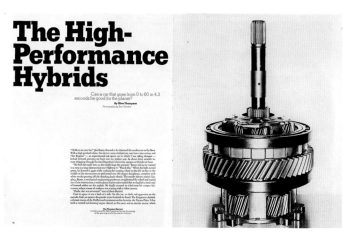

The New York Times Magazine

Janet Froelich, Creative Director; **Arem Duplessis**, Art Director;
Jeff Glendenning, Designer; **Kathy Ryan**, Photo Editor, **Dan Winters**,
Photographer

Magazines / Inside pages

The New York Times Magazine

Janet Froelich, Creative Director; **Arem Duplessis**, Art Director; **Guillermo Nagore**, Designer;
Kathy Ryan, Photo Editor; **Dan Winters**, Photographer

Magazines / Inside pages

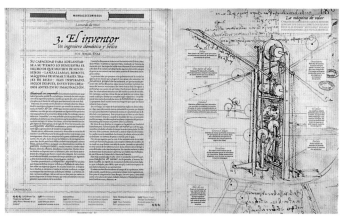

El Mundo Magazine
Madrid, Spain

Rodrigo Sánchez, Art Director & Designer; **María González,** Designer; **Natalia Buño,**
Designer; **Javier Sanz,** Designer; **Eva López,** Designer; **Francisco Alarcos,** Designer;
Carmelo Caderot, Design Director

Magazines / Inside pages

El Mundo Magazine
Madrid, Spain

Rodrigo Sánchez, Art Director & Designer; **María González,** Designer; **Natalia Buño,**
Designer; **Javier Sanz,** Designer; **Eva López,** Designer; **Francisco Alarcos,** Designer;
Carmelo Caderot, Design Director; **Andy Gotts,** Photographer

Magazines / Inside pages

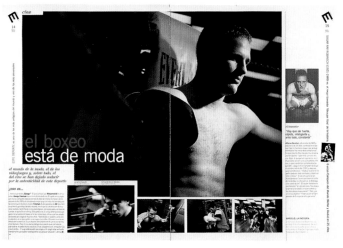

Clarín
Buenos Aires, Argentina

Gustavo Lo Valvo, Art Director; **Adriana Di Pietro,** Art Director; **Laura Escobar,** Designer;
Paula Mizraji, Designer; **Ana Vargas,** Designer; **Alejandro Santiago,** Designer

Magazines / Inside pages

Gaceta Universitaria
Madrid, Spain

Antonio Martín, Design Editor; **José Juan Gámez,** Art Director; **Máximo García,** Photographer

Magazines / Inside pages

Visuals

6

The New York Times Magazine
Janet Froelich, Creative Director; **Arem Duplessis**, Art Director;
Kristina DiMatteo, Designer; **Marco Ventura**, Illustrator
Illustration / Single

The Boston Globe Magazine
Brendan Stephens, Art Director;
Chris Buzelli, Illustrator; **Doug Most**,
Editor; **Dan Zedek**, Design Director
Illustration / Single

Pittsburgh Post-Gazette
Daniel Marsula, Artist
Illustration / Single

The Boston Globe
Heads of State, Illustrator;
Gregory Klee, Art Director;
Jennifer Schuessler, Editor;
Dan Zedek, Design Director
Illustration / Single

Dagens Nyheter
Stockholm, Sweden
Jesper Waldersten, Artist
Illustration / Single

O Independente
Lisbon, Portugal

Sónia Matos, Art Director; **Vasco Colombo,** Illustrator;
Nuno Tiago Pinto, Editor; **Inês Serra Lopes,** Editor in Chief

Illustration / Single

Golf
THE JOURNAL REPORT
THE WALL STREET JOURNAL

HOW SCIENCE CAN IMPROVE YOUR GOLF GAME

The Wall Street Journal
South Brunswick, N.J.

Greg Leeds, Executive Art Director; **Orlie Kraus,** Art Director;
Tomer Hanuka, Illustrator

Illustration / Single

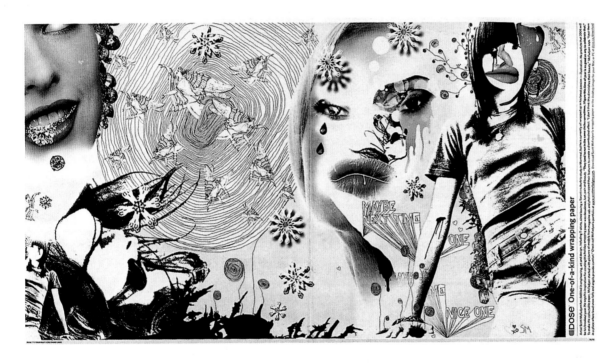

Dose
Toronto

Scott McFadyen, Artist;
Jaspal Riyait, Creative Director

Illustration / Single

Zaman
Yenibosna, Turkey

Fevzi Yazici, Art Director;
Cem Kiziltug, Illustrator

Illustration / Single

Hayatlarımız ve başkaları

Zaman
Yenibosna, Turkey

Fevzi Yazici, Art Director;
Orhan Nalin, Illustrator

Illustration / Single

AKADEMİ
İSLÂM DÜNYASI

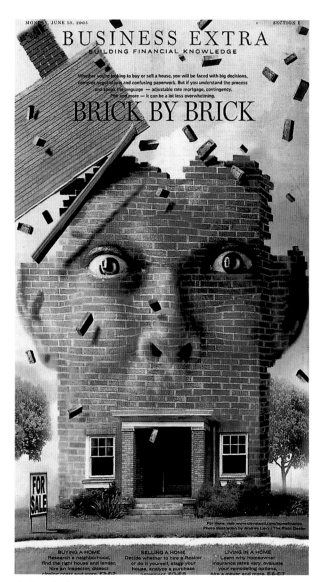

MONDAY, JUNE 13, 2005 SECTION E

BUSINESS EXTRA
BUILDING FINANCIAL KNOWLEDGE

Whether you're looking to buy or sell a house, you will be faced with big decisions, complex negotiations and confusing paperwork. But if you understand the process and speak the language — adjustable rate mortgage, contingency, PMI and more — it can be a lot less overwhelming.

BRICK BY BRICK

FOR SALE

For more, visit www.cleveland.com/homebasics
Photo illustration by Andrea Levy | The Plain Dealer

BUYING A HOME
Research a neighborhood, find the right house and lender, hire an inspector, dissect closing costs and more. E3-E17

SELLING A HOME
Decide whether to hire a Realtor or do it yourself, stage your house, analyze a purchase agreement. E12-E15

LIVING IN A HOME
Learn why homeowner insurance rates vary, evaluate your remodeling options, hire a mover and more. E16-E17

The Plain Dealer
Cleveland

Andrea Levy, Illustrator/Photographer; **Lisa Griffis,** Projects Designer; **Kristen DelGuzzi,** Deputy Business Editor; **David Kordalski,** A.M.E./Visuals; **Mary Vanac,** Section Editor

Illustration / Multiple

Dagens Nyheter
Stockholm, Sweden

Saina Wirsén, Illustrator

Illustration / Multiple

LA PRESSE MONTRÉAL SAMEDI 13 AOÛT 2005 A 3

11 SEPTEMBRE TOUT SUR LE CHAOS

« En voyant les gens sauter. J'ai commencé à me sentir malade. J'avais l'impression de violer un territoire sacré. Ces gens avaient choisi de mourir et je les regardais alors que je n'aurais pas dû. Je me suis retournée vers un mur. Je pouvais entendre les corps heurter le sol. **»**
— Maureen Michelle Shulman, pompière, New York City Fire Department.

Le tribunal s'en est mêlé
TRISTAN PELOQUIN

L'écrasement des tours
D'APRÈS AP

8h45
› En pleine heure de pointe, le vol 11 d'American Airlines, en provenance de Boston, transperce la tour nord du World Trade Center, qui s'enflamme aussitôt.

9h03
› Filmé par les caméras de télé, un deuxième avion parti de Boston, le vol 175 d'United Airlines, percute la tour sud et explose.

9h58
› La tour sud s'effondre, propulsant dans Manhattan un monstrueux nuage de poussière et de débris. Plusieurs pompiers et secouristes meurent écrasés.

10h28
› La tour nord s'écrase sur elle-même, à la manière d'un château de cartes. La fumée et les débris emplissent à nouveau les rues.

Les familles se précipitent pour lire les témoignages
D'APRÈS AP

La Presse
Montréal

Benoit Giguere, Art Director; **Francis Leveillee,** Illustrator; **Michele Ouimet,** A.M.E./News; **Tristan Peloquin,** Journalist

Illustration / Multiple

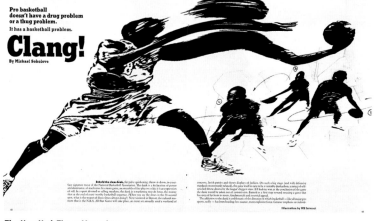

Pro basketball doesn't have a drug problem or a thug problem. It has a basketball problem.

Clang!
By Michael Sokolove

The New York Times Magazine

Janet Froelich, Creative Director; **Arem Duplessis,** Art Director; **Jeff Glendenning,** Designer; **W.K. Interact,** Illustrator

Illustration / Multiple

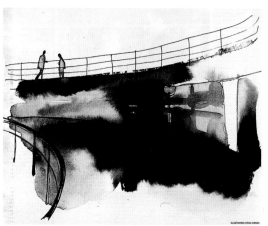

Dagens Nyheter
Stockholm, Sweden

Saina Wirsén, Illustrator

Illustration / Multiple

The New York Times Magazine

Janet Froelich, Creative Director; **Arem Duplessis**, Art Director, Designer; **Kristina Dimatteo**, Designer; **Tomer Hanuka**, Illustrator

Illustration / Multiple

Dagens Nyheter
Stockholm, Sweden

Saina Wirsén, Illustrator

Illustration / Multiple

The New York Times Magazine

Janet Froelich, Creative Director; **Arem Duplessis,** Art Director & Designer; **Kristina Dimatteo,** Designer; **Nathan Fox,** Illustrator

Illustration / Multiple

El Diario de Hoy
San Salvador, El Salvador

Staff

Illustration, Use of

National Post
Toronto

Staff

Illustration, Use of

Frankfurter Allgemeine Sonntagszeitung
Frankfurt am Main, Germany

Staff

Illustration, Use of

Rocky Mountain News
Denver
Todd Heisler, Photographer

Photography / Single photos / General news

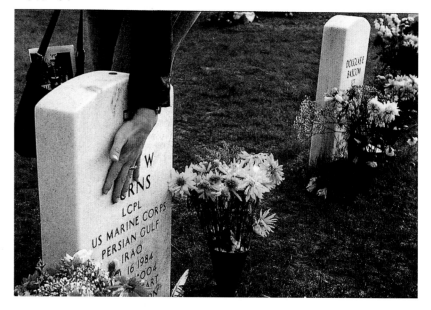

Público
Lisbon, Portugal

José Manuel Fernandes, Director;
Manuel Carvalho, Editorial Director;
Amílcar Correia, Editorial Director; **Pedro Almeida,**
Graphic Editor/Designer; **José Soares,** Designer;
Nuno Costa, Designer; **Vanessa Taxa,** Designer;
Paulo Pimenta, Photographer; **Paulo Ricca,** Editor

Photography / Single photos / General news

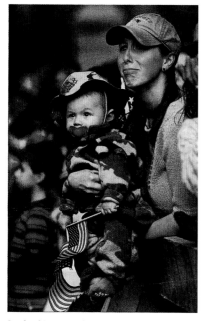

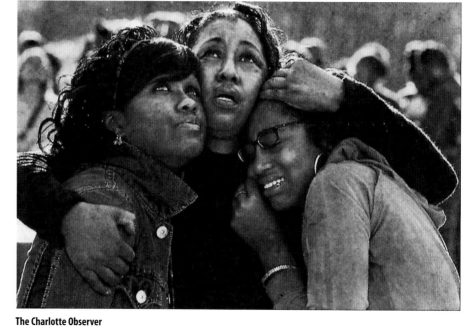

Portland Press Herald
Maine

Shawn Patrick Ouellette, Staff Photographer

Photography / Single photos / General news

The Charlotte Observer
N.C.

Patrick Schneider, Photographer; **Todd Sumlin,** Photo Editor

Photography / Single photos / General news (planned)

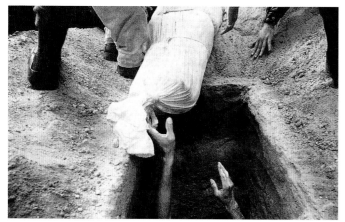

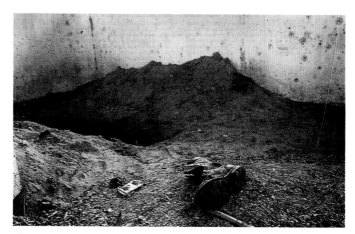

The New York Times
Max Becherer, Photographer
Photography / Single photos / General news

The New York Times
Panos, Photographer
Photography / Single photos / General news

The Beaumont Enterprise
Texas
Mark M. Hancock, Staff Photojournalist
Photography / Single photos / General news

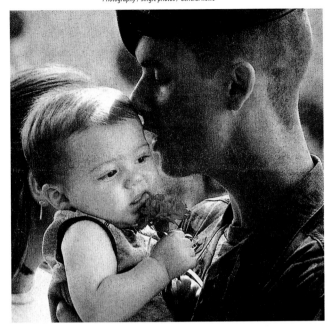

Politiken
Copenhagen, Denmark
Martin Lehmann, Photographer
Photography / Single photos / General news

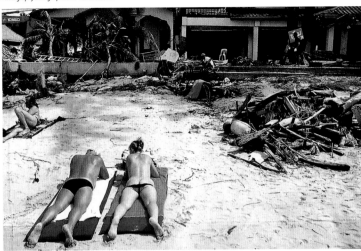

Ming Pao Daily News
Hong Kong
Nick Kwok Hing Fai, Deputy Picture Editor
Photography / Single photos / General news

Detroit Free Press
Susan Tusa, Staff Photographer; **Steve Dorsey,** AME/Presentation;
Nancy Andrews, Director of Photography
Photography / Single photos / General news

The Sacramento Bee
Calif.
Jose Luis Villegas, Photographer; **Tim Reese,** Assistant Director/
Photography
Photography / Single photos / General news

The San Diego Union-Tribune

Howard Lipin, Photographer; **Michael Franklin,** Photo Editor; **Andy Hayt,**
Director of Photography; **Eddie Krueger,** Designer; **Gerald McClard,** Photo Editor

Photography / Single photos / General news

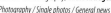

The New York Times
Chang W. Lee, Photographer
Photography / Single photos / General news

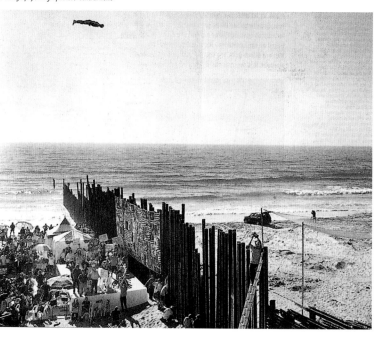

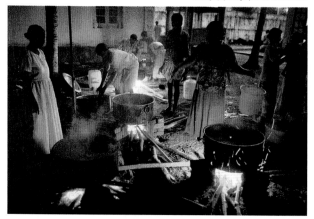

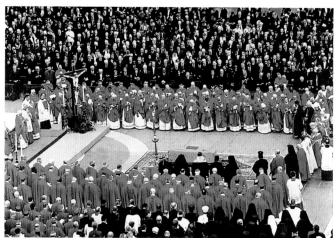

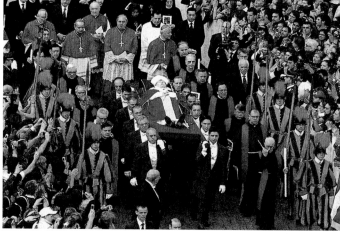

Toronto Star
Hans Deryk, Photographer
Photography / Single photos / General news

Pittsburgh Post-Gazette
Matt Freed, Staff Photographer
Photography / Single photos / General news

The New York Times
Christoph Bangert,
Photographer
*Photography / Single photos /
General news*

The Virginian-Pilot
Norfolk

Yoon S. Byun, Photographer;
Alex Burrows, Director of
Photography; **Deborah Withey,**
Deputy M.E. Presentation

Photography / Single photos /
General news

Seattle Post-Intelligencer
Scott Eklund, Photographer

Photography / Single photos / General news

The Denver Post
Helen H. Richardson, Photographer

Photography / Single photos / General news

Rocky Mountain News
Denver
Linda McConnell, Photographer

Photography / Single photos / General news

The Globe and Mail
Toronto

Fred Lum, Photographer; **Erin Elder,** Photo Editor; **David Pratt,**
Executive Art Director; **Moe Doiron,** Deputy Photo Editor

Photography / Single photos / General news

The Times-Picayune
New Orleans
Chris Granger, Staff Photographer

Photography / Single photos / General news

The New York Times
Richard Patterson, Photographer
Photography / Single photos / General news

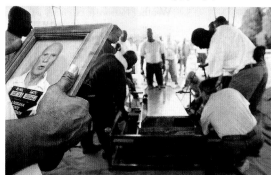

The New York Times
Andrew Testa, Photographer
Photography / Single photos / General news

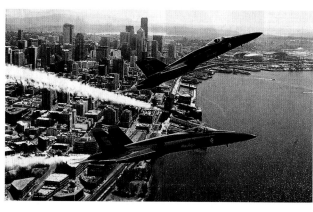

The Seattle Times
Greg Gilbert, Photographer;
Barry Fitzsimmons, Photo
Editor; **Sara Kennedy,** Page
Designer
Photography / Single photos / General news

Seattle Post-Intelligencer
Joshua Trujillo, Staff Photographer
Photography / Single photos / General news

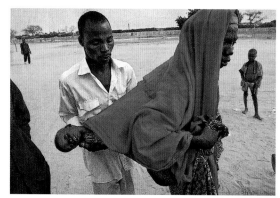

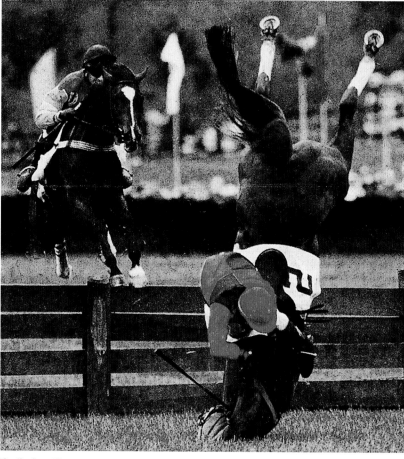

The New York Times
Michael Kambar, Photographer
Photography / Single photos / General news

The Charlotte Observer
N.C.
Yalonda M. James, Photographer; **Todd Sumlin,** Photo/Graphics Editor;
Tiffany Pease, Designer

Photography / Single photos / General news

Milwaukee Journal Sentinel
Wis.

David Joles, Photographer; **Sherman Williams,**
A.M.E./Photography; **Carolyn Ryan,** Designer

Photography / Single photos / General news

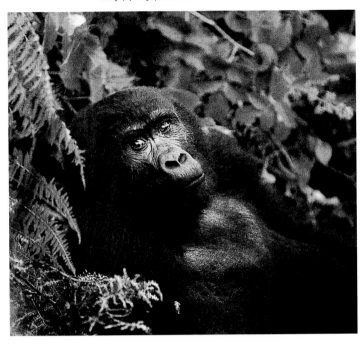

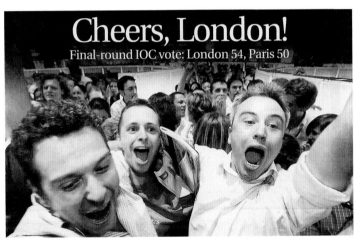

Cheers, London!
Final-round IOC vote: London 54, Paris 50

The Straits Times
Singapore

Ong Chin Kai, Photographer

Photography / Single photos / General news

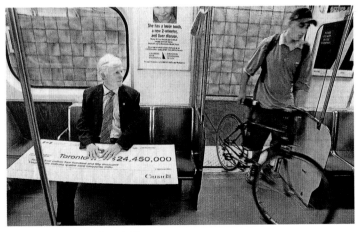

Toronto Star
Steve Russell, Photographer

Photography / Single photos / General news

San Francisco Chronicle

Mike Kepka, Photographer; **Russell Yip,** Photo Editor; **Rick Romarosa,** Photo Editor;
James Merithew, Photo Editor

Photography / Single photos / General news

The San Diego Union-Tribune

John Gibbons, Photographer; **Andy Hayt,** Director of Photography; **Alma Cesena,**
Photo Editor; **Greg Schmidt,** Designer

Photography / Single photos / General news

Morgenavisen Jyllands-Posten
Viby, Denmark

Jan Dagø, Photographer

Photography / Single photos / General news

The Times-Picayune
New Orleans
Kathy Anderson, Staff Photographer
Photography / Single photos / General news

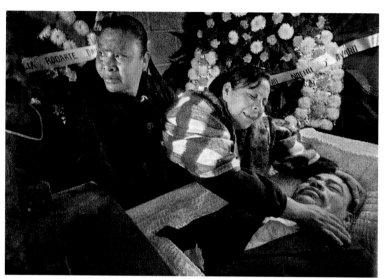

The Sacramento Bee
Calif.
Hector Amezcua, Photographer; **Sue Morrow,** Deputy Director of Photography;
Robert Casey, A.M.E./Visuals
Photography / Single photos / General news

The New York Times
Tyler Hicks, Photographer
Photography / Single photos / General news

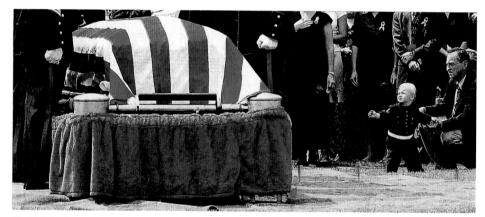

The Plain Dealer
Cleveland
Mike Levy, Photographer
Photography / Single photos / General news

Rocky Mountain News
Denver
Barry Gutierrez, Photographer
Photography / Single photos / General news

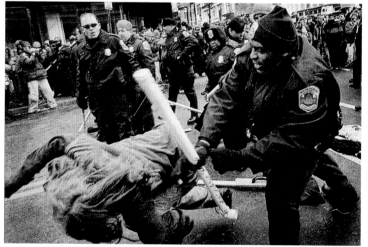

The Baltimore Sun
Amy Davis, Photographer
Photography / Single photos / General news

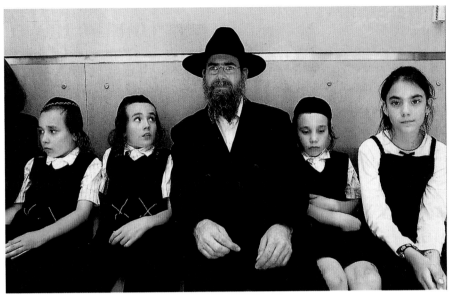

Toronto Star
Charla Jones, Photographer
Photography / Single photos / General news

The Denver Post
Craig F. Walker, Photographer
Photography / Single photos / General news

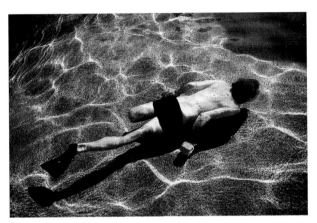

The San Diego Union-Tribune
Dan Trevan, Photographer; Andy Hayt, Director of Photography;
Michael Franklin, Photo Editor; Michael Rocha, Features Design Editor
Photography / Single photos / General news

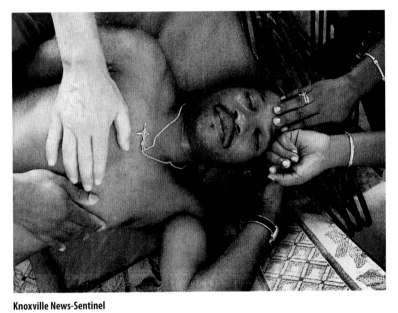

Knoxville News-Sentinel
Tenn.
Michael Patrick, Photographer; Tracey Trumbull, Director of Photography;
Michael Apuan, A.M.E.
Photography / Single photos / General news

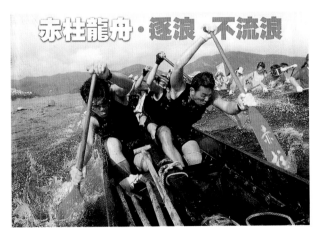

Ming Pao Daily News
Hong Kong
Vik Lai Chun Wing, Photographer
Photography / Single photos / General news

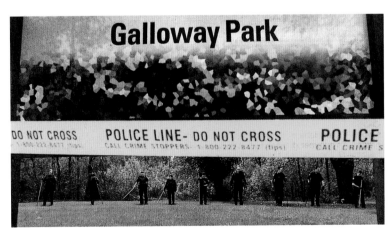

Toronto Star
Tannis Toohey, Photographer
Photography / Single photos / General news

Le Figaro
Paris

Martine Archambault, Photographer; **Sophie Laurent-Lefevre,** Art Director;
Yves Threard, Picture Editor

Photography / Single photos / General news

Kalamazoo Gazette
Mich.

Mark Bugnaski, Photographer

Photography / Single photos / General news

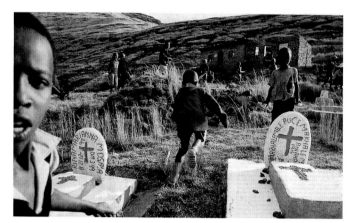

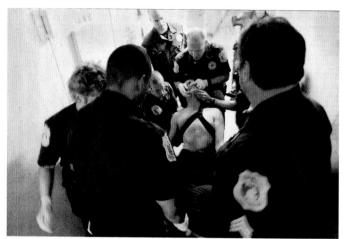

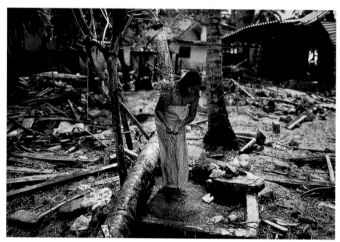

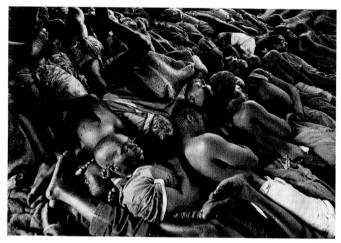

The New York Times
Chang W. Lee, Photographer

Photography / Single photos / General news

The New York Times
Joao Silva, Photographer

Photography / Single photos / General news

Ming Pao Daily News
Hong Kong

Lam Chun Tung, Photographer

Photography / Single photos / General news

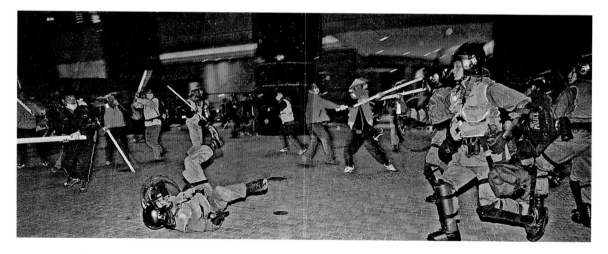

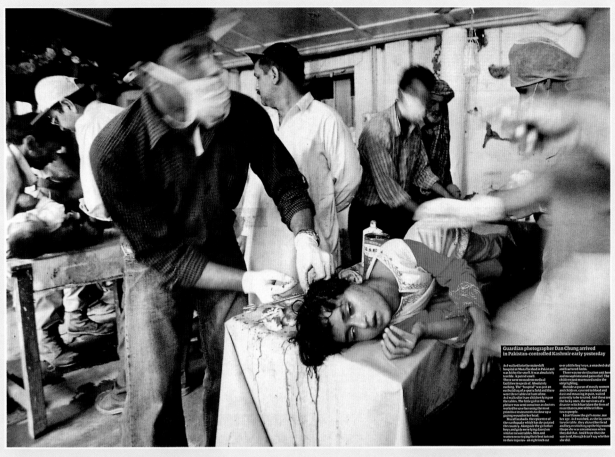

Guardian photographer Dan Chung arrived in Pakistan-controlled Kashmir early yesterday

As I walked into the makeshift hospital at Muzaffarabad in Pakistan I was hit by the smell. It was absolutely terrible. A putrid smell. There were no modern medical facilities to speak of. Absolutely nothing. The "hospital" was just an outbuilding of a sports field and there were three tables in front of me. As I walked in I saw children lying on the tables. The little girl in this picture was semi conscious as doctors worked to save her using the most primitive instruments to close up a gaping wound in her head.

Muzaffarabad is the epicentre of the earthquake which has devastated the country. Alongside the girl other boys and girls were lying dazed on similar torsole tables. Men and women were trying their best tattend to their injuries - an eight inch cut over a little boy's eye, a smashed skull and fractured limbs.

There was no sterilisation unit here and no sophisticated painrelief. The children just murmured under the strip lighting.

Outside a queue of mostly women and children, covered in blood and dust and moaning in pain, waited patiently to be tortated. And these at the lucky ones, the survivors of a disaster which has taken the lives of more than 19,000 of their fellow townspeople.

I don't know the girl's name, nor her age. As I watched, one by one, her tresole table, they shaved her head and gave convulsive shivering when they did that. And I hope that she survived, though I can't say whether she did.

SILVER

The Guardian
London

Dan Chung, Photographer

Photography / Single photos / Spot news

The emotion in this image is so strong. You go to the girl's face first, and you see her pain and suffering as this world of activity spins around her. It captures the chaos of the moment. In this image is everything that's great about photojournalism.

La emoción de esta imagen es potente. Primero se mira la cara de la niña y se ve el dolor y el sufrimiento a medida que todo un mundo de actividad da vueltas alrededor de ella. Capta el caos del momento. En esta imagen está todo lo grandioso del fotoperiodismo.

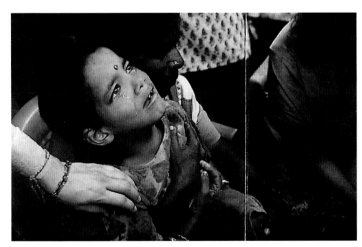

Rocky Mountain News
Denver

Judy DeHaas, Photographer

Photography / Single photos / Spot news

The Boston Globe

Suzanne Kreiter, Photographer; **Paula Nelson,**
Photo Editor; **Dan Zedek,** Design Director

Photography / Single photos / Spot news

Richmond Times-Dispatch
Va.
Dean Hoffmeyer, Staff Photographer
Photography / Single photos / Spot news

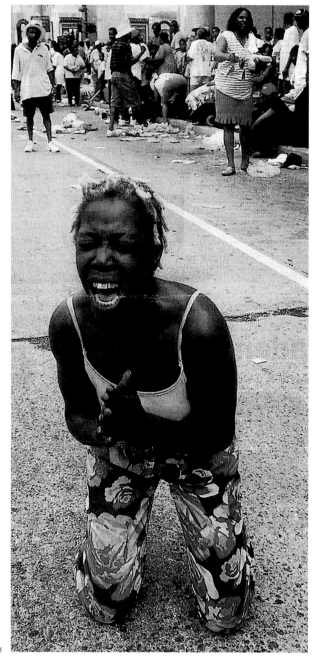

Houston Chronicle
Melissa Phillip, Staff Photographer
Photography / Single photos / Spot news

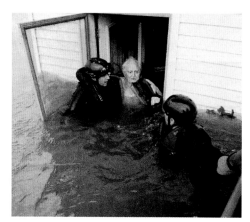

The Times-Picayune
New Orleans
Alex Brandon, Staff Photographer
Photography / Single photos / Spot news

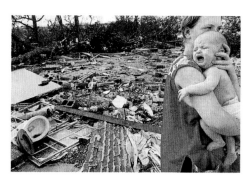

The Charlotte Observer
N.C.
Patrick Schneider, Photographer; **Judy Tell,** Deputy Director of
Photography; **Jim Denk,** Designer
Photography / Single photos / Spot news

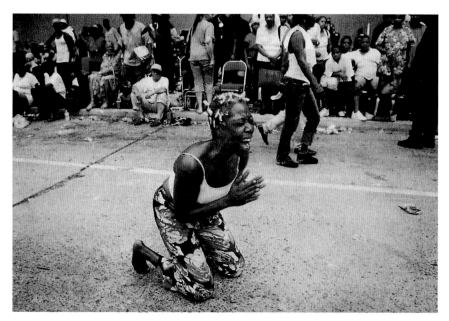

The Times-Picayune
New Orleans
Brett Duke, Staff Photographer
Photography / Single photos / Spot news

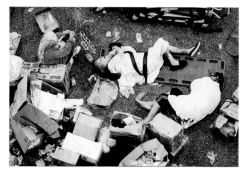

The Star-Ledger
Newark, N.J.
John O'Boyle, Staff Photographer; **Rachel French,** Night Photo
Editor; **Pim VanHemmen,** A.M.E./Photography
Photography / Single photos / Spot news

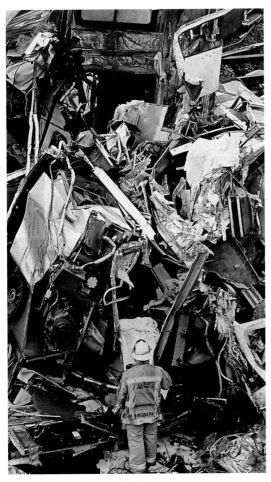

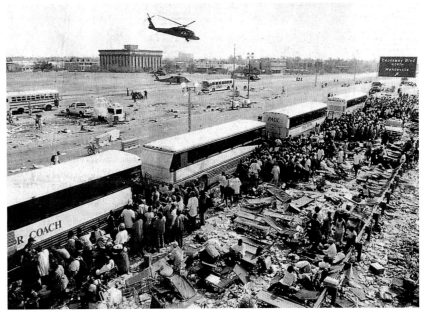

The Times-Picayune
New Orleans
Eliot Kamenitz, Staff Photographer
Photography / Single photos / Spot news

Los Angeles Times
Brian Vander Brug, Photographer; **Photo Staff;**
Bill Gaspard, News Design Director; **Dan Santos,** Design Editor
Photography / Single photos / Spot news

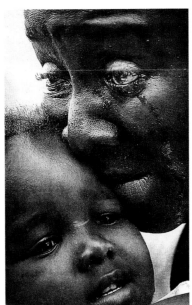

Austin American-Statesman
Texas
Matt Rourke, Staff Photographer; **Zach Ryall,**
Director/Photography
Photography / Single photos / Spot news

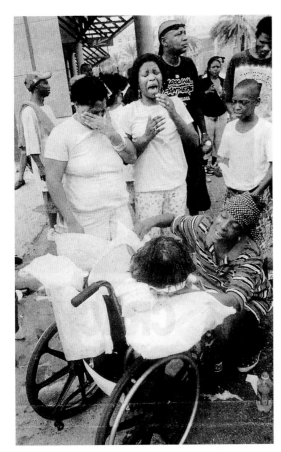

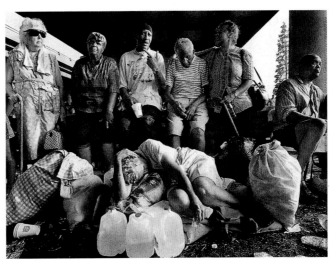

The Times-Picayune
New Orleans
David Grunfeld, Staff Photographer
Photography / Single photos / Spot news

L.A. Weekly
Los Angeles
Carolyn Cole, Photographer; **Photo Staff; Michael Whitley,** Deputy Design Director
Photography / Single photos / Spot news

Los Angeles Times
Carolyn Cole, Photographer; **Photo Staff; Dan Santos,** Design
Editor; **Michael Whitley,** Deputy Design Director;
Bill Gaspard, News Design Director
Photography / Single photos / Spot news

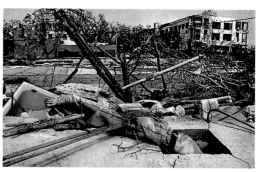

Toronto Star
Lucas Oleniuk, Photographer
Photography / Single photos / Spot news

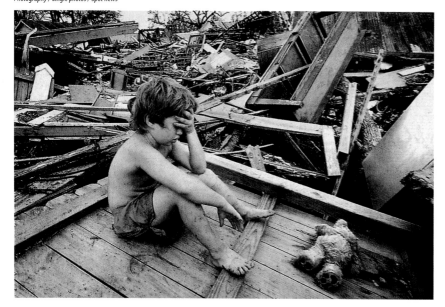

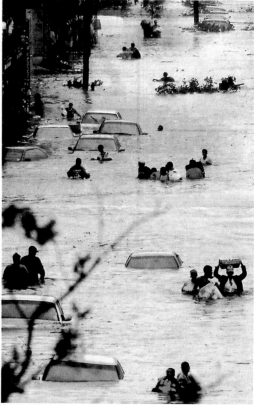

The Virginian-Pilot
Norfolk
Steve Earley, Photographer; **Alex Burrows,** Director of Photography;
Deborah Withey, Deputy M.E., Presentation
Photography / Single photos / Spot news

St. Petersburg Times
Fla.
Douglas R. Clifford, Photographer
Photography / Single photos / Spot news

El Universal
México City
Roberto L. Rock, General Editorial Director; **Francisco Santiago,**
Edition Director; **Oscar Santiago Méndez,** Art and Design Director;
Rubén Álvarez, Information Director; **Raúl Estrella,** Photographer;
Fernando Villa del Angel, Photo Editor; **Damián Martínez,**
Coordinator Design; **Emilio Deheza,** Design Consultant
Photography / Single photos / Spot news

The Globe and Mail
Toronto

John Lehmann, Photographer; **Erin Elder,** Photo Editor; **David Pratt,** Executive Art Director; **Moe Doiron,** Deputy Photo Editor; **Randall Moore,** Assistant Photo Editor

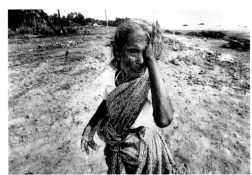

Rocky Mountain News
Denver

Judy DeHaas, Photographer

Photography / Single photos / Spot news

The Daytona Beach News-Journal
Fla.

Roger Simms, Photographer; **Jim Michalowski,** Photo Editor; **Sam Cranston,** A.M.E./Photo

Photography / Single photos / Spot news

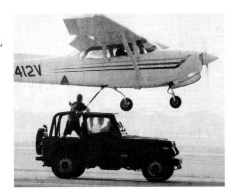

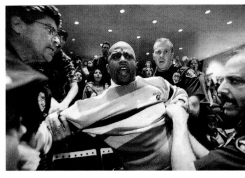

Rocky Mountain News
Denver

Todd Heisler, Photographer

Photography / Single photos / Spot news

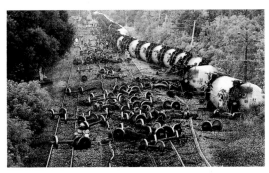

Ottawa Citizen
Bruno Schlumberger, Photographer

Photography / Single photos / Spot news

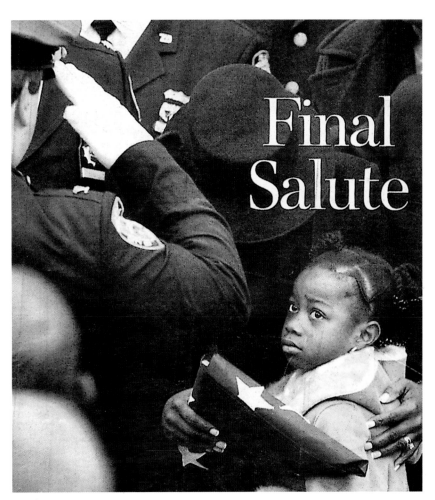

Expreso
Hermosillo, México

Eleazar Escobar, Photographer; **Jesús Bernardo Ballesteros Aguilar,** Photo Editor; **Carlos Villa Domínguez,** Designer; **Giovanna Espriella Moreno,** Art Director; **Juan Carlos Zúñiga,** Editorial Director; **Martín Holguín Alatorre,** General Director; **Alexander Probst Pruneda,** Design Consultant

Photography / Single photos / Spot news

Newsday
Melville, N.Y.

Robert Mecea, Staff Photographer

Photography / Single photos / Spot news

The Times-Picayune
New Orleans

Ted Jackson, Staff Photographer

Photography / Single photos / Spot news

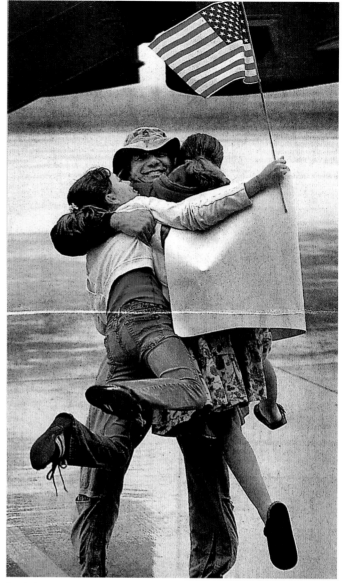

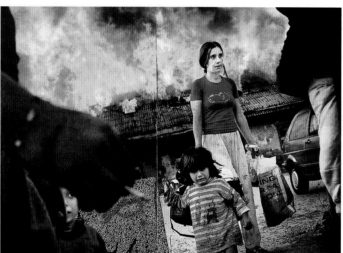

Dagens Nyheter
Stockholm, Sweden

Jonas Lindkvist, Photographer; **Pelle Asplund,** Art Director; **Anneli Steen,** Page Designer

Photography / Single photos / Spot news

Austin American-Statesman
Texas

Ralph Barrera, Staff Photographer; **Zach Ryall,** Director of Photography

Photography / Single photos / Spot news

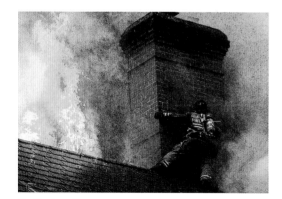

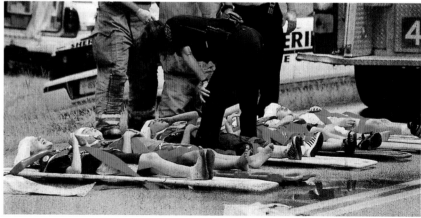

The Charlotte Observer
N.C.

Jeff Siner, Photographer; **Judy Tell,** Deputy Director of Photography; **Jeremy DeLuca,** Designer

Photography / Single photos / Spot news

The Daytona Beach News-Journal
Fla.

Chad Pilster, Photographer; **Jim Michalowski,** Photo Editor; **Sam Cranston,** A.M.E./Photo

Photography / Single photos / Spot news

The Baltimore Sun
Amy Davis, Photographer; **Robert Hamilton,** Director of Photography;
Monty Cook, DME/Presentation & News Editing
Photography / Single photos / Spot news

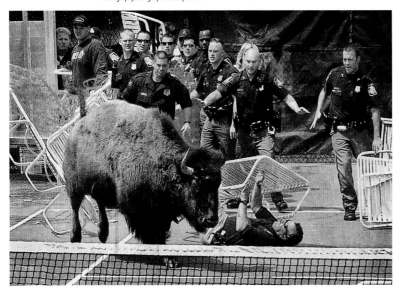

Toronto Star
Charla Jones, Photographer
Photography / Single photos / Spot news

The Guardian
London
Crispin Rodwell, Photographer
Photography / Single photos / Spot news

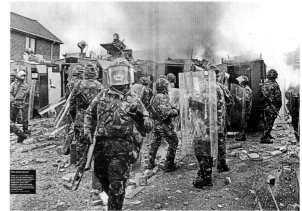

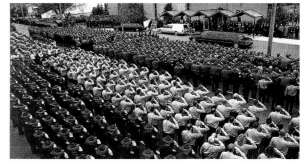

Pioneer Press
St. Paul, Minn.
Ben Garvin, Photographer; **Chris Stanfield,** Photo Director
Photography / Single photos / Spot news

Telegraph Herald
Dubuque, Iowa
Dave Kettering, Senior Photographer
Photography / Single photos / Spot news

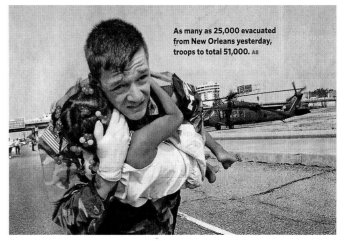

As many as 25,000 evacuated from New Orleans yesterday, troops to total 51,000. A8

Toronto Star
Lucas Oleniuk, Photographer
Photography / Single photos / Spot news

Richmond Times-Dispatch
Va.
Mark Gormus, Staff Photographer
Photography / Single photos / Sports

Hartford Courant
Conn.
Mark Mirko, Staff Photographer
Photography / Single photos / Sports

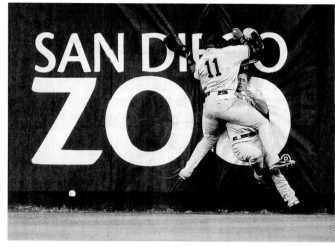

The Star-Ledger
Newark, N.J.
John Munson, Staff Photographer; **Seth Siditsky,** Sports Photo Editor; **Elly Oxman,** Assistant Sports Photo Editor; **Annette Vasquez,** Page Designer; **Tom Bergeron,** Sports Editor; **Pim VanHemmen,** A.M.E./Photography
Photography / Single photos / Sports

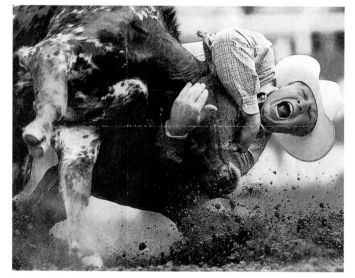

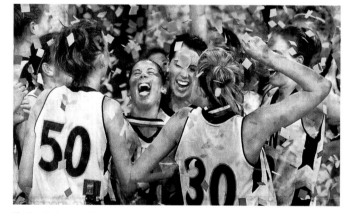

Calgary Herald
Alberta, Canada
Ted Rhodes, Staff Photographer
Photography / Single photos / Sports

The Des Moines Register
Iowa
Andrea Melendez, Photographer
Photography / Single photos / Sports

The Wenatchee World
Wash.
Don Seabrook, Picture Editor
Photography / Single photos / Sports

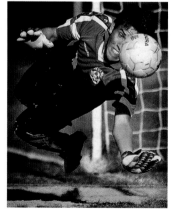

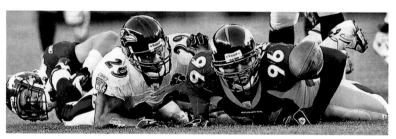

Rocky Mountain News
Denver
Barry Gutierrez, Photographer
Photography / Single photos / Sports

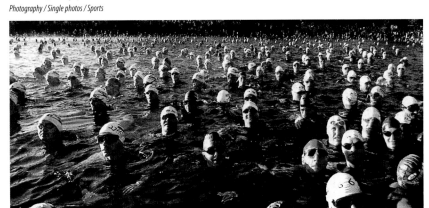

The Atlanta Journal-Constitution
Brant Sanderlin, Staff Photographer
Photography / Single photos / Sports

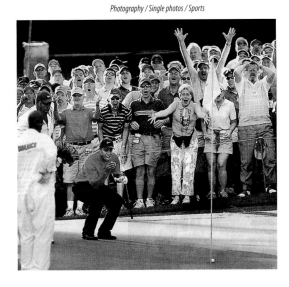

Los Angeles Times

Hal Wells, Photo Editor;
Kirk McKoy, Senior Photo Editor;
Wesley Bausmith, Designer;
Judy Pryor, Designer;
Don Kelsen, Photographer
Photography / Single photos / Sports

Rocky Mountain News
Denver
Joe Mahoney, Photographer
Photography / Single photos / Sports

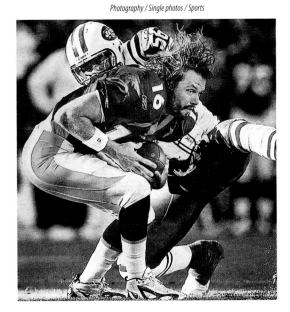

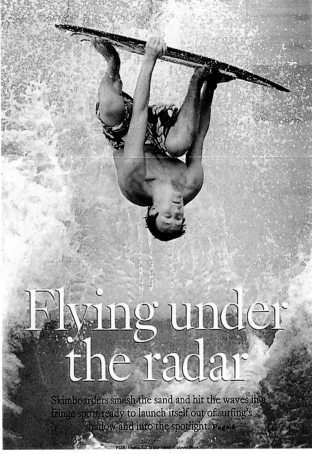

Flying under the radar

Skimboarders smash the sand and hit the waves in a fringe sport ready to launch itself out of surfing's shadow and into the spotlight. Page 4

The Star-Ledger
Newark, N.J.

John Munson, Staff
Photographer; **Seth Siditsky,**
Sports Photo Editor; **Elly Oxman,**
Assistant Photo Editor;
Annette Vasquez, Sports Page
Designer; **Tom Bergeron,** Sports
Editor; **Pim VanHemmen,**
A.M.E./Photography
Photography / Single photos / Sports

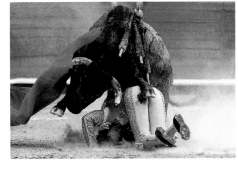

Récord
México City

Ricardo Flores, Photographer;
Daniel Gámez, Photo
Editor; **Pablo Lozano,** Editor;
Alejandro Gómez,
Editorial Director;
Hugo Alberto Sánchez,
Graphics Editor; **Alejo Nájera,**
Design Editor;
Alejandro Belman, Art Director
Photography / Single photos / Sports

The San Diego Union-Tribune
K.C. Alfred, Photographer; **Andy Hayt,** Director of
Photography; **Bruce Huff,** Photo Editor;
Jason Brown, Designer
Photography / Single photos / Sports

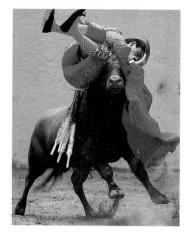

Récord
México City

Ricardo Flores, Photographer; **Daniel Gámez,**
Photo Editor; **Pablo Lozano,** Editor;
Alejandro Gómez, Editorial Director;
Hugo Alberto Sánchez, Graphics Editor;
Alejo Nájera, Design Editor;
Alejandro Belman, Art Director
Photography / Single photos / Sports

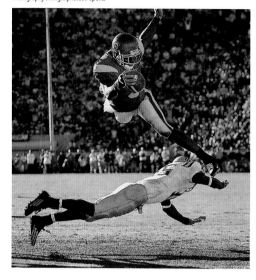

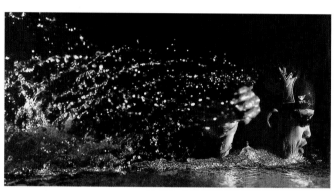

Toronto Star
Steve Russell, Photographer
Photography / Single photos / Sports

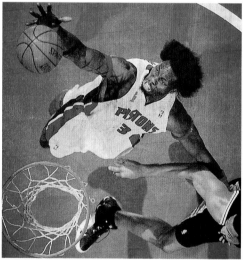

Detroit Free Press
Julian H. Gonzalez, Staff Photographer; **Gene Myers,** Sports Editor;
Diane Weiss, Photo Editor; **Steve Dorsey,** AME/Presentation;
Nancy Andrews, Director/Photography
Photography / Single photos / Sports

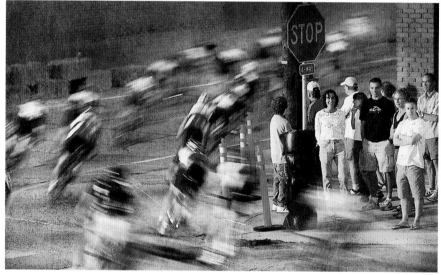

The Wenatchee World
Wash.
Don Seabrook, Photo Editor
Photography / Single photos / Sports

Los Angeles Times
Anne Cusack, Photographer;
Robert St. John, Photo
Editor; **Michael Whitley,**
Deputy Design Director
*Photography / Single photos /
Sports*

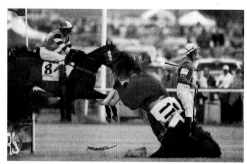

The State
Columbia, S.C.
Todd Bennett, Photographer
Photography / Single photos / Sports

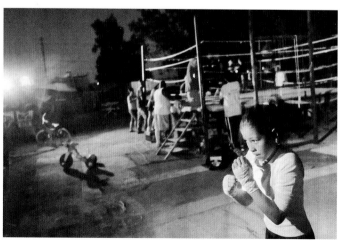

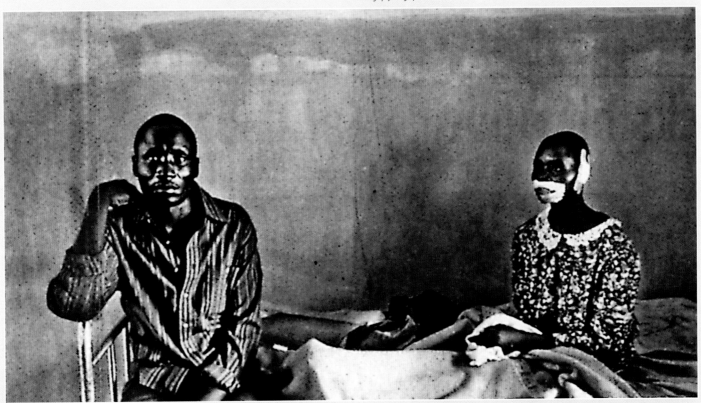

Mutilation is a common tactic of the Lord's Resistance Army, which has been fighting the Ugandan government for nearly two decades. This image of a husband and his mutilated wife is incredibly moving. The looks on their faces, the distance between them is chilling. It's a subtle photo that pulls you in. An example of exceptional photojournalism — you don't even need a caption on this photo.

La mutilación es una táctica común del Ejército de Resistencia del Señor, que ha estado luchando contra el gobierno de Uganda durante casi dos décadas. Esta imagen de un esposo y su mujer mutilada es increíblemente conmovedora. Las expresiones en sus rostros y la distancia entre ellos es aterradora. Es una foto sutil que jala del lector. Es un ejemplo de fotoperiodismo excepcional, tanto que ni siquiera se necesita un pie de foto.

The San Diego Union-Tribune

Sean M. Haffey, Photographer; **Andy Hayt,** Director of Photography; **Bruce Huff,** Photo Editor; **Josh Penrod,** Designer

Photography / Single photos / Sports

Récord

México City

Tonatiuh Figueroa, Photographer; **Daniel Gámez,** Photo Editor; **Pablo Lozano,** Editor; **Alejandro Gomez,** Editorial Director; **Hugo Alberto Sánchez,** Graphics Editor; **Alejo Nájera,** Design Editor; **Alejandro Belman,** Art Director

Photography / Single photos / Sports

The Boston Globe

Lane Turner, Photographer; **Leanne Burden,** Photo Editor; **Dan Zedek,** Design Director

Photography / Single photos / Feature

The Charlotte Observer
N.C.

Patrick Schneider, Photographer; **Judy Tell,** Deputy Director of Photography;
Leslie Wilkinson, News Design Team Leader

Photography / Single photos / Feature

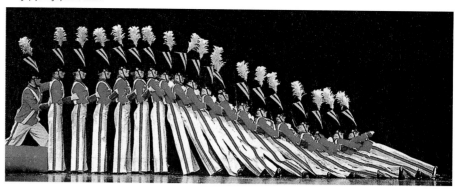

The Seattle Times
Alan Berner, Staff Photographer; **Barbara Kinney,** Photo Editor;
Susan Jouflas, Assistant Art Director/Features

Photography / Single photos / Feature

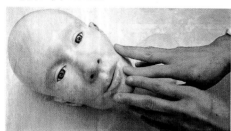

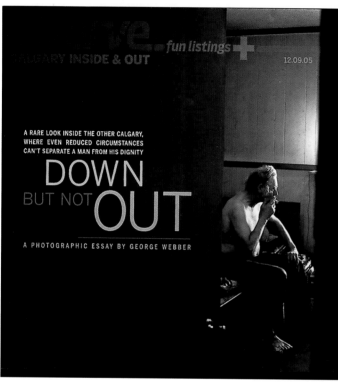

Swerve
Calgary, Alberta, Canada

Shelley Youngblut, Editor in Chief; **George Webber,** Photographer

Photography / Single photos / Feature

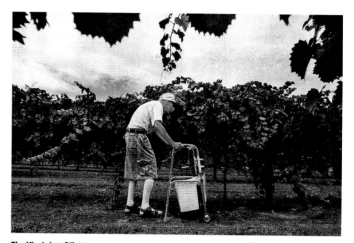

The Virginian-Pilot
Norfolk

Genevieve Ross, Photographer; **Alex Burrows,** Director/Photography;
Deborah Withey, Deputy M.E./Presentation

Photography / Single photos / Feature

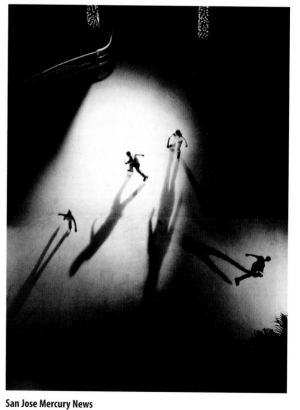

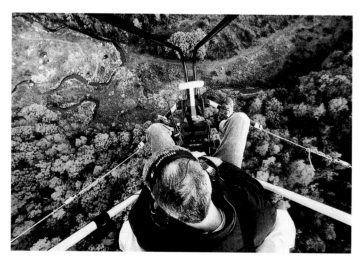

Telegraph Herald
Dubuque, Iowa

Dave Kettering, Senior Photographer

Photography / Single photos / Feature

San Jose Mercury News
Calif.

Pat Tehan, Photographer; **Matt Mansfield,** Deputy M.E.

Photography / Single photos / Feature

The Boston Globe

Emily Reid Kehe, Assistant Art Director; **David L. Ryan,** Photographer; **Doug Most,** Editor; **Brendan Stephens,** Art Director; **Dan Zedek,** Design Director

Photography / Single photos / Feature

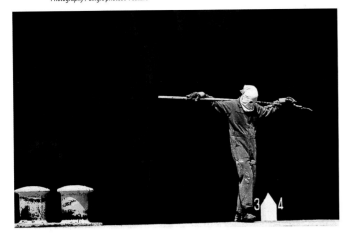

The Denver Post

Andy Cross, Photographer

Photography / Single photos / Feature

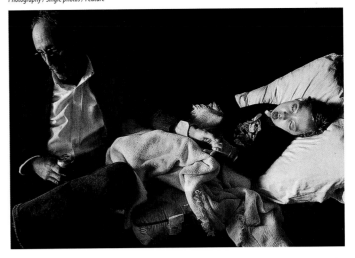

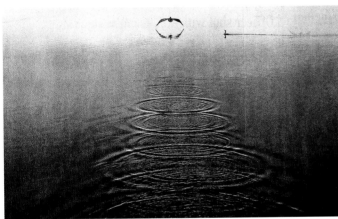

The Virginian-Pilot
Norfolk

Chris Curry, Photographer;
Alex Burrows, Director of
Photography; **Deborah Withey,**
Deputy M.E. Presentation

*Photography / Single photos /
Feature*

The Seattle Times

Alan Berner, Photographer;
Barbara Kinney, Picture Editor;
Sara Kennedy, Page Designer

*Photography / Single photos /
Feature*

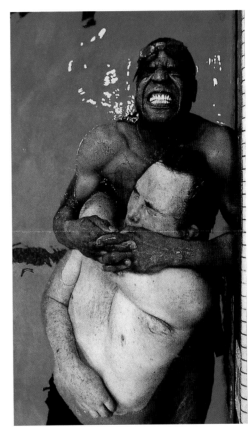

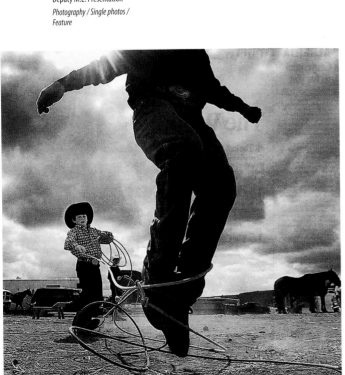

Calgary Herald
Alberta, Canada

Grant Black, Senior Photographer

Photography / Single photos / Feature

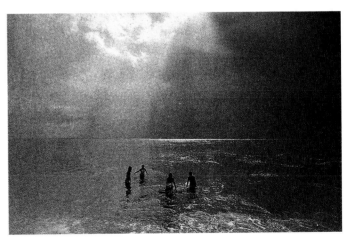

Richmond Times-Dispatch
Va.

Mark Gormus, Staff Photographer

Photography / Single photos / Feature

Rocky Mountain News
Denver
Chris Schneider, Photographer
Photography / Single photos / Feature

The Denver Post
RJ Sangosti, Photographer
Photography / Single photos / Feature

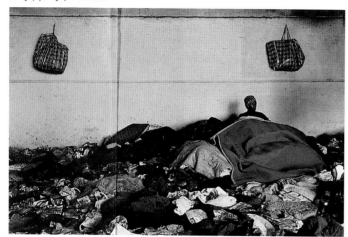

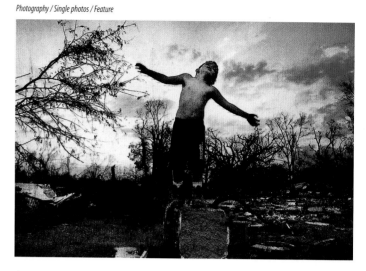

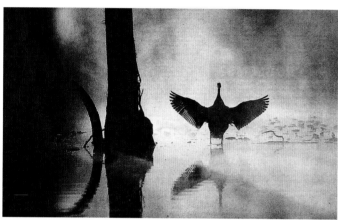

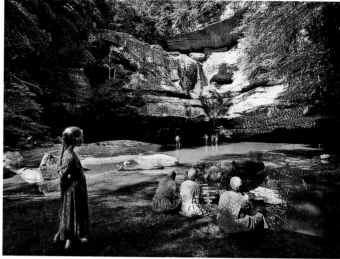

The Plain Dealer
Cleveland
Gus Chan, Photographer
Photography / Single photos / Feature

The Plain Dealer
Cleveland
Chris Stephens, Photographer
Photography / Single photos / Feature

Los Angeles Times
Carolyn Cole, Photographer; **Gail Fisher,** Photo
Editor; **Mary Cooney,** Photo Editor;
Michael Whitley, Deputy Design Director
Photography / Single photos / Feature

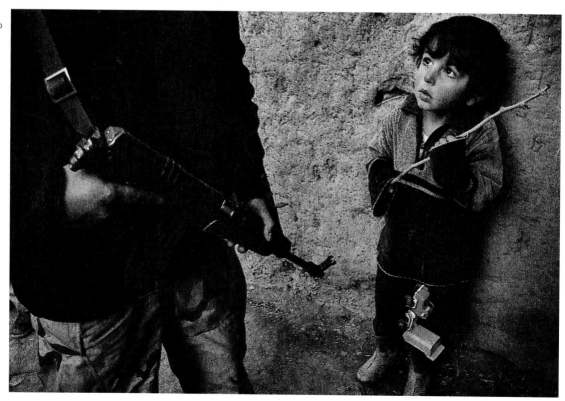

Milwaukee Journal Sentinel
Wis.

Sherman Williams, A.M.E./Photography; **Theresa Schiffer,** Designer; **David Joles,** Photographer

Photography / Single photos / Portrait

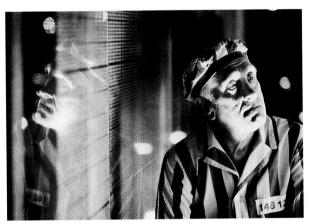

The Boston Globe
Brendan Stephens, Art Director; **Bill Brett,** Photographer; **Doug Most,** Editor; **Dan Zedek,** Design Director

Photography / Single photos / Portrait

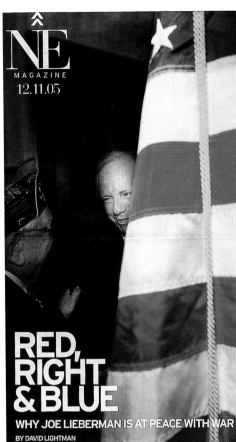

Hartford Courant
Conn.

Michael McAndrews, Staff Photographer

Photography / Single photos / Portrait

RED, RIGHT & BLUE
WHY JOE LIEBERMAN IS AT PEACE WITH WAR
BY DAVID LIGHTMAN

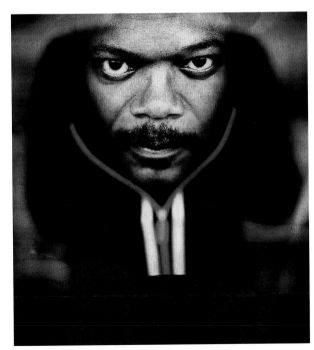

Los Angeles Times
Cindy Hively, Photo Editor; **Kirk McKoy,** Senior Photo Editor; **Jan Molen,** Designer; **Damon Winter,** Photographer

Photography / Single photos / Portrait

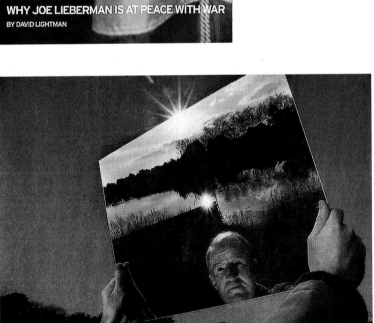

The Virginian-Pilot
Norfolk

Bill Tierman, Photographer; **Alex Burrows,** Director of Photography; **Deborah Withey,** Deputy M.E./Presentation

Photography / Single photos / Portrait

The Globe and Mail
Toronto

Fernando Morales, Photographer; **Erin Elder,** Photo Editor; **David Pratt,** Executive Art Director; **Brian Kerrigan,** Assistant Photo Editor; **David Woodside,** Associate Art Director

Photography / Single photos / Portrait

The Plain Dealer
Cleveland

Andrea Levy, Photographer

Photography / Single photos / Portrait

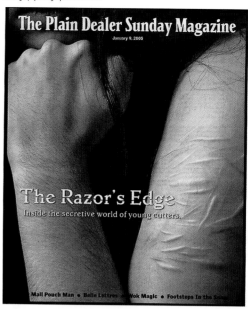

Toronto Star

Lucas Oleniuk, Photographer

Photography / Single photos / Portrait

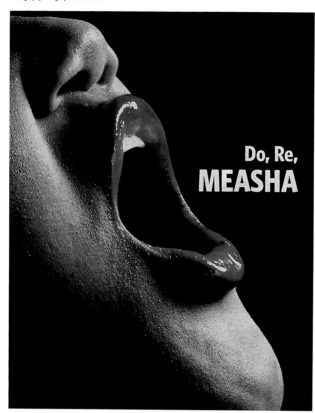

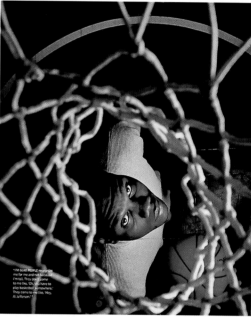

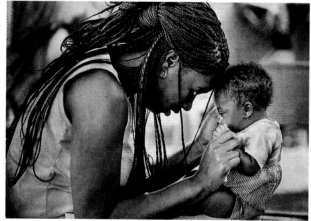

Rocky Mountain News
Denver

Ellen Jaskol, Photographer

Photography / Single photos / Portrait

The Boston Globe Magazine

Emily Reid Kehe, Assistant Art Director; **Dina Rudick,** Photographer; **Doug Most,** Editor; **Brendan Stephens,** Art Director; **Dan Zedek,** Design Director

Photography / Single photos / Portrait

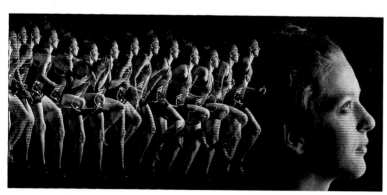

Seattle Post-Intelligencer

Mike Urban, Photographer

Photography / Single photos / Portrait

The Globe and Mail
Toronto

Jim Ross, Photographer; **Erin Elder,** Photo Editor; **David Pratt,** Executive Art Director; **Brian Kerrigan,** Assistant Photo Editor; **Cinders McLeod,** Design Director/Designer

Photography / Single photos / Portrait

Detroit Free Press

J. Kyle Keener, Chief Photographer; **Steve Dorsey,** AME/Presentation; **Nancy Andrews,** Director of Photography

Photography / Single photos / Illustration

The New York Times

Tony Cenicola, Photographer

Photography / Single photos / Illustration

St. Petersburg Times
Fla.

Bob Croslin, Photographer; **Patty Yablonski,** Features Photo Editor

Photography / Single photos / Illustration

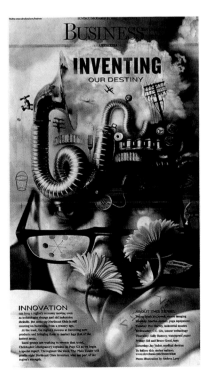

The Plain Dealer
Cleveland

Andrea Levy, Photographer/Illustrator

Photography / Single photos / Illustration

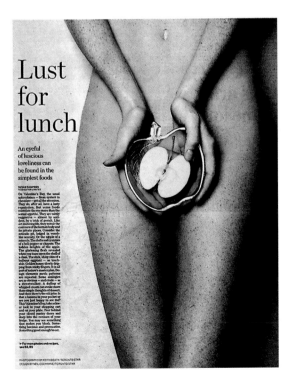

Toronto Star

Keith Beaty, Photographer

Photography / Single photos / Illustration

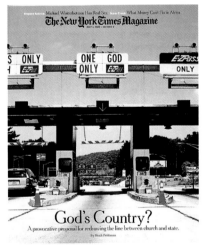

The New York Times Magazine

Janet Froelich, Creative Director; **Arem Duplessis,** Art Director; **Kristina Dimatteo,** Designer; **Kathy Ryan,** Photo Editor; **Jason Fulford,** Photographer

Photography / Single photos / Illustration

The Washington Post Magazine

J Porter, Art Director; **Keith Jenkins,** Photo Editor; **Jennifer Beeson,** Assistant Photo Editor; **Leslie Garcia,** Editorial Production Manager; **Carla Broyles,** Assistant Art Director; **Serge Bloch,** Illustrator

Photography / Single photos / Illustration

The New York Times Magazine

Janet Froelich, Creative Director; **Arem Duplessis,** Art Director; **Jeff Glendenning,** Designer; **Kathy Ryan,** Photo Editor; **Zachary Scott,** Photographer

Photography / Single photos / Illustration

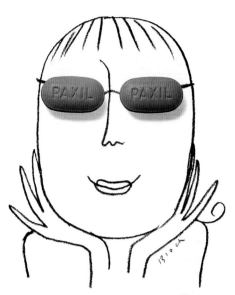

The Oregonian
Portland

Bruce Ely, Photographer; **Patty Reksten,** Director of Photography; **Lisa Cowan,** Designer

Photography / Single photos / Illustration

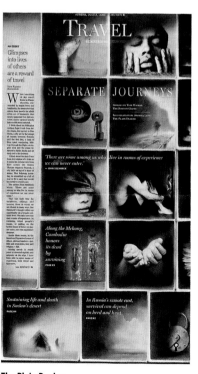

Hartford Courant
Conn.

Chris Moore, Assistant Art Director; **Beth Bristow,** Photo Editor; **Michael Kodas,** Photographer

Photography / Single photos / Illustration

The Plain Dealer
Cleveland

Andrea Levy, Photographer/Illustrator

Photography / Single photos / Illustration

The Plain Dealer
Cleveland

Andrea Levy, Photographer/Illustrator

Photography / Single photos / Illustration

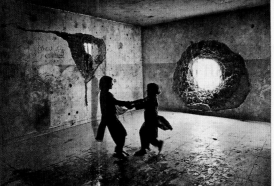

'To beat a woman is to love a woman'

This stunning statement from the lips of a taxi driver reminded Canadian photojournalist LANA SLEZIC just how male-dominated Afghan society remains. But that's hardly the whole story. As her compelling images, currently on display in Toronto, illustrate, the indomitable women of this troubled nation are slowly coming into their own

Behind the lens

SILVER

The Globe and Mail
Toronto

Lana Slezic, Photographer; **Erin Elder,** Photo Editor; **David Pratt,** Executive Art Director; **Brian Kerrigan,** Assistant Photo Editor; **Cinders McLeod,** Design Editor

Photography / Multiple photos / Project page or spread

This is a concisely edited photo spread on the struggle of women in the male-dominated Afghan society. Each image says something different, but all images work together. These photos evoke the sounds of the photo subjects — the girls giggling, the quiet steps up the stairs. The photos communicate the girls' hope and innocence, and the possible darkness of their future.

Ésta es una serie de fotos editada concisamente sobre la lucha de las mujeres en la machista sociedad afgana. Cada imagen dice algo diferente, pero todas funcionan como grupo. Estas fotos evocan los sonidos del tema de las fotos; las niñas que se ríen tímidamente y los silenciosos pasos que suben por la escalera. Las fotos comunican la esperanza y la inocencia de las niñas, y la posible oscuridad de su futuro.

The Times-Picayune
New Orleans, La.

Jennifer Zdon, Staff Photographer

Photography / Single photos / Illustration

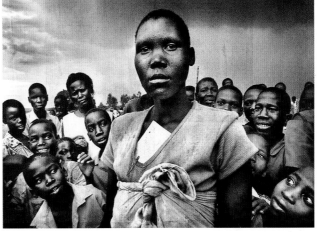

South Florida Sun-Sentinel
Fort Lauderdale

Andrew Innerarity, Staff Photographer

Photography / Single photos / Illustration

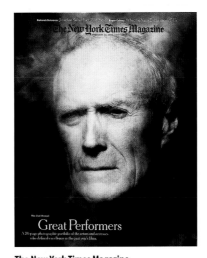

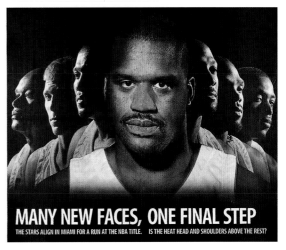

The New York Times Magazine

Janet Froelich, Creative Director; **Arem Duplessis,** Art Director; **Jeff Glendenning,** Designer; **Kathy Ryan,** Photo Editor; **Alexei Hay,** Photographer

Photography / Multiple photos / Project page or spread

The New York Times Magazine

Janet Froelich, Creative Director; **Arem Duplessis,** Art Director; **Guillermo Nagore,** Designer; **Kathy Ryan,** Photo Editor; **Inez Van Lamsweerde,** Photographer; **Vinoodh Matadin**

Photography / Multiple photos / Project page or spread

Toronto Star

Charla Jones, Photographer

Photography / Multiple photos / Project page or spread

The Press Democrat
Santa Rosa, Calif.

Kent Porter, Photographer

Photography / Multiple photos / Project page or spread

The New York Times Magazine

Janet Froelich, Creative Director; **David Sebbah,** Art Director; **Anne Christensen,** Fashion Editor; **Jean-Baptiste Mondino,** Photographer

Photography / Multiple photos / Project page or spread

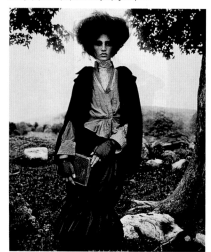

Dagens Nyheter
Stockholm, Sweden

Beatrice Lundborg, Photographer;
Pär Björkman, Photo Editor;
Anneli Steen, Page Designer;
Beatrice Hellman, Art Director

Photography / Multiple photos / Project page or spread

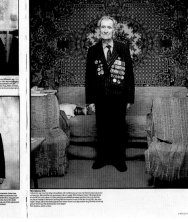

The New York Times Magazine

Janet Froelich, Creative Director; **Arem Duplessis,** Art Director; **Jeff Glendenning,** Designer; **Kathy Ryan,** Photo Editor; **Taryn Simon,** Photographer

Photography / Multiple photos / Project page or spread

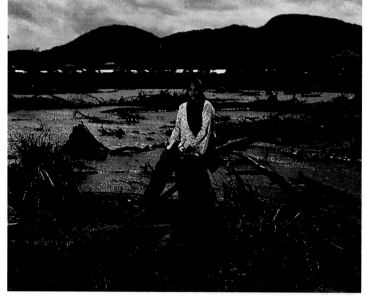

The Gazette
Montreal

Phil Carpenter, Photographer; **Lynn Farrell,** Photo Editor; **Nuri Ducassi,** Design Director; **Stu Cowan,** Sports Editor

Photography / Multiple photos / Project page or spread

The New York Times Magazine

Janet Froelich, Creative Director; **Arem Duplessis,** Art Director & Designer; **Kathy Ryan,** Photo Editor; **Lynsey Addario,** Photographer

Photography / Multiple photos / Project page or spread

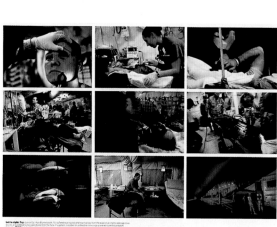

San Francisco Chronicle
Mike Kepka, Photographer; **James Merithew,** Photo Editor

Photography / Multiple photos / Project page or spread

Married, With Child

S.F.'s gay-marriage moment changed one family's status, but not their commitment

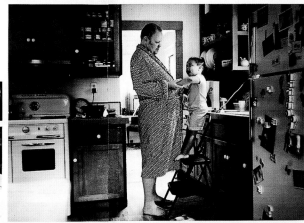

The Record
Kitchener, Ontario, Canada

Mirko Petricevic

Photography / Multiple photos / Series

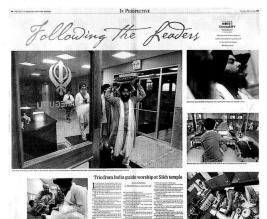

Trio from India guide worship at Sikh temple

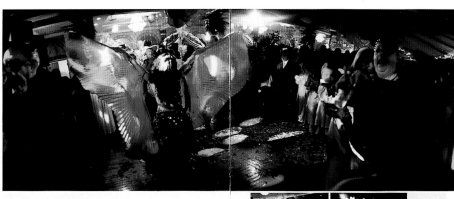

The New York Times Magazine
Janet Froelich, Creative Director; **Arem Duplessis,**
Art Director & Designer; **Kathy Ryan,** Photo Editor;
Elinor Carucci, Photographer

Photography / Multiple photos / Project page or spread

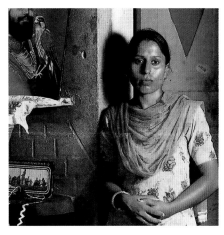

Calgary Herald
Alberta, Canada

Ted Rhodes, Staff Photographer; **Peter Brosseau,** Photo Editor;
Lorne Motley, Deputy Editor; **Malcolm Kirk,** Editor in Chief;
Darren Francey, Page Designer

Photography / Multiple photos / Series

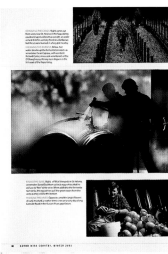

The Press Democrat
Santa Rosa, Calif.

John Burgess, Photographer

Photography / Multiple photos / Project page or spread

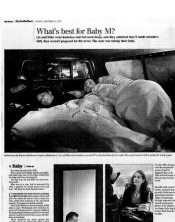

What's best for Baby M?

The Seattle Times
Mike Siegel, Photographer;
Fred Nelson, Photo Editor

*Photography / Multiple photos /
Project page or spread*

Los Angeles Times

Michael Whitley, Deputy Design Director; **Anne Cusack,** Photographer;
Robert St. John, Photo Editor; **Colin Crawford,** A.M.E./Photo;
Kurt Streeter, Writer; **David Bowman,** Copy Editor; **Rick Meyer,** Editor

Photography / Multiple photos / Series

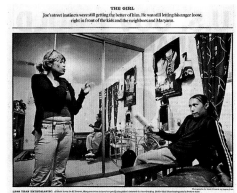

Rocky Mountain News

Denver

Judy DeHaas, Photographer; **Rodolfo Gonzalez,** Photographer

Photography / Multiple photos / Series

The New York Times Magazine

Janet Froelich, Creative Director; **Arem Duplessis,**
Art Director & Designer; **Kathy Ryan,** Photo Editor;
Alec Soth, Photographer

Photography / Multiple photos / Page design

SHEHILA:
"I never want to sleep in a shelter again"

Hardships fuel desire to succeed

Poverty, homelessness define teen's life,
but where she intends to take it

The Star-Ledger

Newark, N.J.

Saed Hindash, Staff Photographer;
Bumper DeJesus, Photo Editor for Perspective;
Lily Lu, Page Designer; **John Hassell,**
Perspective Editor; **Pim VanHemmen,**
A.M.E./Photography

Photography / Multiple photos / Series

The News Tribune

Tacoma, Wash.

Janet Jensen, Staff Photographer;
Russ Carmack, Staff Photographer;
Drew Perine, Staff Photographer

Photography / Multiple photos / Series

KATRINA'S AFTERMATH | THE JOB AHEAD

The Long, Hard Road Back

Los Angeles Times

Carolyn Cole, Photographer; **Gina Ferazzi,** Photographer; **Robert Gauthier,**
Photographer; **Mark Boster,** Photographer; **Genaro Molina,** Photographer;
Colin Crawford, A.M.E./Photography; **Mary Cooney,** Photo Editor;
Steve Stroud, Photo Editor; **Alan Hagman,** Photo Editor; **Julie Rogers,**
Photo Editor

Photography / Multiple photos / Series

The Sacramento Bee
Calif.

Robert Casey, A.M.E. / Visuals; **Sue Morrow,** Deputy Director of Photography; **Tim Reese,** Assistant Director of Photography; **Hector Amezcua,** Photographer

Photography / Multiple photos / Series

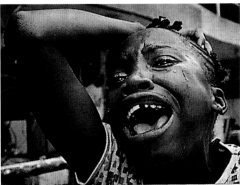

T DORCUS SOMO began dreaming of another world soon after her family died in a mortar burst and she was forced to room and board in strangers' homes. At night, Gift believed her sisters and brother appeared beside her sleeping mat. "Can't ow you to heaven? I want to be with you in heaven," she'd say. Gift was 15.

OMO FALA DUKOE ran toward gun battles with an 47 held high. Slow in speech but deft under fire, the soldier d with a ferocity that was rewarded with grilled meat and s of money. Momo was 14.

MUSU GERTEE had just finished prayers when her world was shattered by a falling rocket. Her father and mother gasped when they saw their only daughter and realized how war had changed her future. Musu's right hand was gone, sliced away by shrapnel. Musu was 6.

Chicago Tribune

Kuni Takahashi, Photographer; **Jonathan Elderfield,** Photo Editor; **Christine Spolar,** Writer; **Mike Miner,** Art Director

Photography / Multiple photos / Series

India's polio plight

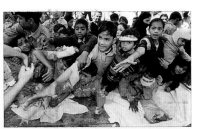

Pittsburgh Tribune-Review

Justin Merriman, Photographer

Photography / Multiple photos / Series

Hartford Courant
Conn.

Suzette Moyer, Director Design & Graphics; **Greg Harmel,** Designer; **John Scanlan,** Director Photography; **Thom McGuire,** A.M.E. Graphics Photography; **Richard Messina,** Photographer

Photography / Multiple photos / Series

"The real Kent is a mishmash, thank God. You can't cubbyhole Kent. It's got so many different facets. ... But it is a mix that works. It's all these diverse things that have to work together."

— Susi Williams

The Globe and Mail
Toronto

Kevin Van Paassen, Photographer; **Erin Elder,** Photo Editor; **David Pratt,** Executive Art Director; **Brian Kerrigan,** Assistant Photo Editor; **David Woodside,** Associate Art Director

Photography / Multiple photos / Series

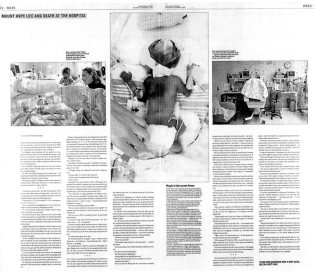

MOUNT HOPE LIFE AND DEATH AT THE HOSPITAL

MS-13: AN INTERNATIONAL FRANCHISE

'I think most of the police departments will agree that you're just getting them off the street for a couple of months.'

Los Angeles Times

Luis Sinco, Photographer; **Gail Fisher,** Photo Editor; **Michael Whitley,** Deputy Design Director; **Kelli Sullivan,** Deputy Design Director; **Joseph Hutchinson,** Creative Director

Photography / Multiple photos / Series

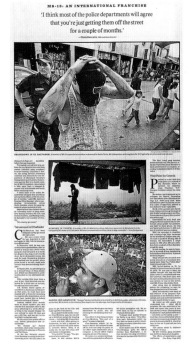

Concord Monitor
N.H.

Dan Habib, Photo Editor; **Preston Gannaway,** Staff Photographer; **Charlotte Thibault,** Graphic Artist; **Vanessa Valdes,** Typographer

Photography / Multiple photos / Page design

Concord Monitor
N.H.

Dan Habib, Photo Editor; **Lori Duff,** Photographer; **Vanessa Valdes,** Typographer

Photography / Multiple photos / Page design

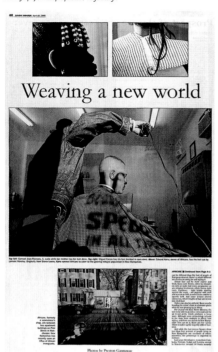

Weaving a new world

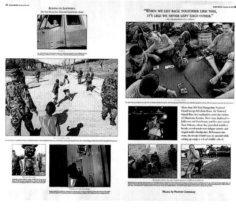

FALL
AS SEEN ON ROUTE 4
PHOTOS BY LORI DUFF

QUIET CROSSROADS AND ANCIENT PASTURELAND

Before fall fades to white, take a drive on the back roads heading Northwest

The New York Times Magazine

Janet Froelich, Creative Director; **Arem Duplessis,** Art Director & Designer; **Kathy Ryan,** Photo Editor; **Dan Winters,** Photographer

Photography / Multiple photos / Page design

Concord Monitor
N.H.

Dan Habib, Photo Editor; **Preston Gannaway,** Staff Photographer

Photography / Multiple photos / Page design

PHOTOGRAPHER'S EYE | SHERRY PETERS

IN PARIS, WE KISS

Los Angeles Times

Francine Orr, Photographer; **Gail Fisher,** Photo Editor; **Colin Crawford,** A.M.E./Photo; **Bill Gaspard,** News Design Director; **Michael Whitley,** Deputy Design Director; **Joseph Hutchinson,** Creative Director

Photography / Multiple photos / Page design

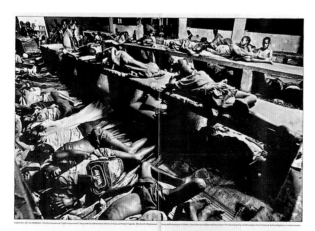

HORROR IN UGANDA
Terrorized by rebels, youths huddle in cities and the displaced languish in wretched camps

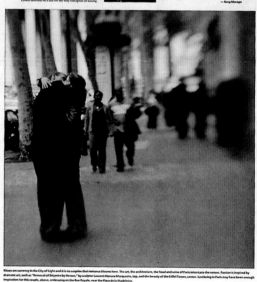

Hartford Courant
Conn.

Mel Shaffer, Designer; **Bruce Moyer,** Photo Editor; **Sherry Peters,** Photographer

Photography / Multiple photos / Page design

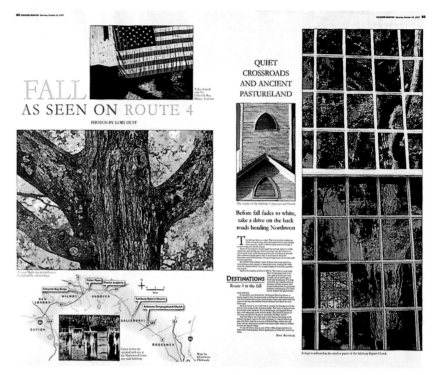

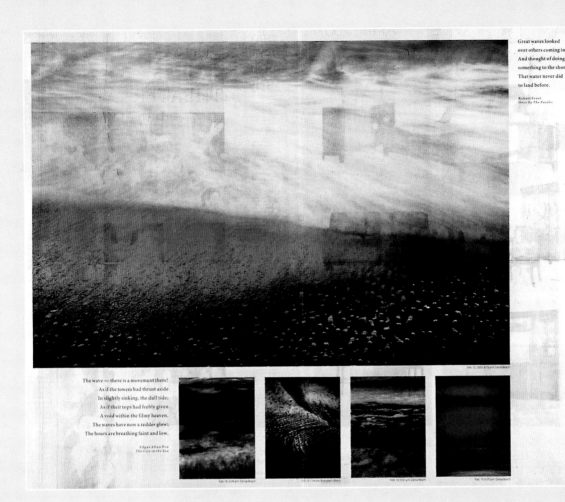

Great waves looked
over others coming in.
And thought of doing
something to the shore
That water never did
to land before.

Robert Frost
Once By The Pacific

The wave — there is a movement there!
As if the towers had thrust aside
In slightly sinking, the dull tide;
As if their tops had feebly given
A void within the filmy heaven.
The waves have now a redder glow;
The hours are breathing faint and low.

Edgar Allan Poe
The City in the Sea

SILVER

South Florida Sun-Sentinel
Fort Lauderdale

Laura Kelly, Features Designer;
Robert Mayer, Staff Photographer;
Mary Vignoles, Deputy Director of
Photography; **Tom Peyton,** Visual Editor;
Tim Rasmussen, Director of Photography;
Tim Frank, DME/Visuals/Creative Director

Photography / Multiple photos / Page design

This type of photography,
depicting the Atlantic
Ocean at sunrise,
isn't usually seen in
newspapers. The tension
between vertical and
horizontal. The wonderful
balance of colors and
white space. The subtle
changes in texture and
tones. This entry rises
above.

Este tipo de fotografía,
que muestra el Océano
Atlántico al amanecer, no
se ve corrientemente en
los periódicos. La tensión
entre los verticales y
los horizontales, el
maravilloso equilibrio de
los colores y el espacio
en blanco, los sutiles
cambios en textura
y tono. Esta pieza
concursante sobresale.

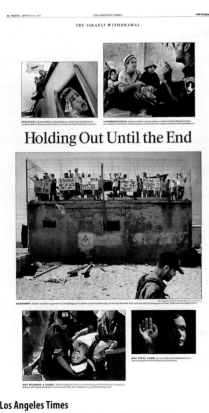

THE ISRAELI WITHDRAWAL

Holding Out Until the End

Los Angeles Times

Michael Whitley, Deputy Design Director; **Brian Vander Brug,**
Photographer; **David Rose,** Design Editor; **Steve Stroud,** Photo Editor;
Alan Hagman, Photo Editor; **Julie Rogers,** Photo Editor

Photography / Multiple photos / Page design

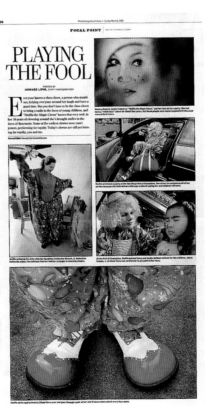

FOCAL POINT

PLAYING THE FOOL

PHOTOS BY
HOWARD LIPIN, STAFF PHOTOGRAPHER

The San Diego Union-Tribune

Amie Defrain, Page Designer; **Howard Lipin,** Photographer;
Michael Franklin, Photo Editor

Photography / Multiple photos / Page design

PROTECTING THE HABITAT

By CHELSEA COSHBOY

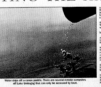
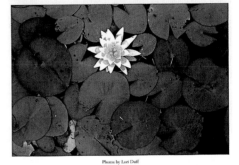

Photos by Lori Duff

Concord Monitor
N.H.

Dan Habib, Photo Editor

Photography / Multiple photos / Page design

San Jose Mercury News
Calif.

Matt Mansfield, Deputy M.E.; **Jonathon Berlin,** Senior Editor/Design & Graphics; **Geri Migielicz,** Director of Photography; **Mark Damon,** Deputy Director of Photography

Photography / Multiple photos / Page design

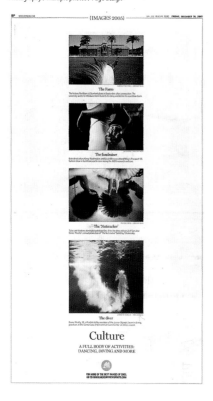

The San Diego Union-Tribune

Amie Defrain, Page Designer; **Peggy Peattie,** Photographer; **Michael Franklin,** Photo Editor

Photography / Multiple photos / Page design

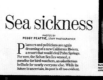
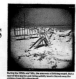
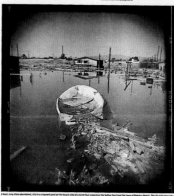

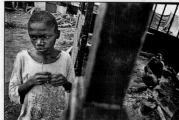
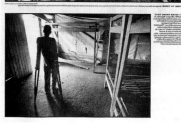

Hartford Courant
Conn.

Mel Shaffer, Designer; **Bruce Moyer,** Photo Editor; **John Woike,** Photographer; **Thom McGuire,** A.M.E. Graphics/Photo

Photography / Multiple photos / Page design

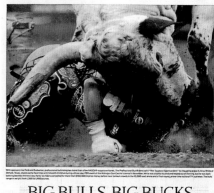
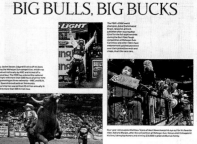

Hartford Courant
Conn.

Suzette Moyer, Designer; **Bruce Moyer,** Photo Editor; **Mark Mirko,** Photographer

Photography / Multiple photos / Page design

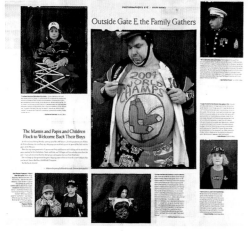

Rocky Mountain News
Denver

Amy Speer, Designer; **Jay Quadracci,** Picture Editor

Photography / Multiple photos / Page design

Los Angeles Times

Wally Skalij, Photographer; **Calvin Hom,** Photo Editor; **Mary Cooney,** Photo Editor; **Kelli Sullivan,** Deputy Design Director; **Michael Whitley,** Deputy Design Director; **Joseph Hutchinson,** Creative Director

Photography / Multiple photos / Page design

Hartford Courant
Conn.

Suzette Moyer, Director of Design/Graphics; **Bruce Moyer,** Photo Editor; **Tia Ann Chapman,** Photographer

Photography / Multiple photos / Page design

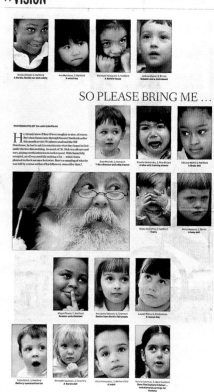

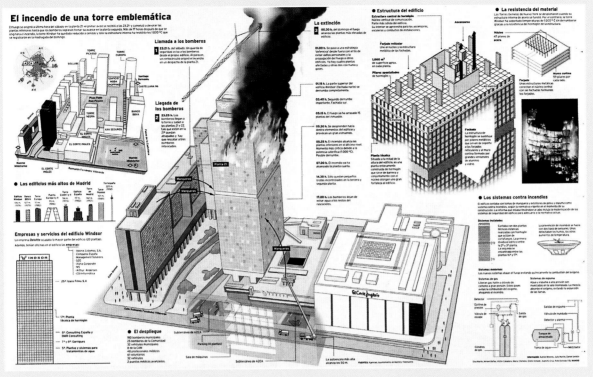

This is a shining example of breaking-news graphics. The information and layout made for an impressive spread. El Mundo artists delivered a great deal of visual effect in little time with much information.

Éste es un brillante ejemplo de gráficos noticiosos de último momento. La información y la diagramación lograron un impresionante serie. Los artista del diario El Mundo entregaron un significativo efecto visual en poco tiempo con mucha información.

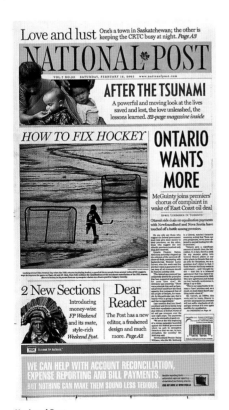

National Post
Toronto

Staff

Photography / Multiple photos, Use of

The Globe and Mail
Toronto

Staff

Photography / Multiple photos, Use of

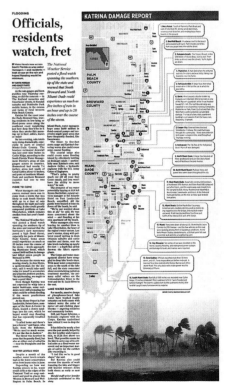

The Miami Herald

Eddie Alvarez, Presentation Editor; **Paul Cheung,** Graphics and Illustration Editor; **Marco Ruiz,** Graphics Reporter

Information graphics / Breaking news / 175,000 and over

Clarín

Buenos Aires, Argentina

Gustavo Lo Valvo, Art Director; **Alejandro Tumas**, Graphic Director;
Pablo Loscri, Graphics Editor; **Staff Artist**

Information graphics / Breaking news / 175,000 and over

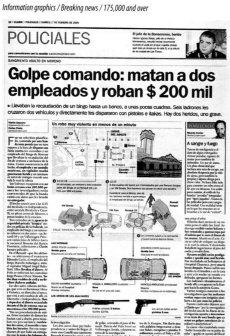

Clarín

Buenos Aires, Argentina

Gustavo Lo Valvo, Art Director; **Alejandro Tumas**, Graphic Director/Artist;
Pablo Loscri, Graphic Editor; **Gerardo Morel**, Artist

Information graphics / Breaking news / 175,000 and over

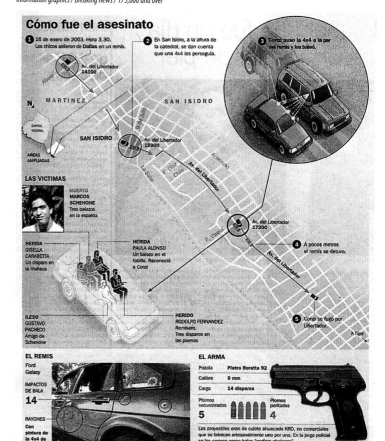

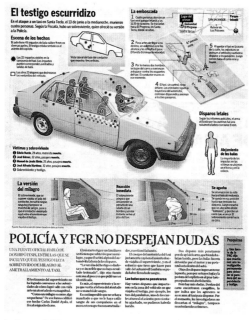

La Prensa Gráfica

San Salvador, El Salvador

Enrique Contreras, Design Editor; **Héctor Ramírez**, Design Co-Editor;
Oscar Corvera, Infographic Artist

Information graphics / Breaking news / 50,000-174,999

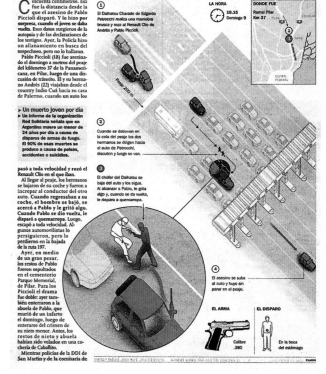

Clarín

Buenos Aires, Argentina

Gustavo Lo Valvo, Art Director; **Alejandro Tumas**, Graphic Director;
Pablo Loscri, Graphic Editor; **Staff Artist**

Information graphics / Breaking news / 175,000 and over

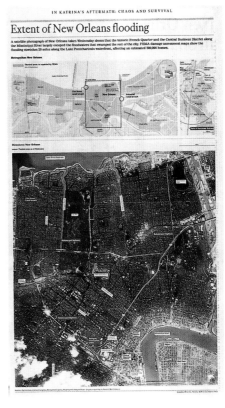

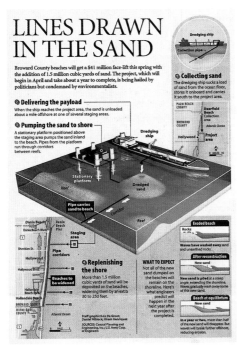

The top graphic:

EL CORREO DOMINGO, 20 DE MARZO DE 2005

Ciudadanos

La excavación de la estación más profunda de Renfe empezará en un mes en Miribilla

LA ESTACIÓN MÁS PROFUNDA DE RENFE
Bilbao Ría 2000 construirá a 42 metros de profundidad un nuevo apeadero para los 40.000 vecinos de Miribilla, San Adrián, Torre Urizar y Larraskitu.

Ría 2000 construirá a 42 metros de la superficie la nueva parada, que **dará servicio a 40.000 bilbaínos**

Será el apeadero de cercanías a menor cota en España

GRÁFICO: FERNANDO G. BAPTISTA



SILVER

El Correo
Vizcaya, Spain

Fernando G. Baptista, Editor

Information graphics / Breaking news / 50,000-174,999

The drawing tells the story so well. It also takes a flat diagram and turns it into a dynamic 3-D drawing that takes readers somewhere they couldn't go.

El dibujo relata la historia muy bien. También toma un diagrama plano y lo convierte en uno dinámico en 3-D y lleva a los lectores a un lugar al cual no podrían ir.

Bottom left graphic title:

LINES DRAWN IN THE SAND

South Florida Sun-Sentinel
Fort Lauderdale

Hiram Henriquez, Senior Graphics Reporter; **Daniel Niblock,** Senior Graphics Reporter; **Len DeGroot,** Assistant Graphics Director; **R. Scott Horner,** Assistant Graphics Director; **Don Wittekind,** Graphic Director; **Tim Frank,** Deputy M.E. Visuals; **Tom Peyton,** Visual Editor

Information graphics / Breaking news / 175,000 and over

Bottom right graphic title:

IN KATRINA'S AFTERMATH: CHAOS AND SURVIVAL

Extent of New Orleans flooding

Los Angeles Times

Lorena Iñiguez, Senior Graphic Artist; **Raoul Rañoa,** Senior Graphic Artist; **Brady MacDonald,** Graphics Reporter; **Les Dunseith,** Graphics Editor; **Joseph Hutchinson,** Creative Director

Information graphics / Breaking news / 175,000 and over

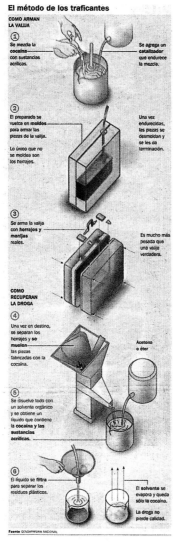

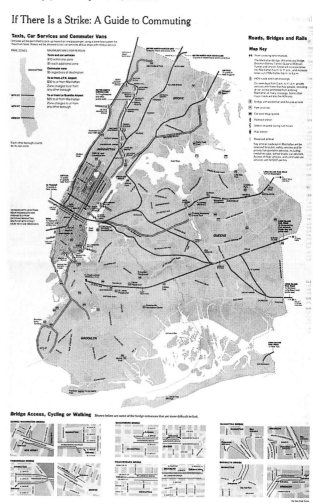

Clarín
Buenos Aires, Argentina

Gustavo Lo Valvo, Art Director;
Alejandro Tumas, Graphic Director;
Pablo Loscri, Graphic Editor; **Staff Artist**

*Information graphics / Breaking news /
175,000 and over*

The New York Times
Staff

Information graphics / Breaking news / 175,000 and over

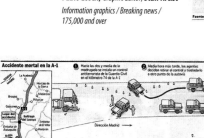

ABC
Madrid, Spain

Fernando Rubio, Chief Editor; **Elena Segura,** Infographics Artist
Information graphics / Breaking news / 175,000 and over

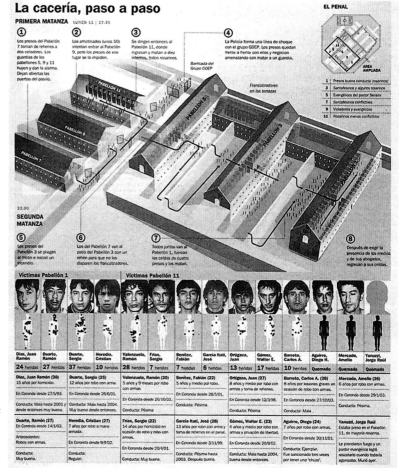

Clarín
Buenos Aires, Argentina

Gustavo Lo Valvo, Art Director;
Alejandro Tumas, Graphic
Director; **Pablo Loscri,** Graphic
Editor; **Staff Artist**

*Information graphics /
Breaking news / 175,000 and over*

ABC
Madrid, Spain

Fernando Rubio, Editor/Director; **Carlos Aguilera,** Infographics Artist

Information graphics / Breaking news / 175,000 and over

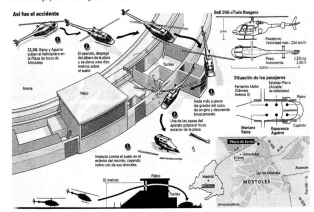

Clarín
Buenos Aires, Argentina

Gustavo Lo Valvo, Art Director; **Alejandro Tumas,** Graphic Director; **Pablo Loscri,**
Graphic Editor; **Staff Artist**

Information graphics / Breaking news / 175,000 and over

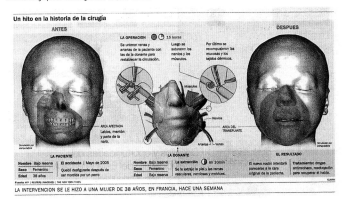

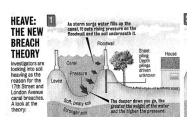

HEAVE: THE NEW BREACH THEORY

Investigators are looking into soil heaving as the reason for the 17th Street and London Avenue canal breaches. A look at the theory:

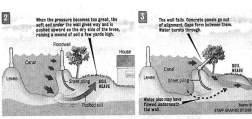

The Times-Picayune
New Orleans

Dan Swenson, Graphic Artist; **Angela Hill,** Graphics Editor

Information graphics / Breaking news / 175,000 and over

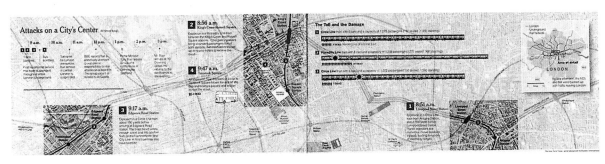

The Times-Picayune
New Orleans

Dan Swenson, Graphic Artist;
Angela Hill, Graphics Editor

Information graphics / Breaking news / 175,000 and over

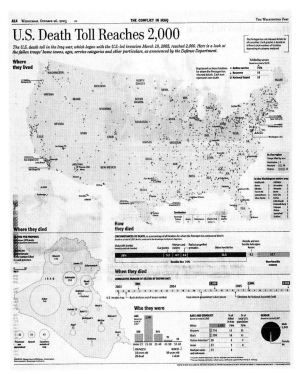

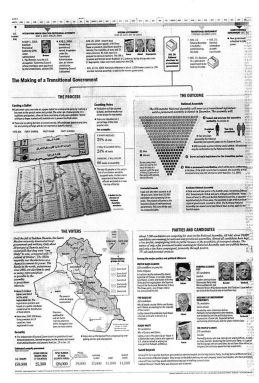

The Washington Post

Mary Kate Cannistra, Cartographer; **Nathaniel Vaughn Kelso,** Cartographer;
Farhana Hossain, News Artist; **Dita Smith,** Graphics Editor;
Robert E. Thomason, Researcher; **Meg Smith,** Researcher;
Larry Nista, Assistant Art Director; **Michael Keegan,** AME/News Art

Information graphics / Breaking news / 175,000 and over

The Washington Post

Farhana Hossain, News Artist; **Dita Smith,** Graphics Editor;
Laris Karklis, Assistant Art Director/Cartography; **Robert E. Thomason,**
Researcher; **Michael Keegan,** AME/News Art

Information graphics / Breaking news / 175,000 and over

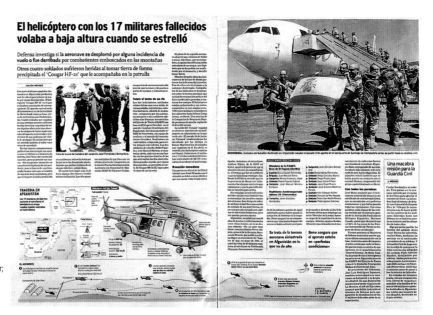

El helicóptero con los 17 militares fallecidos volaba a baja altura cuando se estrelló

Defensa investiga si la aeronave se desplomó por alguna incidencia de vuelo o fue derribada por combatientes emboscados en las montañas

Otros cuatro soldados sufrieron heridas al tomar tierra de forma precipitada el 'Cougar HF-21' que le acompañaba en la patrulla

El Correo
Vizcaya, Spain

Fernando G. Baptista, Editor;
Daniel García, Graphic Artist

Information graphics / Breaking news / 50,000-174,999

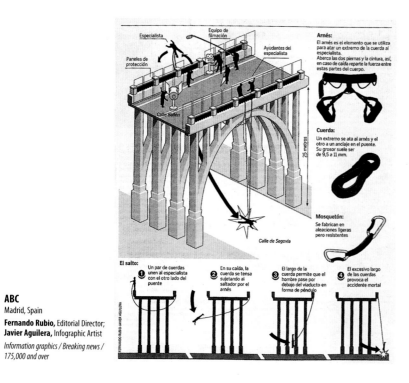

ABC
Madrid, Spain

Fernando Rubio, Editorial Director;
Javier Aguilera, Infographic Artist

Information graphics / Breaking news / 175,000 and over

In Rita's Wake

The Washington Post

Gene Thorp, Cartographer; **Nathaniel Vaughn Kelso,** Cartographer; **Laris Karklis,** Cartographer; **Farhana Hossain,** News Artist; **Seth Hamblin,** Graphics Editor; **Dennis Brack,** Deputy Art Director; **Larry Nista,** Assistant Art Director; **Michael Keegan,** AME/News Art

Information graphics / Breaking news / 175,000 and over

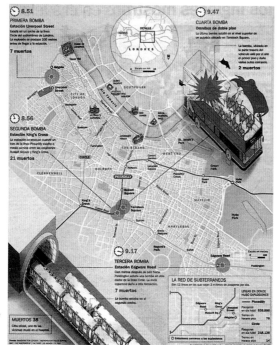

Clarín
Buenos Aires, Argentina

Gustavo Lo Valvo, Art Director; **Alejandro Tumas,** Graphic Director/Artist; **Pablo Loscri,** Graphic Editor/Artist; **Jorge Portaz,** Artist

Information graphics / Breaking news / 175,000 and over

Un avalancha de rocas inutiliza seis kilómetros de la autopista A-8 a la altura de Deba

La vía permaneció cortada todo el día y hoy se espera que den paso en ambos sentidos por el carril de San Sebastián

El Correo
Vizcaya, Spain

Fernando G. Baptista, Editor; **José Miguel Benítez,** Co-Editor

Information graphics / Breaking news / 50,000-174,999

The Orange County Register
Santa Ana, Calif.

Chantal Lamers, Graphics Reporter; **Scott Brown,** Graphic Artist

Information graphics / Non-breaking news, features / 175,000 and over

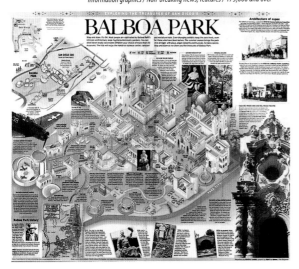

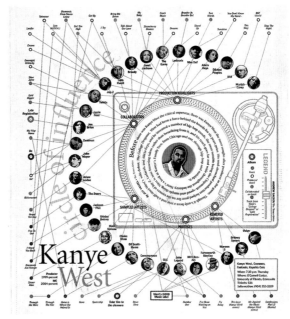

The Florida Times-Union
Jacksonville, Fla.

Andrew Saeger, News Graphic Artist

Information graphics / Non-breaking news, features / 175,000 and over

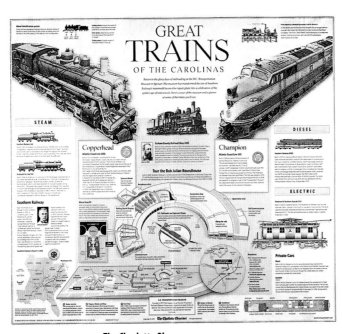

The Charlotte Observer
N.C.

David Puckett, Artist; **Joanne Miller,** Art Director; **Miriam Durkin,** Copy Editor; **Dee-Dee Strickland,** Multimedia Editor; **Sarah Franquet,** Design Director; **Tom Tozer,** Deputy M.E. Presentation

Information graphics / Non-breaking news, features / 175,000 and over

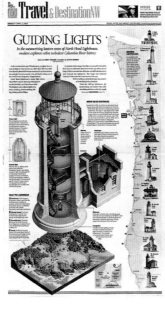

The Oregonian
Portland

Steve McKinstry, Art Director; **Steve Cowden,** Staff Artist

Information graphics / Non-breaking news, features / 175,000 and over

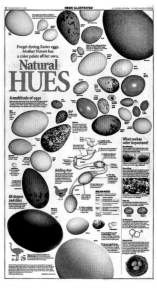

South Florida Sun-Sentinel
Fort Lauderdale

Belinda Long, Graphics Reporter; **Len DeGroot,** Assistant Graphics Director; **R. Scott Horner,** Assistant Graphics Director; **Don Wittekind,** Graphics Director; **Tom Peyton,** Visual Editor

Information graphics / Non-breaking news, features / 175,000 and over

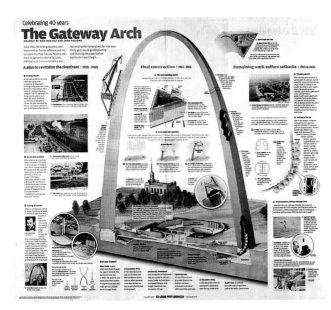

St. Louis Post-Dispatch

Rich Rokicki, Graphic Artist; **John Telford,** Graphic Artist; **Wade Wilson,** Design & Graphics Director

Information graphics / Non-breaking news, features / 175,000 and over

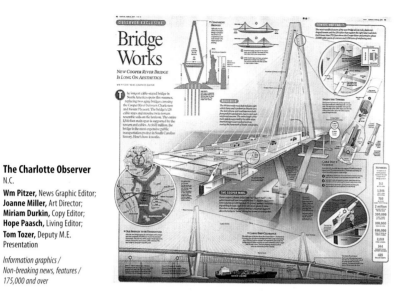

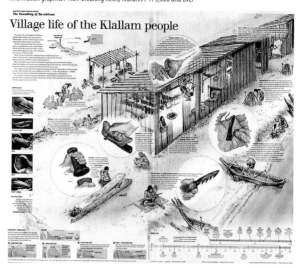

The Charlotte Observer
N.C.

Wm Pitzer, News Graphic Editor;
Joanne Miller, Art Director;
Miriam Durkin, Copy Editor;
Hope Paasch, Living Editor;
Tom Tozer, Deputy M.E.
Presentation

*Information graphics /
Non-breaking news, features /
175,000 and over*

The Seattle Times

Mark Nowlin, News Artist; **Paul Schmid,** News Artist; **Lynda V. Mapes,** Reporter;
Steve Ringman, Photographer; **Ted Basladynski,** Page Designer

Information graphics / Non-breaking news, features / 175,000 and over

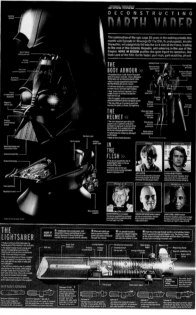

El Mundo
Madrid, Spain

Juantxo Cruz, Infographic Director; **Emilio Amade,** Graphic Artist; **Isabel González,**
Graphic Artist; **Daniel Izeddin,** Researcher; **Julio Martín,** Researcher

Information graphics / Non-breaking news, features / 175,000 and over

The Straits Times
Singapore

Mike M. Dizon, Executive Artist

Information graphics / Non-breaking news, features / 175,000 and over

The Indianapolis Star

Greg Nichols, Graphic Artist;
Robert Dorrell, Graphics Editor;
Phil Mahoney, Sports Designer;
Curt Cavin, Sports Writer;
Scott Goldman, A.M.E./Visuals

*Information graphics /
Non-breaking news, features /
175,000 and over*

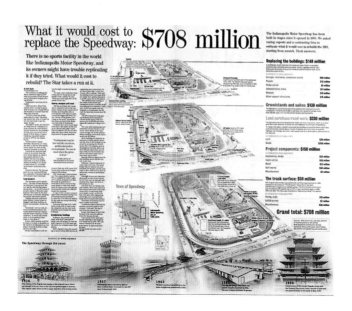

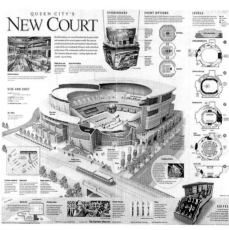

The Charlotte Observer
N.C.

David Puckett, Artist; **Joanne Miller,** Art Director; **Richard Rubin,** Reporter;
Chip Wilson, Copy Editor; **Sarah Franquet,** Design Director; **Tom Tozer,** Deputy
M.E. Presentation

Information graphics / Non-breaking news, features / 175,000 and over

El Correo
Vizcaya, Spain

Fernando G. Baptista, Editor

Information graphics / Non-breaking news, features / 50,000-174,999

El Correo
Vizcaya, Spain

Fernando G. Baptista, Editor

Information graphics / Non-breaking news, features / 50,000-174,999

El Correo
Vizcaya, Spain

Fernando G. Baptista, Editor

Information graphics / Non-breaking news, features / 50,000-174,999

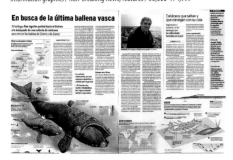

En busca de la última ballena vasca

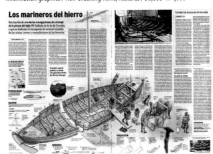

Los marineros del hierro

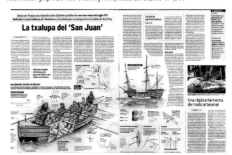

La txalupa del 'San Juan'

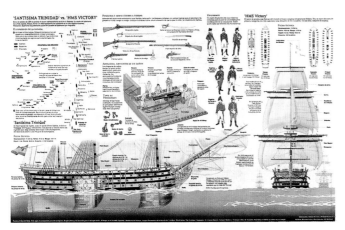

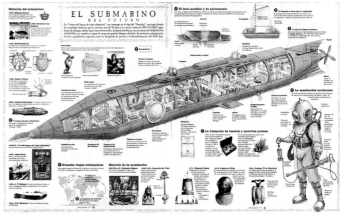

El Mundo
Madrid, Spain

Juantxo Cruz, Infographic Director; **Mariano Zafra,** Graphic Artist;
Rafael Estrada, Graphic Artist; **Alfonso Everlet,** Researcher; **Tristán Ramírez,**
Researcher

Information graphics / Non-breaking news, features / 175,000 and over

El Mundo
Madrid, Spain

Juantxo Cruz, Infographic Director; **Emilio Amade,** Graphic Artist; **Daniel Izeddin,** Researcher

Information graphics / Non-breaking news, features / 175,000 and over

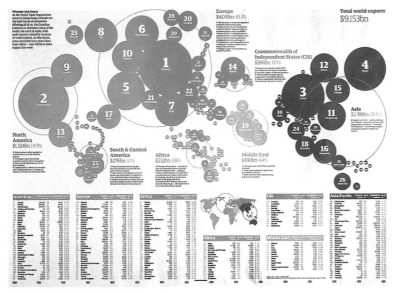

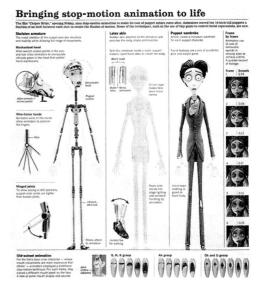

Bringing stop-motion animation to life

The Guardian
London

Staff

Information graphics / Non-breaking news, features / 175,000 and over

Los Angeles Times

Raoul Rañoa, Senior Graphic Artist; **Brady MacDonald,** Graphics Reporter

Information graphics / Non-breaking news, features / 175,000 and over

El Correo
Vizcaya, Spain

José Miguel Benítez, Co-Editor,
Information graphics

Non-breaking news, features / 50,000-174,999

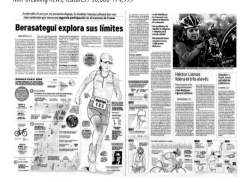

Berasategui explora sus límites

The Times-Picayune
New Orleans

Dan Swenson, Graphic Artist; **Angela Hill,** Graphics Editor

Information graphics / Non-breaking news, features / 175,000 and over

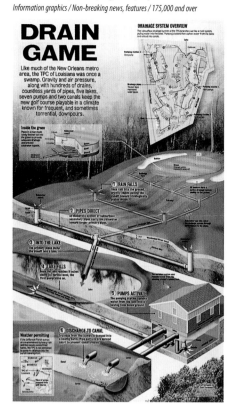

El Correo
Vizcaya, Spain

José Miguel Benítez, Co-Editor

Information graphics / Non-breaking news, features / 50,000-174,999

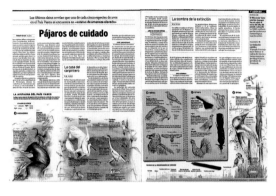

Pájaros de cuidado

Récord
México City

Arturo Fonseca, Art/Graphics
Co-Editor; **Rodrigo Morlesín,**
Designer/Section Designer;
Alejandro Gómez, Editorial Director;
Hugo Alberto Sánchez, Art/Graphics
Editor; **Alejo Nájera,** Design Editor;
Alejandro Belman, Art Director

Information graphics / Non-breaking news, features / 50,000-174,999

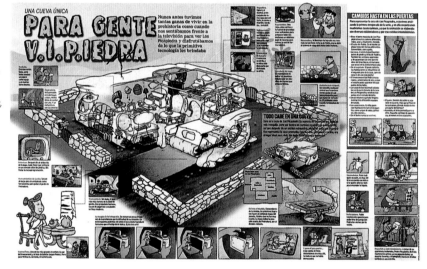

PARA GENTE V.I.P.IEDRA

USA Today
McLean, Va.

Dave Merrill, Illustrator

Information graphics / Charting / 175,000 and over

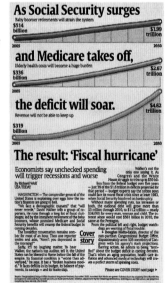

As Social Security surges
and Medicare takes off,
the deficit will soar.
The result: 'Fiscal hurricane'

ABC
Madrid, Spain

Staff

Information graphics / Charting / 175,000 and over

Sociedad
Los universitarios españoles son de izquierdas y uno de cada cuatro aspira a ser funcionario

A Century of Conclaves

Over the past century, the European and Italian presence in the conclaves of cardinals that elect the pope has dropped, as more cardinals have been appointed around the world and air travel has made it possible for far-flung cardinals to reach Rome in time to participate. Italians, who had a majority in the conclaves early in the 20th century, now represent 17 percent of the total.

Where the cardinals participating in the conclaves were from

1903
Pius X
Cardinal Giuseppe Sarto, patriarch of Venice

CARDINALS	62
BALLOTS	7
LENGTH	4 days

EUROPE 90%
NORTH AMERICA 2%
ITALY 61%

1914
Benedict XV
Cardinal Giacomo della Chiesa, archbishop of Bologna, Italy

CARDINALS	57
BALLOTS	3
LENGTH	3 days

EUROPE 96%
NORTH AMERICA 2%
LATIN AMERICA 2%
ITALY 54%

1922
Pius XI
Cardinal Achille Ratti, archbishop of Milan

CARDINALS	53
BALLOTS	14
LENGTH	5 days

EUROPE 100%
ITALY 57%

1939
Pius XII
Cardinal Eugenio Pacelli, secretary of state of the Catholic Church

CARDINALS	62
BALLOTS	3
LENGTH	2 days

NORTH AMERICA 6%
EUROPE 89%
ASIA 3%
ITALY 56%
LATIN AMERICA 3%

1958
John XXIII
Cardinal Angelo Roncalli, patriarch of Venice

CARDINALS	51
BALLOTS	11
LENGTH	4 days

NORTH AMERICA 8%
EUROPE 65%
ASIA 6%
ITALY 33%
LATIN AMERICA 18%
AFRICA 2%
OCEANIA 2%

1963
Paul VI
Cardinal Giovanni Battista Montini, archbishop of Milan

CARDINALS	80
BALLOTS	6
LENGTH	3 days

NORTH AMERICA 5%
EUROPE 60%
ASIA 6%
ITALY 34%
LATIN AMERICA 14%
AFRICA 1%
OCEANIA 1%

1978
John Paul I
Cardinal Albino Luciani, patriarch of Venice

CARDINALS	111
BALLOTS	4
LENGTH	2 days

NORTH AMERICA 10%
EUROPE 50%
ASIA 7%
ITALY 22%
LATIN AMERICA 17%
AFRICA 11%
OCEANIA 4%

1978
John Paul II
Cardinal Karol Wojtyla, archbishop of Krakow, Poland. First non-Italian pope since 1523.

CARDINALS	111
BALLOTS	8
LENGTH	3 days

NORTH AMERICA 11%
EUROPE 50%
ASIA 7%
ITALY 22%
LATIN AMERICA 17%
AFRICA 11%
OCEANIA 4%

The 2005 Conclave
While there are 163 cardinals, only 117 of them are younger than 80, making them eligible to vote. The age limit was set by Pope Paul VI in 1970.

NORTH AMERICA 12%
EUROPE 50%
ASIA 9%
ITALY 17%
LATIN AMERICA 18%
AFRICA 9%

Where Catholics live

With much of the growth in the church occurring outside of Europe, Latin America now makes up more than 4 out of every 10 Catholics. Italy, which has 17 percent of the cardinals eligible to vote, is home to only 5 percent of the world's Catholics.

NORTH AMERICA 7%
EUROPE 25%
ASIA 11%
LATIN AMERICA 43%
ITALY 5%
AFRICA 13%
OCEANIA 1%

Sources: Salvador Miranda, Florida International University; World Christian Database

Matthew Ericson/The New York Times

The New York Times

Matthew Ericson, Graphics Editor

Information graphics / Charting / 175,000 and over

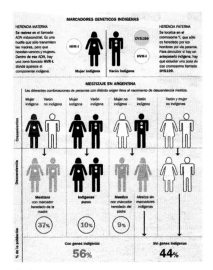

Clarín
Buenos Aires, Argentina

Gustavo Lo Valvo, Art Director; **Alejandro Tumas,** Graphic Director; **Pablo Loscri,** Graphic Editor; **Staff Artist**

Information graphics / Charting / 175,000 and over

128 years of rainfall in Los Angeles

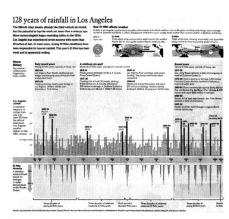

Los Angeles Times

Lorena Iñiguez, Senior Graphic Artist; **Raoul Rañoa,** Senior Graphic Artist; **Brady MacDonald,** Graphics Reporter; **Mark Phillips,** Weather Editor; **Malowy Moore,** Data Analyst; **Les Dunseith,** Graphics Editor

Information graphics / Charting / 175,000 and over

Part 1: Dubious Deals

The two faces of InfoSpace
1998-2001

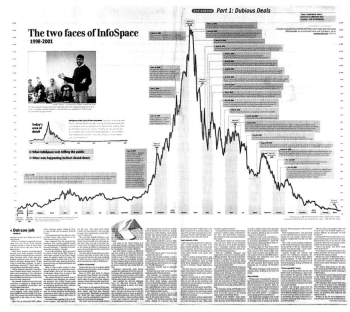

The Seattle Times

Kristopher Lee, News Artist; **Tracy Loeffelholz Dunn,** Page Designer

Information graphics / Charting / 175,000 and over

A season in review

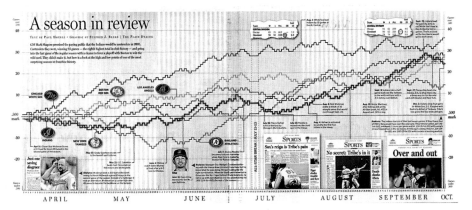

APRIL MAY JUNE JULY AUGUST SEPTEMBER OCT.

The Plain Dealer
Cleveland

Stephen J. Beard, Graphics Reporter; **Emmet Smith,** Designer; **Paul Hoynes,** Reporter; **Roy Hewitt,** Sports Editor; **Ken Marshall,** Graphics Editor; **David Kordalski,** A.M.E./Visuals

Information graphics / Charting / 175,000 and over

The Drive Charts

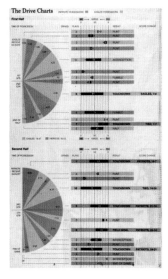

The New York Times

Joe Ward, Graphics Editor

Information graphics / Charting / 175,000 and over

The Seattle Times
Michele Lee McMullen,
News Artist

Information graphics / Charting /
175,000 and over

The high cost of heating your house

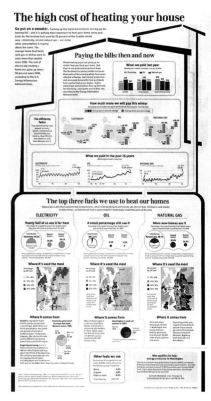

Paying the bills: then and now

The top three fuels we use to heat our homes

ELECTRICITY	OIL	NATURAL GAS
Nearly half of us use it for heat	A small percentage still use it	More new homes use it

The Star-Ledger
Newark, N.J.

Mary Yanni, Graphic Artist

Information graphics / Charting /
175,000 and over

AT&T | 1885–2005

The family 'T' gets smaller

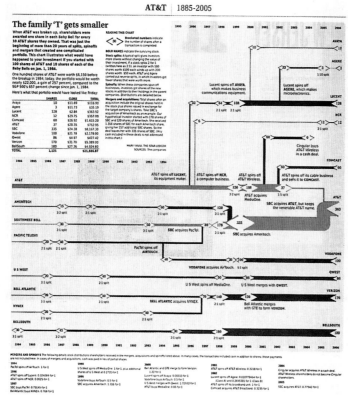

A mounting toll

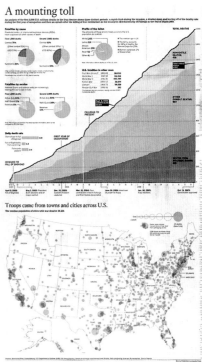

Troops came from towns and cities across U.S.

SOUTH FLORIDA SUN-SENTINEL · sun-sentinel.com

HURRICANE WILMA

C · SUNDAY, OCTOBER 23, 2005 **21A**

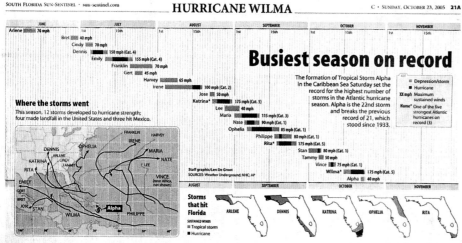

Busiest season on record

The formation of Tropical Storm Alpha in the Caribbean Sea Saturday set the record for the highest number of storms in the Atlantic hurricane season. Alpha is the 22nd storm and breaks the previous record of 21, which stood since 1933.

Where the storms went
This season, 12 storms developed to hurricane strength; four made landfall in the United States and three hit Mexico.

Storms that hit Florida
SUSTAINED WINDS
Tropical storm
Hurricane

Staff graphic/Len De Groot
SOURCES: Weather Underground; NHC; AP

South Florida Sun-Sentinel
Fort Lauderdale

Len DeGroot, Assistant Graphics Director; **R. Scott Horner,** Assistant Graphics Director;
Don Wittekind, Graphic Director; **Tim Frank,** DME/Visuals; **Tom Peyton,** Visual Editor

Information graphics / Charting / 175,000 and over

Los Angeles Times

Doug Stevens, Senior Graphics Artist; **Sandra Poindexter,** Data
Analyst; **Doug Smith,** Data Analyst; **Les Dunseith,** Graphics Editor;
Joseph Hutchinson, Creative Director; **Julie Sheer,** Assistant Graphics
Editor; **Thomas Lauder,** Assistant Graphics Editor; **Michael Whitley,**
Deputy Design Director

Information graphics / Charting / 175,000 and over

The New York Times

Matthew Ericson, Graphics Editor

Information graphics / Charting /
175,000 and over

A Corridor's Limits

While the Acela can reach 150 m.p.h., its average speed is much lower. Unlike many European systems, Amtrak was not able to lay straighter tracks and replace aging wires, limiting the train's speed in many places.

ACELA'S AVERAGE SPEED BETWEEN STATIONS	70 m.p.h	104	75	76	48	74	76	71	133

The 28 miles of track where the Acela Express can reach 150 m.p.h.

Between Washington and New York

HISTORIC TRAVEL TIMES	1965	Afternoon Congressional*	3 hours, 35 minutes
	1985	Express Metroliner	2 hours, 49 minutes
	2005	Acela Express	2 hours, 47 minutes

Between New York and Boston

1965	Yankee Clipper†	4 hours, 15 minutes
1985	Shoreliner Service	4 hours, 18 minutes
2005	Acela Express	3 hours, 22 minutes

Sources: Amtrak; Bureau of Transportation Statistics * Run by the Pennsylvania Railroad. † Run by the New Haven Railroad.

Matthew Ericson/The New York Times

The Dallas Morning News

Sergio Peçanha, Design Editor/Graphics; **Noel G. Gross,** Senior Designer/Editorial; **Sarah Hanan,** Presentation Editor

Information graphics / Charting / 175,000 and over

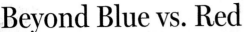

Beyond Blue vs. Red

What you think you know about the U.S. political divide is wrong. America's true colors span a spectrum

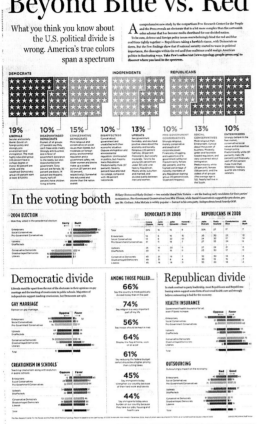

The Washington Post

Laura Stanton, Graphic Artist; **Karen Yourish,** Graphic Editor

Information graphics / Charting / 175,000 and over

Congress Moves to Bolster Personal Savings Rate

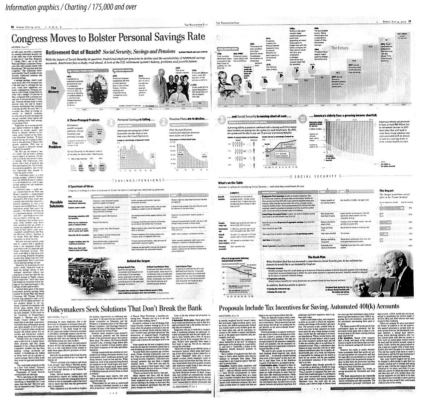

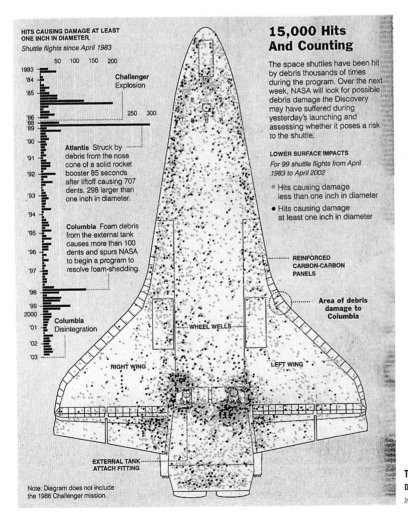

15,000 Hits And Counting

The space shuttles have been hit by debris thousands of times during the program. Over the next week, NASA will look for possible debris damage the Discovery may have suffered during yesterday's launching and assessing whether it poses a risk to the shuttle.

The New York Times

David Constantine, Graphics Editor

Information graphics / Charting / 175,000 and over

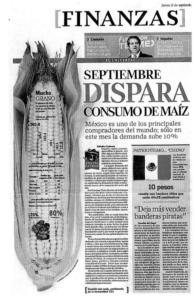

El Universal
México City

Roberto L. Rock, General Editorial Director; **Francisco Santiago,** Edition Director; **Oscar Santiago Méndez,** Art & Design Director; **Rubén Álvarez,** Information Director; **Roberto Aguilar,** Section Editor; **Hugo Loya,** Section Co-Editor; **Tomás Benítez,** Infographic and Illustration Coordinator; **Mauricio Gonzalez,** Infographic Artist; **Emilio Deheza,** Design Consultant

Information graphics / Charting / 50,000-174,999

The Times-Picayune
New Orleans

Dan Swenson, Graphic Artist

Information graphics / Mapping / 175,000 and over

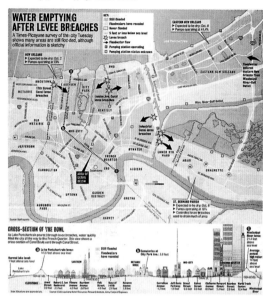

The New York Times

Archie Tse, Graphics Editor; **Joe Burgess,** Graphics Editor

Information graphics / Mapping / 175,000 and over

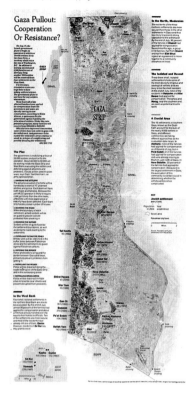

The Dallas Morning News

Layne Smith, Graphic Director; **Sergio Peçanha,** Design Editor/Graphics; **Tom Setzer,** Staff Artist

Information graphics / Mapping / 175,000 and over

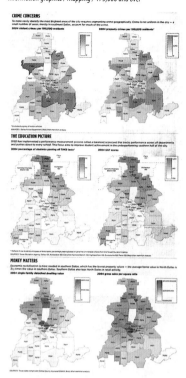

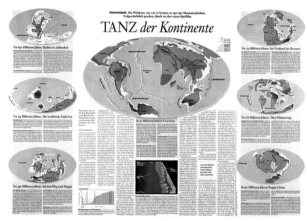

Frankfurter Allgemeine Sonntagszeitung
Frankfurt am Main, Germany

Thomas Heumann, Infographics Director; **Karl-Heinz Döring,** Infographics Artist; **Doris Oberneder,** Layouter; **Anja Horn,** Layouter (Kircher-Burkhardt); **Ulf von Rauchhaupt,** Science Editor

Information graphics / Mapping / 175,000 and over

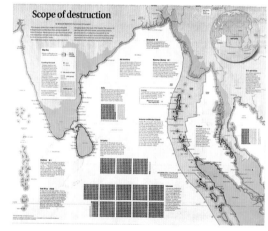

The Star-Ledger
Newark, N.J.

Hassan Hodges, Graphics Artist

Information graphics / Mapping / 175,000 and over

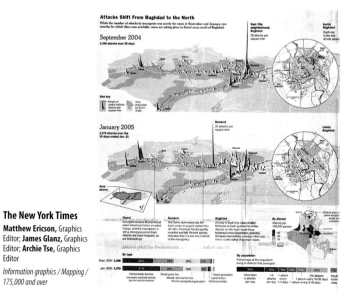

The New York Times

Matthew Ericson, Graphics Editor; **James Glanz,** Graphics Editor; **Archie Tse,** Graphics Editor

Information graphics / Mapping / 175,000 and over

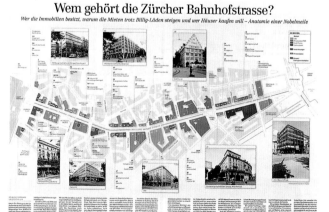

SonntagsZeitung
Zürich, Switzerland

Edith Huwiler, Infographics Artist; **Stefan Semrau,** Art Director

Information graphics / Mapping / 175,000 and over

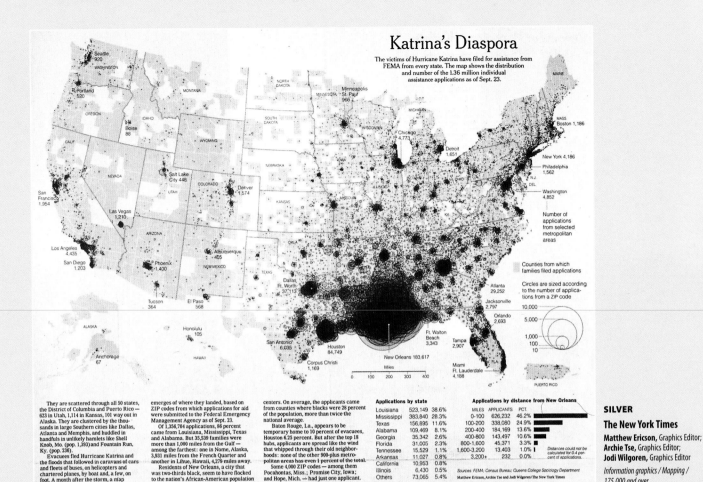

Katrina's Diaspora

The victims of Hurricane Katrina have filed for assistance from FEMA from every state. The map shows the distribution and number of the 1.36 million individual assistance applications as of Sept. 23.

Seattle 920
R-Portland 520
Boise 88
Salt Lake City 448
San Francisco 1,954
Denver 1,574
Las Vegas 1,210
Los Angeles 4,435
San Diego 1,203
Phoenix 1,400
Albuquerque 405
Tucson 364
El Paso 568
Dallas, Ft. Worth 37,113
San Antonio 6,035
Houston 84,749
Corpus Christi 1,169
New Orleans 183,617
Ft. Walton Beach 3,343
Tampa 2,907
Miami Ft. Lauderdale 4,188
Orlando 2,693
Jacksonville 2,797
Atlanta 29,252
Washington 4,852
DEL
Philadelphia 1,562
New York 4,186
Boston 1,186
Detroit 1,651
Chicago 4,773
Minneapolis St. Paul 966
Honolulu 105
Anchorage 67

Number of applications from selected metropolitan areas

Counties from which families filed applications

Circles are sized according to the number of applications from a ZIP code
10,000
5,000
1,000
100
10

Miles
0 100 200 300 400

PUERTO RICO

They are scattered through all 50 states, the District of Columbia and Puerto Rico — 623 in Utah, 1,114 in Kansas, 101 way out in Alaska. They are clustered by the thousands in large Southern cities like Dallas, Atlanta and Memphis, and huddled in handfuls in unlikely hamlets like Shell Knob, Mo. (pop. 1,393) and Fountain Run, Ky. (pop. 236).

Evacuees fled Hurricane Katrina and the floods that followed in caravans of cars and fleets of buses, on helicopters and chartered planes, by boat and, a few, on foot. A month after the storm, a map

emerges of where they landed, based on ZIP codes from which applications for aid were submitted to the Federal Emergency Management Agency as of Sept. 23.

Of 1,356,704 applications, 86 percent came from Louisiana, Mississippi, Texas and Alabama. But 35,539 families were more than 1,000 miles from the Gulf — among the farthest: one in Nome, Alaska, 3,931 miles from the French Quarter and another in Lihue, Hawaii, 4,279 miles away.

Residents of New Orleans, a city that was two-thirds black, seem to have flocked to the nation's African-American population

centers. On average, the applicants came from counties where blacks were 28 percent of the population, more than twice the national average.

Baton Rouge, La., appears to be temporary home to 10 percent of evacuees, Houston 6.25 percent. But after the top 18 hubs, applicants are spread like the wind that whipped through their old neighborhoods: none of the other 900-plus metropolitan areas has even 1 percent of the total.

Some 4,000 ZIP codes — among them Pocahontas, Miss.; Promise City, Iowa; and Hope, Mich. — had just one applicant.

Applications by state

Louisiana	523,149	38.6%
Mississippi	383,840	28.3%
Texas	156,895	11.6%
Alabama	109,469	8.1%
Georgia	35,342	2.6%
Florida	31,005	2.3%
Tennessee	15,529	1.1%
Arkansas	11,027	0.8%
California	10,953	0.8%
Illinois	6,430	0.5%
Others	73,065	5.4%

Applications by distance from New Orleans

MILES	APPLICANTS	PCT.
0-100	626,232	46.2%
100-200	338,080	24.9%
200-400	184,169	13.6%
400-800	143,497	10.6%
800-1,600	45,371	3.3%
1,600-3,200	13,403	1.0%
3,200+	232	0.0%

Distances could not be calculated for 0.4 percent of applications.

Sources: FEMA; Census Bureau; Queens College Sociology Department
Matthew Ericson, Archie Tse and Jodi Wilgoren/The New York Times

SILVER

The New York Times

Matthew Ericson, Graphics Editor;
Archie Tse, Graphics Editor;
Jodi Wilgoren, Graphics Editor

Information graphics / Mapping / 175,000 and over

How many people had to move after Hurricane Katrina? And where did they move? This map shows you, and it shows the connectivity of the nation. It also shows the power of information rendered in a creative way.

¿Cuánta gente tuvo que mudarse después del huracán Katrina? ¿A dónde se fueron? Este mapa lo muestra, y demuestra la conectividad del país. También muestra el poder de la información entregada de forma creativa.

Growing by leaps and bounds

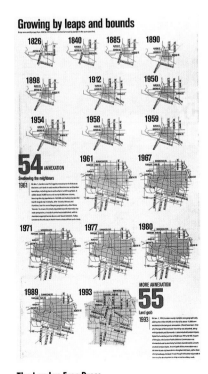

1826 1840 1885 1890
1898 1912 1950
1954 1958 1959
54 ANNEXATION
Swallowing the neighbors
1961 1961 1967
1971 1977 1980
1989 1993
55 Land grab
MORE ANNEXATION
1993

The London Free Press
Ontario, Canada

Susan Batsford, Designer; **Paul Berton,** Editor in Chief;
Joe Ruscitti, M.E.

Information graphics / Mapping / 50,000-174,999

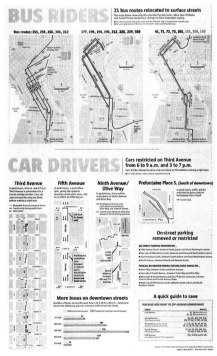

BUS RIDERS — 21 bus routes relocated to surface streets

Bus routes: 255, 256, 266, 306, 312
177, 190, 194, 196, 212, 225, 229, 550
41, 71, 72, 73, 301, 101, 106, 150

CAR DRIVERS

Cars restricted on Third Avenue from 6 to 9 a.m. and 3 to 7 p.m.

Third Avenue
Fifth Avenue
Ninth Avenue/Olive Way
Prefontaine Place S. (South of downtown)

On-street parking removed or restricted

More buses on downtown streets

A quick guide to save

The Seattle Times

Kriss Chaumont, News Artist

Information graphics / Mapping / 175,000 and over

Shootings in Philadelphia

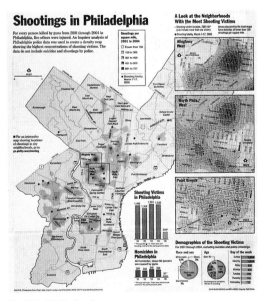

For every person killed by guns from 2001 through 2004 in Philadelphia, five others were injured. An Inquirer analysis of Philadelphia police data was used to create a density map showing the highest concentrations of shooting victims. The data do not include suicides and shootings by police.

A Look at the Neighborhoods With the Most Shooting Victims

Allegheny West
North Phila. West
Point Breeze

Shooting Victims in Philadelphia
Homicides in Philadelphia
Demographics of the Shooting Victims

The Philadelphia Inquirer

Kevin Burkett, Director of Newsroom Graphics & Design;
John Duchneskie, Graphics Editor; **Ben Koski,** Graphic Artist;
Rose Ciotta, Computer Assisted Reporter

Information graphics / Mapping / 175,000 and over

Lexington Herald-Leader
Ky.

Kenny Monteith, Presentation Editor; **Mark Cornelison,** Photographer; **Jason Moon,** Designer; **Ron Garrison,** Visual Editor; **Sharon Ruble,** Assistant Visual Editor; **Sally Scherer,** Features Editor

Miscellaneous

The Guardian
London

Staff

Miscellaneous

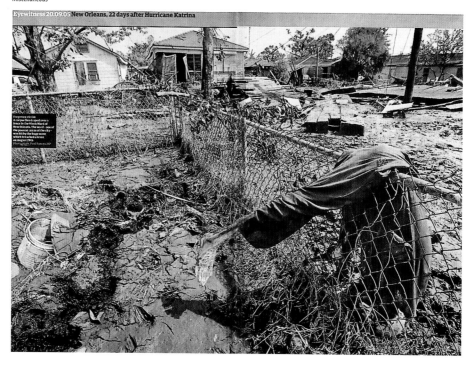

Eyewitness 20.09.05 New Orleans, 22 days after Hurricane Katrina

Chicago Tribune

Keith Claxton, Graphic Artist; **Max Rust,** Graphics Reporter; **Alex Garcia,** Photographer; **Patrick T. Reardon,** Reporter; **Tim Bannon,** Tempo Editor; **Hugo Espinoza,** Art Director; **Tom Heinz,** Art Director

Information graphics / Mapping / 175,000 and over

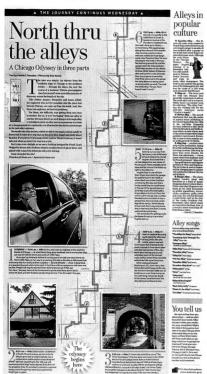

Wisconsin State Journal
Madison

Laura Sparks, Graphics Editor; **Mira Sotirovic,** Visiting Associate Professor, Professor of Journalism, University of Illinois

Information graphics / Mapping / 50,000-174,999

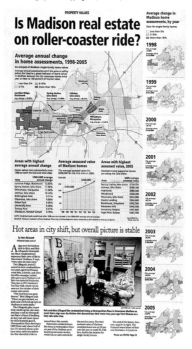

A Day of Hope and Havoc
New Orleans residents finally see a chance of escaping the devastated city, whose troubles grow to include fire.

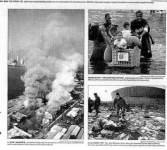

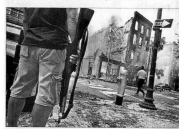

Los Angeles Times

Michael Whitley, Deputy Design Director; **Carolyn Cole,** Photographer; **Robert Gauthier,** Photographer; **Staff Photo Editor**

Miscellaneous

InDepth

SIX DAYS
OCT. 16-21, 2005, IN PICTURES

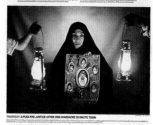

San Jose Mercury News
Calif.

Matt Mansfield, Deputy M.E.; **Jonathon Berlin,** Senior Editor/Design and Graphics; **Nick Masuda,** Designer; **Jeff Hindenach,** Designer; **Daymond Gascon,** Designer

Miscellaneous

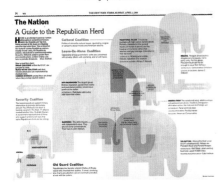

The New York Times
Staff

Information graphics, Use of

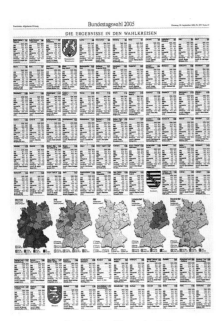

Frankfurter Allgemeine Zeitung
Frankfurt am Main, Germany
Staff

Information graphics, Use of

The Oregonian
Portland

Michelle D. Wise, Visuals Editor;
Marv Bondarowicz, Photographer;
René Eisenbart, Artist; **Joan Carlin,** Editor

Miscellaneous

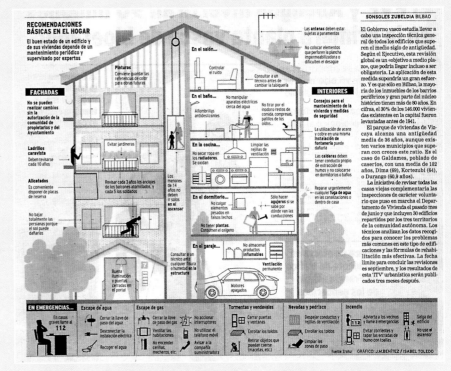

SONSOLES ZUBELDIA BILBAO

SILVER

El Correo
Vizcaya, Spain
Staff

Information graphics, Use of

A pocos metros de San Pedro

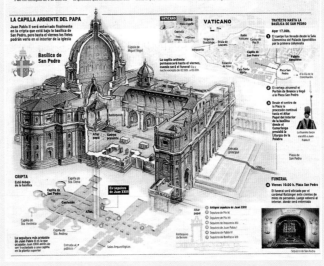

Flip to pages deep into El Correo, and the depth and beauty of the graphics never drop. Every graphic is elegant. Every graphic is consistent. Every graphic answers key questions about the stories it tells. Every graphic matches the design of the paper and is well integrated with the text. It is like a thread that flows from beginning to end.

Basta con dar vuelta las páginas de El Correo, y la profundidad y la belleza de los gráficos nunca decae. Cada uno de los gráficos es elegante. Cada uno es consistente. Cada uno responde las preguntas fundamentales sobre las historias que relata. Cada uno calza con el diseño del diario y está bien integrado con el texto. Es como un hilo que va de principio a fin.

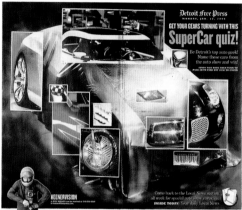

The Gold Coast Bulletin

Southport, Australia

Bob Gordon, Editor in Chief; **Bill Key,** Design Editor;
Sean Dutton, Senior Designer

Miscellaneous

Having trouble figuring out the cars that make up the Free Press SuperCar? Here's a clue to one of the photos:

For a mere $440,000, this exotic German car could be yours.

Remember, if you name the make and model of each vehicle that inspired our SuperCar, you'll be entered in the drawing for the grand prize — a portrait session for you and your family with Free Press Chief Photographer J. Kyle Keener. To enter the contest, visit the Free Press Web site at www.freep.com/autoshowcontest and complete the official entry form. We'll accept up to 10 entries per person or e-mail address, but they must be received by noon Monday. All entries must be submitted online; we will not accept entries in person or by mail or phone. Come back to Local News on Wednesday for another hint!

**NORTH AMERICAN
INTERNATIONAL
AUTO SHOW**

Where: Cobo Center, Detroit
Public show: Through Jan. 23
Times: 9 a.m.-10 p.m. through Jan. 22, 9 a.m.-7 p.m. Jan. 23
Ticket prices: $12; 65 and older: $6; Child: 12 and younger free with parent or guardian
More information: Visit www.naias.com

Stop by the Free Press booth when you're at the auto show. The booth is on Cobo's main concourse, near the Wayne Hall entrance. You'll get to meet Free Press columnists, plus pick up free copies of our 24-page special report: "GM, Asia and the new reality."

If you can't make it to the auto show but would like to read the GM series, originally published Dec. 20-23, we'll mail you a copy for $2. Just call 313-222-6598. Or you can check out the series at www.freep.com.

Here's the schedule of columnist appearances at the Free Press booth:
Today: Artist Mike Thompson from noon-2 p.m.; Mike Rosenberg, 2-4 p.m.; Mark Phelan, 4-6 p.m.
Wednesday: Mike Wendland, noon-2 p.m.; Mark Phelan, 4-6 p.m.

The Virginian-Pilot

Norfolk

Lori Kelley, Designer; **Deborah Withey,** Deputy M.E.
Presentation; **Erica Smith,** Copy Editor/Researcher;
Marquita Smith, Portsmouth Team Leader;
Jane Elizabeth, Senior Metro Editor;
Norm Shafer, Photo Editor

Miscellaneous

Small Newspapers

7

Sun Journal
Lewiston, Maine

Heather McCarthy, Senior Design Editor; **Pete Gorski,** News Artist; **Paul Wallen,** M.E./Visuals

News design, sections / Business / 49,999 and under

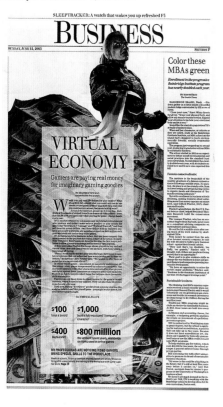

Sun Journal
Lewiston, Maine

Paul Wallen, M.E. / Visuals; **Steve Sherlock,** Sports Editor; **Bill Foley,** Assistant Sports Editor; **Ryan Powell,** Sports Design Editor

News design, sections / Sports / 49,999 and under

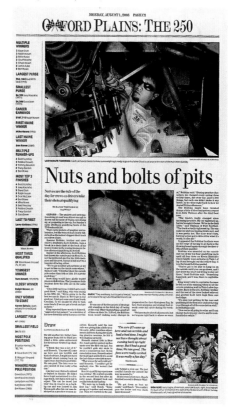

Sun Journal
Lewiston, Maine

Paul Wallen, M.E. / Visuals; **Peter Phelan,** AME/Nights; **Megan Lavey,** Design Editor; **Alicia Ford,** Design Editor

News design, sections / A-Section / 49,999 and under

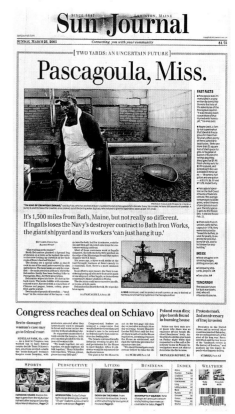

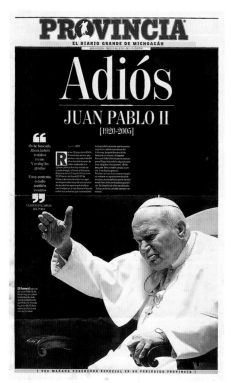

Periódico Provincia
Morelia, México

Àngel Muñoz Juárez, Designer, Photographer, Illustrator, Editor; **Erik Knobl,** Design Director; **Arcelia Guadarrama,** Editor/Co-Director; **Pablo César Carrillo,** Content Co-Director; **Manuel Baeza,** Editorial Director; **Luis Enrique López,** General Director

News design, page(s) / A-Section / 49,999 and under

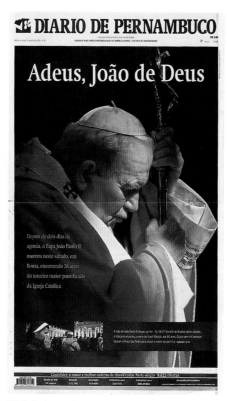

Diário De Pernambuco
Recife, Brazil

Vera Ogando, Newsroom Director; **Luis Carlos Ferrari,** Executive Editor; **Paula Losada,** Front Page Editor; **Humberto Santos,** Assistant Editor; **Christiano Mascaro,** Art Editor/Designer; **Otavio De Souza,** Photo Editor

News design, page(s) / A-Section / 49,999 and under

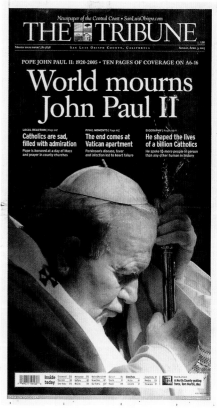

The Tribune
San Luis Obispo, Calif.

Joe Tarica, Presentation Editor

News design, page(s) / A-Section / 49,999 and under

Kitsap Sun
Bremerton, Wash.

Colin Smith, Deputy Design Director;
Chuck Nigash, A.M.E. Design; **Staff**

*News design, page(s) / A-Section / 49,999
and under*

a.m. De León
León, México

Adrián Palma Arvizu, Graphics Coordinator
/ Designer; **Leopoldo García Lugo,**
Co-Editor; **Saúl Molina Rodríguez,**
Photographer; **Ismael Sandoval,** Illustrator;
Raúl Olmos Castillo, Editorial Director;
Enrique Gómez Orozco, General Editorial
Director

*News design, page(s) / A-Section / 49,999
and under*

Beaver County Times
Beaver, Pa.

Clif Page, Photo Editor / Designer; **Kevin Lorenzi,** Photographer

News design, page(s) / A-Section / 49,999 and under

Expreso
Hermosillo, México

Giovanna Espriella Moreno, Designer/
Illustrator; **Myrna Alonso Félix,** Editor;
Juan Carlos Zúñiga, Editorial Director;
Martin Holguín Alatorre, General
Director; **Alexander Probst Pruneda,**
Design Consultant

News design, page(s) / Local / 49,999 and under

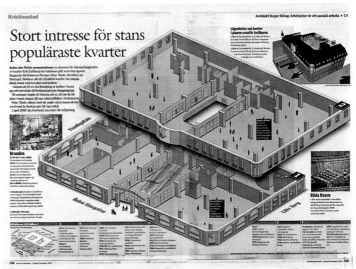

Kristianstadsbladet
Koping, Sweden

Fredrik Björnsson, Graphic
Artist; **Ingela Rutberg,** Graphic
Artist; **Rickard Frank,** Graphic
Artist

*News design, page(s) / Local /
49,999 and under*

Sun Journal
Lewiston, Maine

Megan Lavey, Design Editor; **Pete Gorski,** Staff Artist; **Jose Leiva,**
Photographer; **Heather McCarthy,** Design Editor

News design, page(s) / A-Section / 49,999 and under

Sun Journal
Lewiston, Maine

Heather McCarthy, Design Editor; **Pete Gorski,** Staff Artist; **Paul Wallen,**
M.E./Visuals; **Megan Lavey,** Design Editor

News design, page(s) / A-Section / 49,999 and under

Sun Journal
Lewiston, Maine

Paul Wallen, M.E. / Visuals; **Megan Lavey,** Design Editor;
Heather McCarthy, Design Editor

News design, page(s) / A-Section / 49,999 and under

Sun Journal
Lewiston, Maine

Paul Wallen, M.E. / Visuals; **Alicia Ford,** Design Editor; **Pete Gorski,**
News Artist; **Daryn Slover,** Photographer

News design, page(s) / A-Section / 49,999 and under

Sun Journal
Lewiston, Maine

Paul Wallen, M.E. / Visuals; **Pete Gorski,** News Artist; **Ryan Powell,**
Design Editor; **Megan Lavey,** Design Editor

News design, page(s) / A-Section / 49,999 and under

Sun Journal
Lewiston, Maine

Paul Wallen, M.E. / Visuals

News design, page(s) / A-Section / 49,999 and under

El Comercio
Gijon, Spain

David Fernandez Lucas, Art Director; **Luis Suárez,** Designer; **Susana García,** Graphic Artist; **Juanjo Díaz,** Designer; **Alfonso Espiniella,** Designer; **Daniel Castaño,** Illustrator

News design, page(s) / Local / 49,999 and under

Bluffton Today
S.C.

Ernie Smith, Designer

News design, page(s) / Local / 49,999 and under

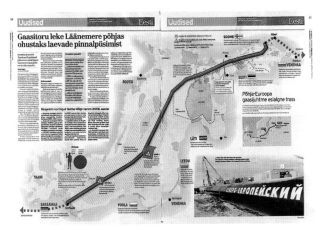

Eesti Päevaleht
Tallinn, Estonia

Jaanus Pilrsalu, Editor; **Alari Paluots,** Graphic Artist; **Cases I Associats,** Layouter; **Merike Pinn,** Art Director; **Priit Hõbemagi,** Editor in Chief

News design, page(s) / Local / 49,999 and under

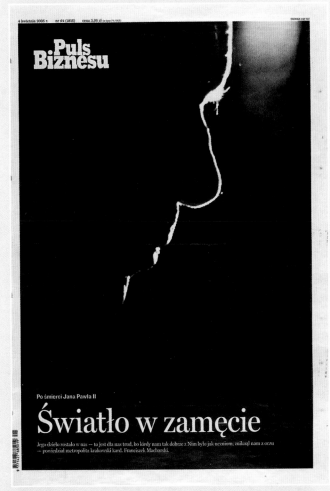

SILVER

Puls Biznesu
Warsaw, Poland

Jacek Utko, Art Director

News design, page(s) / A-Section / 49,999 and under

This is an elegant, wonderful use of an elegant, poignant photo. For a Polish newspaper that has likely covered the pope considerably, this stands as innovative and creative. There was nothing like it among the other designs we judged.

Éste es un uso elegante y maravilloso de una foto elegante y conmovedora. Para un diario polaco que probablemente ha cubierto el acontecer sobre el Papa en forma considerable, esta página destaca por ser innovadora y creativa. No hubo nada parecido entre los demás diseños evaluados.

Sun Journal
Lewiston, Maine

Ryan Powell, Sports Design Editor; **Paul Wallen,**
M.E./Visuals; **Pete Gorski,** News Artist; **Staff**

News design, page(s) / Sports / 49,999 and under

SUPER BOWL XXXIX

MONDAY, FEBRUARY 7, 2005 · PAGE C1

2002: SUPER BOWL XXXVI · PATRIOTS 20 · RAMS 17
2004: SUPER BOWL XXXVIII · PATRIOTS 32 · PANTHERS 29

PATRIOTS vs. EAGLES

MONDAY, FEBRUARY 7, 2005 · SECTION C

TRIPLE CROWN CHAMPIONS!!!

VICTORY MOVES BELICHICK AHEAD OF LOMBARDI...

ALL-TIME WINNINGEST COACH IN PLAYOFF HISTORY

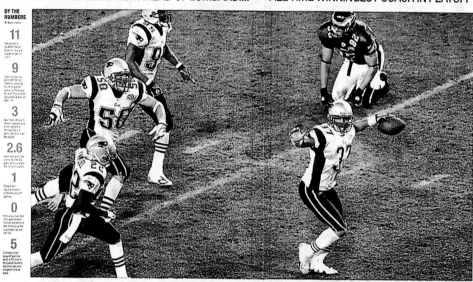

Patriots weather Philly's best shot

1ST QUARTER · 2ND QUARTER · 3RD QUARTER · 4TH QUARTER

El Gráfico
Antiguo Cuscatlán,
El Salvador

José Jaén, Designer;
Cristian Villalta,
Editor; **Editorial Staff;**
Illustration Staff

*News design, page(s) / Sports /
49,999 and under*

HANSEL DE ARABIA

El galo Peterhansel ganó en Atar y consolida aún más su liderato en el rally automovilístico Dakar 2005.

Luto en Dakar

El Gráfico
Antiguo Cuscatlán,
El Salvador

José Jaén, Designer;
Cristian Villalta,
Editor; **Editorial Staff;**
Photography Staff

*News design, page(s) / Sports /
49,999 and under*

SOBRE VIVIENTES

Francia y Mitsubishi, los grandes ganadores; el recuerdo de los caídos los hizo a todos un poco perdedores.

GRAN PREMIO DE ESPAÑA DE FÓRMULA-1 · EL COMERCIO · SÁBADO 7 DE MAYO DE 2005

El trazado de Montmeló no tiene misterios para el asturiano, que podría conducir aquí con los ojos cerrados

Trece curvas sin secretos

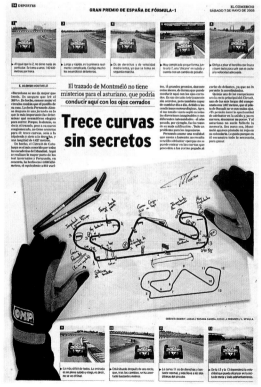

El Comercio
Gijón, Spain

David Fernandez Lucas, Art Director; **Luis Suárez,** Designer; **Susana García,** Graphic
Artist; **Juanjo Díaz,** Designer; **Alfonso Espiniella,** Designer; **Daniel Castaño,** Illustrator

News design, page(s) / Sports / 49,999 and under

Sun Journal
Lewiston, Maine

Ryan Powell, Sports Design Editor; **Paul Wallen,** M.E./Visuals;
Sports Staff

News design, page(s) / Sports / 49,999 and under

The Nevada Sagebrush
University of Nevada, Reno

Shawn Barcroft, Design Editor

News design, page(s) / Sports / 49,999 and under

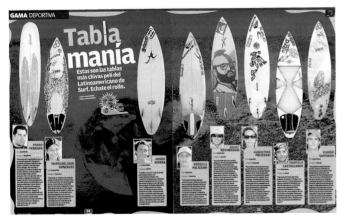

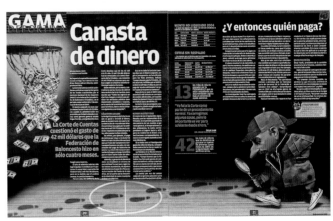

El Gráfico
Antiguo Cuscatlán, El Salvador

Alexander Rivera, Designer; **Cristian Villalta,** Editor;
Carlos Reina, Editor; **Javier Aparicio,** Photographer

News design, page(s) / Sports / 49,999 and under

El Gráfico
Antiguo Cuscatlán, El Salvador

Alexander Rivera, Designer; **Cristian Villalta,** Editor;
Roxana Huezo, Editor; **Ulises Martínez,** Illustrator

News design, page(s) / Sports / 49,999 and under

El Diario Impacto
México City

Daniel González Hernández, Designer; **Juan Pablo Simón,** Editor; **Alexandro Medrano,** Art Director; **Juan Bustillos,** General Editorial Director; **Hugo Paez,** Editorial Director; **Roberto Cruz,** M.E.

News design, page(s) / Sports / 49,999 and under

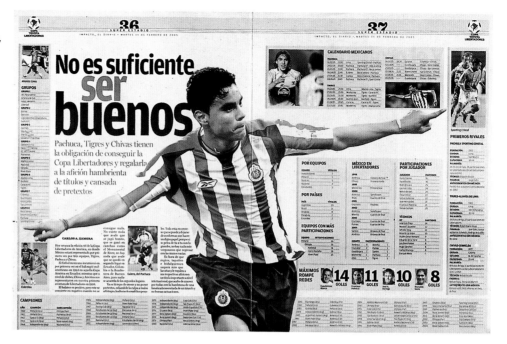

Sundsvalls Tidning
Sundsvall, Sweden

Fredrik Lindahl, Designer; **Linus Wallin,** Photographer; **Mathas Eriksson,** Reporter

News design, page(s) / Sports / 49,999 and under

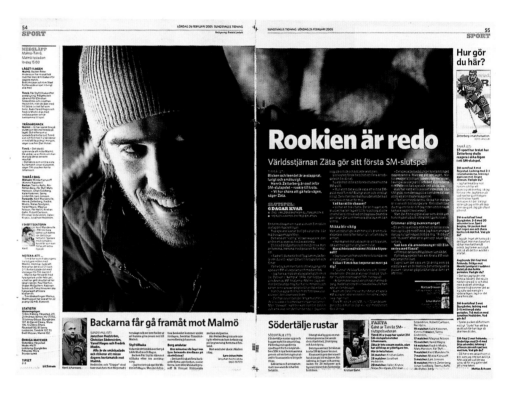

El Gráfico
Antiguo Cuscatlán, El Salvador

Alexander Rivera, Designer; **Cristian Villalta,** Editor; **Rodrigo Arias,** Editor; **Francisco Belloso,** Photographer

News design, page(s) / Sports / 49,999 and under

El Diario Impacto
México City

José Servando Ramos Cruz, Designer; **Carlos Armando Zamora,** Editor;
Alexandro Medrano, Editor; **Juan Bustillos,** General Editorial Director;
Hugo Paez, Editor Director; **Roberto Cruz,** M.E.

News design, page(s) / Sports / 49,999 and under

Periódico Provincia
Morelia, México

Juan Luis Hurtado, Editor; **Oscar Villavicencio,** Editor; **Erik Knobl,**
Design Director; **Arcelia Guadarrama,** Editor/Co-Director;
Pablo César Carrillo, Content Subdirector; **Manuel Baeza,** Editorial Director;
Luis Enrique López, General Director

News design, page(s) / Sports / 49,999 and under

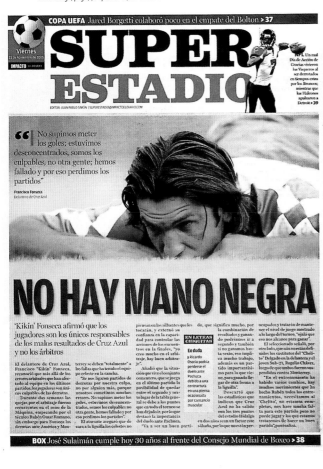

El Diario Impacto
México City

Alexandro Medrano,
Art Director; **Juan Pablo Simón,**
Editor; **Juan Bustillos,** General
Editorial Director;
Hugo Paez, Editorial Director;
Roberto Cruz, M.E.

*News design, page(s) / Sports /
49,999 and under*

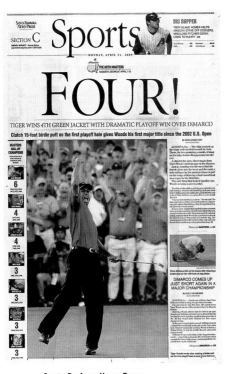

Santa Barbara News-Press
Calif.

Nick Masuda, Deputy Sports Editor; **Gerry Spratt,**
Sports Editor; **Jerry Roberts,** Executive Editor/News

News design, page(s) / Sports / 49,999 and under

a.m. De León
León, México

Luis Gerardo Lugo, Editor; **Jorge Armando Lira,** Illustrator;
Adrián Palma Arvizu, Graphics Coordinator/Designer;
Raúl Olmos Castillo, Editorial Director; **Enrique Gómez Orozco,**
General Editorial Director

News design, page(s) / Sports / 49,999 and under

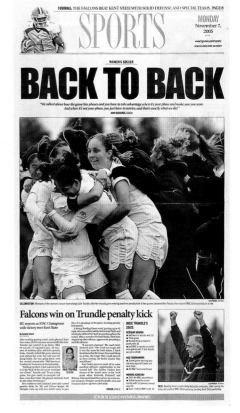

BG News
Bowling Green State University (Ohio)

Mike Metzger, Design Editor; **Patrick Maynard,** Graphics Editor;
Josh Phillips, Photographer

News design, page(s) / Sports / 49,999 and under

Charlotte Hill-Cobb, Artist; **Don Renfroe,** Design Director

News design, page(s) / Business / 49,999 and under

WirtschaftsBlatt
Vienna, Austria

Gerhard Marschall, Editor; **Maria Kment,** Layouter; **Jan Schwieger,**
Art Director

News design, page(s) / Business / 49,999 and under

Karjalainen
Joensuu, Finland

Kimmo Penttinen, Art Director/Layout; **Heikki Kotilainen,** Illustrator/
Layout; **Petri Vähä,** Editor

News design, page(s) / Business / 49,999 and under

Atlanta Business Chronicle

John D. White, Senior Designer; **James C. Watts,** Creative Director;
Jeff Mahurin, Production Director

News design, page(s) / Business / 49,999 and under

Atlanta Business Chronicle

James C. Watts, Creative Director; **John D. White,** Senior Designer;
Jeff Mahurin, Productions Director

News design, page(s) / Business / 49,999 and under

Sun Journal
Lewiston, Maine

Heather McCarthy, Senior Design Editor;
Pete Gorski, Staff Artist

News design, page(s) / Business / 49,999 and under

WirtschaftsBlatt
Vienna, Austria

Hans Pleininger, Editor; **Jan Schwieger,** Layout & Art Direction

News design, page(s) / Business / 49,999 and under

WirtschaftsBlatt
Vienna, Austria

Arno Maierbrugger, Editor; **Matthias Netopilek,**
Layouter; **Jan Schwieger,** Illustrator & Art Director

News design, page(s) / Business / 49,999 and under

The Bulletin
Bend, Ore.

Anders Ramberg, Presentation Editor; **Renee Fullerton,**
Designer; **Julie Johnson,** At Home Editor; **Denise Costa,**
Features Editor; **John Costa,** Editor in Chief; **Melissa Jansson,**
Staff Photographer

Feature design, sections / Food / 49,999 and under

Forum Diplomatik
Istanbul, Turkey

Erol Sengül, Creative Director

News design, page(s) / Business / 49,999 and under

Postimees
Tartu, Estonia

Vahur Kalmre, Design Editor; **Ove Maidla,** Photographer;
Juhani Püttsepp, Reporter; **Artur Borissenko,** Graphic Artist

News design, page(s) / Inside page / 49,999 and under

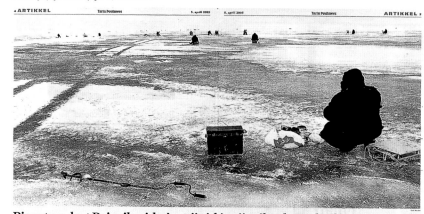

Piprateradest Peipsil said pingviinid ja siis sikuskamehed

La Palma
West Palm Beach, Fla.

Mark Edelson, Page Designer;
Em Mendez, Editor

*News design, page(s) / Inside page /
49,999 and under*

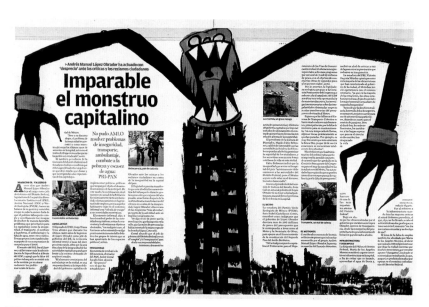

El Imparcial
Hermosillo, México

Hugo Èric Pérez, Designer;
Carlos René Gutiérrez,
Illustrator; **Vicente Gallardo,**
Editor; **Miyoshi Katsuda,** Art
Director & Designer

*News design, page(s) / Inside page /
49,999 and under*

El Diario Impacto
México City

Alexandro Medrano, Art Director / Illustrator; **David Casco Sosa,** Editor; **Juan Bustillos,** General
Editorial Director; **Hugo Paez,** Editorial Director; **Roberto Cruz,** M.E.

News design, page(s) / Inside page / 49,999 and under

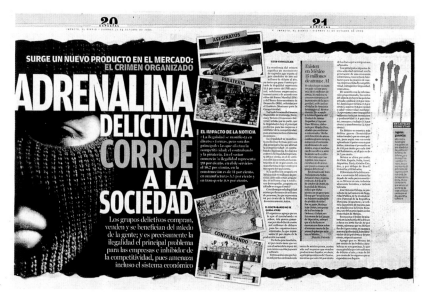

El Diario Impacto
México City

Juan Carlos Gutiérrez Alvarez, Designer;
David Casco Sosa, Editor; **Alexandro Medrano,**
Art Director; **Juan Bustillos,** General Editorial
Director; **Hugo Paez,** Editorial Director;
Roberto Cruz, M.E.

News design, page(s) / Inside page / 49,999 and under

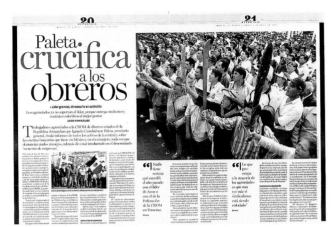

El Diario Impacto
México City

Elizabeth Medina Martinez, Designer; **Heriberto Ochoa,** Editor; **Alexandro Medrano,** Art Director; **Juan Bustillos,** General Editorial Director; **Hugo Paez,** Editorial Director; **Roberto Cruz,** M.E.

News design, page(s) / Inside page / 49,999 and under

El Diario Impacto
México City

Daniel González Hernández, Designer; **Luis Enrique Rivera,** Editor; **Alexandro Medrano,** Art Director; **Juan Bustillos,** General Editorial Director; **Hugo Paez,** Editorial Director; **Roberto Cruz,** M.E.

News design, page(s) / Inside page / 49,999 and under

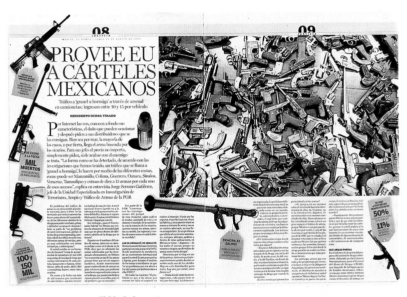

El Diario Impacto
México City

Daniel González Hernández, Designer; **Enrique Sánchez Márquez,** Editor; **Alexandro Medrano,** Art Director; **Juan Bustillos,** General Editorial Director; **Hugo Paez,** Editorial Director; **Roberto Cruz,** M.E.

News design, page(s) / Inside page / 49,999 and under

Expreso
Hermosillo, México

Adrián Figueroa, Designer; **Eduardo Sánchez,** Editor; **Giovanna Espriella Moreno,** Art Director; **Juan Carlos Zúñiga,** Editorial Director; **Martín Holguín Alatorre,** General Director; **Alexander Probst Pruneda,** Design Consultant

News design, page(s) / Inside page / 49,999 and under

Sur
Malaga, Spain

Ma Dolores de la Vega, Section Designer; **Rafael Ruiz,** Designer; **Baldomero Villanueva,** Designer; **Fernando González,** Designer; **Francisco Sánchez Ruano,** Art Director; **Alberto Torregrosa,** Editorial Design Consultant

News design, page(s) / Other / 49,999 and under

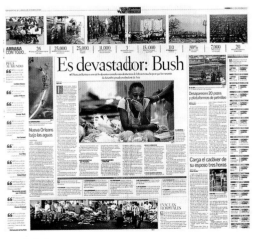

a.m. De León
León, México

Gabriela Muñiz, Editor; **Adrián Palma Arvizu,** Graphics Coordinator/Designer; **Raúl Olmos Castillo,** Editorial Director; **Enrique Gómez Orozco,** General Editorial Director

News design, page(s) / Inside page / 49,999 and under

El Diario Impacto
México City

Daniel González-Hernández, Designer; **Luis Enrique Rivera,** Editor; **Alexandro Medrano,** Art Director;
Juan Bustillos, General Editorial Director; **Hugo Paez,** Editorial Director; **Roberto Cruz,** M.E.

News design, page(s) / Inside page / 49,999 and under

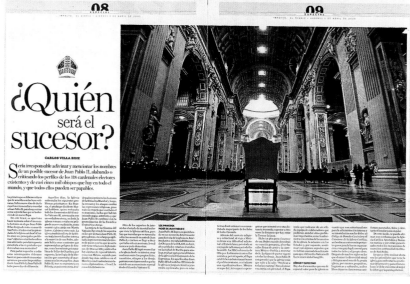

El Imparcial
Hermosillo, México

Gabriel Martínez, Designer;
Vicente Gallardo, Editor;
Miyoshi Katsuda, Art Director

*News design, page(s) / Inside page /
49,999 and under*

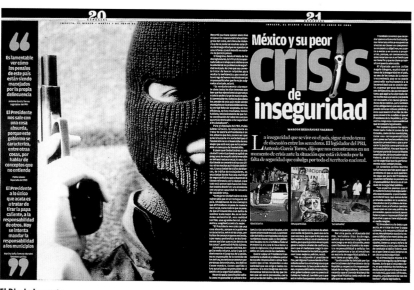

Expreso
Hermosillo, México

Adrián Figueroa, Designer;
Angélica Uriarte, Editor;
Giovanna Espriella Moreno,
Art Director;
Juan Carlos Zúñiga,
Editorial Director;
Martin Holguín Alatorre,
General Director;
Alexander Probst Pruneda,
Design Consultant

*News design, page(s) / Inside page /
49,999 and under*

El Diario Impacto
México City

Daniel González Hernández, Designer; **David Casco Sosa,** Editor; **Alexandro Medrano,** Art Director;
Juan Bustillos, General Editorial Director; **Hugo Paez,** Editorial Director; **Roberto Cruz,** M.E.

News design, page(s) / Inside page / 49,999 and under

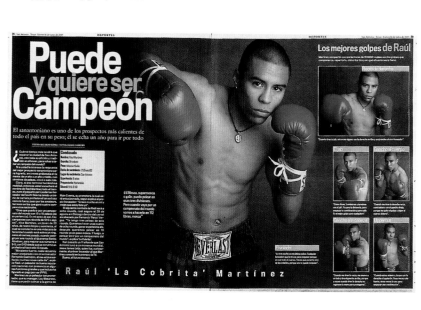

Rumbo
San Antonio, Texas

Bruno García, Designer; **Jaime R. Carrero,** Photographer/
Photo Editor; **Ricardo López,** Section Editor;
Norma Ramírez, Design Coordinator; **Rodolfo Jiménez,**
Deputy Art Director; **Adrián Alvarez,** Art Director;
Gabriel Sama, M.E.; **Jonathan Friedland,** VP/Editorial;
Edward Schumacher, Executive Editor

News design, page(s) / Inside page / 49,999 and under

Zeta Weekly
Tijuana, México

Ariel Freaner, Designer/Digital Illustrator; **J. Jesus Blancornelas,** Editor/Co-Director; **Ramon Blanco,** Photographer

News design, page(s) / Other / 49,999 and under

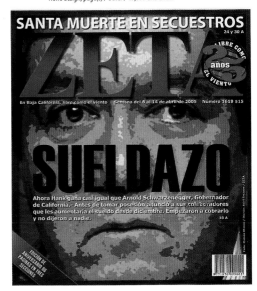

Zeta Weekly
Tijuana, México

Ariel Freaner, Designer/Digital Illustrator; **J. Jesus Blancornelas,** Editor/Co-Director

News design, page(s) / Other / 49,999 and under

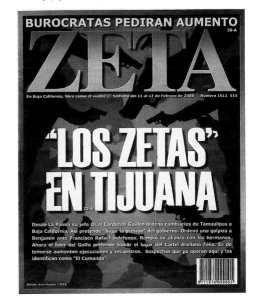

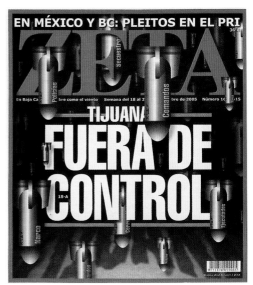

Zeta Weekly
Tijuana, México

Ariel Freaner, Designer/Digital Illustrator/Photographer; **J. Jesus Blancornelas,** Editor/Co-Director

News design, page(s) / Other / 49,999 and under

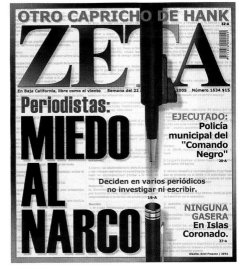

Zeta Weekly
Tijuana, México

Ariel Freaner, Designer/Digital Illustrator; **J. Jesus Blancornelas,** Editor/Co-Director

News design, page(s) / Other / 49,999 and under

Zeta Weekly
Tijuana, México

Ariel Freaner, Designer/Digital Illustrator; **J. Jesus Blancornelas,** Editor/Co-Director

News design, page(s) / Other / 49,999 and under

O Independente
Lisbon, Portugal

Sónia Matos, Art Director; **Luis Lázaro,** Illustrator;
Fernando Barata, Designer; **Natacha Pereira,**
Editor; **Inês Serra Lopes,** Editor in Chief

News design, page(s) / Other / 49,999 and under

WirtschaftsBlatt
Vienna, Austria

Peter Muzik, Chief Editor; **Jan Schwieger,** Art Director

News design, page(s) / Other / 49,999 and under

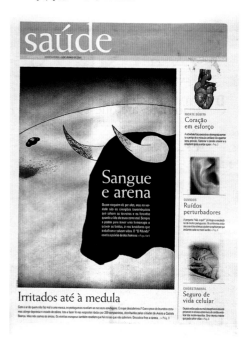

10 Jahre WirtschaftsBlatt

Premiere war am 6. Oktober 1995. Seit damals sind 2465 Ausgaben erschienen.
Österreichs einzige Special Interest-Tageszeitung hat sich am Markt bestens etabliert.
In dieser Beilage werfen wir einen Blick zurück – zehn Jahre Wirtschaft im Zeitraffer.

WirtschaftsBlatt
Vienna, Austria

Gerhard Marschall, Editor; **Jan Schwieger,** Layouter;
Richard Tanzer, Photographer

News design, page(s) / Other / 49,999 and under

WirtschaftsBlatt
Vienna, Austria

Gerhard Marschall, Editor; **Jan Schwieger,**
Layout & Art Director; **Günter Peroutka,**
Photographer

News design, page(s) / Other / 49,999 and under

International Press Spanish Edition
Tokyo

Julio Kohji Shiiki, Art Editor & Designer;
Roger Hiyane Yzena, Designer

Feature design, page(s) / Opinion / 49,999 and under

Sun Journal
Lewiston, Maine

Ursula Albert, Features Editor; **Paul Wallen,** M.E./
Visuals; **Corey LaFlamme,** Design Editor

Feature design, sections / Lifestyle / 49,999 and under

The Free Lance-Star
Fredericksburg, Va.

Meredith Sheffer, Page Designer

Feature design, page(s) / Opinion / 49,999 and under

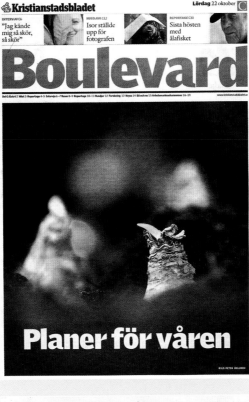

Planer för våren

SILVER

Kristianstadsbladet
Koping, Sweden

Maria Nilson, Page Designer / Editor; **Jörgen Svensson,** Project Editor

Feature design, sections / Lifestyle / 49,999 and under

These sections stand above the others
in this category. The consistent, elegant
cover layouts complement the excellent
use of typography and inside space, and
the design enhances the readability.

Estas secciones se destacan de
las demás en esta categoría.
Las diagramaciones de portada
consistentes y elegantes complementan
el excelente uso de la tipografía y
el espacio en el interior, y el diseño
magnifica la lecturabilidad.

Tid att skörda, dags att så

Kitsap Sun
Bremerton, Wash.

Tara Elliott, Designer; **Chuck Nigash,** A.M.E. Design;
Colin Smith, Deputy Design Director

Feature design, page(s) / Lifestyle / 49,999 and under

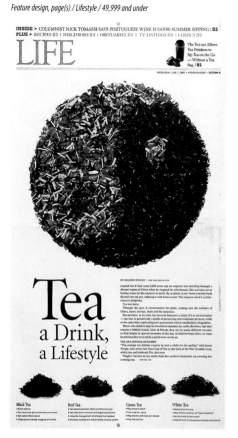

The Free Lance-Star
Fredericksburg, Va.

Meredith Sheffer, Page Designer; **Suzanne Carr,** Photographer

Feature design, page(s) / Lifestyle / 49,999 and under

The Free Lance-Star
Fredericksburg, Va.

Meredith Sheffer, Page Designer; **Dana Romanoff,** Photographer

Feature design, page(s) / Lifestyle / 49,999 and under

O Independente
Lisbon, Portugal

Sónia Matos, Art Director & Designer; **Joana Petiz,** Editor;
Inês Serra Lopes, Editor in Chief

Feature design, page(s) / Lifestyle / 49,999 and under

O Independente
Lisbon, Portugal

Sónia Matos, Art Director & Designer; **Joana Petiz,** Editor;
Inês Serra Lopes, Editor in Chief

Feature design, page(s) / Lifestyle / 49,999 and under

La Palma
West Palm Beach, Fla.

Sergio Patrucco, Designer

Feature design, page(s) / Lifestyle / 49,999 and under

El Diario Impacto
México City

Daniel González Hernández, Designer; **Max Vite,** Editor; **Alexandro Medrano,** Art Director; **Juan Bustillos,** General Editorial Director; **Hugo Paez,** Editorial Director; **Roberto Cruz,** M.E.

Feature design, page(s) / Lifestyle / 49,999 and under

El Diario Impacto
México City

Horacio Trejo Rivera, Designer; **Max Vite,** Editor; **Alexandro Medrano,** Art Director; **Juan Bustillos,** General Editorial Director; **Hugo Paez,** Editorial Director; **Roberto Cruz,** M.E.

Feature design, page(s) / Lifestyle / 49,999 and under

Sun Journal
Lewiston, Maine

Ursula Albert, Features Editor; **Paul Wallen,** M.E./Visuals; **Corey LaFlamme,** Design Editor; **Russ Dillingham,** Photographer

Feature design, page(s) / Lifestyle / 49,999 and under

Al Día
Dallas

Danielle Levkovits, Designer; **Paulina Magdaleno,** Section Editor; **Fernando Hernandez,** Design Editor; **Alfredo Berríos,** News Editor; **Alfredo Carbajal,** M.E.; **Gilbert Bailon,** Publisher/Editor

Feature design, page(s) / Lifestyle / 49,999 and under

The Free Lance-Star
Fredericksburg, Va.

Catherine Davis, Design Editor; **Reza Marlashti,** Photographer

Feature design, page(s) / Lifestyle / 49,999 and under

Kitsap Sun
Bremerton, Wash.

Jessica Randklev, Illustrator; **Tara Elliott,** Designer; **Chuck Nigash,** A.M.E. Design

Feature design, page(s) / Lifestyle / 49,999 and under

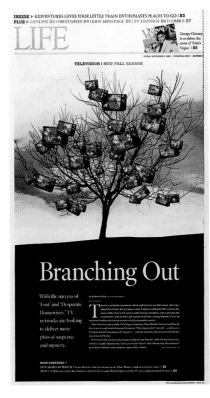

The Tribune

San Luis Obispo, Calif.

Rex Chekal, Page Designer

Feature design, page(s) / Entertainment / 49,999 and under

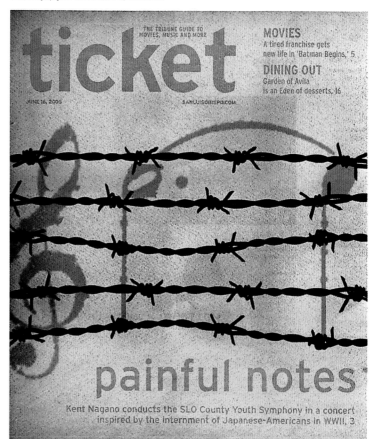

Sun Journal

Lewiston, Maine

Ursula Albert, Features Editor

Feature design, page(s) / Entertainment / 49,999 and under

La Prensa

Panamá City

Lourdes de Obaldía, Design Editor; **Humberto Rueda,** Designer;
Daniel González, Designer

Feature design, page(s) / Entertainment / 49,999 and under

The Muskegon Chronicle

Mich.

Kevin Kyser, Art Director & Designer

Feature design, page(s) / Entertainment / 49,999 and under

Periódico Provincia

Morelia, México

Eduardo Estrada, Editor; **Juan Carlos Ortega,** Editor; **Erik Knobl,** Design
Director; **Arcelia Guadarrama,** Editorial Subdirector; **Pablo César Carrillo,**
Content Subdirector; **Manuel Baeza,** Editorial Director;
Luis Enrique López, General Director

Feature design, page(s) / Entertainment / 49,999 and under

Le Devoir
Montréal

Christian Tiffet, Art Director

Feature design, page(s) / Entertainment / 49,999 and under

Le Devoir
Montréal

Christian Tiffet, Art Director

Feature design, page(s) / Entertainment / 49,999 and under

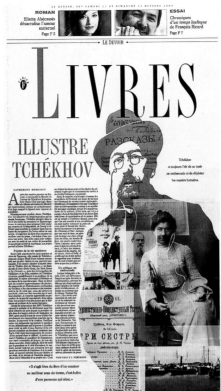

The Tuscaloosa News
Ala.

Tracy Cox, Designer

Feature design, page(s) / Entertainment / 49,999 and under

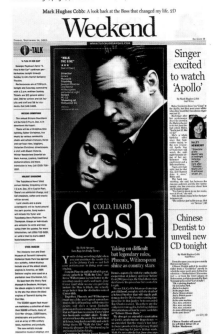

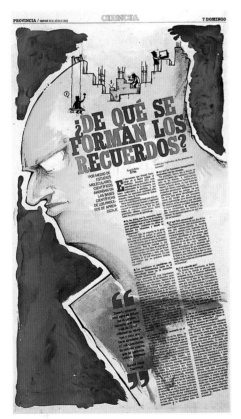

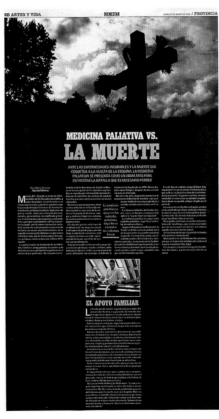

Periódico Provincia
Morelia, México

Noe Laguna, Editor; **Erik Knobl,** Design Director; **Arcelia Guadarrama,**
Editorial Subdirector; **Pablo César Carrillo,** Content Subdirector;
Manuel Baeza, Editorial Director; **Luis Enrique López,** General Director

Feature design, page(s) / Entertainment / 49,999 and under

Periódico Provincia
Morelia, México

Hamlet Ortíz, Designer; **Noe Laguna,** Editor; **Erik Knobl,** Design Director;
Arcelia Guadarrama, Editorial Subdirector; **Pablo César Carrillo,** Content
Subdirector; **Manuel Baeza,** Editorial Director; **Luis Enrique López,**
General Director

Feature design, page(s) / Entertainment / 49,999 and under

Periódico Provincia
Morelia, México

Hamlet Ortíz, Designer; **Erik Knobl,** Design Director;
Arcelia Guadarrama, Editorial Subdirector; **Pablo César Carrillo,**
Content Subdirector; **Manuel Baeza,** Editorial Director;
Luis Enrique López, General Director

Feature design, page(s) / Entertainment / 49,999 and under

El Diario Impacto
México City

Alexandro Medrano, Art Director; **Fabián Lavalle,** Editor; **Juan Bustillos,** General Editorial Director; **Hugo Paez,** Editorial Director; **Roberto Cruz,** M.E.

Feature design, page(s) / Entertainment / 49,999 and under

Periódico Provincia
Morelia, México

Eduardo Estrada, Editor; **Juan Carlos Ortega,** Editor; **Erik Knobl,** Design Director; **Arcelia Guadarrama,** Editorial Subdirector; **Pablo César Carrillo,** Content Subdirector; **Manuel Baeza,** Editorial Director; **Luis Enrique López,** General Director

Feature design, page(s) / Home, real estate / 49,999 and under

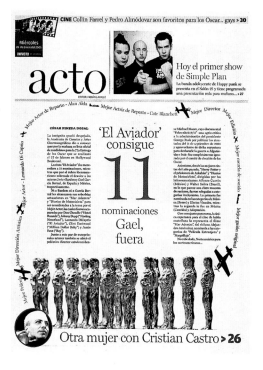

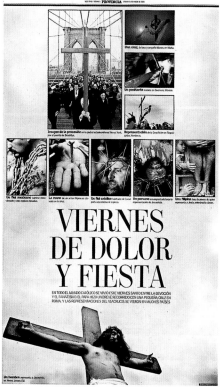

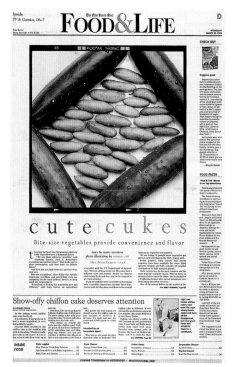

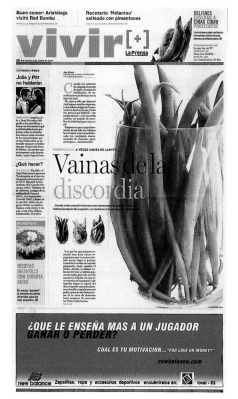

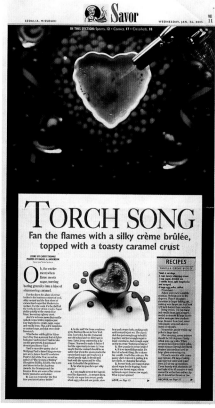

The Free Lance-Star
Fredericksburg, Va.

Meredith Sheffer, Page Designer

Feature design, page(s) / Food / 49,999 and under

La Prensa
Panamá City

Lourdes de Obaldía, Design Editor; **Paola Ying,** Designer; **Loida González,** Designer

Feature design, page(s) / Food / 49,999 and under

The Sedalia Democrat
Mo.

Lucas Soltow, Copy Editor

Feature design, page(s) / Food / 49,999 and under

Taipei Times
Taipei, Taiwan

June Hsu, Designer; **David Momphard,** Reporter

Feature design, page(s) / Travel / 49,999 and under

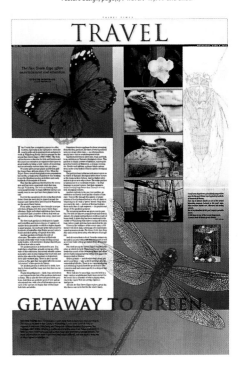

TRAVEL

GETAWAY TO GREEN

The Free Lance-Star
Fredericksburg, Va.

Catherine Davis, Design Editor

Feature design, page(s) / Travel / 49,999 and under

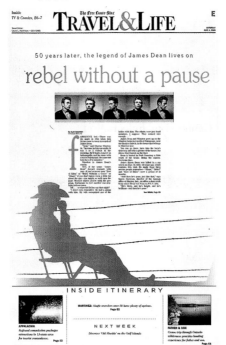

Inside
TV & Comics, E6–7

TRAVEL & LIFE

50 years later, the legend of James Dean lives on

rebel without a pause

INSIDE ITINERARY

Jacksonville Journal-Courier
Ill.

Guido Strotheide, Designer; **Clayton Stalter,** Photographer; **Steve Copper,** Design Editor

Feature design, page(s) / Other / 49,999 and under

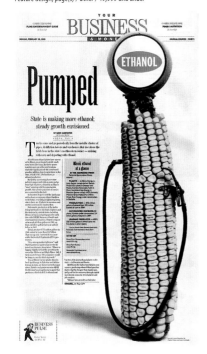

BUSINESS & MONEY

Pumped

State is making more ethanol; steady growth envisioned

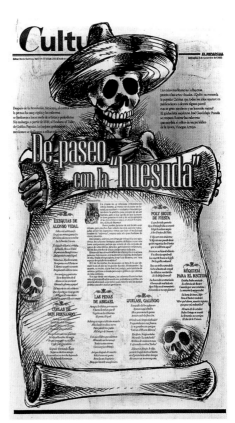

Cultura

De paseo con la "huesuda"

EXEQUIAS DE ALONSO VIDAL

POLY SIGUE DE FIESTA

COPLAS PARA DON FERNANDO

LAS PENAS DE ABIGAIL

¡JUÍLAS!, GALINDO

RÉQUIEM PARA EL RECTOR

El Imparcial
Hermosillo, México

Alejandro Tostado, Designer; **Oliver León,** Illustrator; **Martín Contreras,** Editor; **Miyoshi Katsuda,** Art Director

Feature design, page(s) / Other / 49,999 and under

Cultura

Unidos por las letras

Investigadores de importantes universidades participaron en el Coloquio Internacional de Literatura Mexicana e Hispanoamericana

Impartirán un taller de video

REFORZAR

LAZOS

Buscan mayores intercambios

Presentarán nuevo libro

El Imparcial
Hermosillo, México

Alejandro Tostado, Designer; **Martín Contreras,** Editor; **Miyoshi Katsuda,** Art Director

Feature design, page(s) / Other / 49,999 and under

caderno de

domingo

Como anda seu apetite sexual?

Diário De Pernambuco
Recife, Brazil

Vera Ogando, Newsroom Director; **Luis Carlos Ferrari,** Executive Editor; **Christiano Mascaro,** Art Editor & Designer; **Otavio De Souza,** Photo Editor; **Lydia Barros,** Editor; **Glauco Spíndola,** Photographer

Feature design, page(s) / Other / 49,999 and under

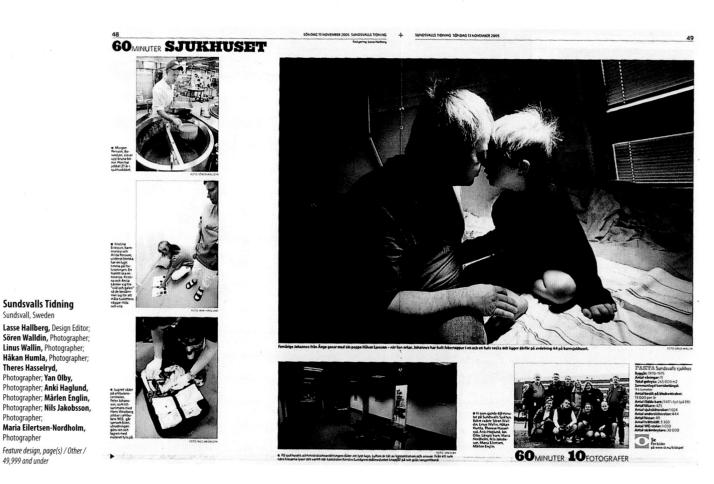

Femårige Johannes från Ånge gosar med sin pappa Håkan Larsson - när han orkar. Johannes har haft febertoppar i en och en halv vecka och ligger därför på avdelning 44 på barnsjukhuset.

60MINUTER **10**FOTOGRAFER

Sundsvalls Tidning
Sundsvall, Sweden

Lasse Hallberg, Design Editor;
Sören Walldin, Photographer;
Linus Wallin, Photographer;
Håkan Humla, Photographer;
Theres Hasselryd,
Photographer; **Yan Olby,**
Photographer; **Anki Haglund,**
Photographer; **Mårlen Englin,**
Photographer; **Nils Jakobsson,**
Photographer;
Maria Eilertsen-Nordholm,
Photographer

*Feature design, page(s) / Other /
49,999 and under*

El Semanario
México City

Marco Antonio Román, Art Director; **Kyoshi Hayakawa,** Design Editor;
Abraham Solis, Illustrator; **César Martínez Aznárez,** Chief Editor;
Samuel García Angúlo, Director

Feature design, page(s) / Other / 49,999 and under

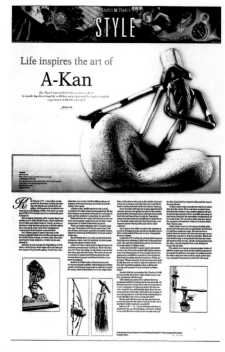

Taipei Times
Taipei, Taiwan

Wanjiun Lee, Designer; **Yi-chun Chen,** Design Editor

Feature design, page(s) / Other / 49,999 and under

Jacksonville Journal-Courier
Ill.

Guido Strotheide, Designer; **Steve Copper,** Designer

Feature design, page(s) / Other / 49,999 and under

SUPERFICIE DE TRENCADÍS
Las fachadas brillarán en la noche...

LA PLATEA, ANTES Y DESPUÉS
La Sala Principal....

Un buque insignia para la ópera

El complejo cultural es una enorme estructura capaz de albergar a más de 4.000 personas en sus auditorios y con una superficie útil de 37.000 metros cuadrados

VÍCTOR ROMERO

Plataformas en voladizo

EL PENÚLTIMO PROYECTO DE LA CIUDAD DE LAS ARTES

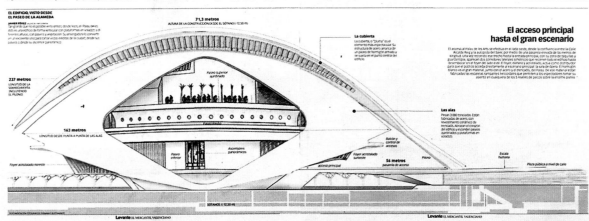

EL EDIFICIO, VISTO DESDE EL PASEO DE LA ALAMEDA

JAVIER PÉREZ

El acceso principal hasta el gran escenario

La cubierta

Las alas

237 metros LONGITUD DE LA SOBRECUBIERTA (INCLUYENDO EL PILÓN)

71,3 metros ALTURA DE LA CONSTRUCCIÓN DESDE EL SÓTANO I: 12,50 m

163 metros LONGITUD DESDE PUNTA A PUNTA DE LAS ALAS

56 metros

Levante EL MERCANTIL VALENCIANO

Levante EL MERCANTIL VALENCIANO

Levante-EMV
Valencia, Spain
Javier Pérez Belmonte, Visual Journalist
Feature design, page(s) / Other / 49,999 and under

Testimonio escalofriante del
HOLOCAUSTO NAZI

Vanguardia
Saltillo, México
Edgar de la Garza, Art Director; **Edson García,** Design Coordinator;
Aurora Balderas, Graphic Designer; **Luis Eduardo Mendoza,** Editor
Feature design, page(s) / Other / 49,999 and under

OCTUBRE

AGENDA 2005 | 21

NACIONAL

ECONOMÍA Y NEGOCIOS

INDICADORES

INTERNACIONAL

El Semanario
México City
Marco Antonio Román, Art Director; **Kyoshi Hayakawa,** Design Editor;
César Martínez Aznárez, Chief Editor; **Samuel García Angúlo,** Director
Feature design, page(s) / Other / 49,999 and under

southwest **life** neighbors to know. scenes to see.

May 23–June 5, 2005

Soft-spoken, but not
quiet

Jen Chilstrom is an accomplished designer, visual artist and original, mature writer — and she's just 26.

BY ANNA PRATT

Southwest Journal
Minneapolis
Bryan Nanista, Visual Editor
Feature design, page(s) / Other / 49,999 and under

By Anna Pratt

The Soo Line Garden:
ANNUAL or PERENNIAL?

Fearing development, Midtown Greenway gardeners seek ways to make their garden permanent

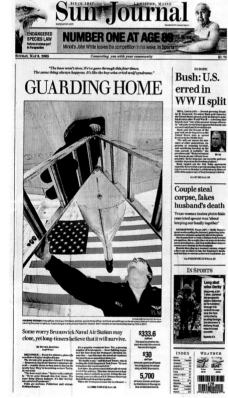

'Developers view it as a vacant lot, but we see it as beauty. We've built our community there.'

— LIZ RACZKOWSKI, WHO GARDENS ON THE SOO LINE SITE NEAR WEST 28TH STREET & GARFIELD AVENUE

Creating community

The not-so-secret garden

What does the property owner want?

southwest **life**
neighbors to know.

PHOTOS BY RICH RYAN

(Main above) Gardener Stephanie Munch came to Soo Line for the camaraderie and the chance to plant vegetables. Snapshots from the garden show the myriad efforts of the 100 gardeners.

Southwest Journal
Minneapolis

Bryan Nanista, Visual Editor

Page-design portfolio / Combination / 49,999 and under

10 VOTE POLITICS

The bridge between Turkish and foreign business communities:
DEİK

Rana YİRCALI
DEİK Board Chairman

Networks are the most valuable asset of DEİK

The main function of DEİK is to establish relations that the business circles need and to enable Turkish companies to meet with their foreign counterparts.

Forum Diplomatik
Istanbul, Turkey

Erol Sengül, Creative Director

Page-design portfolio / News / 49,999 and under

RATES RISE IN JULY: Consolidate college loans now, or pay more F6

BUSINESS

SUNDAY, JUNE 5, 2005 Sun Journal SECTION F

Fining fat

Obese workers may have to reach past their bellies and into their pockets when firms charge them more for health insurance.

By KATIE NOAH

The U.S. Centers for Disease Control and Prevention reported that $117 billion in health costs in 2000 were linked to obesity-related illnesses.

Employers hold most of the cards

Signing bonuses are gone and wages are lower, but the job market for grads is improving.

By IVAN COS

'Babes' balk at weigh-ins, weight limits

By SCHUYLER DIXON

Sun Journal
Lewiston, Maine

Heather McCarthy, Senior Design Editor

Page-design portfolio / News / 49,999 and under

SINCE 1847 LEWISTON, MAINE

Sun·Journal
sunjournal.com

ENDANGERED SPECIES LAW **NUMBER ONE AT AGE 80**
Minot's John White leaves the competition in his wake, In Sports

SUNDAY, MAY 8, 2005 Connecting you with your community $1.75

"The base won't close. We've gone through this four times. The same thing always happens. It's like the boy-who-cried-wolf syndrome."

GUARDING HOME

EUROPE
Bush: U.S. erred in WWII split

By DANIEL HAUGER
Staff Writer

Couple steal corpse, fakes husband's death
Texas woman insists plot to hide conviction spouse was 'about keeping our family together'

GEOGRAPHIC: Texas (AP) —

IN SPORTS

Long shot wins Derby

Some worry Brunswick Naval Air Station may close, yet long-timers believe that it will survive.

$333.6 million

$30

5,700

INDEX WEATHER

Sun Journal
Lewiston, Maine

Megan Lavey, Design Editor

Page-design portfolio / News / 49,999 and under

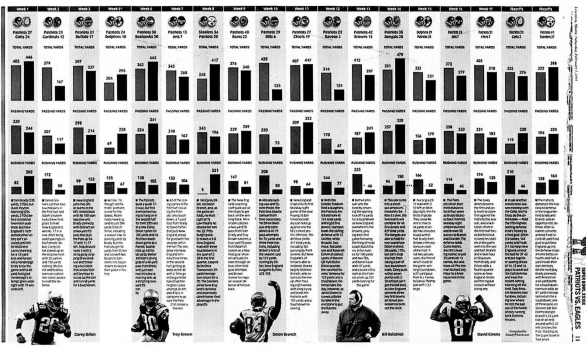

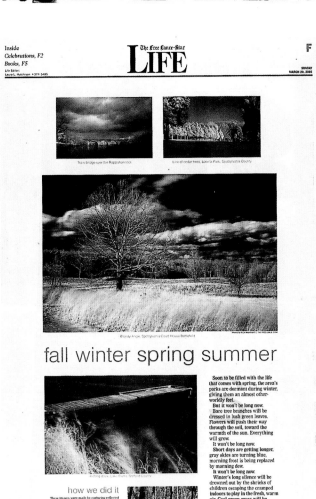

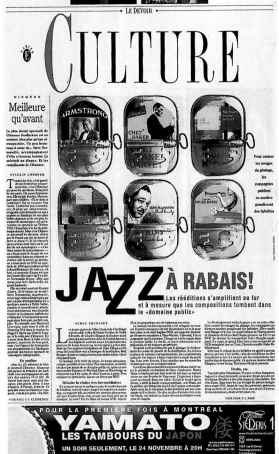

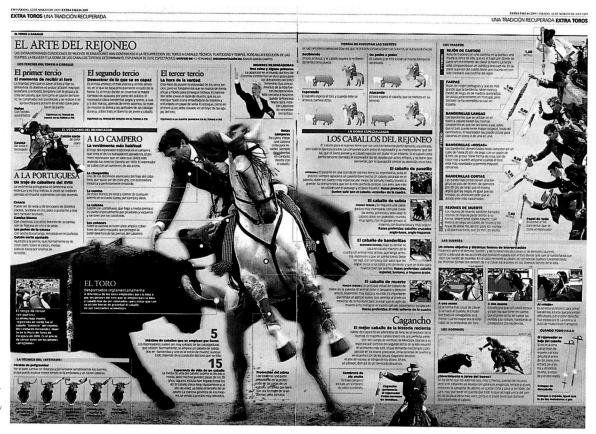

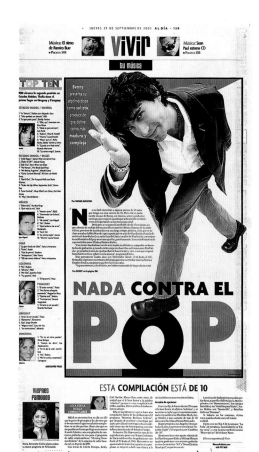

Levante-EMV
Valencia, Spain

Herminio Javier Fernandez,
Visual Journalist

Page-design portfolio / Features / 49,999 and under

Al Dia
Dallas

Danielle Levkovits, Designer

Page-design portfolio / Features / 49,999 and under

Puls Biznesu
Warsaw, Poland

Jacek Utko, Art Director

Page-design portfolio / News / 49,999 and under

Levante-EMV
Valencia, Spain
Javier Pérez Belmonte, Visual Journalist
Page-design portfolio / Features / 49,999 and under

El Mundo
Madrid, Spain
Manuel De Miguel, Designer
Page-design portfolio / Magazine / 49,999 and under

FENWAY BY THE NUMBERS

$8/hr. The Boston Herald pays Roger Guilbeault $8 an hour to give out free papers as fans enter the stadium.

1 lb. Lindsay Hoffman, 5, of Connecticut, bites into a Monster Dog on Yawkey Way. Approximately 16,000 hot dogs are sold per game, or 1.3 million a year.

100 degrees Chris Bergstrom, 24, as Wally the Green monster. Temperatures inside the suit regularly hit 100 degrees.

33/50/200 33 Boston police officers patrol a typical game. At a Yankee game, 50 are in place; for a playoff game, 200 keep order.

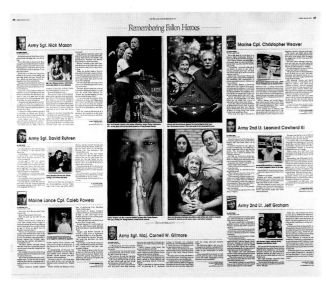

The Free Lance-Star
Fredericksburg, Va.
Sara Davidson, Designer
Page-design portfolio / Combination / 49,999 and under

4:30 a.m. Gabriel Kerry is a member of the "Clean Team" that scrubs bathrooms and concession areas long before the fans arrive. Kerry arrived at 4:30 a.m. for a 1 p.m. game. By 10 a.m. he was catching a nap on a picnic table near the right field "Big Concourse."

Photos and text by Dan Habib

Concord Monitor
N.H.
Dan Habib, Photo Editor
Page-design portfolio / Combination / 49,999 and under

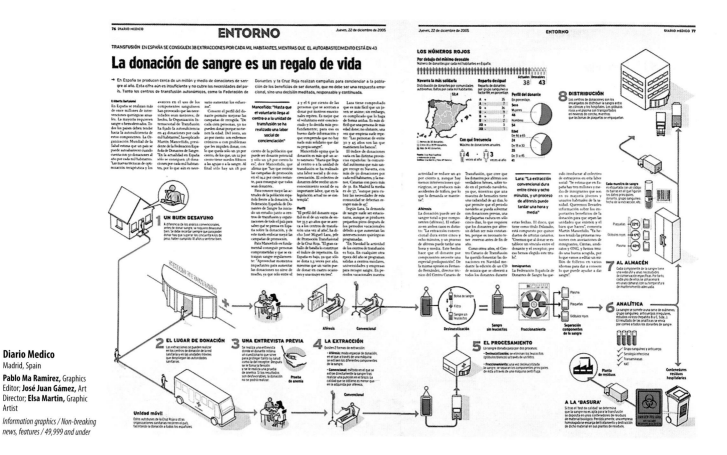

TRANSFUSIÓN EN ESPAÑA SE CONSIGUEN 38 EXTRACCIONES POR CADA MIL HABITANTES, MIENTRAS QUE EL AUTOABASTECIMIENTO ESTÁ EN 43

La donación de sangre es un regalo de vida

Diario Medico
Madrid, Spain

Pablo Ma Ramirez, Graphics Editor; **José Juan Gámez**, Art Director; **Elsa Martin**, Graphic Artist

Information graphics / Non-breaking news, features / 49,999 and under

COVERSTORY

Rural areas and small towns such as Columbia are increasingly becoming the destination for illegal immigrants

PURSUING THE AMERICAN DREAM

Yang Lei had watched as friends and fellow villagers began trickling off to America, and he couldn't help but notice the steady stream of money and success stories that had started flowing back from them. He knew that, as a Chinese peasant who'd only finished middle school, he lacked the education, English language ability and marketable skills required to make it to America legitimately.

UNAUTHORIZED RESIDENTS IN THE UNITED STATES

LEGAL IMMIGRATION THROUGH HISTORY

IMMIGRANTS' HOMELAND

Columbia Missourian
Robbie Ketcham; Reuben Stern

Information graphics / Charting / 49,999 and under

Special Coverage

8

Omaha World-Herald
Neb.

Dave Elsesser, Deputy Design Director; **Jennie Glaser,** Designer;
Steve Sinclair, Sports Editor; **Thad Livingston,** Deputy Sports Editor

Special coverage / Single subject

El Diario de Hoy
San Salvador, El Salvador

Juan Durán, Art Director & Designer; **Teodoro Wilson Torres Lira,** Graphics Editor;
Jorge Castillo, Infographic Editor; **José Santos,** Infographic Co-Editor; **Remberto Rodríguez,**
Graphics Co-Editor; **Geraldine Varela,** Journalist; **Oscar Tenorio,** Editor

Special coverage / Single subject

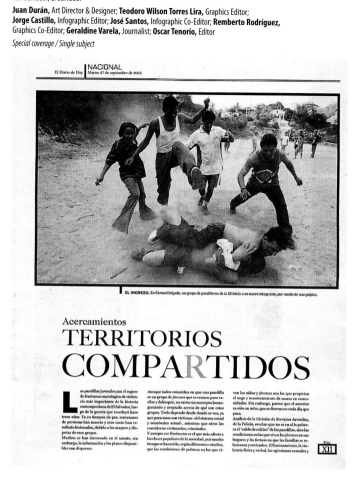

La Presse
Montréal

Benoit Giguere, Art Director;
Francis Leveillee, Illustrator;
David Lambert, Illustrator
& Designer; **Louise Leduc,**
Journalist; **Michele Ouimet,**
A.M.E./News; **Eric Trottier,** M.E.

Special coverage / Single subject

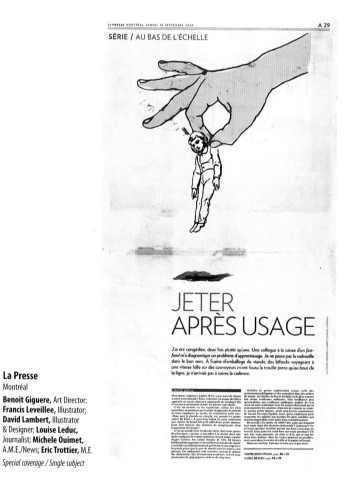

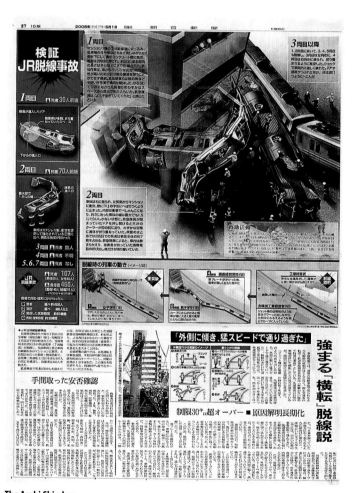

The Asahi Shimbun
Tokyo

Wataru Furuya, Graphics Designer; **Guo Yi,** Graphics Designer

Special coverage / Single subject

Lethal Beauty

HOME & GARDEN
FURNITURE FIT FOR A MOGUL'S MANSION

SPORTS
FOOTBALL AND RODEO PART OF PICKETT FAMILY

San Francisco Chronicle

SATURDAY, NOVEMBER 5, 2005

NO.2 OFFICIAL AT UC QUITS SUDDENLY

University probes possibility of favoritism in hiring of friend and son of provost

Lethal Beauty

Family fights an HMO for 4-year-old's life

C.W. Nevius

CAMPAIGN COUNTDOWN

Governor seeks late lift at polls

He campaigns for his 4 initiatives as support dwindles

Protests against Bush turn violent

Index / WEATHER

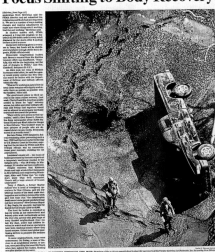

KATRINA'S AFTERMATH

Focus Shifting to Body Recovery

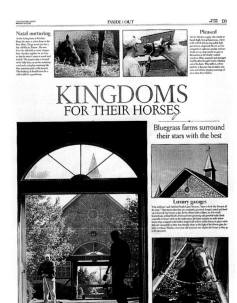

INSIDE | OUT D3

Natal nurturing

Pleased

KINGDOMS
FOR THEIR HORSES

Bluegrass farms surround their stars with the best

Luxury garages

Everyone must exercise

Manicured

Barn beautiful

SILVER

San Francisco Chronicle

Nanette Bisher, Creative Director;
Matt Petty, Art Director; **Frank Mina,** Art Director;
Christina Koci Hernandez, Photographer;
John Storey, Photographer; **Kathleen Hennessy,**
Photo Editor; **Todd Trumball,** Infographics;
Tamara Straus, Editor; **Robert Rosenthal,** Editor

Special coverage / Single subject

This series on suicide on the Golden Gate bridge is one of restraint. The contained front-page summary allows the inside story to start with its own integrity. There's really nice pacing with many places to take a break from the narrative — portraits, documentary photos and graphics. The thick rules tie the package and designate its serious tone.

Esta serie sobre el suicidio en el conocido puente de San Francisco se destaca por su autocontrol. El restringido sumario en la portada permite que el relato en el interior pueda comenzar con su propia integridad. Hay un ritmo realmente agradable, con muchos instantes para tomar un descanso de la narración; retratos, fotos documentales y gráficos. Las gruesas líneas atan el paquete informativo y le dan un tono serio.

Los Angeles Times

Michael Whitley, Deputy Design Director; **Bill Gaspard,** News Design Director;
Joseph Hutchinson, Creative Director; **Dan Santos,** Design Editor; **Alex Brown,** Design Editor; **Bill Sheehan,** Graphics Editor; **Dave Campbell,** Graphics Editor; **Lorraine Wang,** Graphics Editor; **David Rose,** Design Editor; **Mark Yemma,** Design Editor

Special coverage / Single subject

Lexington Herald-Leader
Ky.

Jason Moon, Designer;
Kenny Monteith, Presentation Editor; **Brian Simms,** Designer;
Ron Garrison, Visual Editor;
Dennis Varney, Designer;
Randy Medema, Designer;
Marilyn Cecil, Designer;
Kim Parson, A.M.E./Nights;
Staff

Special coverage / Single subject

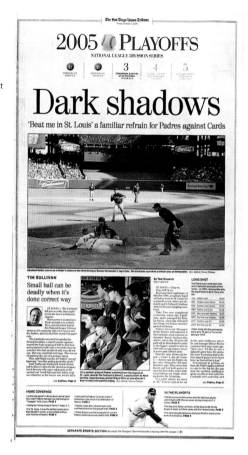

The San Diego Union-Tribune

Josh Penrod, Designer; Jason Brown, Designer;
Bruce Huff, Photo Editor; John McCutchen,
Photographer; K.C. Alfred, Photographer;
Sean M. Haffey, Photographer;
Nadia Borowski Scott, Photographer;
Michael Price, Presentation Editor; Brian Cragin,
Deputy Graphics Editor; Shaffer Grubb, Graphic Artist

Special coverage / Single subject

Welt am Sonntag

Berlin

Staff

Special coverage / Single subject

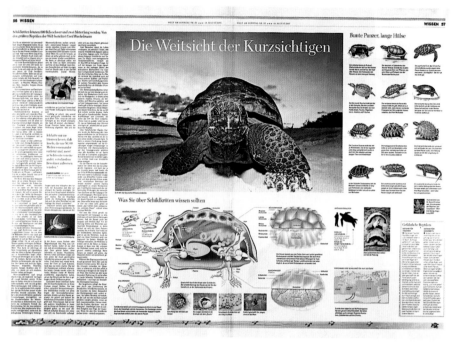

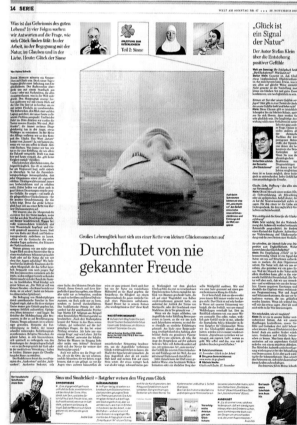

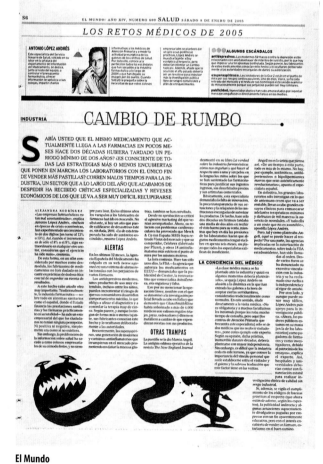

Welt am Sonntag

Berlin

Staff

Special coverage / Single subject

El Mundo

Madrid, Spain

Carmelo Caderot, Art Director & Designer; Jose Carlos Saiz, Designer

Special coverage / Sections, with ads

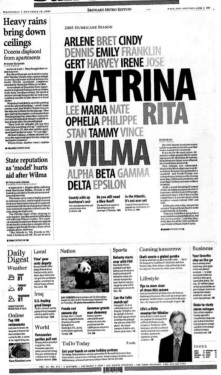

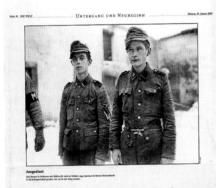

There are smart details everywhere you look on these pages about wine appreciation. The understated use of color, the inviting and airy white space, the clever touches in the nameplate — all these details ooze class. The clever wraparound invites you to the back page. This is not something you read and throw away. It's meant to be kept.

Hay detalles inteligentes donde se mire en estas páginas sobre apreciación del vino. El sutil uso del color, el espacio en blanco atractivo y amplio, los astutos toques en la mancheta; todos esos detalles evidencian un alto nivel. El inteligente marco lleva al lector a la última página. Esto no es algo que se lee y se bota, sino que se ha de guardar.

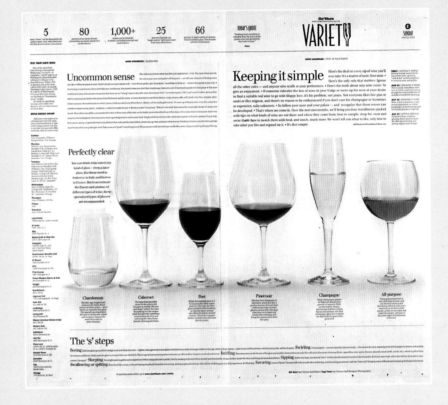

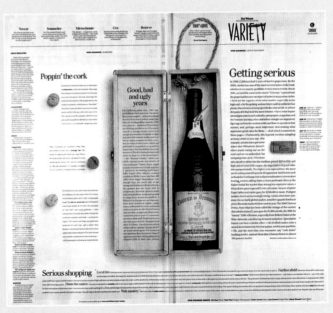

El Correo
Vizcaya, Spain

Diego Zúñiga, Art Director; **Alberto Torregrosa,** Editorial Art & Design
Consultant; **María del Carmen Navarro,** Design Editor;
Mikel García Macías, Designer; **Ana Espligares,** Designer;
Aurelio Garrote, Designer; **Laura Piedra,** Designer; **Rafael Marañón,**
Designer; **Pacho Igartua,** Designer

Special coverage / Sections, no ads

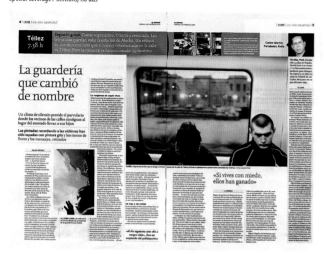

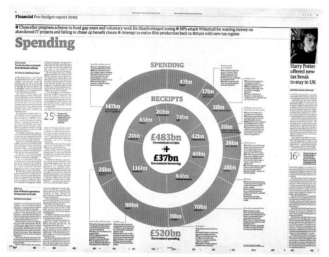

The Guardian
London

Staff

Special coverage / Sections, no ads

Diario La Nacion
Buenos Aires, Argentina

Carmen Piaggio, Art Director; **Silvana Segu,**
Designer; **Mariana Trigo Viera,** Designer;
Andrea Platon, Designer

Special coverage / Sections, with ads

El Comercio
Lima, Peru

Orlando Lazo, Graphic Designer; **César Arias,** Graphic Designer; **Victor Aguilar,** Illustrator;
Paola Damonte Vegas, Design Editor

Special coverage / Sections, with ads

El Gráfico
Antiguo Cuscatlán, El Salvador

Agustín Palacios, Design Coordinator; **José Jaén,** Designer; **Rodrigo Baires,** Redactor;
Juan José, Illustrator; **Cristian Villalta,** Editor; **Photography Staff**

Special coverage / Sections, with ads

Clarín
Buenos Aires, Argentina

Gustavo Lo Valvo, Art Director;
Carlos Vázquez, Design Editor

Special coverage / Sections, no ads

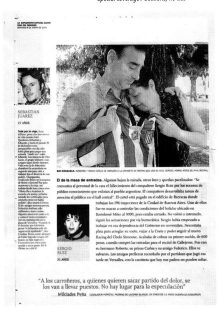

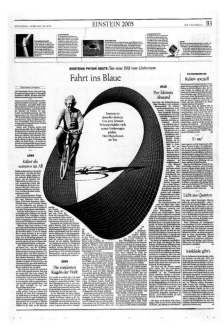

Der Tagesspiegel
Berlin

Bettina Seuffert, Designer

Special coverage / Sections, no ads

SILVER

El Correo
Vizcaya, Spain

Diego Zúñiga, Art Director; **Alberto Torregrosa,** Editorial Art & Design Consultant;
María del Carmen Navarro, Design Editor; **Mikel García Macías,** Designer; **Ana Espligares,**
Designer; **Aurelio Garrote,** Designer; **Laura Piedra,** Designer; **Rafael Marañón,** Designer;
Pacho Igartua, Designer

Special coverage / Sections, with ads

This special section on the 60-year career of cartoonist Don Celes never drops a stitch, sustaining its concept through the section. The pages appear as cartoon panels with interaction between the photos and art, the creator and his character. This is a gift for readers who have had a relationship with this man and his work for many years.

Esta sección especial sobre los 60 años de carrera del ilustrador humorista Don Celes no pierde la puntada nunca, llevando el concepto a lo largo de toda la sección. Estas páginas se presentan como paneles de tiras cómicas con interacción entre las fotos y el arte, el creador y su personaje. Es un regalo para los lectores que han tenido toda una relación con este hombre y su obra por muchos años.

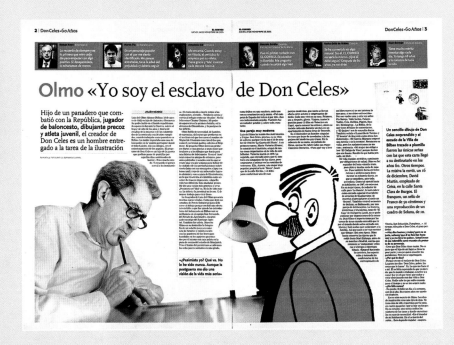

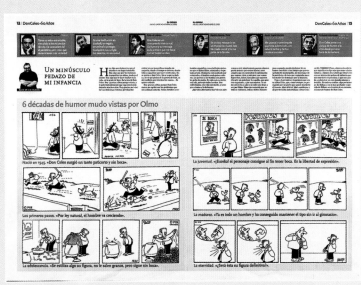

THE MANE EVENT

He is the star turn of the Lions tour but with the PR machine in overdrive it takes some reading between the lines to find the real Gavin Henson

By Claire Cronin

'I don't think you are remembered if you don't make the Test side and that's what it's all about. I am determined to make a mark on this tour'

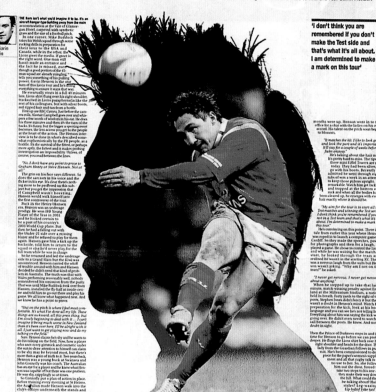

ELIMINATION WALTZ BEGINS IN EARNEST

After a patchy opening win over Bay of Plenty, the clock is ticking down for Lions coach Clive Woodward to find the right centre pairing to face the All Blacks in three weeks' time

By Alasdair Reid, Chief Rugby Writer

Sunday Herald
Glasgow, Scotland

Stephen Penman, Sports Editor; **Roddy Thomson,** Deputy Sports Editor; **Kathryn Course,** Chief Sports Sub Editor; **Elaine Livingstone,** Picture Editor

Special coverage / Sections, with ads

The Star-Ledger
Newark, N.J.

George Frederick, Deputy Design Director; **Linda Grinbergs,** Presentation Editor; **Hassan Hodges,** Graphics Artist; **Mary Jo Patterson,** Reporter; **Joel Pisetzner,** Copy Editor; **Pim VanHemmen,** A.M.E./Photo

Special coverage / Sections, no ads

Indonesia

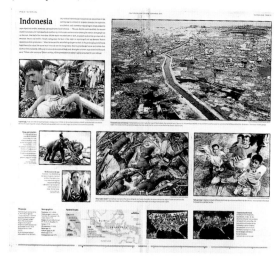

Not your father's Lincoln museum

With a sly blend of scholarship and showmanship, a new museum re-introduces our 16th president and places us in his world

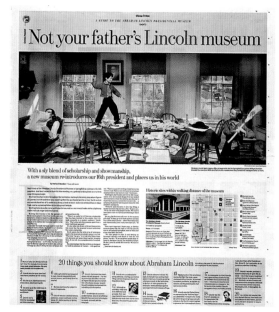

20 things you should know about Abraham Lincoln

Chicago Tribune

Tom Heinz, Designer; **Keith Claxton,** Graphic Artist; **Van Tsui,** Graphics Coordinator; **E. Jason Wambsgans,** Photographer; **Geoffrey Black,** Photo Editor; **Patrick T. Reardon,** Reporter; **Lilah Lohr,** Editor; **Jane Hunt,** Senior News Editor

Special coverage / Sections, no ads

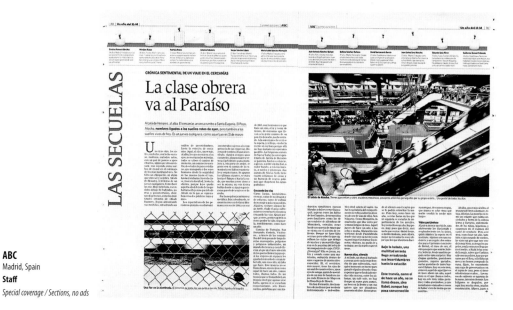

LAS SECUELAS

CRÓNICA SENTIMENTAL DE UN VIAJE EN EL CERCANÍAS

La clase obrera va al Paraíso

ABC
Madrid, Spain

Staff

Special coverage / Sections, no ads

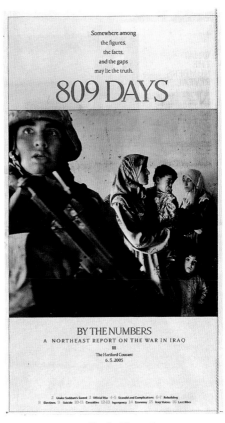

Somewhere among
the figures,
the facts,
and the gaps
may lie the truth.

809 DAYS

BY THE NUMBERS
A NORTHEAST REPORT ON THE WAR IN IRAQ
III
The Hartford Courant
6.5.2005

Hartford Courant
Conn.

Timothy Reck, Graphic Artist / Designer;
Suzette Moyer, Director/Design & Graphics &
Designer; **Bruce Moyer,** Photo Editor;
Thom McGuire, A.M.E. Graphics/Photo

Special coverage / Sections, with ads

ARKIV ERNST VAN NORDE 2004

Med en historia som
skrämmer

Föräldrarna dog när han var 14 år. Som vuxen har det funnits kopplingar med Hells Angels, han
har fått sparken från flera klubbar och han har dömts till fyra månaders fängelse efter ett
krogslagsmål.
Stig Tøfting är en ny stor profil i allsvenskan och hans historia läm-
nar ingen oberörd.
▶▶ Vänd

Sydsvenskan
Malmö, Sweden

Ulf Jarveik, Page Designer; **Lars Dareberg,** Photographer

Special coverage / Sections, with ads

A 28 — LA PRESSE MONTRÉAL MARDI 20 SEPTEMBRE 2005

DOSSIER / LE NIGER AFFAMÉ

DES VENTRES CREUX
QUI DÉFIENT LA MORT

À ZINDER, NIGER
REPORTAGE PHOTO MARTIN TREMBLAY

La Presse
Montréal

Benoit Giguere, Art Director;
Jacques-Olivier Bras, Designer; **Michele Ouimet,**
A.M.E./News; **Eric Trottier,** M.E.; **Pascale Breton,**
Journalist; **Martin Tremblay,** Photographer;
Alain-Pierre Hovasse, Photo Director

Special coverage / Sections, with ads

1965-1974

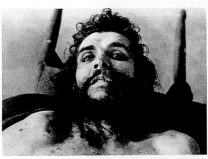

1965-1974

Clarín
Buenos Aires, Argentina

Gustavo Lo Valvo, Art Director; **Federico Sosa,** Design Editor

Special coverage / Sections, with ads

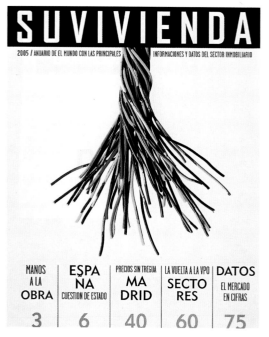

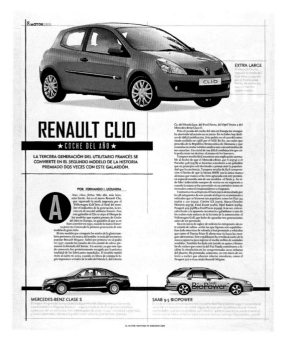

El Mundo
Madrid, Spain

Carmelo Caderot, Art Director & Designer; **Jose Carlos Saiz,** Designer

Special coverage / Sections, with ads

El Mundo
Madrid, Spain

Carmelo Caderot, Art Director & Designer; **Jose Carlos Saiz,** Designer

Special coverage / Sections, no ads

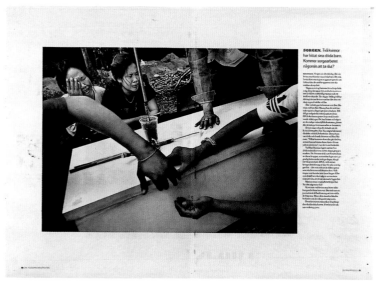

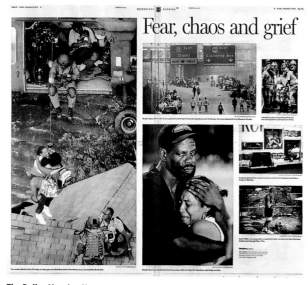

Dagens Nyheter
Stockholm, Sweden

Anne-Marie Möglund, Layouter; **Mattias Hermansson,** Project Editor;
Pär Björkman, Photo Editor; **Paul Hansen,** Photographer

Special coverage / Sections, no ads

The Dallas Morning News

Noel G. Gross, Designer

Special coverage / Sections, with ads

Hartford Courant
Conn.

Wes Rand, Graphic Artist; **Suzette Moyer,** Director/Design &
Graphics; **Bruce Moyer,** Photo Editor; **Tom Brown,** Photographer;
Thom McGuire, A.M.E. Graphics/Photo; **John Scanlan,** Director/
Photography

Special coverage / Sections, no ads

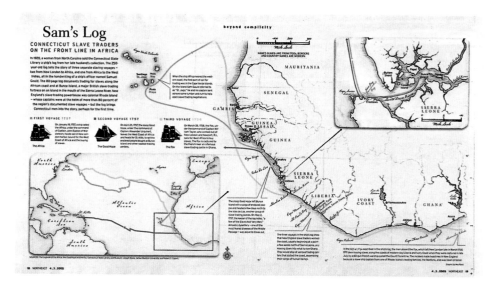

Frankfurter Allgemeine Sonntagszeitung
Frankfurt am Main, Germany

Peter Breul, Art Director & Designer; **Christian Mathias Pohlert,** Picture Editor; **Daniel Deckers,** Editor; **Juan Antonio Kerle,** Designer/Photographer

Special coverage / Sections, no ads

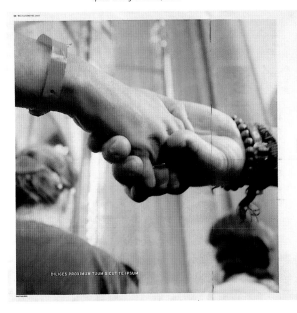

DILIGES PROXIMUM TUUM SICUT TE IPSUM

EL MUNDO / SÁBADO 12 / FEBRERO 2005

MARILYN

7

EL IMPACTO DE LA CARNE

Sabía desplazar el peso de una nalga a otra, tumbarse como una diosa, pintar sus labios con boca de beso y, en definitiva, irradiar sexo por todos los poros de su cuerpo. Por Lourdes Ventura

Bert Stern realizó 2.700 sensuales fotografías de Marilyn semanas antes de su muerte.

AMOR EN CONSERVA

PLAYBOY

Feminidad para gays / por Luis Antonio de Villena

"Andy Warhol se parece a Marilyn Monroe", fotografía del estadounidense Christopher Makos.

—¿QUÉ ME PONGO PARA DORMIR?... CHANEL Nº 5—

El Mundo
Madrid, Spain

Carmelo Caderot, Art Director & Designer; **Manuel De Miguel,** Designer

Special coverage / Sections, no ads

SUNDAY, OCTOBER 30, 2005
PIECES OF BRIAN 5

Hartford Courant
Conn.

Suzette Moyer, Director Design & Graphics; **David Grewe,** Photo Editor; **John Scanlan,** Director of Photography; **Thom McGuire,** A.M.E./Design & Photo; **Brad Clift,** Photographer

Special coverage / Sections, no ads

2 LIGA 05/06 EL MUNDO, JUEVES 25, AGOSTO 2005

SAMBA PARA LA LIGA

ORFEO SUAREZ

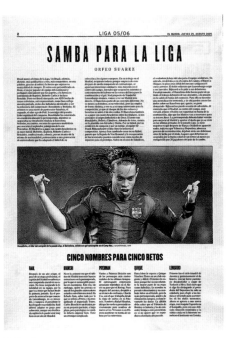

CINCO NOMBRES PARA CINCO RETOS

El Mundo
Madrid, Spain

Carmelo Caderot, Art Director & Designer; **Manuel De Miguel,** Designer; **Ulises Culebro,** Illustrator

Special coverage / Sections, with ads

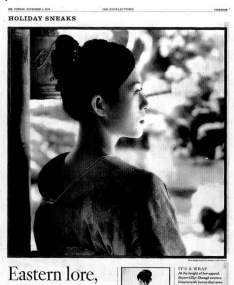

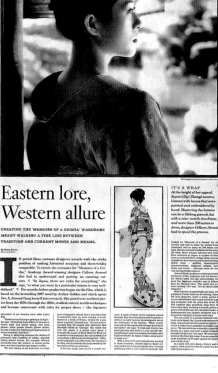

Eastern lore, Western allure

CREATING THE 'MEMOIRS OF A GEISHA' WARDROBE MEANT WALKING A FINE LINE BETWEEN TRADITION AND CURRENT MODES AND MEANS.

By Mimi Avins

IN period films, costume designers wrestle with the sticky problem of making historical accuracy and theatricality compatible. To create the costumes for "Memoirs of a Geisha," Academy Award-winning designer Colleen Atwood also had to understand and portray an exacting culture. "In Japan, there are rules for everything," she says, "so what you wear in a particular season is very well-defined." For months before production began on the film, which is based on the bestselling 1997 novel by Arthur Golden and which opens Dec. 9, Atwood flung herself into research. She pored over archival photos from the 1920s through the 1940s, studied exotic textile techniques and became conversant with rules for proper dress — the Japanese

equivalent of not wearing white after Labor Day.

IT'S A WRAP
At the height of her appeal, Sayuri (Ziyi Zhang) wears a kimono with leaves that were painted and embroidered by hand. Mastering the kimono can be a lifelong pursuit, but with a nine-month timeframe and more than 300 actors to dress, designer Colleen Atwood had to speed the process.

Los Angeles Times

Paul Gonzales, Deputy Design Director/Features;
Christian Potter Drury, Design Director/Features; **Steven E. Banks,** Design Editor; **Jim Brooks,** Design Editor; **Tim Hubbard,** Design Editor; **Pete Metzger,** Design Editor; **Cindy Hively,** Photo Editor

Special coverage / Multiple sections, with ads

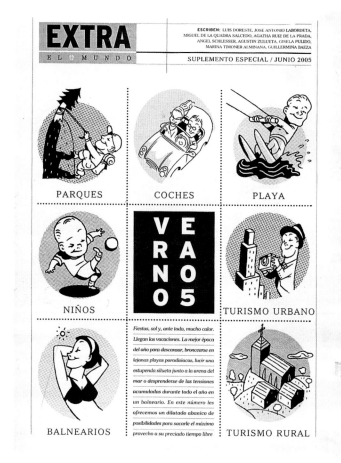

EXTRA EL MUNDO — SUPLEMENTO ESPECIAL / JUNIO 2005

ESCRIBEN: LUIS DORESTE, JOSE ANTONIO LABORDETA, MIGUEL DE LA QUADRA SALCEDO, AGATHA RUIZ DE LA PRADA, ANGEL SCHLESSER, AGUSTIN ZULUETA, GISELA PULIDO, MARINA TIMONER ALMINANA, GUILLERMINA BAEZA

PARQUES COCHES PLAYA

NIÑOS VERANO 05 TURISMO URBANO

BALNEARIOS TURISMO RURAL

Fiestas, sol y, ante todo, mucho calor. Llegan las vacaciones. La mejor época del año para descansar, broncearse en lejanas playas paradisiacas, lucir una estupenda silueta junto a la arena del mar o desprenderse de las tensiones acumuladas durante todo el año en un balneario. En este número les ofrecemos un dilatado abanico de posibilidades para sacarle el máximo provecho a su preciado tiempo libre

El Mundo
Madrid, Spain

Carmelo Caderot, Art Director & Designer; **Manuel De Miguel,** Designer; **Raul Arias,** Illustrator

Special coverage / Section covers

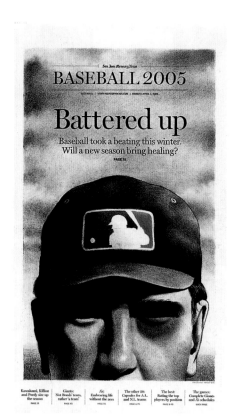

San Jose Mercury News

BASEBALL 2005

Battered up

Baseball took a beating this winter. Will a new season bring healing?

PAGE 36

San Jose Mercury News
Calif.

Matt Mansfield, Deputy M.E.; **Kevin Wendt,** News & Sports Design Director; **Kenney Marlatt,** Designer; **Doug Griswold,** Illustrator

Special coverage / Section covers

SPRING HOME & GARDEN
Friday, April 8, 2006 | The Columbus Dispatch | Special Section

Paint, plant, enjoy!

Itching to make a change around your place this spring? You could paint a room or plant a garden to achieve that new view. But, before you buy a brush or choose a bulb, peruse this section for helpful tips. Then, get busy!

PHOTO ILLUSTRATION BY JILLIAN WELSH

The Columbus Dispatch
Ohio

Jillian Welsh, Artist; **Scott Minister,** Art Director; **Becky Kover,** Section Coordinator

Special coverage / Section covers

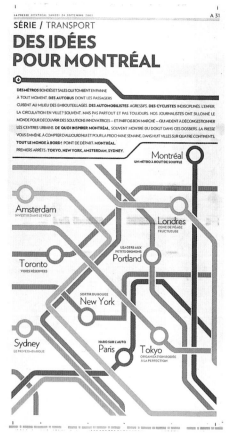

SÉRIE / TRANSPORT

DES IDÉES POUR MONTRÉAL

DES MÉTROS BONDÉS ET SALES QUI TOMBENT EN PANNE À TOUT MOMENT. DES AUTOBUS DONT LES PASSAGERS CUISENT AU MILIEU DES EMBOUTEILLAGES. DES AUTOMOBILISTES AGRESSIFS, DES CYCLISTES INDISCIPLINÉS, L'ENFER. LA CIRCULATION EN VILLE? SOUVENT. MAIS PAS PARTOUT ET PAS TOUJOURS. NOS JOURNALISTES ONT SILLONNÉ LE MONDE POUR DÉCOUVRIR DES SOLUTIONS INNOVATRICES — ET PARFOIS BON MARCHÉ — QUI AIDENT À DÉCONGESTIONNER LES CENTRES URBAINS. DE QUOI INSPIRER MONTRÉAL, SOUVENT MONTRÉ DU DOIGT DANS CES DOSSIERS. LA PRESSE VOUS EMMÈNE. À COMPTER D'AUJOURD'HUI ET POUR LA PROCHAINE SEMAINE, DANS HUIT VILLES SUR QUATRE CONTINENTS. TOUT LE MONDE À BORD! POINT DE DÉPART: MONTRÉAL. PREMIERS ARRÊTS: TOKYO, NEW YORK, AMSTERDAM, SYDNEY.

Montréal
Amsterdam Londres
Toronto Portland
New York
Sydney Paris Tokyo

La Presse
Montréal

Benoit Giguere, Art Director; **David Lambert,** Designer; **Michele Ouimet,** A.M.E./News; **Eric Trottier,** M.E.

Special coverage / Section covers

Sun Journal
Lewiston, Maine
Paul Wallen, M.E. Visuals
Special coverage / Section covers

The Charlotte Observer
N.C.
Michael Tribble, News Design Team Leader; **Mary Ann Lawrence,** Assistant Sports Editor/Design; **Sarah Franquet,** Design Director
Special coverage / Section covers

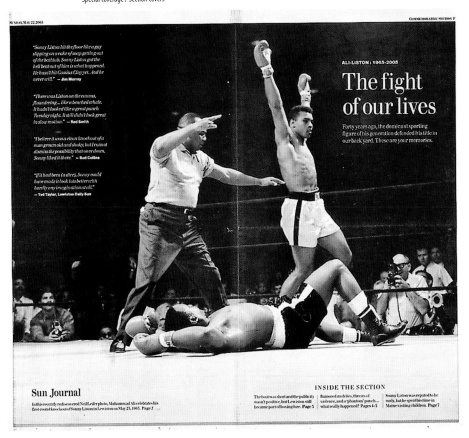

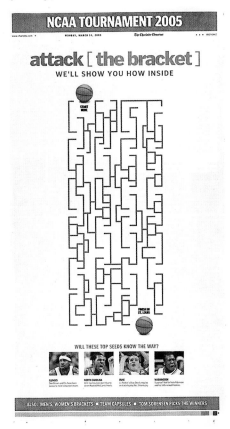

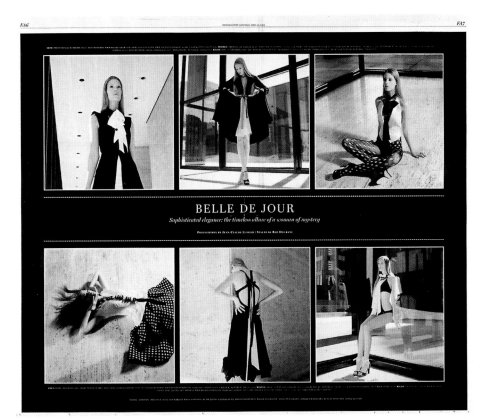

National Post
Toronto
Christine Dewairy, Post Fashion/Art Director; **Sarah Murdoch,** M.E./Features;
Jean-Claude Lussier, Photographer; **Gayle Grin,** M.E./Presentation; **Douglas Kelly,**
Editor in Chief
Special coverage / Section pages / Inside page or spread

El Mundo
Madrid, Spain
Carmelo Caderot, Art Director & Designer; **Manuel De Miguel,** Designer
Special coverage / Section covers

The Wall Street Journal

South Brunswick, N.J.

Greg Leeds, Executive Art Director; **Orlie Kraus,** Art Director; **Serge Bloch,** Illustrator

Special coverage / Section covers

St. Petersburg Times

Fla.

Terry Chapman, Senior Designer; **Joshua Engleman,** Features Designer; **Ron Brackett,** Newsart Director; **Patty Cox,** A.M.E./Presentation; **Don Morris,** Senior Artist

Special coverage / Section covers

The San Diego Union-Tribune

Heather Barber, Page Designer; **Cristina Martinez,** Illustrator; **Michael Price,** Presentation Editor; **Chris Ross,** News Design Editor; **Hieu Phan,** Section Editor

Special coverage / Section covers

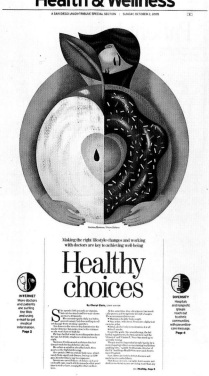

Detroit Free Press

Christoph Fuhrmans, Designer; **Gene Myers,** Sports Editor; **Diane Weiss,** Photo Editor; **Amy Leang,** Photographer; **Steve Dorsey,** AME/Presentation

Special coverage / Section covers

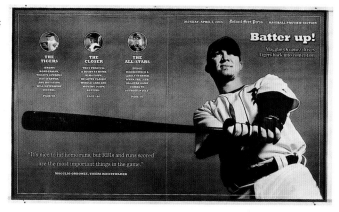

San Antonio Express-News

Texas

Dennis Ochoa, Assistant Art Director/Features

Special coverage / Section covers

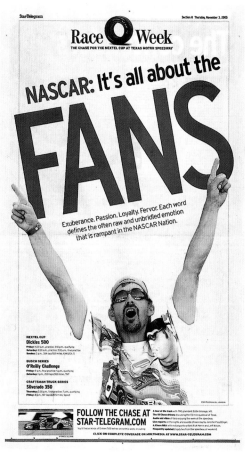

Fort Worth Star-Telegram

Texas

Michael Currie, Assistant Sports Editor; **Jill Johnson,** Photographer

Special coverage / Section covers

Hartford Courant
Conn.

Jim Kuykendall, Designer; **Cloe Poisson,**
Photographer; **Suzette Moyer,** Art Director

Special coverage / Section covers

The Columbus Dispatch
Ohio

Patrick Kastner, Page Designer; **Scott Minister,** Art Director;
Ray Stein, Sports Editor; **Becky Kover,** Section Coordinator;
Neal C. Lauron, Photographer

Special coverage / Section covers

Welt am Sonntag
Berlin

Staff

Reprints

The Star-Ledger
Newark, N.J.

Robert F. Russo, Designer;
Mitsu Yasukawa, Photographer;
Pablo Colón, Features Design Director

Special coverage / Section covers

The Columbus Dispatch
Ohio

Scott Minister, Art Director & Designer; **Becky Kover,** Section Coordinator;
Eric Albrecht, Photographer

Special coverage / Section covers

National Post
Toronto

Christine Dewairy, Art Director; **Sarah Murdoch,** M.E./Features;
Richard Bernaroin, Photographer; **Gayle Grin,** M.E./Presentation;
Douglas Kelly, Editor in Chief

Special coverage / Section covers

Wie gut sind Sie als Ihr eigener Manager?

Haben Sie sich selbst, Ihre Termine und Prioritäten im Griff? Der Selbst- und Zeitmanagement-Test gibt Ihnen Aufschluss

SonntagsZeitung
Zürich, Switzerland

Tobias Gaberthuel, Designer; **Stefan Semrau,** Art Director

Special coverage / Section pages / Inside page or spread

Helden für die Ewigkeit

Aufwändig produzierte Videos verdichten das Lebensgefühl der weltweiten Boarderszene

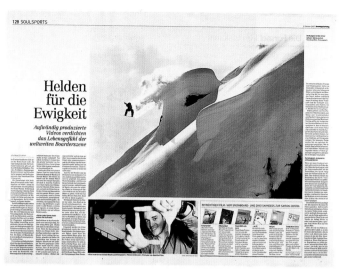

SonntagsZeitung
Zürich, Switzerland

Tobias Gaberthuel, Designer; **Stefan Semrau,** Art Director

Special coverage / Section pages / Inside page or spread

SPECIAL REPORT
Iven and Gary belonged to a nearly invisible group of teens living on society's margins, without a parent's help, without a real home

ON THE EDGE | CHAPTER ONE

SHARING A SECRET

The Baltimore Sun

Andre F. Chung, Photographer; **Liz Bowie,** Reporter; **Dudley Brooks,** A.M.E./Photography; **Michelle Deal-Zimmerman,** A.M.E. Graphics/Design; **Monty Cook,** D.M.E./Presentation & News Editing

Reprints

PRO FOOTBALL
2005 PREVIEW

Uphill battle

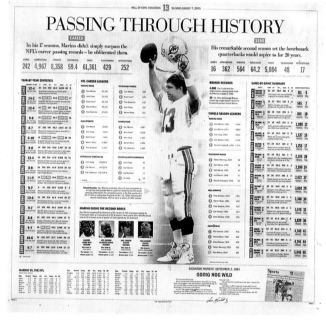

The Seattle Times

Mark McTyre, Designer; **Paul Schmid,** Illustrator

Special coverage / Section covers

PASSING THROUGH HISTORY

The Palm Beach Post
West Palm Beach, Fla.

Chris Rukan, Sports Design Director; **Hal Habib,** Writer; **Mark Bradley,** Copy Editor; **Rick Ingebritson,** Copy Editor; **Nick Moschella,** Executive Sports Editor; **Dave Tepps,** Deputy Sports Editor

Special coverage / Section pages / Inside page or spread

The New York Times
Staff

Special coverage / Section pages / Inside page or spread

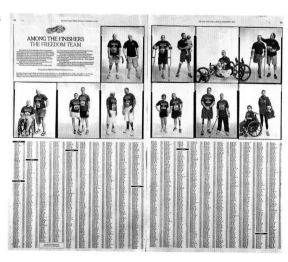

AMONG THE FINISHERS
THE FREEDOM TEAM

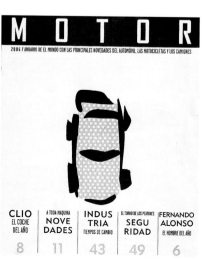

El Mundo
Madrid, Spain

Carmelo Caderot, Art Director & Designer; **Jose Carlos Saiz,** Designer

Special coverage / Section covers

Toronto Star

Richard Lautens, Photographer; **Spencer Wynn,** Designer; **Adam Gutteridge,** Editor

Special coverage / Section covers

Prostate Cancer

UNMASKING AN AVOIDABLE KILLER

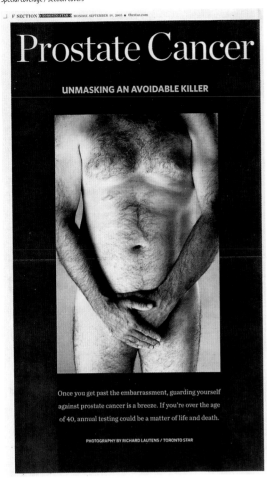

Once you get past the embarrassment, guarding yourself against prostate cancer is a breeze. If you're over the age of 40, annual testing could be a matter of life and death.

PHOTOGRAPHY BY RICHARD LAUTENS / TORONTO STAR

Breast Cancer

THE LONG STRUGGLE TO BEAT THE DISEASE

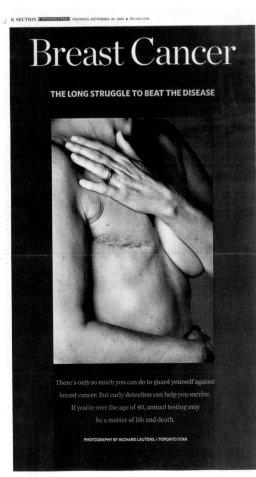

There's only so much you can do to guard yourself against breast cancer. But early detection can help you survive. If you're over the age of 40, annual testing may be a matter of life and death.

PHOTOGRAPHY BY RICHARD LAUTENS / TORONTO STAR

Toronto Star

Richard Lautens, Photographer; **Spencer Wynn,** Designer; **Adam Gutteridge,** Editor

Special coverage / Section covers

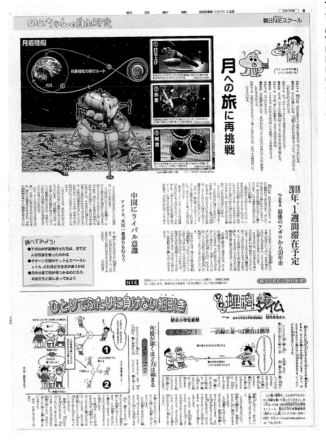

The Asahi Shimbun
Tokyo

Ami Kurita, Graphics Designer; **Yosuke Miyashita,** Graphics Designer; **Toki Sasaki,** Graphics Designer; **Yuki Hara,** Graphics Designer; **Teppei Noguchi,** Graphics Designer; **Shinya Uemura,** Graphics Designer

Reprints

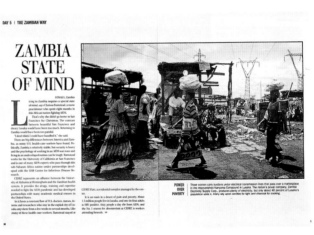

ZAMBIA STATE OF MIND

The Birmingham News
Ala.

Napo Monasterio, Page Designer; **Bernard Troncale,** Senior Photographer; **Dave Parks,** Senior Reporter; **Rick Frennea,** Senior Page Designer; **Virginia Martin,** Health Editor

Reprints

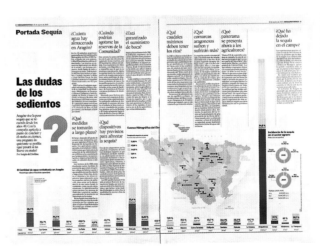

Portada Sequía

Las dudas de los sedientos

Heraldo de Aragón
Zaragoza, Spain

Pilar Ostalé, Designer; **Iban Santos,** Designer; **Ana Pérez,** Designer; **Kristina Urresti,** Designer; **Jorge Mora,** Designer

Reprints

The Washington Post

Patterson Clark, Illustrator;
Gene Thorp, Cartographer;
Fred Barbash, Writer;
Tracy Grant, Kidspost Editor

Reprints

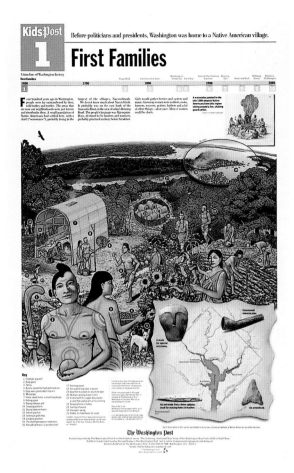

National Post

Toronto

Douglas Kelly, Editor in Chief; **Gayle Grin,** M.E./Presentation; **Laura Koot,**
News Presentation; **Rob McKenzie,** Editor, Page 1

Reprints

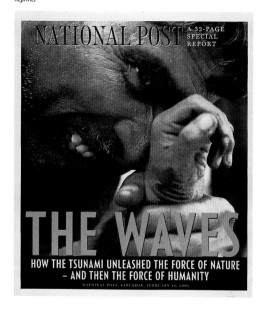

San Francisco Chronicle

Frank Mina, Senior Art Director/News; **Deanne Fitzmaurice,** Photographer;
Meredith May, Reporter; **David Lewis,** Editor; **Narda Zacchino,** Reprint Editor;
Kathleen Hennessy, Photo Editor

Reprints

Heraldo de Aragón

Zaragoza, Spain

Javier Errea, Art Director;
Pilar Ostalé, Designer;
Ana Pérez, Designer;
Kristina Urresti, Designer;
Asier Barrio, Designer

Reprints

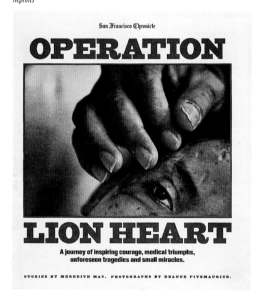

Gulf News

Dubai, United Arab Emirates

Douglas Okasaki, Designer

Reprints

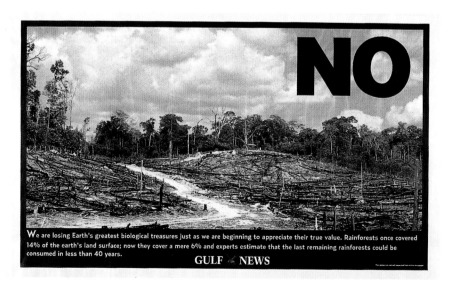

Portfolios

9

The Boston Globe

Vic DeRobertis, Art Director & Designer

Page-design portfolio / News / 175,000 and over

The Boston Globe

David Schutz, Assistant Design Director/News

Page-design portfolio / News / 175,000 and over

San Jose Mercury News

Calif.

Tracy Cox, Senior Designer

Page-design portfolio / News / 175,000 and over

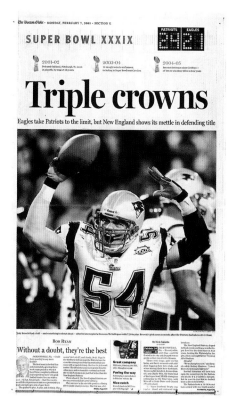

The Boston Globe

Brian Gross, Designer

Page-design portfolio / Sports / 175,000 and over

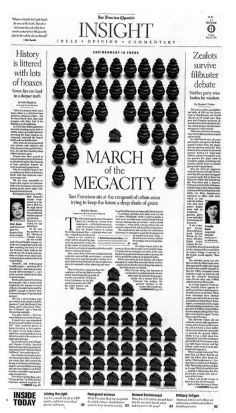

San Francisco Chronicle

Rick Nobles, Designer

Page-design portfolio / News / 175,000 and over

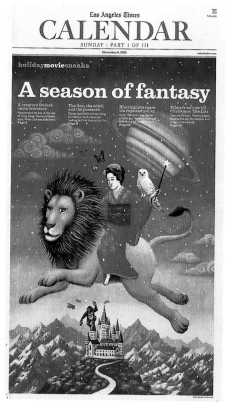

Los Angeles Times

Paul Gonzales, Deputy Design Director/Features

Page-design portfolio / Features / 175,000 and over

The Wall Street Journal
South Brunswick, N.J.
Orlie Kraus, Art Director
Page-design portfolio / News / 175,000 and over

Technology
THE JOURNAL REPORT
THE WALL STREET JOURNAL.

How Old Media Can Survive in a New World

The digital revolution threatens to push the traditional newspaper, television, music and advertising industries into the dustbin of history. Here's what they might do to avoid that fate.

The Seattle Times
Erin Jang, Designer/Illustrator
Page-design portfolio / Features / 175,000 and over

City Weekly
BOSTON SUNDAY GLOBE, FEBRUARY 6, 2005

DORCHESTER

The wit on the bus goes round and round

By Johnny Diaz
GLOBE STAFF

Baby, it's cold inside

As heating costs soar, thermostats take a dive in Boston homes

SILVER

The Boston Globe
Lesley Becker, Designer
Page-design portfolio / News / 175,000 and over

These City Weekly pages represent some of the smartest work in the competition. Illustration, typography and even a routine mug shot of a house turn into graphics that tell stories. There is a wide range of solutions and a wonderful sense of innovation in this local section, not known elsewhere for its visual sophistication.

Estas páginas sobre la ciudad en los siete días es uno de los trabajo más inteligentes de la competencia. La ilustración, la tipografía e incluso la rutinaria foto pequeña de una casa convertida en gráficos que relata lo ocurrido. Hay una amplia gama de soluciones y un maravilloso sentido de innovación en esta sección local, desconocida en otros ámbitos por su sofisticación visual.

San Jose Mercury News
Calif.

Stephanie Grace Lim, Features Design Director

Page-design portfolio / Features / 175,000 and over

San Francisco Chronicle
Matt Petty, Art Director

Page-design portfolio / Features / 175,000 and over

San Francisco Chronicle
Matt Petty, Art Director

Page-design portfolio / Features / 175,000 and over

Göteborgs-Posten
Goteborg, Sweden

Gunilla Wernhamn, Designer

Page-design portfolio / Features / 175,000 and over

San Francisco Chronicle
Matt Petty, Art Director

Page-design portfolio / Features / 175,000 and over

Hartford Courant
Conn.

Nicole Dudka, Designer/Illustrator

Page-design portfolio / Features / 175,000 and over

DESTINATIONS
TRAVEL AND LEISURE FROM NEAR TO FAR · Pittsburgh Post-Gazette · SUNDAY, AUGUST 7, 2005

Section **F**

The floating tea house in Yu Yuan Gardens offers such delights as freshly picked and hand-roasted spring Jing tea. Yu Yuan Gardens is a 400-year-old enclave featuring traditional cuisine, architecture and garden design.

SHANGHAI
S U R P R I S E S

FOREIGN YET FAMILIAR, CITY RECLAIMS TITLE OF 'PARIS OF THE EAST'

By Chris Welsch

Kites soar before sunrise on the Bund, the famous road of finance and business that runs beside the Huangpu River.

Artists' colony takes root deep in the heart of Texas

By Sophia Dembling
Travel Arts Syndicate

MARFA, Texas

SHARING THE ROAD

David Longstreath, Associated Press

Pittsburgh Post-Gazette

Steve Urbanski, Page Design Editor

Page-design portfolio / Combination / 175,000 and over

Boston Sunday Globe

Ideas
& Children's Books
OVER THE RAINBOW The power of secret places **E6**
REQUIRED READING Reviewing today's high school curricula **E7**
RHYMERS Poetry aimed at the small reader **E7**
FINE LINES An interview with author-illustrator Uri Shulevitz **E8**
GOODBYE, WORLD, GOODNIGHT MOON Escapes for children and their parents **E8**
CRIME SCRIBE In "A Reading Life," the legacy of Evan Hunter **E9**

JULY 17, 2005

Thinking big: Personalized medicine **E12**

Stoicism in the ranks E4
By Christopher Shea

C. Vann Woodward's strange career E2
By Clay Risen

Bubble rap E5
A cartoon by Sage Stossel

AND…
Fenway's faithful, Google's mappers, Willie Nelson's reggae covers, and more E2-3

IDEAS ONLINE
In "Looking for the exit," Drake Bennett examines the uses of the term "exit strategy" and finds that, while it has become a political mantra since the interventions of the 1990s, many experts today find the concept hollow, even dangerous, when applied to Iraq. Does the US need an exit strategy in Iraq? And what kind of strategy would it be? Record your thoughts on a message board by visiting www.boston.com/ideas

LOOKING FOR THE EXIT

The term 'exit strategy' has become a political mantra. But some wonder if it represents any strategy at all.

BY DRAKE BENNETT

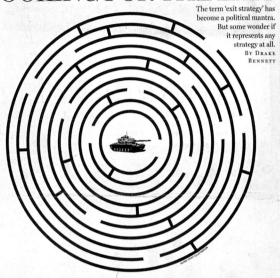

AS AMERICA'S THIRD summer in Iraq wears on, with a fragile, squabbling National Assembly in Baghdad and an unflaggingly murderous insurgency, talk in Washington has turned to exit strategies. Representative Walter Jones Jr., Republican of North Carolina, has introduced a bipartisan resolution calling for a troop withdrawal starting in October 2006. Senator Russell Feingold, Democrat of Wisconsin, has introduced a similar measure. And as reported last week, the latest in a series of leaked top-secret British memos reveals that the United States and Britain have drawn up plans, at least on the level of contingency, for cutting combined forces in Iraq from the current 160,000 to 66,000 by early next year.

As Representative Martin Meehan, Democrat of Lowell, told the Globe two weeks ago, "The case for an exit strategy is only growing stronger every day."

Like "mission creep" and "quagmire," the use of the term "exit strategy" tends to rise as public frustration with an overseas military intervention increases. And indeed, the case for an exit strategy would seem to be commonsensical. As Aesop said, "Affairs," and not only of the romantic kind, "are easier of entrance than of exit; and it is but common prudence to see our way out before we venture in."

Yet there are those who question what kind of strategy, exactly, an exit strategy represents. Is setting a timetable for withdrawal a strategy at all? Or, as **EXIT, E4**

Drake Bennett is the staff writer for Ideas. E-mail drbennett@globe.com.

In the Commonwealth

Bright flight
Is the Bay State's vaunted 'creative class' coming or going? | By ROBERT DAVID SULLIVAN

THREE YEARS AGO, in his best-selling book "The Rise of the Creative Class," economist and George Mason University business professor Richard Florida argued against the widespread belief that sunshine, cheap land, and low taxes would determine which regions of the United States would prosper over the next few decades. More important, he wrote, are the "three Ts"—technology, talent, and tolerance—characterized by the presence of high-tech industry, a highly educated workforce, and a population diverse enough to include, among other things, a large number of immigrants and a sizeable gay community. When the three Ts are in place, the argument goes, a region is able to attract still more highly skilled workers in what Florida calls "creative" occupations—not just artists but also scientists, engineers, and entrepreneurs of all types.

Robert David Sullivan is an associate editor of CommonWealth, a quarterly journal published by MassINC, a nonpartisan think tank in Boston. A longer version of this article appears in the upcoming summer issue, available online at massinc.org/commonwealth later this week.

CREATIVE CLASS, E5

ARTISTS ENGINEERS SCIENTISTS
NOW LEAVING

SILVER

The Boston Globe

Gregory Klee, Designer

Page-design portfolio / News / 175,000 and over

As long as anyone can remember, the books and opinions sections have been the dreariest of the Sunday paper. Yet with these sections from The Boston Globe, they are reincarnated. Smart, inviting ideas dominate each cover. Better yet, beyond these great concepts, the pages are stunningly simple, lively and sophisticated.

Hasta donde se sabe, las secciones sobre libros y opiniones han sido las más áridas del diario del domingo. Sin embargo, con estas secciones del Boston Globe, tienen una nueva vida. Conceptos inteligentes y atractivos dominan cada portada. Mejor aun, más allá de esos grandes conceptos, las páginas son increíblemente simples, vivaces y sofisticadas.

Ideas & Books

THE POLITICS OF **PAIN**

Common ground

The Oregonian
Portland
Francesca Genovese-Finch, Designer
Page-design portfolio / Combination / 175,000 and over

El Mundo
Madrid, Spain
Carmelo Caderot, Art Director & Designer
Page-design portfolio / Features / 175,000 and over

TRADING UP
PATIENCE AND DISCIPLINE FRAME AN ARCHITECT'S DREAM HOUSE

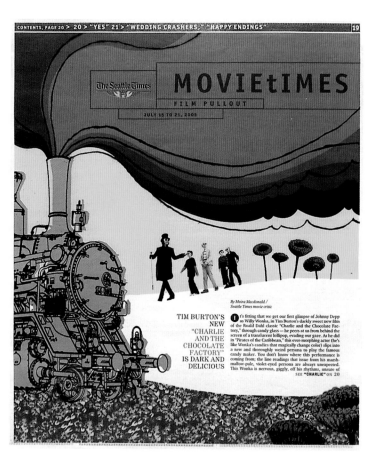

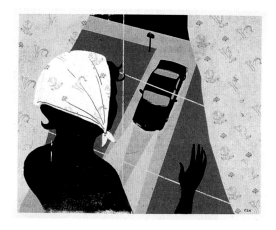

The Seattle Times
Erin Jang, Illustrator
Illustration portfolio, individual

The Boston Globe Magazine
Christopher Silas Neal, Illustrator
Illustration portfolio, individual

El Mundo Metropoli
Madrid, Spain
Raúl Arias, Illustrator
Illustration portfolio, individual

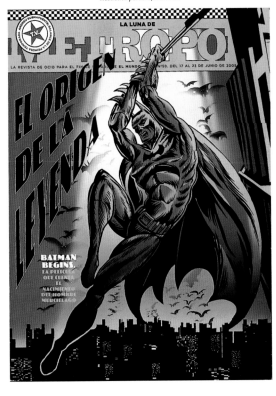

Dagens Nyheter
Stockholm, Sweden
Saina Wirsén, Illustrator
Illustration portfolio, individual

C A M P U S

CURSO 2005/ 2006

CUÁLES SON LAS PRINCIPALES OFERTAS PARA CURSAR UN MÁSTER EN ESPAÑA; CÓMO ELEGIR EL CURSO QUE MEJOR SE ADAPTA A SUS NECESIDADES; DÓNDE ESTUDIARLO Y CUÁNTO PAGAR POR ÉL: EL MUNDO DA LAS RESPUESTAS EN LAS PRÓXIMAS 36 PÁGINAS A ESTOS Y OTROS INTERROGANTES

PARA ENCONTRAR UN TRABAJO MEJOR

250 MASTER

SILVER

El Mundo
Madrid, Spain
Carmelo Caderot, Art Director & Designer
Page-design portfolio / Features / 175,000 and over

These page designs apply an elegant simplicity to their subject matter — capitalizing upon the striking contrast of the black-and-white illustrations and paying close attention to the tone, weight and detail of the display typography.

Los diseños de esta página emplean una elegante simplicidad en el tema: Ponen el acento en el fuerte contraste de las ilustraciones en blanco y negro, y prestan mucha atención al tono, el peso y el detalle de la tipografía.

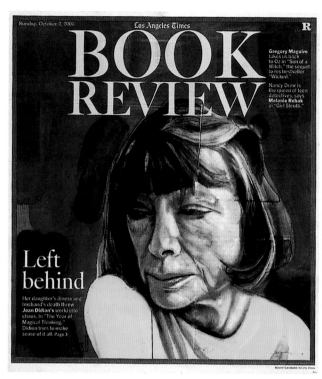

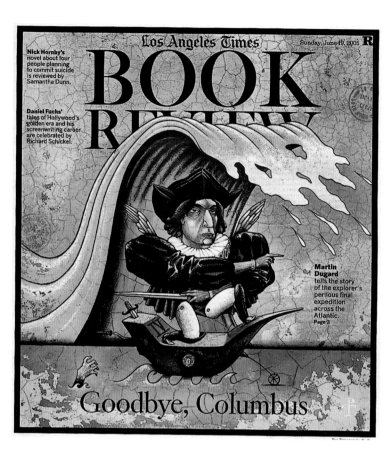

Los Angeles Times

Christian Potter Drury, Design Director/Features; **Wesley Bausmith,** Deputy Design Director; **Carol Kaufman,** Design Editor; **Scott Laumann,** Illustrator

Illustration portfolio, staff

The Palm Beach Post
West Palm Beach, Fla.

Carolyn Drake, Staff Photographer

Photo portfolio, individual

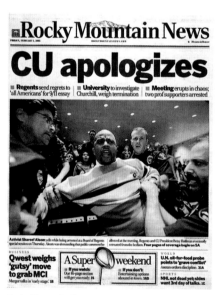

Rocky Mountain News
Denver

Todd Heisler, Photographer

Photo portfolio, individual

Concord Monitor
N.H.

Preston Gannaway, Staff Photographer

Photo portfolio, individual

Suburban Living

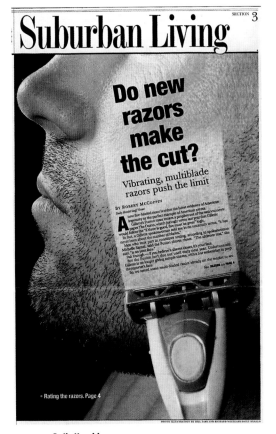

Do new razors make the cut?

Vibrating, multiblade razors push the limit

BY ROBERT McCOPPIN
Daily Herald staff Writer

A new five-bladed razor is either the latest evidence of American ingenuity or the perfect example of American excess.

Gillette's Fusion razor jokingly writes last year's Daily Herald newspaper.The Onion, which jokingly writes last year about Gillette, would follow the "if there is good, five means we go overboard logic.

In fact, a Gillette spokeswoman told me in no uncertain terms, "It has never been about the number of blades."

Men who took part in consumer testing, according to spokeswoman said, "I'm on your face."

Michelle Szynal, said the Fusion shaves closer, "The ultimate time," she said.

Put through — if you believe it shaves closer, it's your face. Unfortunately, the Fusion isn't does our want early next year. Unfortunately, Gillette is on tougher getting sample shaves, with a bit enthusiasm to prep the reporter's face.

So we tested some multi bladed razors already on the market to see

See RAZORS on PAGE 4

• Rating the razors. Page 4

PHOTO ILLUSTRATION BY BILL ZARS AND RICHARD WESTFALL/DAILY HERALD

Daily Herald
Arlington Heights, Ill.

Bill Zars, Photographer

Photo portfolio, individual

VOLLEYBALL

PLAYER OF THE YEAR

ALLISON DAVIS

SETTER • EVANGELICAL CHRISTIAN SCHOOL • SENIOR

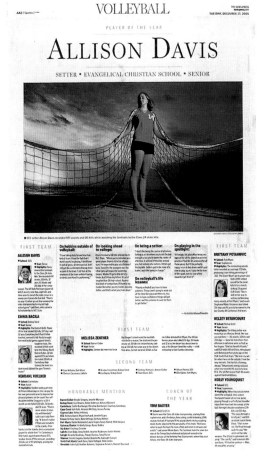

ANDREW WEST/THE NEWS-PRESS

The News-Press
Fort Myers, Fla.

Andrew West, Photographer

Photo portfolio, individual

AVENUE

Arts, Culture & Society

EISENMAN'S UNDULATING FIELD

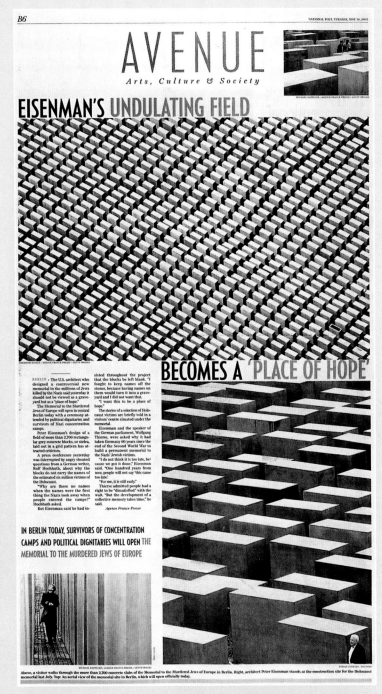

BECOMES A 'PLACE OF HOPE'

BERLIN - The U.S. architect who designed a controversial new memorial to the millions of Jews killed by the Nazis said yesterday it should not be viewed as a graveyard but as a "place of hope."

The Memorial to the Murdered Jews of Europe will open in central Berlin today with a ceremony attended by political dignitaries and survivors of Nazi concentration camps.

Peter Eisenman's design of a field of more than 2,700 rectangular grey concrete blocks, or stelea, laid out in a grid pattern has attracted criticism.

A press conference yesterday was interrupted by angry shouted questions from a German writer, Rolf Hochhuth, about why the blocks do not carry the names of the estimated six million victims of the Holocaust.

"Why are there no names when the names were the first thing the Nazis took away when people entered the camps?" Hochhuth asked.

But Eisenman said he had insisted throughout the project that the blocks be left blank. "I fought to keep names off the stones, because having names on them would turn it into a graveyard and I did not want that.

"I want this to be a place of hope."

The stories of a selection of Holocaust victims are briefly told in a visitors' centre situated under the memorial.

Eisenman and the speaker of the German parliament, Wolfgang Thierse, were asked why it had taken Germany 60 years since the end of the Second World War to build a permanent memorial to the Nazis' Jewish victims.

"I do not think it is too late, because we got it done," Eisenman said. "One hundred years from now, people will not say 'this came too late.'

"For me, it is still early."

Thierse admitted people had a right to be "dissatisfied" with the wait. "But the development of a collective memory takes time," he said.

Agence France-Presse

IN BERLIN TODAY, SURVIVORS OF CONCENTRATION CAMPS AND POLITICAL DIGNITARIES WILL OPEN THE MEMORIAL TO THE MURDERED JEWS OF EUROPE

Above, a visitor walks through the more than 2,700 concrete slabs of the Memorial to the Murdered Jews of Europe in Berlin. Right, architect Peter Eisenman stands at the construction site for the Holocaust memorial last July. Top: An aerial view of the memorial site in Berlin, which will open officially today.

SILVER

National Post
Toronto

Donna MacMullin, Features Presentation Editor

Page-design portfolio / Combination / 175,000 and over

These stand-alone Avenue pages are a visual delight. Each page is a treat to the reader, a gift in the newspaper. There is no redundancy in the various solutions, with each page distinct. Anyone who came across this page would pause, and you can't ask for much more. The designers even have some fun with the readers, changing the underline under the page's title to reflect the subject.

Estas páginas independientes de la sección Avenue son un agrado visual. Cada página es un regalo al lector, un regalo en el diario. No hay redundancia en la variedad de soluciones, ya que cada página es única. Cualquiera que se encuentre con esta página haría una pausa, y no se puede pedir aun más. Los diseñadores incluso se entretienen con los lectores al cambiar la línea bajo el título de la página para reflejar el tema.

The Commercial Appeal
Memphis, Tenn.

Karen Pulferfocht, Photographer; **Nikki Boertman**, Photographer; **Matthew Craig**, Photographer; **Lance Murphy**, Photographer; **A.J. Wolfe**, Photographer; **John K. Nelson**, Design Director; **John Sale**, Photo Director; **Michael McMullan**, Photo Editor; **Jeff McAdory**, Photo Editor; **Dave Darnell**, Chief Photographer

Photo portfolio, staff

The Plain Dealer
Cleveland

Mike Levy, Photographer

Photo portfolio, individual

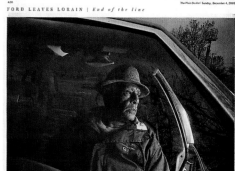

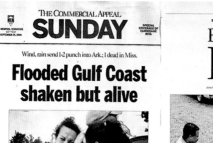

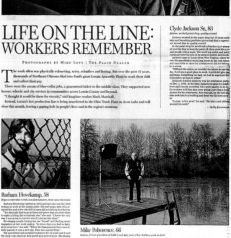

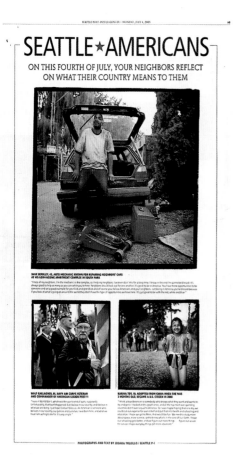

Seattle Post-Intelligencer
Kurt Schlosser, Designer; **Joshua Trujillo**, Photographer

Special news topics / Editor's choice, local/regional

Los Angeles Times
Michael Whitley, Deputy Design Director; **Kelli Sullivan**, Deputy Design Director; **Joseph Hutchinson**, Creative Director; **Francine Orr**, Photographer; **Gail Fisher**, Photo Editor

Photo portfolio, staff

The Palm Beach Post
West Palm Beach, Fla.

Bruce R. Bennett, Photographer; **Gary Coronado**, Photographer; **Carolyn Drake**, Photographer; **Allen Eyestone**, Photographer; **Richard Graulich**, Photographer; **Damon Higgins**, Photographer; **Greg Lovett**, Photographer; **Tim Stepien**, Photographer; **Lannis Waters**, Photographer

Photo portfolio, staff

San Francisco Chronicle

Kim Komenich, Photographer; **Mike Kepka,** Photographer;
Brant Ward, Photographer; **Penni Gladstone,** Photographer;
Randy Greenwell, Director of Photography; **Kathleen Hennessy,** Deputy
Director of Photography; **James Merithew,** Photo Editor;
Russell Yip, Photo Editor; **Dan Jung,** Photo Editor; **Rick Romagosa,** Photo Editor

Photo portfolio, staff

El Mundo - M2
Madrid, Spain

Angel Casaña, Photography Chief

Photo portfolio, staff

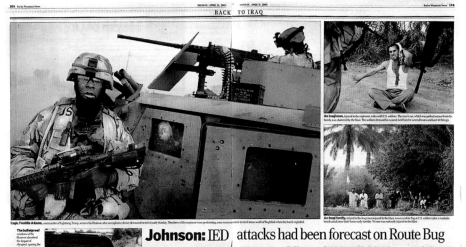

Rocky Mountain News
Denver

Todd Heisler, Photographer; **Chris Schneider,** Photographer;
Rodolfo Gonzalez, Photographer; **Judy DeHaas,** Photographer;
Joe Mahoney, Photographer; **Marc Piscotty,** Photographer

Photo portfolio, staff

ABC
Madrid, Spain

Staff

Information-graphics portfolio, staff / Extended coverage / 175,000 and over

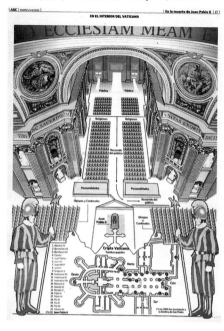

El Mundo
Madrid, Spain

Juantxo Cruz, Infographics Director; **Staff Graphic Artists; Staff Researchers**

Information-graphics portfolio, staff / Extended coverage / 175,000 and over

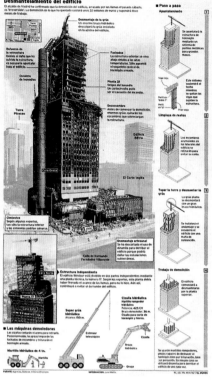

Star Tribune
Minneapolis

Karen Youso, Staff Writer; **Laurie Harker,** Designer; **Mark Boswell,** Graphic Artist; **Jane Friedmann,** Graphics Reporter; **Jerry Holt,** Photographer; **Gail Rosenblum,** Editor; **Kathe Connair,** Production Editor; **Lisa Clausen,** Design Editor; **Ray Grumney,** Graphics Editor; **Randy Miranda,** Project Editor

Information-graphics portfolio, staff / Extended coverage / 175,000 and over

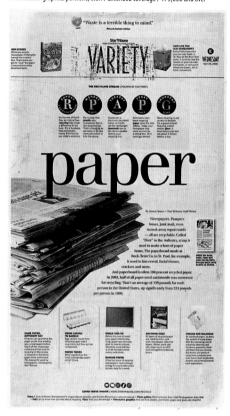

El Correo
Vizcaya, Spain

Fernando G. Baptista, Editor; **José Miguel Benítez,** Co-Editor; **Gonzalo de las Heras,** Graphic Artist; **Daniel García,** Graphic Artist; **María Almela,** Graphic Artist; **Jorge Dragonetti,** Graphic Artist; **Isabel Toledo,** Graphic Artist

Information-graphics portfolio, staff / Extended coverage / 50,000-174,999

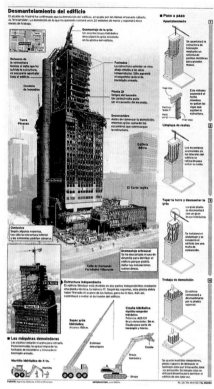

El Correo
Vizcaya, Spain

Fernando G. Baptista, Editor

Information-graphics portfolio, individual / Breaking news / 50,000-174,999

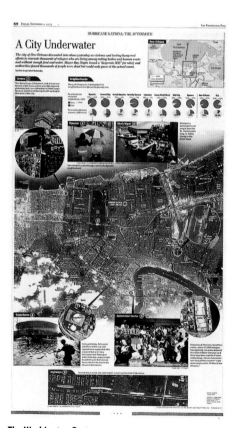

The Washington Post
Staff

Information-graphics portfolio, staff / Extended coverage / 175,000 and over

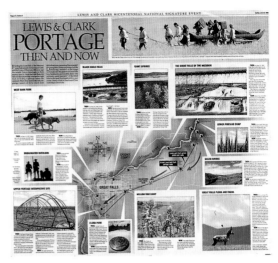

Great Falls Tribune
Mont.

Také Uda, Design Editor

*Information-graphics portfolio, individual /
Non-Breaking news / 49,999 and under*

The New York Times

Jonathan Corum, Graphics Editor

Information-graphics portfolio, staff / Breaking news / 175,000 and over

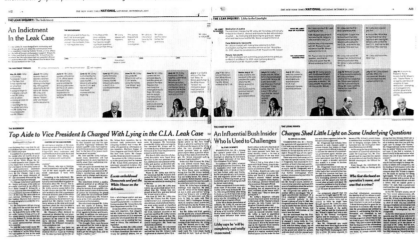

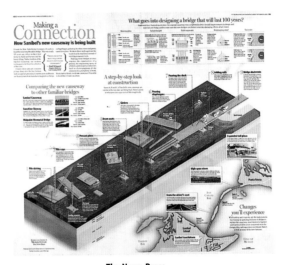

The News-Press
Fort Myers, Fla.

Mike Donlan, Graphics Editor

*Information-graphics portfolio, individual /
Non-breaking news / 50,000-174,999*

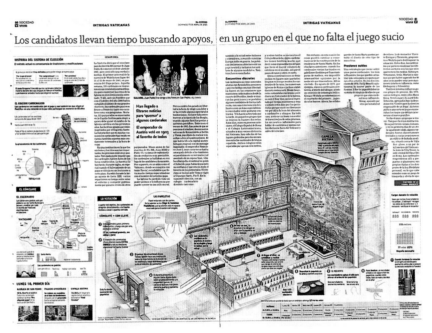

El Correo
Vizcaya, Spain

Fernando G. Baptista, Editor; **José Miguel Benítez,** Co-Editor; **Gonzalo de las Heras,** Graphic Artist;
Daniel García, Graphic Artist; **María Almela,** Graphic Artist; **Jorge Dragonetti,** Graphic Artist; **Isabel Toledo,** Graphic Artist

Information-graphics portfolio, staff / Breaking news / 50,000-174,999

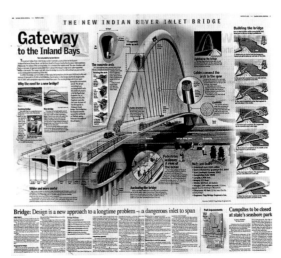

The News Journal
Wilmington, Del.

Dan Garrow, Graphics Director

*Information-graphics portfolio, individual /
Non-breaking news / 50,000-174,999*

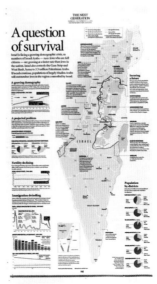

South Florida Sun-Sentinel
Fort Lauderdale

Karsten Ivey, Senior Graphics Reporter;
Len DeGroot, Assistant Graphics Director;
R. Scott Horner, Assistant Graphics Director;
Don Wittekind, Graphics Director; **Tim Frank,**
Deputy M.E. of Visuals

*Information-graphics portfolio, staff / Extended
coverage / 175,000 and over*

El Mundo
Madrid, Spain

Chema Matia, Graphic Artist

Information-graphics portfolio, individual / Non-breaking news / 175,000 and over

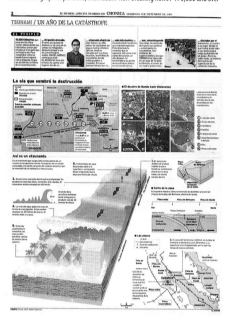

El Mundo
Madrid, Spain

Beatriz Santacruz, Graphic Artist

Information-graphics portfolio, individual / Non-breaking news / 175,000 and over

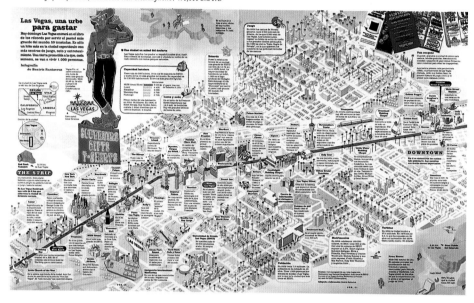

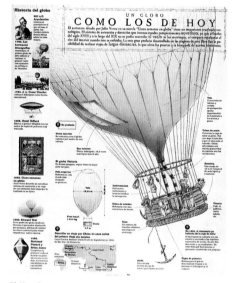

El Mundo
Madrid, Spain

Emilio Amade, Graphic Artist

Information-graphics portfolio, individual / Non-breaking news / 175,000 and over

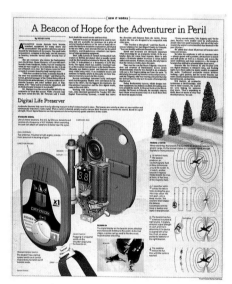

The New York Times

Frank O'Connell, Graphics Editor

Information-graphics portfolio, individual / Non-breaking news / 175,000 and over

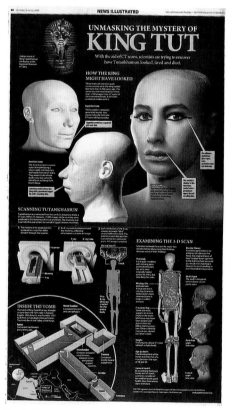

South Florida Sun-Sentinel
Fort Lauderdale

Karsten Ivey, Senior Graphics Reporter

Information-graphics portfolio, individual / Non-breaking news / 175,000 and over

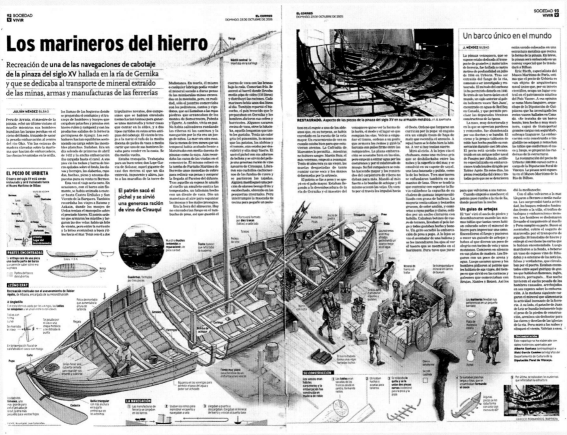

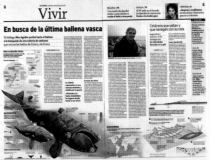

SILVER

El Correo
Vizcaya, Spain

Fernando G. Baptista, Editor

*Information-graphics portfolio, individual /
Non-breaking news / 50,000-174,999*

The artist uses a
variety of styles that
match the subject
matter. The graphics
are incorporated into
the pages so well that
they blend with the
publication. The level
of this body of work
shines above and
beyond. It transcends
language.

El artista usa una
variedad de estilos
que calza con el
tema. Los gráficos
están incorporados
en las páginas tan
bien que se fusionan
con el diario. El nivel
de estos trabajos se
destaca por encima y
a lo lejos. Trasciende
el lenguaje.

El Mundo
Madrid, Spain

Staff

Information-graphics portfolio, staff / Non-breaking news / 175,000 and over

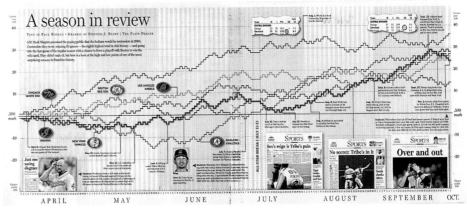

The Plain Dealer
Cleveland

Stephen J. Beard, Graphics Reporter

Information-graphics portfolio, individual / Non-breaking news / 175,000 and over

El Mundo
Madrid, Spain

Juantxo Cruz, Infographics Director; **Mariano Zafra,** Graphic Artist;
Javier Caballero, Researcher

Information-graphics portfolio, staff / Non-breaking news / 175,000 and over

El Mundo
Madrid, Spain

Juantxo Cruz, Infographics Director; **Raquel Nieto,** Graphic Artist

Information-graphics portfolio, staff / Non-breaking news / 175,000 and over

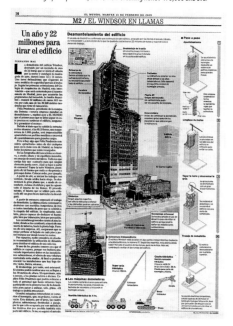

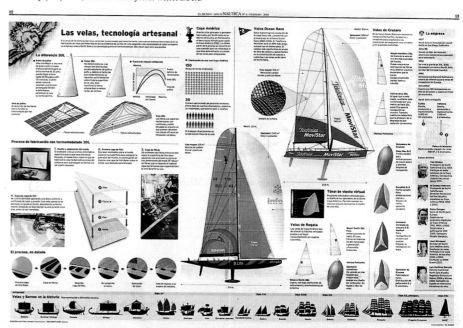

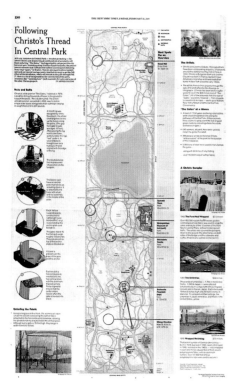

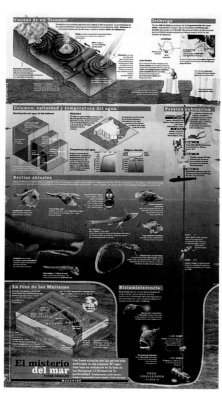

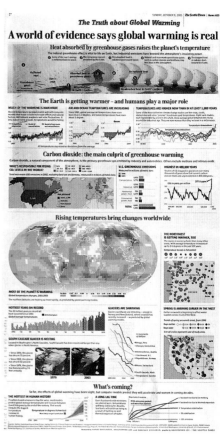

The New York Times
Staff

Information-graphics portfolio, staff / Non-breaking news / 175,000 and over

El Mundo
Madrid, Spain

Juantxo Cruz, Infographics Director; **Emilio Amade,** Concept/Design &
Graphic Artist; **Carlos Martínez,** Graphic Artist; **Daniel Izeddin,** Researcher;
Enrique Muñoz, Researcher; **Javier Munera,** Researcher

Information-graphics portfolio, staff / Non-breaking news / 175,000 and over

The Seattle Times

Michele Lee McMullen, Graphic Artist; **Kriss Chaumont,** Graphic Artist;
Mark Nowlin, Graphic Artist; **Paul Schmid,** Graphic Artist; **Kristopher Lee,**
Graphic Artist; **Whitney Stensrud,** Assistant Art Director

Information-graphics portfolio, staff / Non-breaking news / 175,000 and over

Redesigns

10

Reforma
México City

Lázaro Ríos, Editorial Director; **Guillermo Toledo,** Graphics
Subdirector; **Ricardo del Castillo,** Graphics Subdirector;
Fernando Jáuregui, Graphics Subdirector; **José Grajeda,** Graphics
Subdirector; **Alejandro Banuet,** Graphics Subdirector; **Mario García,**
Design Consultant; **Rodrigo Fino,** Design Consultant; **Paula Ripoll,**
Design Consultant; **Remigio Badano,** Designer

Redesigns / Overall newspaper

Superdeporte
Valencia, Spain

Herminio Javier Fernandez, Design Consultant

Redesigns / Overall newspaper

Sunday Herald
Glasgow, Scotland

Staff

Redesigns / Overall newspaper

After

After

After

Before

Before

Before

Toronto Star

Carl Neustaedter, A.M.E. Design; **Devin Slater**, Designer; **Alison Uncles**, Sunday Editor

Redesigns / Overall newspaper

ARREST, BUT NO RELIEF Chatham toddler still missing after man detained. A2
THE KARLA CIRCUS Outside prison, onlookers sell sausages, wait for 'eyes of evil.' A3
WIMBLEDON In the longest women's final in the tournament's history, Venus prevails. B1

SUNDAY

TORONTO STAR
July 3, 2005
thestar.com

LIVE 8 A SPECIAL EDITION
WILL IT HELP HER?

The girl toiling with a hoe faces a monumental struggle to stay alive in Niger, two years into a widely ignored famine. Yesterday, hundreds of musicians drew world attention to systems and attitudes that keep millions of Africans like her in dire poverty. Now, they've laid her future at the feet of the G-8 leaders.

LIVE 8 FROM BARRIE TO BERLIN: A3, A6-A13

Reaction: The real issues are unfair trade and inside corruption, say Africans in Toronto. A3
Rosie DiManno: Behind the wall of global sound, a sobering message delivered in a snap. A6
Ben Rayner: Television wasn't up to the task of covering simultaneous events. A11
Sandro Contenta: G-8 summit could be a recipe for disillusionment. A12

PLUS
Linda Diebel: The inside story on how Toronto lost the concert. BUZZ, C1
Peter Scowen on a Toronto architect's plan to fix the world. IDEAS, D1
Karen Palmer: Why I didn't go.to Live 8. IDEAS, D3

The CIBC Unlimited Chequing Account

It's life without limits.
• Unlimited transactions • No monthly fee
• Unlimited access • No surprises

Visit any branch, cibc.com or call 1-800-465-CIBC (2422) today.

For what matters.

After

SUNDAY STAR

MOSTLY CLOUDY. HIGH 2 C · JANUARY 9, 2005 · thestar.com

SEX IN THE SUBURBS
Why Desperate Housewives is so seductive. A&E, E1

NFL PLAYOFFS
St. Louis beats Seattle; Jets take San Diego. SPORTS, B1

ICON OF AN AGE
Einstein fascinates a century after E=mc² NEWS, A3

'TRAGEDY OF A MILLION GRIEFS' | PM leads national day of mourning

'Asia's pain is our own'

U.N. chief's tour sparks controversy

Frustration dogs journey to disaster zone

Why immigrants fare better outside the GTA

Before

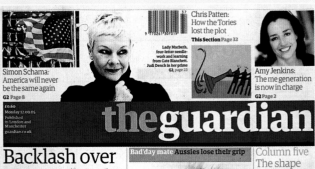

£0.60
Monday 12.09.05
Published in London and Manchester
guardian.co.uk

the guardian

Chris Patten: How the Tories lost the plot This Section Page 32

Lady Macbeth, four-letter needlework and learning from Cate Blanchett. Judi Dench in her prime. G2, page 23

Amy Jenkins: The me generation is now in charge G2 Page 2

Simon Schama: America will never be the same again G2 Page 8

Backlash over Blair's school revolution

City academy plans condemned by ex-education secretary Morris

Patrick Wintour and Rebecca Smithers

UK link to terror snatches

Ian Cobain and Richard Norton-Taylor

Bad'day mate Aussies lose their grip

Shane Warne at the Oval yesterday. Sport ▶ Photograph: Kieran Doherty/Reuters

Column five
The shape of things to come

Alan Rusbridger

Continued on page 3 ▶

National	Law	International	Financial
Police chief blames Orangemen for riots	Judges may block deportations	Israeli troops leave Gaza after 38 years	Sky's Premiership rights under threat

Bigger isn't always better...

After

SILVER

The Guardian
London

Mark Porter, Creative Director; **Sarah Habershon**, Redesign Team; **Mark Leeds**, Redesign Team; **Mike Booth**, Redesign Team; **Richard Turley**, Redesign Team; **Kevin Wilson**, News Page Designer; **Chris MacKay**, News Page Designer

Redesigns / Overall newspaper

When The Guardian transformed itself to Berliner tabloid, it added a new personality to the best traits of its broadsheet design. The redesign reinterprets the paper, with beautiful, consistent attention to typographical details, their structure and their rhythm. The tone is very light — a good adjustment given the format change. It handles color very well, with control on every page. The design went from very nicely done to something even better. It's "the full shilling."

Cuando The Guardian pasó a ser de tamaño tabloide Berliner, añadió una nueva personalidad a lo mejor del tamaño estándar. El rediseño interpreta al periódico, con una linda y consistente atención a los detalles tipográficos, su estructura y ritmo. El tono es muy liviano – un buen ajuste al nuevo formato. El diseño pasó de estar muy bien hecho a algo incluso mejor. Un gran logro.

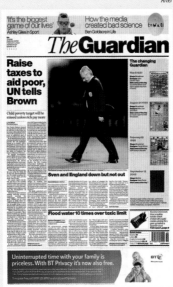

The Guardian

Raise taxes to aid poor, UN tells Brown

Child poverty target will be missed unless rich pay more

Sven and England down but not out

Flood water 10 times over toxic limit

The changing Guardian

Uninterrupted time with your family is priceless. With BT Privacy it's now also free.

Before

El Comercio
Lima, Peru

Claudia Burga-Cisneros, Design Editor, Designer; **José Antonio Mesones,** Designer; **Jorge Senisse,** Designer; **Leopoldo Best,** Designer; **Guillermo Figueroa,** Photo Editor

Redesigns / Overall newspaper

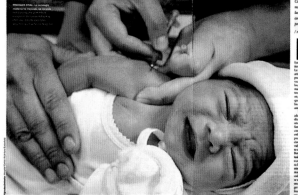

After

Before

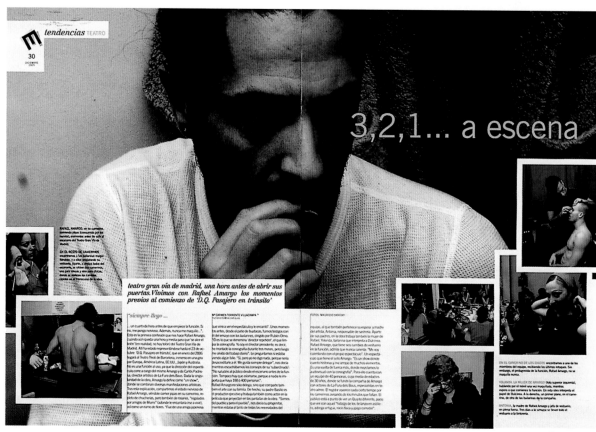

After

Gaceta Universitaria
Madrid, Spain

Antonio Martin, Design Editor; **José Juan Gámez,** Art Director; **Ricardo Mendi,** Designer; **Marisol García,** Designer; **Ana Donadios,** Designer; **Blanca Serrano,** Designer; **Pedro Pablos,** Designer; **Raúl Gámez,** Designer

Redesigns / Section

Before

Star Tribune
Minneapolis
Staff
Redesigns / Overall newspaper

After

Before

Rzeczpospolita
Warsaw, Poland

Marek Knap, Art Director; **Marek Trojanowski,** Senior Designer
Redesigns / Overall newspaper

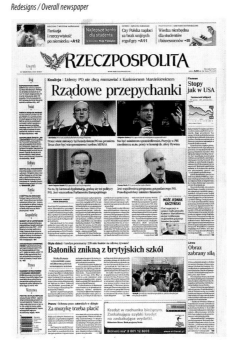

After

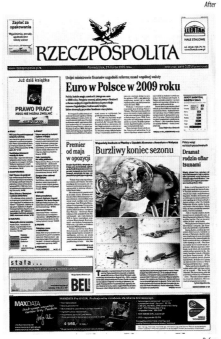

Before

El Correo de Andalucia
Madrid, Spain

Carlos Perez-Díaz, Editorial Director; **Montse Ortiz Roca,** Designer;
Staff
Redesigns / Overall newspaper

After

Before

Milwaukee Journal Sentinel
Wis.

Carolyn Ryan, Features Page Designer; **Lonnie Turner,** Features Design Editor;
Lou Saldivar, Graphics Editor; **Becky Lang,** Health Editor; **Christine McNeal,**
Deputy M.E.

Redesigns / Section

After

The Dallas Morning News

Marilyn Bishkin, Design Editor; **Mary Jennings,** Designer; **Lisa Veigel,** Designer;
Kerri Abrams, Designer; **Douglas Jones,** Designer; **Maggi Manning,** Designer;
Lynn Nguyen, Designer; **Tom Huang,** Features Editor; **Lisa Kresl,** Assistant M.E./Lifestyles;
Jennifer Okamoto, Assistant Features Editor

Redesigns / Section

After

Before

ABC
Madrid, Spain

Staff

Redesigns / Section

After

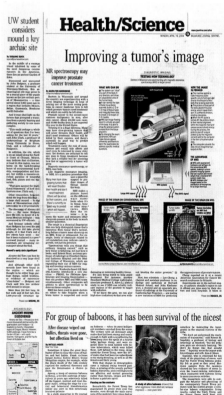

Before

Star Tribune
Minneapolis
Staff
Redesigns / Section

After

Before

El Diario de Hoy
San Salvador, El Salvador

Juan Durán, Art Director; **Jorge Castillo,** Infographic Editor; **José Santos,** Infographic Co-Editor

Redesigns / Section

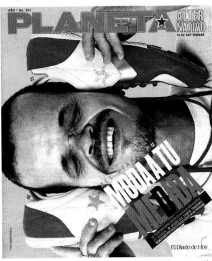

After

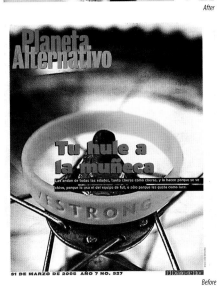

Before

The Herald on Sunday
Auckland, New Zealand

Matthew Straker, Art Director; **Rob Cox,** Designer; **Tim Hamilton,** Designer; **Naomi Rowley,** Designer

Redesigns / Section

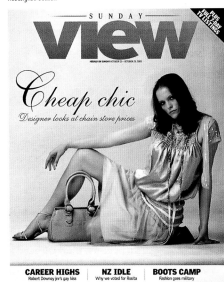

After

Before

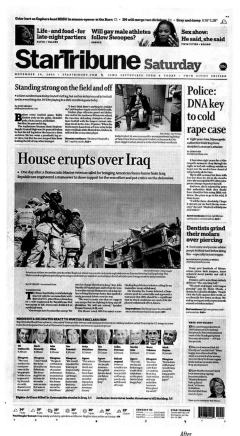
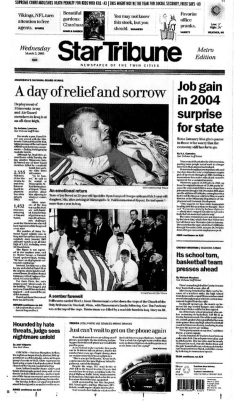

Star Tribune
Minneapolis
Staff
Redesigns / Page

Star Tribune
Minneapolis
Staff
Redesigns / Page

The Boston Globe
Vic DeRobertis, Art Director & Designer
Redesigns / Page

weather

Wilma threatens United States

remembering

Photographer Diana Watters, 43

BUSINESS FILTER
A WEEKLY CATCH OF STORIES YOU DON'T WANT TO MISS

'Innovative' last week

High Tech 25

Life Sciences 25

Personal Tech

Smart clothes at smart prices

After

After

After

WEATHER

PAUL DOUGLAS' TWIN CITIES FORECAST

Funeral Notices

Bakken's Schroeder dies at 58

Two-vehicle accident kills Jordan woman, 50

THE BOSTON GLOBE

High Tech 50

Photoshop is pricey, but worth it

Firefox success is music to rival's ears

Before

Before

Before

The San Diego Union-Tribune

Josh Penrod, Designer; **Chris Ross,** News Design Editor; **Michael Price,**
Presentation Editor

Redesigns / Page

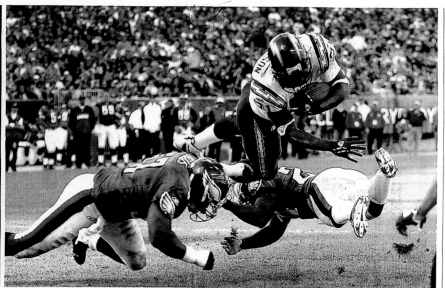

After

Before

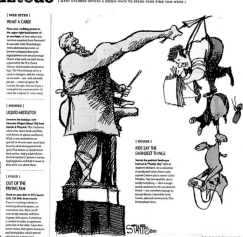

The Birmingham News
Ala.

Napo Monasterio, Page Designer; **Mark Baggett,**
Graphic Artist; **Rick Frennea,** Senior Page Designer;
Scott Walker, A.M.E.; **Alec Harvey,** Features Editor;
Wayne Marshall, Art Director; **Kristen Powell,**
Design Consultant

Redesigns / Page

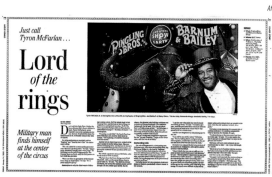

After

Before

Detroit Free Press

Emiliana Sandoval, Editor;
Steve Dorsey, Designer, AME/
Presentation; Staff

Redesigns / Page

After

Before

Richmond Times-Dispatch

Va.

Staff

Redesigns / Page

After

Before

The Sacramento Bee

Calif.

Brian Scott Ching, Art Director & Designer; Val B. Mina, Design Director;
Barbara Stubbs, Assistant Design Director; Sarah Lopez Williams,
Features Editor; Sue Morrow, Deputy Photo Director; Kevin German,
Photographer

Redesigns / Page

After

Before

UNCOMMON WESTERNERS

She wins friends for lions, wolves and bears

Janelle Holden is in the business of changing minds — including her own. Holden, the coexistence director for the nonprofit Predator Conservation Alliance, grew up on a cattle ranch on the Great Plains, just east of the Rocky Mountain Front. When grizzly bears began moving into the area in the 1980s, her father was far from delighted.

Holden, the daughter of two Republican legislators, followed her parents' political path. During college, she interned with Montana Sen. Conrad Burns, and later served as assistant communications director for Sen. Larry Craig of Idaho, both Republicans and longtime opponents of predator recovery. After a year in Washington, D.C., Holden made her way back West, eventually moving to Colorado to work for two small-town newspapers.

Holden soon realized that the West was no longer the place she remembered or imagined. Oil and gas drilling and mining were changing the public lands, and while she still agreed with Republicans' fiscal values, she began to question the party's recent resistance to environmental laws and regulations.

In 2000, while she was working as the agriculture and public-lands reporter for the Cortez Journal and the Durango Herald, her political convictions received a serious jolt. Holden's managing editor invited her to see then-presidential candidate Ralph Nader speak in Durango.

Holden found that several of Nader's positions, such as legalizing the production of hemp for paper and clothing, made sense to her. "I'm a Republican, and I agree with this guy," she thought. "How can this be?" After the speech, she concluded, "I'm probably not in sync with Republicans on conservation anymore."

A few years later, Holden came upon an advertisement for a position with the nonprofit Predator Conservation Alliance in Montana. She thought it might be a way for her to work on the environmental issues she cared about. "I grew up on a ranch with grizzly bears," she thought. "Maybe they'll hire me." She was right.

The alliance had noticed that, although conservationists were winning a lot of battles on behalf of predators in the courtroom, they weren't gaining many new allies on the ground. The Range Riders Project, one of several that Holden manages, aims to do just that, working in partnership with the Madison Valley Ranchlands Group, an association of ranchers in southwest Montana.

The project has hired riders to patrol the sagebrush and stay near the livestock 24 hours a day, in hopes that the presence of humans and horses will deter wolves.

After only two field seasons, it's too early to claim success, but no Madison Valley cows were killed by wolves this summer or the last. The project has been duplicated in the Boulder Valley south of Big Timber, Mont., with similarly encouraging results.

And Holden can take part of the credit for local ranchers' enthusiasm. "She works for an environmental group with a big, scary name," says Todd Graham, ranch manager for the Sun Ranch in the Madison Valley, "but she plays her cards really well in front of a group of ranchers. Those are her ranch smarts coming into play."

"I wouldn't say I've converted anyone into a wolf lover," Holden laughs. But a local rancher recently told her he would no longer shoot a wolf on sight. And Holden is even beginning to win her family over: Her father has joined the Predator Conservation Alliance. These days, he has two bumper stickers on his truck. One reads: Save the Front — Drill It. The other is PCA's Lions and Wolves and Bears, Oh Yes!

BY MELYNDA COBLE

The author is a freelance writer in Livingston, Montana.

NAME
Janelle Holden

VOCATION
Coexistence Director,
Predator Conservation
Alliance

AGE 28

HOME BASE
Livingston, Montana

CLAIM TO FAME
Reducing conflicts between
humans and predators

Janelle Holden on a "predator-friendly" sheep ranch north of Bozeman, Montana. SEAN SPERRY

www.hcn.org **High Country News** 7

High Country News
Paonia, Colo.

Cindy Wehling, Art Director & Designer; **Sean Sperry,** Photographer; **Andre Delgalvis,** Photographer; **Greg Hanscom,** Editor; **Paul Larmer,** Executive Director; **Michelle Nijhuis,** Contributing Editor

Redesigns / Page

Transforming the Forest Service
Maverick bureaucrat Wendy Herrett
UNCOMMON WESTERNERS

"I left a lot of promise to succeed for other women. It wasn't just Wendy who would fail."
—Wendy Herrett, former Forest Service supervisor

After

Before

After

Before

The Times of Northwest Indiana
Munster

Theresa Badovich, Creative Director; **Erica Smith,** News Design Team Leader; **Mark Bieganski,** Visual Editor; **Staff**

Redesigns / Page

The Gazette

Montreal

Nuri Ducassi, Designer & Design Director;
Mark Tremblay, Entertainment Editor

Redesigns / Page

San Jose Mercury News

Calif.

Matt Mansfield, Deputy M.E.; **Jonathon Berlin,** Senior Editor/
Design & Graphics; **Kevin Wendt,** News and Sports Design Director;
Nick Masuda, Designer

Redesigns / Page

The Star-Ledger

Newark, N.J.

Pablo Colón, Design Director & Designer; **Rosemary Parillo,** Editor;
Jenifer D. Braun, Writer; **Vicki Hyman,** Writer

Redesigns / Page

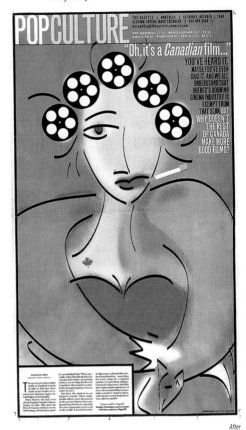

After

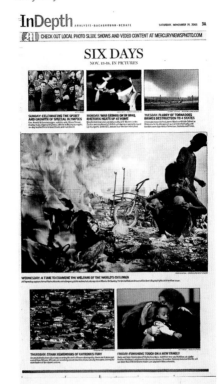

After

After

Before

Before

Before

PEOPLE

A

Abrams, Kerri, 256
Addario, Lynsey, 162
Agliano, Kiely, 107
Aguilar, Roberto, 181
Aguilar, Victor, 222
Aguilera, Carlos, 173
Aguilera, Javier, 174
Aigner, Erin, 55, 57
Alarcos, Francisco, 123-124, 128
Alay, Yasemin, 105
Albert, Ursula, 203, 205-206
Albrecht, Eric, 231
Alexandre, Carlos, 75
Alfano, Ellen, 72
Alfred, K.C., 64, 94, 152, 220
Almeida, Pedro, 81, 134
Almela, María, 59, 246-247
Alvarez, Adrián, 200
Alvarez, Eddie, 169
Álvarez, Rubén, 146, 181
Alvin, Åke, 98
Amade, Emilio, 38, 176-177, 248, 250
Americo Camargo, Luiz, 103, 117
Amezcua, Hector, 140, 165
Amon, Joe, 30, 59
Anderson, Beth, 72
Anderson, Kathy, 140
Andreazzi, Maria Suely, 103, 117
Andrews, Nancy, 135, 152, 159
Andrus, Elyssa, 46
Anesti, Katerina, 104
Angle, Melissa, 66, 94
Apak Studio, 68
Aparicio, Javier, 193
Apple, Charles, 96
Apuan, Michael, 141
Archambault, Martine, 142
Arell, Karin Teghammer, 118
Arias, César, 222
Arias, Raúl, 69-70, 228, 241
Arias, Rodrigo, 194
Armando Zamora, Carlos, 195
Armstrong, Cassie, 66, 94
Asplund, Pelle, 148
Åstrand, Karl, 119
Atwood, Liz, 258
Averyt, Libby, 90
Ayhan, Ahmet, 105

B

Badano, Remigio, 252
Badovich, Theresa, 262
Baeza, Manuel, 188, 195, 206-208
Baggett, Mark, 260
Bailon, Gilbert, 205
Baily, Cody, 72
Bain, Jennifer, 116
Baires, Rodrigo, 68, 222
Balderas, Aurora, 211
Ball, Tim, 99

Ballesteros Aguilar, Jesús Bernardo, 147
Bang, Solveig, 103
Bangert, Christoph, 136
Banks, Steven E., 50, 109, 228
Bannon, Tim, 184
Banuet, Alejandro, 252
Baptista, Fernando G., 59, 171, 174, 177, 246-247, 249
Baranov, Ilya, 122
Barata, Fernando, 202
Barbash, Fred, 234
Barber, Heather, 230
Barcroft, Shawn, 193
Barrera, Ralph, 148
Barrio, Asier, 234
Barros, Lydia, 209
Basladynski, Ted, 176
Batsford, Susan, 183
Batterbury, Sophie, 102
Bausmith, Wesley, 34, 95, 151, 242
Bayliss, Kevin, 97
Beard, Stephen J., 179, 249
Beaty, Keith, 159
Becerra, Eva, 82
Becherer, Max, 134
Becker, Lesley, 37, 80, 237
Beeson, Jennifer, 160
Belloso, Francisco, 100, 194
Belman, Alejandro, 82-83, 86, 89, 151-153, 178
Belmonte, Javier Pérez, 211, 215
Beltrán, Jorge, 81
Benítez, José Miguel, 59, 174, 178, 246-247
Benítez, Tomás, 181
Bennett, Amy Beth, 59
Bennett, Bruce R., 244
Bennett, Todd, 152
Bensinger, Gail, 96
Bergeron, Tom, 150-151
Bergstrom, Linda, 117
Berlin, Jonathon, 62-63, 168, 184, 263
Bernard, Catherine, 115
Bernaroin, Richard, 231
Berner, Alan, 66, 154-155
Berríos, Alfredo, 205
Berton, Paul, 183
Best, Leopoldo, 254
Bieganski, Mark, 262
Birger, Georgy, 111
Birmingham, Patrick, 90
Birrell, Ian, 97
Bisher, Nanette, 68, 96, 112, 219, 226
Bishkin, Marilyn, 256
Bjorkman, Pär, 96, 108
Björnsson, Fredrik, 189
Black, Geoffrey, 224
Black, Grant, 155
Blanchard, John, 96
Blanco, Ramon, 201
Blancornelas, J. Jesus, 90, 201
Bloch, Serge, 160, 230
Blow, Charles M., 54-55
Bodkin, Tom, 54-55, 57
Boertman, Nikki, 244
Bogdas, Nicole, 30
Boho, Jonathan, 59
Bondarowicz, Marv, 185

Booth, Mike, 253
Borchuck, James, 108
Borisova, Irina, 122
Borissenko, Artur, 198
Boster, Mark, 164
Boström, Annelie, 98
Boswell, Mark, 246
Boulogne, Mauricio, 68
Bowie, Liz, 232
Bowman, David, 100, 164
Boysal, Babur, 105
Brack, Dennis, 67, 174
Brackett, Ron, 230
Bradley, Mark, 232
Brandon, Alex, 144
Brannan, Ben, 123
Bras, Jacques-Olivier, 225
Brault, Bernard, 107
Braun, Jenifer D., 263
Breite, Thea, 37, 81, 87
Brennan, Angela, 107
Breton, Pascale, 225
Brett, Bill, 157
Breul, Peter, 104, 110, 121, 227
Bristow, Beth, 58, 108, 116, 160
Broadwater, Beth, 94
Brooke, Jeff, 83
Brooks, Dudley, 232
Brooks, Jim, 50, 228
Brosseau, Peter, 163
Brown, Alex, 219
Brown, Jason, 94, 152, 220
Brown, Joe, 68, 112
Brown, Scott, 175
Brown, Tom, 226
Broyles, Carla, 160
Bugnaski, Mark, 142
Bulow, Per, 43
Buño, Natalia, 123-124, 128
Burden, Leanne, 153
Burga-Cisneros, Claudia, 254
Burgess, Joe, 182
Burgess, John, 163
Burke, Chuck, 87
Burkett, Kevin, 183
Burmeister, Heike, 123
Burrows, Alex C., 96, 137, 141, 154-155, 157
Burton, Bonita, 66, 91, 94
Bustillos, Juan, 194-195, 198-200, 205, 208
Buzelli, Chris, 130
Byun, Yoon S., 137

C

Caballero, Javier, 250
Caderot, Carmelo, 69, 123, 126, 128, 220, 226-229, 232, 240-241
Cain, J. Damon, 46
Cairney, Joan, 115
Câmara, Vasco, 104, 111, 113-116
Campbell, Dave, 34, 51, 53, 75, 219
Campbell, David, 60, 85
Campos, Francisco, 99
Cannistra, Mary Kate, 173
Carbajal, Alfredo, 205
Carlin, Joan, 73, 185
Carmack, Russ, 164

Carpenter, Phil, 162
Carr, Suzanne, 204
Carranza, Wilson, 92, 93
Carrero, Jaime R., 200
Carrillo, Pablo César, 188, 195, 206-208
Carroll, Chris, 54
Carucci, Elinor, 163
Carvalho, Ana, 126
Carvalho, Manuel, 81, 134
Casaña, Angel, 245
Casco Sosa, David, 198, 200
Casey, Robert, 140, 165
Castagnola, Andrew, 72
Castaño, Daniel, 191-192
Castillo, Jorge, 81, 92-93, 96, 218, 257
Castresana, Valeria, 115
Cavin, Curt, 176
Cecil, Marilyn, 219
Cenicola, Tony, 159
Cervantes, Alberto, 83
Cesena, Alma, 139
Chan, Gus, 60, 156
Chapman, Terry, 230
Chapman, Tia Ann, 168
Chaumont, Kriss, 67, 183, 250
Chekal, Rex, 72, 206
Chen, Yi-chun, 210
Cherney, Charles, 88
Cheung, Paul, 169
Chiaramonte, Vincent J., 86
Chimeno, Mario, 38
Ching, Brian Scott, 261
Christ, Kirk, 34, 95
Christensen, Anne, 162
Chuang, Tamará, 88
Chung, Andre F., 232
Chung, Dan, 143
Ciotta, Rose, 183
Cipolla, Stefano, 98
Clark, Patterson, 234
Clausen, Lisa, 110, 118, 221, 246
Claxton, Keith, 184, 224
Clifford, David, 126
Clifford, Douglas R., 146
Clift, Brad, 227
Clifton, Denise, 66
Cochrane, Neil, 116
Cole, Carolyn, 52-53, 145-146, 156, 164, 184
Colombo, Vasco, 131
Colombo, Verónica, 115
Colón, Pablo, 231, 263
Connair, Kathe, 246
Constantine, David, 55, 181
Contreras, Enrique, 92, 93, 99, 170
Contreras, Martín, 209
Cook, Monty, 44, 149, 232, 258
Cooney, Mary, 34, 51-53, 156, 164, 168
Copper, Steve, 209-210
Corbett, Allison, 58, 97
Cornelison, Mark, 184
Coronado, Gary, 244
Correia, Amílcar, 81, 134
Corum, Jonathan, 54, 247
Corvera, Oscar, 93, 170
Costa, Denise, 197
Costa, John, 197
Costa, Nuno, 81, 134

Couig, Caroline, 62-63
Course, Kathryn, 73, 224
Coutinho, Isabel, 110, 116
Cowan, Lisa, 160
Cowan, Stu, 162
Cowden, Steve, 56, 175
Cox, Amanda, 54
Cox, Patty, 230
Cox, Randy, 76
Cox, Rob, 257
Cox, Tracy, 207, 236
Cragin, Brian, 220
Craig, Matthew, 244
Cranston, Sam, 147, 148
Crawford, Colin, 34, 51-53, 100, 164, 166
Croslin, Bob, 159
Cross, Andy, 46, 155
Cruz, Juantxo, 38, 169, 176-177, 246, 250
Cruz, Roberto, 194-195, 198-200, 205, 208
Cuffaro, Marie A., 107
Culebro, Ulises, 227
Curley, John, 96
Currie, Michael, 72, 230
Curry, Chris, 155
Cusack, Anne, 100, 152, 164

D

Dagø, Jan, 139
Dahmen, Ursula, 104
Damon, Mark, 62-63, 168
Damonte Vegas, Paola, 222
Dareberg, Lars, 225
Darnell, Dave, 244
Davenport, Arlice, 74
Davenport, Jane, 88
David, Mark, 84
Davidson, Linda, 94
Davidson, Sara, 215
Davies, Tristan, 102
Davis, Amy, 140, 149
Davis, Catherine, 205, 209, 213
Davis, Mike, 56
de Almeida, João Bosco Adelino, 74-75, 79, 93, 117
de la Garza, Edgar, 211
de la Vega, Mª Dolores, 92, 94, 189
de las Heras, Gonzalo, 59, 246, 247
De Miguel, Manuel, 69, 215, 227-229
de Obaldía, Lourdes, 206, 208
De Repentigny, Alain, 115
de Repentigny, Yves, 115
De Souza, Otavio, 188, 209
Deal-Zimmerman, Michelle, 232
Deckers, Daniel, 227
Defrain, Amie, 167-168
DeGroot, Len, 171, 175, 180, 247
DeHaas, Judy, 43, 143, 147, 164, 245
Deheza, Emilio, 146, 181
DeJesus, Bumper, 164
del Carmen Navarro, María, 222-223
del Castillo, Ricardo, 252
Delgalvis, Andre, 262
DelGuzzi, Kristen, 132
DeLuca, Jeremy, 148

Demirel, Selcuk, 56
DeMuesy, Scott, 77
Denk, Jim, 144
DeRobertis, Vic, 81, 236, 259
Deryk, Hans, 66, 136
Deshalyt, Irina, 122
DeVault, Amy, 74
Dewairy, Christine, 229, 231
Di Pietro, Adriana, 128
Díaz, Angel, 38
Díaz, Juanjo, 191, 192
Dick, David, 65, 96, 102
Dilger, Michael, 90, 221
Dillingham, Russ, 205
Dimatteo, Kristina, 124, 127, 130, 133, 159
Dinsmore, Pam, 113
Dizon, Mike M., 176
Doiron, Moe, 137, 147
Donadios, Ana, 254
Donelger, Jorge, 115
Donlan, Mike, 247
Donnofrio, Don, 57
Döring, Karl-Heinz, 121, 182
Dorrell, Robert, 99, 176
Dorsey, Steve, 86, 135, 152, 159, 186, 230, 261
Draeger, Jan, 103
Dragonetti, Jorge, 59, 246, 247
Drake, Carolyn, 56, 242, 244
Drejenstam, Christina, 119
Drury, Christian Potter, 34, 50, 95, 112, 228, 242
Dubeux, Ana, 74-75, 79, 93, 117
Ducassi, Nuri, 74, 88, 107-108, 120, 162, 263
Duchneskie, John, 183
Dudka, Nicole, 112, 116, 239
Duff, Lori, 166
Dugger, Jason, 49, 99
Duke, Brett, 144
Dumanli, Ekrem, 105
Dumas, Hugo, 115
Dunkley, Troy, 103
Dunseith, Les, 34, 51-53, 171, 179-180
Duplessis, Arem, 56, 124, 127-128, 130, 132-133, 159-164, 166
Durán, Juan, 81, 92-93, 96, 218, 257
Durkin, Miriam, 175-176
Dutton, Sean, 186
Duyos, Robert, 30

E

Earle, John, 96
Earley, Steve, 146
Edelson, Mark, 82, 89, 198
Edetoff, Stefan, 118
Eilertsen-Nordholm, Maria, 210
Eisenbart, René, 185
Eklund, Scott, 137
Elder, Erin, 72, 76, 137, 147, 157-158, 161, 165
Elderfield, Jonathan, 165
Elizabeth, Jane, 186
Elliott, Tara, 204, 205
Elman, Julie, 78
Elsesser, Dave, 86, 218

Ely, Bruce, 56, 160
Engleman, Joshua, 230
Englin, Mårlen, 210
Enslow, Ray, 52
Ericson, Matthew, 54-55, 57, 179-180, 182-183
Eriksson, Mathas, 194
Errea, Javier, 234
Errett, Ben, 90, 116
Escobar, Eleazar, 147
Escobar, Laura, 128
Espiniella, Alfonso, 191-192
Espinoza, Hugo, 184
Espligares, Ana, 222-223
Espriella Moreno, Giovanna, 147, 189, 199-200
Estrada, Eduardo, 206, 208
Estrada, Rafael, 38, 177
Estrella, Raùl, 146
Everlet, Alfonso, 177
Eyestone, Allen, 244

F

Faille, Mike, 87
Fairfield, Hannah, 54-55, 57
Farrell, Lynn, 93, 162
Fazenda, João, 126
Fearnow, Jessica, 72
Félix, Myrna Alonso, 189
Fender, Mike, 99
Ferazzi, Gina, 164
Ferguson, Susan, 108, 120
Fernanadez Lucas, David, 192
Fernandes, José Manuel, 79, 81, 104, 110, 111, 113-116, 126, 134
Fernandes, Plácido, 74-75, 79
Fernandez, Herminio Javier, 214, 252
Fernandez, Sergio, 111
Ferrari, Luis Carlos, 188, 209
Ferraz, Renato, 93
Ferreira Santos, Nuno, 110
Ferris, Kristina, 97
Fidelman, Brian, 54
Figueredo, Itamar, 74
Figueroa, Adrián, 199-200
Figueroa, Guillermo, 254
Figueroa, Tonatiuh, 153
Filgueiras, Paulo, 97
Filipov, David, 37, 81
Finch, Rob, 56
Fino, Rodrigo, 252
Fisher, Gail, 34, 52-53, 156, 165-166, 244
Fitzgerald, Barry, 57
Fitzgerald, Shane, 90
Fitzmaurice, Deanne, 234
Fitzpatrick, David, 88
Fitzsimmons, Barry, 66, 138
Fleming, John, 86
Flores, Ricardo, 151-152
Fluker, Fred, 86
Fogel, Larry, 67
Foley, Bill, 48, 188
Folkver, Per, 43, 123
Fong, Marvin, 60
Fonseca, Arturo, 178
Fontanarrosa, Daniel, 111

Ford, Alicia, 188, 190
Forrest, Jim, 94
Fortier, Michel, 75
Fox, Nathan, 133
Francey, Darren, 163
Francis, Jamie, 56
Frandsen, Finn, 106
Frank, Rickard, 189
Frank, Tim, 61, 107, 167, 171, 180, 247
Franklin, Michael, 136, 141, 168
Franquet, Sarah, 175-176, 229
Frazier, Craig, 112
Freaner, Ariel, 90, 201
Frederick, George, 95, 224
Freed, Matt, 136
Freibe, Richard, 121
Freiberg, Ellen E., 108
French, Rachel, 144
Frenette, Brad, 90
Frennea, Rick, 233, 260
Frennesson, Peter, 106
Friebe, Richard, 121
Friedland, Jonathan, 200
Friedmann, Jane, 246
Friesen, Mark, 76
Froelich, Janet, 56, 122, 124, 127-128, 130, 132-133, 159-164, 166
Fuda, Silvina, 115
Fuhrmans, Christoph, 86, 230
Fulford, Jason, 159
Fullerton, Renee, 197
Furuya, Wataru, 218

G

G.A. Campos, Maria Isabel, 105
Gaberthuel, Tobias, 121, 232
Gad, Victor, 85
Gagnon, Jean-Sebastien, 87
Gallardo, Vicente, 198, 200
Gámez, Daniel, 151-153
Gámez, José Juan, 127-128, 216, 254
Gámez, Raúl, 254
Gannaway, Preston, 166, 242
Garbers, Sandra, 103
Garcia, Alex, 184
García, Bruno, 200
García, Daniel, 59, 174
García, Edson, 211
Garcia, Leslie, 160
Garcia, Marco, 86
García, Mario, 252
García, Marisol, 254
García, Máximo, 128
García, Susana, 191-192
García Angúlo, Samuel, 210-211
García Lugo, Leopoldo, 189
García Macías, Mikel, 222-223
Garrison, Ron, 184, 219
Garrote, Aurelio, 222-223
Garrow, Dan, 247
Garvin, Ben, 149
Gascon, Daymond, 184
Gaspard, Bill, 34, 51-53, 75, 89, 145-146, 166, 219
Gauthier, Robert, 53, 164, 184

PEOPLE

Genovese-Finch, Francesca, 73, 240
Gentil, Cristine, 74, 79
German, Kevin, 261
Gibbons, John, 139
Giguere, Benoit, 87, 95, 107-108, 115, 123, 132, 218, 225, 228
Gil, Victor, 102
Gilbert, Greg, 66, 138
Gilles, Mc, 107
Gimenez, Josemar, 74-75, 79, 93, 117
Gladstone, Penni, 245
Glanz, James, 57, 182
Glaser, Jennie, 218
Glen, Susan, 123
Glendenning, Jeff, 124, 128, 132, 160-162
Goldman, Scott, 99, 176
Gómez, Alejandro, 82-83, 86, 89, 151-153, 178
Gómez Orozco, Enrique, 189, 195, 199
Gonzales, Paul, 50, 112, 228, 236
González, Fernando, 92, 94, 199
González, Isabel, 38, 176
Gonzalez, Julian H., 152
González, Loida, 208
González, María, 123-124, 128
Gonzalez, Mauricio, 181
Gonzalez, Rodolfo, 43, 164, 245
González Hernández, Daniel, 194, 199-200, 205-206
Gordon, Bob, 186
Gormus, Mark, 150, 155
Gorobets, Alla, 111
Gorski, Pete, 48, 188, 190, 192, 197
Gotts, Andy, 128
Gottschalk, Angela, 66, 72
Graham, Coryanne, 74
Grajeda, José, 252
Granger, Chris, 137
Grant, Rob, 73, 85
Grant, Tracy, 234
Grarup, Jan, 43
Graulich, Richard, 244
Greene, Jeff, 60
Greenhalg, Laura, 105
Greenwell, Randy, 68, 245
Grenestam, Berit, 118
Grewe, David, 58, 80, 227
Griffis, Lisa, 88, 132
Grin, Gayle, 76-77, 87, 90-92, 94, 116, 229, 231, 234
Grinbergs, Linda, 224
Griswold, Doug, 62, 228
Grondahl, Mika, 55
Gross, Brian, 44, 84, 89, 236
Gross, G. Noel, 181, 226
Grubb, Shaffer, 220
Grumney, Ray, 246
Grunfeld, David, 145
Guadarrama, Arcelia, 188, 195, 206-208
Gugliotta, Bill, 60
Guimaraes, Jorge, 110-111, 116
Gutierrez, Barry, 140, 150
Gutiérrez, Carlos René, 198
Gutiérrez Alvarez, Juan Carlos, 198
Gutteridge, Adam, 233
Guzmán, Raúl, 82

H

Haag, Jim, 96
Habershon, Sarah, 253
Habib, Dan, 166-167, 215
Habib, Hal, 232
Haddix, Carol, 118
Haentjens, Bob, 121
Haffey, Sean M., 64, 94, 152, 220
Hagelquist, Jörgen, 119
Haglund, Anki, 210
Hagman, Alan, 34, 51, 53, 164, 167
Hallberg, Lasse, 210
Hällström, John, 119
Hamblin, Seth, 94, 174
Hamilton, Robert, 149
Hamilton, Tim, 257
Hampton, Paul, 28
Hamtil, Michael, 99
Hanan, Sarah, 181
Hancock, Mark M., 135
Hanika, Iris, 110
Hanscom, Greg, 98, 262
Hansen, Paul, 226
Hansen, Søren, 123
Hanuka, Tomer, 131, 133
Hara, Yuki, 233
Hardy, Chris, 68
Harershon, Sarah, 103
Harker, Laurie, 246
Harmel, Greg, 58, 80, 97, 165
Harris, Doug, 82
Harris, Nancy, 124
Harvey, Alec, 260
Hassell, John, 164
Hasselryd, Theres, 210
Hausen, Paul, 108
Hawkins, Steve R., 50
Hay, Alexei, 161
Hayakawa, Kyoshi, 210-211
Hayt, Andy, 136, 139, 141, 152-153
Head, Jared, 28
Heinz, Tom, 109, 184, 224
Heisler, Stephanie, 119
Heisler, Todd, 33, 43, 134, 147, 242, 245
Hellberg, Malin, 109
Hellman, Beatrice, 108, 119, 162
Henderson, John, 65
Hennessy, Kathleen, 219, 234, 245
Henriquez, Hiram, 61, 171
Hermansson, Mattias, 226
Hernandez, Christina Koci, 219
Hernandez, Fernando, 205
Hernández, Sara, 109
Herrström-Gemzell, Jenny, 96, 107, 108
Heumann, Thomas, 121, 182
Hewitt, Roy, 60, 84, 85, 179
Hicks, Tyler, 140
Higgins, Damon, 244
Hill, Angela, 64, 117, 173, 178
Hill, Joannah, 258
Hill-Cobb, Charlotte, 196
Hindash, Saed, 164
Hindenach, Jeff, 62, 184
Hine, HyunJu Chappel, 62
Hively, Cindy, 50, 157, 228
Ho, Eddie, 67
Hõbemagi, Priit, 191

Hodges, Hassan, 182, 224
Hoffer, Mark, 109
Hoffmeyer, Dean, 144
Hogue, Michael, 49, 99
Holguín Alatorre, Martin, 147, 189, 199-200
Hollyfield, Amy, 77
Holt, Jerry, 246
Holub, David, 90
Hom, Calvin, 168
Horn, Anja, 182
Horner, R. Scott, 171, 175, 180, 247
Horse, Harry, 65
Hossain, Farhana, 173-174
Hovasse, Alain-Pierre, 87, 95, 107, 115, 225
Howitt, Keith, 102
Hoynes, Paul, 179
Hsu, June, 209
Huang, Tom, 256
Hubbard, Tim, 34, 50, 95, 228
Huber, Red, 66, 94
Huezo, Roxana, 193
Huff, Bruce, 64, 94, 152-153, 220
Humla, Håkan, 210
Hundley, Sam, 78
Hunt, Jane, 224
Hurst, Thomas James, 66
Hurtado, Juan Luis, 195
Huschka, Robert, 186
Hutchinson, Joseph, 34, 50-53, 75, 89, 95, 165-166, 168, 171, 180, 219, 244
Huwiler, Edith, 182
Hybel, Kjeld, 43, 106
Hyman, Vicki, 263

I

Icassatti, Miguel, 103, 117
Igartua, Pacho, 222-223
Ilsøe, Christian, 106, 123
Ingebritson, Rick, 232
Iniguez, Lorena, 34, 51, 75, 171, 179
Innerarity, Andrew, 161
Ivey, Karsten, 30, 247-248
Izeddin, Daniel, 176-177, 250

J

Jackson, Josh, 75
Jackson, Ted, 148
Jacob, Ralf, 103
Jaén, José, 100, 192, 222
Jakobsson, Nils, 210
James, Yalonda M., 138
Jang, Erin, 70, 113, 237, 240
Jansson, Melissa, 197
Jarveik, Ulf, 225
Jaskol, Ellen, 158
Jáuregui, Fernando, 252
Jchoofs, Nico, 121
Jean, Carline, 30
Jenkins, Keith, 160
Jennings, Mary, 256
Jensen, Charlotte, 111
Jensen, Janet, 164

JibJab Media, 52
Jiménez, Rodolfo, 200
Johnson, Jill, 109, 230
Johnson, Julie, 197
Joles, David, 139, 157
Jones, Charla, 66, 141, 149, 153, 161
Jones, Douglas, 256
Jones, Steve, 86
José, Juan, 68, 99, 100, 127-128, 216, 222, 254
José da Paz, Severino, 117
Jouflas, Susan, 72, 154
Juárez, Àngel Muñoz, 188
June, Dwuan, 94
Jung, Dan, 245
Júnior, Euler, 97

K

Kahler, Karl, 62
Kai, Ong Chin, 139
Kalmre, Vahur, 198
Kambar, Michael, 138
Kamdila, Dimitra, 104
Kamenitz, Eliot, 145
Kamidoi, Wayne, 57, 73
Kaplan, Blake, 28
Karklis, Laris, 173-174
Kastner, Patrick, 231
Katsuda, Miyoshi, 198, 200, 209
Kaufman, Carol, 242
Keegan, Michael, 67, 173-174
Keener, J. Kyle, 159, 186
Kehe, Emily Reid, 155, 158
Kellams, Mike, 88
Kelley, Gary, 84
Kelley, Lori, 186
Kelly, Colleen, 118
Kelly, Douglas, 76-77, 87, 90-92, 94, 116, 229, 231, 234
Kelly, Laura, 61, 167
Kelsen, Don, 151
Kelso, Karen, 87-88
Kelso, Nathaniel Vaughn, 173-174
Kempeneers, Patricia, 121
Kennedy, Sara, 138, 155
Kepka, Mike, 139, 163, 245
Kerle, Juan Antonio, 227
Kerrigan, Brian, 157-158, 161, 165
Ketcham, Robbie, 216
Kettering, Dave, 149, 154
Key, Bill, 186
Kilgallen, Margaret, 112
Kin, Marian, 121
Kinney, Barbara, 66, 154-155
Kirk, Malcolm, 163
Kiziltug, Cem, 105, 131
Klee, Gregory, 104, 130, 239
Klemm, Barbara, 110
Klocke, Michael, 221
Kment, Maria, 196
Knap, Marek, 255
Knobl, Erik, 188, 195, 206-208
Kodas, Michael, 160
Kohlbauer, Don, 64
Komenich, Kim, 245
Komives, Stephen, 66, 91, 94
Konradi, Mark, 99
Koot, Laura, 76, 92, 94, 234

Kordalski, David, 60, 84-85, 88, 132, 179
Koski, Ben, 183
Kotilainen, Heikki, 196
Kover, Becky, 228, 231
Kow, Ilan, 103, 117
Krämer, Barbara, 103
Kraus, Orlie, 131, 230, 237
Kreiter, Suzanne, 143
Kresl, Lisa, 256
Kroll, John, 88
Krueger, Eddie, 136
Kurita, Ami, 233
Kuther, Andreas, 104, 110, 121
Kuykendall, Jim, 58, 80, 97, 231
Kwok Hing Fai, Nick, 135
Kyser, Kevin, 206

L

Labak, Aleta, 86
LaFlamme, Corey, 203, 205
Laforet, Vincent, 55
Laguna, Noe, 207
Lai Chun Wing, Vik, 141
Lambert, David, 108, 218, 228
Lambert, Ken, 66
Lamers, Chantal, 175
Lang, Becky, 256
Larmer, Paul, 98, 262
Larsen, Alexis, 110, 117
Lauder, Thomas, 52, 180
Laughlin, Michael, 30
Laumann, Scott, 242
Laurent-Lefevre, Sophie, 142
Lauron, Neal C., 231
Lautens, Richard, 233
Lavalle, Fabián, 208
Lavey, Megan, 188, 190, 212
Lawrence, Mary Ann, 229
Layton, Steve, 88
Lazar, Zohar, 115
Lázaro, Luis, 202
Lazo, Orlando, 222
Leang, Amy, 230
Leavell, Garry, 99
Leduc, Louise, 218
Lee, Chang W., 136, 142
Lee, Jeanine, 93
Lee, Kristopher, 67, 179, 250
Lee, Wanjiun, 210
Leeds, Greg, 131, 230
Leeds, Mark, 253
Lehmann, John, 147
Lehmann, Martin, 135
Leigh, Ann, 57
Leiva, Jose, 190
Lenz, Kristin, 88
León, Oliver, 209
Leung, Shirley, 87
Leveillee, Francis, 87, 115, 132, 218
Levkovits, Danielle, 205, 214
Levy, Andrea, 60, 84-85, 132, 158-160
Levy, Mike, 60, 140, 244
Lewis, Charles, 87
Lewis, David, 234
Lewtons, Richard, 66
Lim, Stephanie Grace, 109, 238

Lindahl, Fredrik, 194
Lindkvist, Jonas, 148
Lipin, Howard, 136, 167
Lira, Jorge Armando, 195
Livingston, Thad, 218
Livingstone, Elaine, 65, 73, 96, 224
Lo Valvo, Gustavo, 115, 128, 170, 172-174, 179, 223, 225
Loeffelholz Dunn, Tracy, 179
Logan, Michael, 103
Lohr, Lilah, 109, 224
Long, Belinda, 30, 175
Long, John, 116
López, Eva, 123-124, 128
López, Luis Enrique, 188, 195, 206-208
López, Ricardo, 200
Lopez Williams, Sarah, 261
Lorenzi, Kevin, 189
Lortie, Marie-Claude, 107-108
Losada, Paula, 188
Loscri, Pablo, 170, 172-174, 179
Loubere, Phil, 62, 87
Lourenco, Gil, 79
Lovett, Greg, 244
Loya, Hugo, 181
Lozano, Pablo, 151-153
Lu, Lily, 164
Lucas, David Fernandez, 191
Lugo, Luis Gerardo, 195
Lukens, Victoria, 123
Lum, Fred, 137
Lund, Rick, 72
Lundborg, Beatrice, 107, 162
Lussier, Jean-Claude, 229
Lutz, Judy, 75
Lyle, Carrie, 258
Lyons, Ken, 66, 94

M

MacDonald, Brady, 53, 171, 177, 179
MacIvor, Rod, 151
MacKay, Chris, 253
MacMullin, Donna, 116, 243
Madonik, Rick, 66
Magalhães, Beto, 97
Magdaleno, Paulina, 205
Mahoney, Joe, 43, 151, 245
Mahoney, Phil, 99, 176
Mahurin, Jeff, 196
Maidla, Ove, 198
Maierbrugger, Arno, 197
Malkasian, Ian, 56
Malok, Andre, 95
Malone, Michael, 62
Maloney, Brenna, 67
Manning, Maggi, 256
Mansfield, Matt, 62-63, 87, 154, 168, 184, 228, 263
Maoloni, Isabella, 98
Mapes, Lynda V., 176
Mar, Rod, 66, 72
Marañón, Rafael, 222-223
Marcelo, Carlos, 74-75, 79, 93, 117
Marlashti, Reza, 205
Marlatt, Kenney, 228
Marois, Michel, 87
Marschall, Gerhard, 196, 202

Marsh, Bill, 57
Marshall, Ken, 179
Marshall, Wayne, 260
Marsters, David, 82
Marsula, Daniel, 130
Martía, Chema, 38
Martin, Antonio, 128, 254
Martin, Elsa, 216
Martín, Julio, 38, 176
Martin, Virginia, 233
Martínez, Carlos, 250
Martinez, Cristina, 230
Martínez, Damián, 146
Martínez, Gabriel, 200
Martínez, Ulises, 193
Martínez Aznárez, César, 210-211
Marton, Andrew, 109
Marx, Damon, 99
Mascaro, Christiano, 188, 209
Masuda, Nick, 184, 195, 263
Matadin, Vinoodh, 161
Matia, Chema, 248
Matiisen, Janet, 105
Matos, Sónia, 32, 131, 202, 204
Mattsson, Jonny, 47
Maximchenko, Svetlana, 111
May, Meredith, 234
Mayer, Robert, 30, 61, 167
Mayer III, Emmett, 64, 117
Maynard, Patrick, 195
McAdory, Jeff, 244
McAlley, John, 109
McAllister, Steve, 83
McAndrews, Michael, 58, 157
McCarthy, Heather, 188, 190, 197, 212
McClard, Gerald, 136
McConnell, Linda, 137
McCoy, James P., 86
McCrimmon, Cyrus, 86
McCutchen, John, 94, 220
McFadyen, Scott, 131
McGuire, Thom, 45, 58, 80, 97, 165, 168, 225-227
McKean, Jason, 115
McKenzie, Rob, 234
McKinstry, Steve, 56, 175
McKoy, Kirk, 50, 151, 157
McLeod, Cinders, 158, 161
McLeod, Kagan, 116
McMullan, Michael, 244
McMullen, Michele Lee, 67, 180, 250
McNeal, Christine, 256
McParland, Kelly, 92, 94
McTyre, Mark, 72, 232
Mecea, Robert, 147
Medema, Randy, 219
Medina Martinez, Elizabeth, 199
Medrano, Alexandro, 194-195, 198-200, 205, 208
Megson, Jody, 83
Melendez, Andrea, 150
Mendes, Marcos, 117
Mendez, Em, 198
Mendi, Ricardo, 254
Mendoza, Luis Eduardo, 211
Merithew, James, 96, 139, 163, 245
Merrill, Dave, 178
Merriman, Justin, 165
Mery, Poly, 104
Mesones, José Antonio, 254

Messina, Richard, 58, 97, 165
Metzger, Mike, 195
Metzger, Pete, 34, 50, 95, 228
Meurice, Stephan, 76-77, 92, 94
Meyer, Linus, 108
Meyer, Rick, 100, 164
Michalowski, Jim, 147, 148
Michelin, Marcos, 97
Migielicz, Geri, 63, 168
Miller, Joanne, 175-176
Miller, Monique, 109
Mina, Frank, 96, 219, 234
Mina, Val B., 113, 261
Miner, Mike, 117, 165
Minister, Scott, 42, 228, 231
Miranda, Adriano, 126
Miranda, Randy, 246
Mirko, Mark, 58, 150, 168
Miyashita, Yosuke, 233
Mizraji, Paula, 128
Möglund, Anne-Marie, 226
Molcak, Kathryn, 105
Molen, Jan, 34, 95, 157
Molina, Genaro, 51, 164
Molina Rodríguez, Saúl, 189
Mollering, David, 64
Momphard, David, 209
Monasterio, Napo, 233, 260
Mondino, Jean-Baptiste, 162
Monroe, Bryan, 28
Monteith, Kenny, 184, 219
Moody, Matt, 53
Moon, Jason, 184, 219
Moore, Chris, 160
Moore, Malowy, 179
Moore, Randall, 147
Mora, Jorge, 73, 94, 233
Morales, Fernando, 157
Morance, Peter, 87
Moreira, Julio, 79, 97
Morel, Gerardo, 170
Morgan, Michael, 74
Morlesín, Rodrigo, 178
Morley, Sarah, 102
Morris, Don, 230
Morrow, Sue, 140, 165, 261
Moschella, Nick, 82, 232
Most, Doug, 130, 155, 157-158
Motley, Lorne, 163
Moy, Kim, 88
Moyer, Bruce, 45, 58, 166, 168, 225-226
Moyer, Suzette, 45, 58, 80, 97, 108, 112, 116, 119, 165, 168, 225-227, 231
Muldt, Maria, 96
Muller, Ingrid, 46, 86
Mullin, John, 97
Mulvey, Michael, 99
Munera, Javier, 250
Muñiz, Gabriela, 199
Muñoz, Enrique, 250
Munson, John, 150-151
Murdoch, Sarah, 229, 231
Murphey, Lance, 42
Murphy, Angela, 76, 77
Murphy, Christine, 87
Murphy, Lance, 244
Muzik, Peter, 202
Myers, Gene, 86, 152, 230

PEOPLE

N

Nadel, Adam, 45
Nagore, Guillermo, 128, 161
Nájera, Alejo, 82-83, 86, 89,
 151-153, 178
Nakamura, Motoya, 56
Nalin, Orhan, 131
Nanista, Bryan, 211-212
Nash, Noel, 49, 99
Neal, Christopher Silas, 240
Neal, Ron, 50
Needley, Michael, 76
Nelson, Fred, 66, 163
Nelson, John K., 42, 244
Nelson, Paul, 78, 96
Nelson, Paula, 143
Nesbit, Vickie, 56
Neto, Dulce, 126
Netopilek, Matthias, 197
Neumann, Jeff, 80
Neustaedter, Carl, 72-73, 85, 93, 253
Nguyen, Lynn, 256
Niblock, Daniel, 171
Nichols, Catherine, 118
Nichols, Greg, 99, 176
Nieto, Raquel, 250
Nigash, Chuck, 189, 204, 205
Nijhuis, Michelle, 262
Nilson, Maria, 203
Ninomiya, Erik, 96
Nista, Larry, 173-174
Nobles, Rick, 236
Noguchi, Teppei, 233
Nørregard, Claus, 111
Norris, Adrian, 72, 76
Nowak, Rudy, 28
Nowlin, Mark, 67, 176, 250
Nunes, Luis Pedro, 111
Nyeland, Søren, 43, 106, 111, 123

O

O'Boyle, John, 144
O'Connell, Frank, 248
O'Donnell, Conor, 92
Oberneder, Doris, 121, 182
Ochoa, Dennis, 230
Ochoa, Heriberto, 199
Ogando, Vera, 188, 209
Okamoto, Jennifer, 256
Okasaki, Douglas, 234
Olby, Yan, 210
Oleniuk, Lucas, 66, 81, 146, 149, 158
Oliveros, Matilde, 115
Olmos Castillo, Raúl, 189, 195, 199
Omori, Dale, 60
Orellana, Gabriel, 100
Orellana, Magno, 93
Orr, Francine, 34, 52, 53, 166, 244
Ortega, Juan Carlos, 206, 208
Ortíz, Hamlet, 207
Ortiz Roca, Montse, 255
Osci, Vanina, 125, 127
Ostalé, Pilar, 73, 94, 233-234
Østergren, Tomas, 43, 106, 123
Ouellette, Shawn Patrick, 134

Ouimet, Michele, 95, 107-108, 123,
 132, 218, 225, 228
Oxman, Elly, 150-151

P

Paasch, Hope, 176
Pablo Simón, Juan, 194-195
Pablos, Pedro, 254
Paez, Hugo, 194-195, 198-200, 205,
 208
Page, Clif, 189
Pai, 62
Palacios, Agustín, 68, 100, 222
Palle, Henrik, 111
Palma Arvizu, Adrián, 189, 195, 199
Palmer, Randy, 110, 117
Paluots, Alari, 191
Pang, Debra, 73
Panos, 134
Papakosta, Mary, 102
Pardo, Antonio, 127
Parillo, Rosemary, 263
Parks, Dave, 233
Parley, Graham, 73, 85
Parson, Kim, 219
Paslay, Jeff, 72
Patrick, Michael, 141
Patrucco, Sergio, 204
Patterson, Mary Jo, 224
Patterson, Richard, 138
Pease, Tiffany, 138
Peattie, Peggy, 168
Peçanha, Sergio, 181-182
Pedrosa, Wilson, 103, 117
Peloquin, Tristan, 132
Peña, Enrique, 92
Penman, Stephen, 73, 83, 224
Penrod, Josh, 64, 94, 153, 220, 260
Penttinen, Kimmo, 196
Pereira, Natacha, 202
Pérez, Ana, 73, 94, 233-234
Pérez, Hugo Èric, 198
Perez-Díaz, Carlos, 255
Perine, Drew, 164
Peroutka, Günter, 202
Peters, Sherry, 119, 166
Petiz, Joana, 204
Petricevic, Mirko, 163
Petty, Matt, 68, 112, 219, 238
Peyton, Tom, 30, 59, 107, 167, 171,
 175, 180
Pfeifer, Jack, 55
Phan, Hieu, 230
Phelan, Peter, 188
Phillip, Melissa, 144
Phillips, Josh, 195
Phillips, Mark, 179
Piaggio, Carmen, 222
Piedra, Laura, 222-223
Pierro, Wendy, 74
Pilrsalu, Jaanus, 191
Pilster, Chad, 148
Pimenta, Paulo, 134
Pinchin, Neil, 87-88
Pinheiro, Flavio, 103, 105, 117
Pinn, Merike, 191
Pinto, Hugo, 104, 111, 113-116, 126
Piscotty, Marc, 43, 245

Pisetzner, Joel, 224
Pitzer, Wm, 176
Platon, Andrea, 222
Pleininger, Hans, 197
Pohlert, Christian Mathias, 227
Poindexter, Sandra, 52, 180
Poisson, Cloe, 231
Portaz, Jorge, 174
Porter, J, 160
Porter, Kent, 162
Porter, Mark, 253
Powell, Kristen, 260
Powell, Ryan, 188, 190, 192-193,
 213
Power, Peter, 66
Powers, Jack, 92
Powers, Scott, 115
Prager, Michael, 120
Pratt, David, 72, 76, 83, 137, 147,
 157-158, 161, 165
Prekas, Antonis, 102
Price, Larry, 46
Price, Michael, 64, 220, 230, 260
Probst Pruneda, Alexander, 147,
 189, 199-200
Pryor, Judy, 34, 95, 151
Puckett, David, 175-176
Pulferfocht, Karen, 244
Püttsepp, Juhani, 198

Q

Quadracci, Jay, 168
Quezada, Ricardo, 99

R

Rach, Alan, 105
Rachles, Ed, 96
Racovali, John, 92, 94
Ralha, Leonardo, 32
Ramberg, Anders, 197
Ramírez, Héctor, 92-93, 99, 170
Ramírez, Norma, 200
Ramirez, Pablo Ma, 216
Ramírez, Tristán, 177
Ramos, Marcelo, 75, 79
Ramos Cruz, José Servando, 195
Ramsbottom, Sara, 123
Ramsess, Akili-Casundria, 62-63
Rand, Wes, 226
Randklev, Jessica, 205
Rañoa, Raoul, 51, 53, 171, 177, 179
Rasmussen, Randy, 56
Rasmussen, Tim, 30, 59, 167
Ravenscraft, Stephen, 117
Reagan, Denise, 61
Reardon, Patrick T., 184, 224
Reck, Timothy, 116, 119, 225
Redactor Staff, Orellana, 100
Reese, Tim, 135, 165
Reina, Carlos, 193
Reinken, Tom, 53
Reksten, Patty, 56, 76, 160
Renfroe, Don, 196
Rhodes, Ted, 150, 163
Ricca, Paulo, 134

Rich, Mike, 106
Richards, Eugene, 127
Richardson, Helen H., 137
Riche, Epha, 99
Rinaldi, Angelo, 98
Ringborg, Maria, 119
Ringman, Steve, 176
Ríos, Lázaro, 252
Rios, Raymundo, 83, 89
Ripoll, Paula, 252
Rivera, Alexander, 99-100, 193-194
Rivera, Horacio Trejo, 205
Rivera, Luis Enriquez, 199-200
Rivest, Andre, 107, 123
Riyait, Jaspal, 131
Roberts, Janet, 55
Roberts, Jerry, 195
Roberts, Julie, 53
Rocha, Michael, 141
Rochette, Jen, 108
Rock, Roberto L., 146, 181
Rodas, Esteban, 93, 99
Rodriguez, Alejandro, 89
Rodriguez, Edel, 112
Rodríguez, Hugo, 92
Rodriguez, Paul, 52
Rodríguez, Remberto, 92-93, 96,
 218
Rodríguez, Víctor Edú, 82
Rodwell, Crispin, 149
Roemers, Martin, 104
Rogers, Andy, 91
Rogers, Julie, 34, 51, 164, 167
Rokicki, Rich, 175
Romagosa, Rick, 245
Román, Marco Antonio, 210-211
Romanoff, Dana, 204
Romarosa, Rick, 139
Ros, Alejandro, 125, 127
Rosato, Juliana, 125
Rose, David, 167, 219
Rosenblum, Gail, 246
Rosenthal, Robert, 219
Ross, Bob, 84
Ross, Chris, 230, 260
Ross, Genevieve, 154
Ross, Jim, 158
Rossi, Max, 79
Rossi, Silvia, 98
Rourke, Matt, 145
Rowley, Naomi, 257
Roy, Alexandre, 107
Roy, François, 107
Rubin, Richard, 176
Rubio, Fernando, 172-174
Ruble, Sharon, S, 184
Rudick, Dina, 158
Rueda, Humberto, 206
Ruiz, Marco, 169
Ruiz, Rafael, 92, 94, 199
Rukan, Chris, 82, 232
Ruscitti, Joe, 183
Russell, Chris, 42
Russell, Steve, 139, 152
Russo, Robert F., 231
Rust, Max, 184
Rutberg, Ingela, 189
Rutherhagen, Johan, 109-110
Ryall, Zach, 145, 148
Ryan, Carolyn, 139, 256
Ryan, David L., 155

Ryan, Jay, 109
Ryan, Kathy, 56, 124, 127-128, 159-164, 166
Rydqvist, Jenny, 106

S

Sackowski, Kyle, 87
Sadler, Evangeline, 108
Saeger, Andrew, 175
Saglam, Mustafa, 105
Saiz, Jose Carlos, 220, 226, 232
Salazar, Arturo Adrián, 82
Saldivar, Lou, 256
Sale, John, 42, 244
Sales, Fabio, 103, 105, 117
Sales, Kleber, 117
Salgado, Sebastiao, 98
Sama, Gabriel, 200
Sánchez, Alejandro, 153
Sánchez, Eduardo, 199
Sánchez, Francisco, 89, 92, 94, 199
Sánchez, Hugo Alberto, 82-83, 86, 89, 151-153, 178
Sánchez, Rodrigo, 40, 70, 123-124, 126, 128
Sánchez Márquez, Enrique, 199
Sánchez Ruano, Francisco, 92, 94, 199
Sanderlin, Brant, 151
Sandoval, Emiliana, 261
Sandoval, Ismael, 189
Sanghvi, Uma, 89
Sangosti, RJ, 156
Santacruz, Beatriz, 38, 248
Santamaría, Mauricio, 99
Santanna, Marcelo, 97
Santiago, Alejandro, 128
Santiago, Francisco, 146, 181
Santiago Méndez, Oscar, 146, 181
Santos, Dan, 34, 53, 145-146, 219
Santos, Humberto, 188
Santos, Iban, 73, 94, 233
Santos, José, 81, 92-93, 96, 218, 257
Sanz, Javier, 123-124, 128
Sasaki, Toki, 233
Sætternissen, Peter, 106
Scanlan, John, 45, 58, 80, 97, 116, 165, 226-227
Scattarella, Kraig, 56
Scherer, Sally, 184
Schierlitz, Tom, 127
Schiffer, Theresa, 157
Schlosser, Kurt, 244
Schlumberger, Bruno, 147
Schmid, Paul, 67, 176, 232, 250
Schmid, Thomas, 104
Schmidt, Greg, 139
Schmidt, Olaf, 123
Schneider, Chris, 43, 156, 245
Schneider, Patrick, 134, 144, 154
Schneider, Rob, 49, 99
Schrammel, Britt-Marie, 107-109
Schuessler, Jennifer, 104, 130
Schumacher, Edward, 200
Schutz, David, 37, 81, 236
Schwieger, Jan, 196-197, 202
Scott, Andrew P., 49
Scott, Nadia Borowski, 64, 220

Scott, Zachary, 160
Seabrook, Don, 150, 152
Sebbah, David, 122, 127, 162
Sedgewick, Katherine, 93
Segal, Adrián, 115
Segu, Silvana, 222
Segura, Elena, 172
Seibert, Carl, 30
Semrau, Stefan, 121, 182, 232
Sengül, Erol, 197, 212
Senisse, Jorge, 254
Seper, Vic, 84
Serra Lopes, Inês, 32, 131, 202, 204
Serrano, Blanca, 254
Setzer, Tom, 182
Seuffert, Bettina, 223
Shackelford, Lucy, 67
Shafer, Norm, 96, 186
Shaffer, Mel, 58, 166, 168
Shankweiler, Linda, 76
Sheehan, Bill, 219
Sheer, Julie, 180
Sheffer, Meredith, 48, 203-204, 208
Sherlock, Steve, 48, 188
Shiiki, Julio Kohji, 105-106, 203
Shoun, Brenda, 87-88
Siditsky, Seth, 150-151
Siegel, Mike, 163
Silva, Darron, 75
Silva, Joao, 142
Simms, Brian, 219
Simms, Roger, 147
Simon, Taryn, 124, 162
Sinclair, Steve, 218
Sinco, Luis, 53, 165
Siner, Jeff, 148
Sirois, Alexandre, 123
Skalij, Wally, 168
Slater, Devin, 72-73, 85, 93, 253
Slezic, Lana, 161
Slover, Daryn, 190
Smith, Andrew, 90
Smith, Colin, 46, 189, 204
Smith, Dita, 173
Smith, Doug, 51-52, 180
Smith, Emmet, 60, 84-85, 179
Smith, Erica, 186, 262
Smith, Ernie, 191
Smith, Howard, 86
Smith, Jami C., 63
Smith, Layne, 182
Smith, Marquita, 186
Smith, Meg, 173
Smith-Rodden, Martin, 96
Snow, Tim, 108
Soares, José, 81, 134
Sokolova, Tatiana, 111
Solis, Abraham, 210
Soltow, Lucas, 208
Søndergaard, Bo, 43, 106
Sorooshian, Roxanne, 65, 96, 102
Sosa, Federico, 225
Soth, Alec, 164
Sotirovic, Mira, 184
Soutar, Paul, 74
Sparks, Laura, 184
Speer, Amy, 168
Spengler, Margaret, 113
Sperry, Sean, 262
Spíndola, Glauco, 209
Spolar, Christine, 165

Spooneybarger, Michael, 90
Sports Staff, 193
Spratt, Gerry, 195
St. John, Robert, 100, 152, 164
Stalter, Clayton, 209
Stanfield, Chris, 149
Stanton, Laura, 67
Starkey, Mike, 60, 85
Staublin, Grant, 87
Steen, Anneli, 108, 148, 162
Stein, Ray, 231
Stensrud, Whitney, 67, 250
Stephens, Brendan, 130, 155, 157-158
Stephens, Chris, 156
Stepien, Tim, 244
Stern, Reuben, 216
Stevens, Doug, 51, 53, 75, 180
Stewart, Chuck, 88
Stocker, Mike, 30
Stoddard, Scott, 91
Stollorz, Volker, 121
Stone, Kevin, 49
Storey, John, 219
Strachan, Eric, 75
Straker, Matthew, 257
Straus, Tamara, 219
Strawser, Kris, 74
Streeter, Kurt, 100, 164
Strickland, Dee-Dee, 175
Strotheide, Guido, 209-210
Stroud, Steve, 34, 51, 53, 75, 89, 164, 167
Stubbs, Barbara, 113, 261
Suárez, Luis, 191
Suhanic, Gigi, 87
Suhay, Robert, 96
Sullivan, Kelli, 34, 95, 165, 168, 244
Sullivan, Mike, 74
Sumlin, Todd, 134, 138
Summers, Dustin, 120
Sureck, Shana, 80
Sutherland, John, 46
Svensson, Jörgen, 203
Swall, Lexey, 75
Sweet, Doug, 107, 120
Swenson, Dan, 64, 117, 173, 178, 182

T

Tajes, Luis, 74-75, 79, 93
Takahashi, Kuni, 165
Tanzer, Richard, 202
Tarica, Joe, 72, 188
Taxa, Vanessa, 81, 134
Tehan, Pat, 154
Telford, John, 175
Tell, Judy, 144, 148, 154
Tenorio, Oscar, 218
Tepps, Dave, 82, 232
Testa, Andrew, 138
Thibault, Charlotte, 166
Thiede, Ed, 94
Thole, Tippi, 110, 221
Thomas, JT, 98
Thomason, Robert E., 173
Thomma, Norbert, 104
Thomson, Roddy, 73, 224

Thorp, Gene, 67, 174, 234
Threard, Yves, 142
Tiago Pinto, Nuno, 131
Tierman, Bill, 157
Tiffet, Christian, 207, 213
Timms, Trevor, 84
Toledo, Guillermo, 252
Toledo, Isabel, 59, 246-247
Toohey, Tannis, 141
Torregrosa, Alberto, 92, 94, 199, 222-223
Torres, Leonardo, 86
Torres Lira, Teodoro Wilson, 81, 92-93, 96, 218
Tostado, Alejandro, 209
Tozer, Tom, 175, 176
Trapnell, Tom, 52
Tremblay, Mark, 263
Tremblay, Martin, 87, 225
Trevan, Dan, 141
Tribble, Michael, 229
Trigo Viera, Mariana, 222
Troch, Jon, 121
Trojanowski, Marek, 255
Troncale, Bernard, 233
Trottier, Armand, 115
Trottier, Eric, 95, 218, 225, 228
Trujillo, Joshua, 138, 244
Trumball, Todd, 219
Trumbull, Tracey, 141
Tsang, Wilson, 103
Tse, Archie, 54-55, 57, 182-183
Tsui, Van, 224
Tuck, Andrew, 123
Tumas, Alejandro, 170, 172-174, 179
Tung, Lam Chun, 142
Turley, Richard, 253
Turner, James, 104
Turner, Jamie, 85
Turner, Lane, 87, 120, 153
Turner, Lonnie, 256
Tusa, Susan, 135

U

Uda, Také, 247
Uemura, Shinya, 233
Ulloa, Sylvia, 62
Uncles, Alison, 72-73, 85, 93, 253
Urban, Mike, 158
Urbanski, Steve, 239
Uriarte, Angélica, 200
Urresti, Kristina, 73, 94, 233-234
Utko, Jacek, 191, 214

V

Vähä, Petri, 196
Vaia, Sandro, 103, 105, 117
Valdes, Vanessa, 166
VanHemmen, Pim, 144, 150-151, 164, 224
Van Lamsweerde, Inez, 161
Van Paassen, Kevin, 165
Vanac, Mary, 132
Vander Brug, Brian, 145
Vangeemput, Ren, 121

PEOPLE

VanHemmen, Pim, 144, 150-151, 164, 224
Vanover, Rhonda, 30
Varela, Geraldine, 218
Vargas, Ana, 128
Varney, Dennis, 219
Vasquez, Annette, 150-151
Vault 49 Illustrator, 127
Vázquez, Carlos, 223
Veigel, Lisa, 256
Veletakos, Nikos, 102
Velez, Chris, 49, 99
Ventura, Marco, 130
Ver Elst, Pieter, 121
Vidrio, Jorge, 90
Vigneault, Alexandre, 115
Vignoles, Mary, 30, 61, 167
Villa del Angel, Fernando, 146
Villa Domínguez, Carlos, 147
Villacorta, Orus, 68
Villalta, Cristian, 68, 99, 100, 192-194, 222
Villanueva, Baldomero, 92, 94, 199
Villarreal, Benjamin J., 74
Villavicencio, Oscar, 195
Villegas, Jose Luis, 135
Villegas-Nika, Valentina, 102, 104
Viruega, Pablo, 83
Vite, Max, 205
von Rauchhaupt, Ulf, 182

Whitley, Michael, 34-35, 51-53, 75, 84, 89, 100, 145-146, 152, 156, 164-168, 180, 184, 197, 219, 244
Whittle, James, 103
Wile, Jon, 85
Wilgoren, Jodi, 183
Wilkinson, Leslie, 154
Williams, Celeste, 72
Williams, Greg, 90
Williams, Sherman, 139, 157
Wilson, Chip, 176
Wilson, Kevin, 253
Wilson, Wade, 175
Winter, Damon, 50, 157
Winters, Dan, 128, 166
Winther, Tine-Maria, 43
Wirsén, Saina, 132-133, 241
Wischnewski, Katja, 90
Wise, Michelle D., 185
Withey, Deborah, 78, 96, 137, 146, 154-155, 157, 186
Wittekind, Don, 171, 175, 180, 247
Wohlfahrt, Rainer, 121
Woike, John, 58, 168
Wolfe, A.J., 244
Woodside, David, 83, 157, 165
Workman, Michael, 44
Wright, Randy, 46
Wynn, Spencer, 81, 233

W

W.K. Interact, 132
Wadden, Ron, 87
Waldersten, Jesper, 108, 110, 130
Walker, Craig F., 141
Walker, Richard, 65, 96, 102
Walker, Scott, 260
Wallace, Catherine, 74
Wallace, Peter, 37
Walldin, Sören, 210
Wallen, Paul, 48, 188, 190, 192-193, 203, 205, 229
Wallin, Linus, 194, 210
Wambsgans, E. Jason, 224
Wang, Chin, 120
Wang, Lorraine, 34, 51, 53, 75, 219
Ward, Brant, 245
Ward, Joe, 179
Wasserman, Jeff, 76-77, 92, 94
Waters, Lannis, 244
Waters, Randy, 28
Watts, James C., 196
Webber, George, 154
Wehling, Cindy, 98, 262
Weiss, Diane, 152, 230
Weissenmayer, Barbara, 121
Wells, Hal, 50, 151
Welsh, Jillian, 228
Wendt, Kevin, 28, 62, 87, 228, 263
Wernhamn, Gunilla, 47, 119, 238
West, Andrew, 243
White, John, 30
White, John D., 196

XYZ

Xipolitidou, Afroditi, 104

Yablonski, Patty, 108, 159
Yanni, Mary, 180
Yasukawa, Mitsu, 231
Yazici, Fevzi, 105, 131
Yee, Ted, 117
Yeh, Tomas, 119
Yemma, Mark, 219
Yi, Guo, 218
Ying, Paola, 208
Yip, Russell, 139, 245
Youngblut, Shelley, 154
Yourish, Karen, 181
Youso, Karen, 246
Yuill, Peter, 258
Yule, Dorothy, 96
Yzena, Roger Hiyane, 105-106, 203

Zacchino, Mike, 56
Zacchino, Narda, 234
Zafra, Mariano, 38, 177, 250
Zars, Bill, 243
Zdon, Jennifer, 171
Zedek, Dan, 37, 44, 81, 84, 87, 89, 104, 120, 130, 143, 153, 155, 157-158
Zerman, Mariana, 115
Zimmerman, Steve, 59
Zúñiga, Aarón C., 83, 86, 89
Zúñiga, Diego, 222-223
Zúñiga, Juan Carlos, 147, 189, 199-200

A

ABC (Madrid, Spain), 172-174, 178, 224, 246, 256
a.m. De León (León, México), 189, 195, 199
Akzia (Moscow), 111
Albuquerque Tribune, The (N.M.), 196
Asahi Shimbun, The (Tokyo), 218, 233
Atlanta Business Chronicle, 196
Atlanta Journal-Constitution, The, 151
Austin American-Statesman (Texas), 145, 148
Australian, The (Sydney), 84

B

Baltimore Sun, The, 44, 140, 149, 232, 258
Beaumont Enterprise, The (Texas), 135
Beaver County Times, (Beaver, Pa.), 189
Berliner Morgenpost (Berlin), 103
BG News (Bowling Green State University, Ohio), 195
Birmingham News, The (Ala.), 233, 260
Bluffton Today (S.C.), 191
Boston Globe, The, 36-37, 44, 80-81, 84, 87, 89, 104, 120, 130, 143, 153, 155, 157-158, 236, 237, 239-240, 259
Boston Globe Magazine, The, 130, 158, 240
Buffalo News, The (N.Y.), 86
Bulletin, The (Bend, Ore.), 197

C

Calgary Herald (Alberta, Canada), 105, 150, 155, 163
Charlotte Observer, The (N.C.), 100, 134, 138, 144, 148, 154, 175-176, 229
Chicago Tribune, 88, 95, 109, 115, 117-118, 165, 184, 224
Clarín (Buenos Aires, Argentina), 115, 117, 128, 170, 172-174, 179, 223, 225
Columbia Missourian, 216
Columbus Dispatch, The (Ohio), 42, 228, 231
Comercio, El (Gijon, Spain), 191-192
Comercio, El (Lima, Peru), 222, 254
Commercial Appeal, The (Memphis, Tenn.), 42, 244
Concord Monitor (N.H.), 166-167, 215, 242
Corpus Christi Caller-Times (Texas), 90
Correio Braziliense (Brasilia, Brazil), 74-75, 79, 93, 117
Correo, El (Vizcaya, Spain), 59, 171, 174, 177, 178, 185-222, 223, 246-247, 249
Correo de Andalucia, El (Madrid, Spain), 255

D

Dagens Nyheter (Stockholm, Sweden), 96, 107-110, 119, 130, 132-133, 148, 162, 226, 241
Daily Herald (Arlington Heights, Ill.), 243
Daily Herald (Provo, Utah), 46
Dallas Morning News, The, 49, 88, 99, 181-182, 226, 256
Dayton Daily News (Ohio), 110, 117
Daytona Beach News-Journal (Fla.), 147, 148
Denver Post, The, 46, 80, 86, 137, 141, 155, 156
Des Moines Register, The (Iowa), 150

Detroit Free Press, 86, 135, 152, 159, 186, 230, 261
Devoir, Le (Montréal), 207, 213
Día, Al (Dallas), 205, 214
Diario de Hoy, El (San Salvador, El Salvador), 81, 92-93, 96, 133, 218, 257
Diário De Pernambuco (Recife, Brazil), 188, 209
Diario Impacto, El (México City), 194-195, 198-200, 205, 208
Diario La Nacion (Buenos Aires, Argentina), 222
Diario Medico (Madrid, Spain), 216
Dose (Toronto), 131

E

Eesti Päevaleht (Tallinn, Estonia), 191
Estado de Minas (Belo Horizonte, Brazil), 79, 97
Estado de São Paulo, O (São Paulo, Brazil), 103, 105, 117
Ethnos Tis Kiriakis (Athens, Greece), 102
Expreso (Hermosillo, México), 147, 189, 199, 200

F

Financial Times Deutschland (Hamburg, Germany), 123
Florida Times-Union, The (Jacksonville), 175
Fort Worth Star-Telegram (Texas), 72, 109, 230
Forum Diplomatik (Istanbul, Turkey), 197, 212
Frankfurter Allgemeine Sonntagszeitung (Frankfurt am Main, Germany), 104, 110, 121, 133, 182, 227
Frankfurter Allgemeine Zeitung (Frankfurt am Main, Germany), 185
Free Lance-Star, The (Fredericksburg, Va.), 48, 203-205, 208-209, 213, 215

G

Gaceta, La (San Miguel de Tucumån, Argentina), 111
Gaceta Universitaria (Madrid, Spain), 127-128, 254
Gazette, The (Montreal), 74, 88, 93, 107-108, 120, 162, 263
Globe and Mail, The (Toronto), 72, 76, 83, 137, 147, 157-158, 161, 165, 169
Gold Coast Bulletin, The (Southport, Australia), 186
Göteborgs-Posten (Goteborg, Sweden), 47, 118-119, 238
Gráfico, El (Antiguo Cuscatlán, El Salvador), 68, 99, 100, 192-194, 222
Great Falls Tribune (Mont.), 247
Guardian, The (London), 16-19, 77, 103, 143, 149, 177, 184, 222, 253
Gulf News (Dubai, United Arab Emirates), 234

H

Hartford Courant (Conn.), 45, 58, 80, 97, 108, 112, 116, 119, 150, 157, 160, 165, 166, 168, 225-227, 231, 239
Herald on Sunday, The (Auckland, New Zealand), 257

Heraldo de Aragón (Zaragoza, Spain), 73, 94, 233-234
High Country News (Paonia, Colo.), 98, 262
Houston Chronicle, 144

I

Imparcial, El (Hermosillo, México), 198, 200, 209
Independent, The (London), 97
Independent on Sunday, The (London), 102, 123
Independente, O (Lisbon, Portugal), 32-33, 131, 202, 204
Indianapolis Star, The, 99, 176
International Press Portuguese Edition (Tokyo), 105-106
International Press Spanish Edition (Tokyo), 106, 203
Irish Examiner, The (Cork, Ireland), 92

J

Jacksonville Journal-Courier (Ill.), 209-210

K

Kalamazoo Gazette (Mich.), 142
Karjalainen (Joensuu, Finland), 196
Kitsap Sun (Bremerton, Wash.), 189, 204-205
Knoxville News-Sentinel (Tenn.), 141
Kristianstadsbladet (Koping, Sweden), 189, 203

L

L.A. Weekly (Los Angeles), 145
LAS / 12-Pagina (Buenos Aires, Argentina), 125
Le Figaro (Paris), 142
Levante-EMV (Valencia, Spain), 211, 214-215
Lexington Herald-Leader (Ky.), 184, 219
Light (Moscow), 122
London Free Press, The (London, Ontario, Canada), 183
Los Angeles Times, 34-35, 50-53, 75, 84, 89, 95, 100, 109, 112, 145-146, 151-152, 156-157, 164-166, 168, 171, 177, 179-180, 184, 219, 228, 236, 242, 244

M

Miami Herald, The, 169
Milwaukee Journal Sentinel (Wis.), 139, 157, 256
Ming Pao Daily News (Hong Kong), 102, 135, 141, 142
Morgenavisen Jyllands-Posten (Viby, Denmark), 139
Mundo, El, - M2 (Madrid, Spain), 245
Mundo, El (Madrid, Spain), 38-39, 69, 169, 176-177, 215, 220, 226-229, 232, 240-241, 246, 248-250
Mundo Magazine, El (Madrid, Spain), 123-124, 128
Mundo Metropoli, El (Madrid, Spain), 40, 70, 126, 241
Muskegon Chronicle (Mich.), 206

PUBLICATIONS

N

Naftermporiki (Athens, Greece), 104
Naples Daily News (Fla.), 75
National Post (Toronto), 76-77, 87, 90-92, 94, 116, 133, 169, 229, 231, 234, 243
Nevada Sagebrush, The (University of Nevada, Reno), 193
New York Times, The, 54-55, 57, 73, 87, 89, 96, 98, 134, 136, 138, 140, 142, 159, 172, 179, 180-183, 185, 232, 247-248, 250
New York Times Magazine, The, 56, 122, 124, 127-128, 130, 132-133, 159-164, 166
News & Record (Greensboro, N.C.), 74, 82
News Journal, The (Wilmington, Del.), 247
News Tribune, The (Tacoma, Wash.), 164
News-Press, The (Fort Myers, Fla.), 243, 247
Newsday (Melville, N.Y.), 147

O

Omaha World-Herald (Neb.), 86, 218
Orange County Register, The (Santa Ana, Calif.), 87-88, 175
Oregonian, The (Portland), 56, 73, 76, 160, 175, 185, 240
Orlando Sentinel (Fla.), 66, 91, 94
Östgöta Correspondenten (Linköping, Sweden), 98, 118
Ottawa Citizen, 147, 151

P

Palm Beach Post, The (West Palm Beach, Fla.), 56, 82, 89, 232, 242, 244
Palma, La (West Palm Beach, Fla.), 198, 204
Patriot-News, The (Harrisburg, Pa.), 74
Periódico Provincia (Morelia, México), 188, 195, 206-208
Philadelphia Inquirer, The, 183
Pioneer Press (St. Paul, Minn.), 149
Pittsburgh Post-Gazette, 130, 136, 239
Pittsburgh Tribune-Review, 165
Plain Dealer, The (Cleveland), 60, 84-85, 88, 132, 140, 156, 158-160, 179, 244, 249
Politiken (Copenhagen, Denmark), 43, 106, 111, 123, 135
Portland Press Herald (Maine), 134
Postimees (Tartu, Estonia), 198
Prensa, La (Panamá City), 206, 208
Prensa Gráfica, La (San Salvador, El Salvador), 92-93, 99, 170
Press Democrat, The (Santa Rosa, Calif.), 162, 163
Presse, La (Montréal), 87, 95, 107, 108, 115, 123, 132, 218, 225, 228
Público (Lisbon, Portugal), 79, 81, 104, 110-111, 113-116, 126, 134
Puls Biznesu (Warsaw, Poland), 191, 214

R

Radar-Pagina/12 (Buenos Aires, Argentina), 125, 127
Récord (México City), 82-83, 86, 89, 151-153, 178
Record, The (Kitchener, Ontario, Canada), 163
RedEye (Chicago), 74
Reforma (México City), 252
Repubblica, La (Rome), 98
Richmond Times-Dispatch (Va.) 144, 150, 155, 261
Rocky Mountain News (Denver), 33, 43, 134, 137, 140, 143, 147, 150-151, 156, 158, 164, 168, 242, 245
Rumbo (San Antonio, Texas), 200
Rzeczpospolita, The (Warsaw, Poland), 20-23

S

Sacramento Bee, The (Calif.), 113, 135, 140, 165, 261
St. Louis Post-Dispatch, 175
St. Petersburg Times, The (Fla.), 77, 108, 146, 159, 230
San Antonio Express-News (Texas), 230
San Diego Union-Tribune, The, 64, 94, 136, 139, 141, 152-153, 167-168, 220, 230, 260
San Francisco Chronicle, 68, 96, 112, 139, 163, 219, 234, 236, 238, 245
San Jose Mercury News (Calif.), 28, 62-63, 87, 109, 154, 168, 184, 228, 236, 238, 263
Santa Barbara News-Press (Calif.), 195
Savannah Morning News (Ga.), 75
Seattle Post-Intelligencer, 91, 137-138, 158, 244
Seattle Times, The, 66-67, 70, 72, 113, 138, 154-155, 163, 176, 179, 180, 183, 232, 237, 240, 250
Sedalia Democrat, The (Mo.), 208
Semanario, El (México City), 210-211
SonntagsZeitung (Zürich, Switzerland), 121, 182, 232
South China Morning Post (Hong Kong), 103
South Florida Sun-Sentinel (Fort Lauderdale), 30-31, 59, 61, 107, 161, 167, 171, 175, 180, 221, 247, 248
Southwest Journal (Minneapolis), 211-212
Star Tribune (Minneapolis, Minn.), 72, 110, 118, 221, 246, 255, 257-259
Star-Ledger, The (Newark, N.J.), 95, 144, 150-151, 164, 180, 182, 224, 231, 263
State, The (Columbia, S.C.), 152
Straits Times, The (Singapore), 139, 176
Sun Herald, The (Biloxi, Miss.), 28-29
Sun Journal (Lewiston, Maine), 48, 188, 190, 192, 193, 197, 203, 205-206, 212-213, 229
Sunday Herald (Glasgow, Scotland), 65, 69, 73, 83, 96, 102, 224, 252
Sunday Morning Post (Hong Kong), 103
Sundsvalls Tidning (Sundsvall, Sweden), 194, 210
Superdeporte (Valencia, Spain), 252
Sur (Malaga, Spain), 92, 94, 199
Swerve (Calgary, Alberta, Canada), 154
Sydsvenskan (Malmö, Sweden), 106, 225

T

Tagesspiegel, Der (Berlin), 104, 223
Taipei Times (Taiwan), 209, 210
Tampa Tribune, The (Fla.), 90, 107
Telegraph Herald (Dubuque, Iowa), 149, 154
Times of Northwest Indiana, The (Munster), 106, 262
Times-Picayune, The (New Orleans), 26-27, 64, 78, 117, 137, 140, 144-145, 148, 173, 178, 182, 291
Toronto Star, 66-67, 72-73, 81, 85, 93, 116, 136, 139, 141, 146, 149, 152-153, 158-159, 161, 233, 253
Tribune, The (San Luis Obispo, Calif.), 72, 188, 206
Tuscaloosa News, The (Ala.), 207

U

Universal, El (México City), 146, 181
Upsala Nya Tidning (Uppsala, Sweden), 119
USA Today (McLean, Va.), 178

V

Vacature (Groot-Bygaarden, Belgium), 121
Vanguardia (Saltillo, México), 211
Virginian-Pilot, The (Norfolk), 78, 96, 137, 146, 154, 155, 157, 186

W

Wall Street Journal, The (South Brunswick, N.J.), 131, 230, 237
Washington Post, The, 67, 94, 173-174, 181, 234, 246
Washington Post Magazine, The, 160
Welt, Die (Berlin), 90, 221
Welt am Sonntag (Berlin), 78, 220, 231
Wenatchee World, The (Wash.), 150, 152
Wichita Eagle, The (Kan.), 74
WirtschaftsBlatt (Vienna, Austria), 196-197, 202
Wisconsin State Journal (Madison), 184

Z

Zaman (Istanbul, Turkey), 105, 131
Zeta Weekly (Tijuana, México), 90, 201